DATE DUE

TRADITIONS
OF JAPANESE ART

TRADITIONS OF JAPANESE ART

SELECTIONS
FROM THE KIMIKO AND JOHN POWERS
COLLECTION

JOHN M. ROSENFIELD
SHŪJIRŌ SHIMADA

FOGG ART MUSEUM
HARVARD UNIVERSITY
1970

Photographic credits

Otto E. Nelson, New York City

1, 2, 5–10, 12–16, 18–21, 23–27, 30, 32, 34–36, 38, 39, 46, 47, 50–56, 62, 66, 67, 83, 90–94, 98, 109, 111, 116, 120, 137, 138, 140, 150, 152, 153; color 13, 62, 83, 144

Fogg Art Museum (James K. Ufford and Michael Nedzweski)

3, 4, 11, 22, 28, 29, 31, 37, 40–45, 48, 57–61, 63–65, 68–71, 73, 75–77, 80, 84–89, 95–97, 99–108, 109 (det.), 112–115, 117–119, 121, 123–133, 141–143, 145–149, 151; color 22, 49, 69, 94, 115, 146

Geoffrey Clements, New York City

72, 74, 78, 79, 134–136; color 44, 72, 107, 135

L.C.C. No. 76–133788

FOREWORD

The exhibition "Traditions of Japanese Art: Selections from the Kimiko and John Powers Collection" represents a collaborative effort that has been unusually broad and felicitous. It has brought together in harmony East and West, collectors and connoisseurs, established scholars and those taking their first steps in a field that is to be their specialty. Mr. and Mrs. Powers have been generously willing to part with their treasures for a long period of time, so students and experts alike have been able, through close and repeated examinations, to become intimately acquainted with objects of a kind that are rarely available for study outside Japan.

In this exhibition the Fogg Museum continues a long tradition of cooperation with private collectors, especially collectors in the field of Asian art. In the early years of this century, Denman Ross, long associated with the Fogg, brought back from the Orient distinguished objects then little known in the West. Hervey Wetzel, Grenville Winthrop, and Charles Hoyt, through gift and bequest, enormously strengthened the Fogg's initial meager holdings of Eastern Art. Contemporary American collectors, such as John Crawford, Earl Morse, C. Adrian Rübel, and Philip Hofer, have lent generously, sometimes entire exhibitions. Langdon Warner, our first Curator of Oriental Art, and his followers not only added to the Fogg's exhibitions of Asian Art; they also began assembling the invaluable tools of scholarly research. With the continuing assistance of Adrian Rübel, the resources in books and photographs of the Fogg's Oriental Library are becoming virtually unique in the Western world.

In the preparation of this particular catalogue, two distinguished Japanese art historians and connoisseurs, Shūjirō Shimada, Professor of Art at Princeton, and Ichimatsu Tanaka, working in Tokyo, have given thoughtful assistance, as have many other Japanese scholars. A special effort has been made in the catalogue to bring before the American public some of the extraordinary achievements of Japanese connoisseurship, achievements which have been little known in the West.

Naturally our greatest thanks go to Mr. and Mrs. Powers, the perceptive and enthusiastic connoisseurs who with sustained energy and taste have formed the remarkable collection here described. We wish to acknowledge not only their generosity in permitting it to be carefully studied but for allowing it to travel from the East Coast to Seattle, and back to Princeton for its last showing.

The young scholars who, under careful guidance, have worked on the preparation of the exhibition, have laid a groundwork in connoisseurship and have essayed their competence as future scholars and curators. A wider public will, we hope, make discoveries of their own.

AGNES MONGAN
Director, Fogg Art Museum

PREFACE

The collection of Kimiko and John Powers reflects most major aspects of Japanese art from prehistoric times to the recent past. In building their collection, the Powers have been adventuresome and creative, guided by strong personal preferences; their outlook, moreover, has been influenced by developments in contemporary American art, for which they are equally enthusiastic. At the same time they have followed very much the pattern of private collectors in Japan, with strong holdings in calligraphy, archaeological material, and Buddhist ritual implements—in addition to the familiar areas of painting and sculpture. Such specialized material is often overlooked in the West, but it offers unique insights into the origins and character of Japanese taste. Because of the Powers' encyclopedic interests, theirs is as broad and inclusive as any private collection outside of Japan, yet by no means does it convey all areas of connoisseurship. No attempt has been made to collect as though compulsively filling every page of a stamp album.

The Powers have generously made their collection available to the faculty and students of Harvard and Princeton for prolonged study and exhibition. In this way they are hoping to encourage the serious connoisseurship of Japanese art in the West, which, with some notable exceptions, has not kept pace with the brilliant beginnings in the days of Fenollosa, the de Goncourts, and Charles Freer. It is true that Japanese art is becoming as much a part of world culture as German Romantic music. Most educated Westerners have experienced, in one way or another, works of print masters like Hokusai and Utamaro; the brilliantly ornate, gilded screens of the Momoyama period; the landscapes of Sesshū; the frolicking animals of "Toba Sōjō"; Zen monasteries and their gardens; ceramics of the tea ceremony; the grave icons of early Buddhist sculpture and painting. But the aesthetic resources of Japan are far richer and far more pertinent to the universal issues in the study of art than Westerners generally realize.

From the extensive Powers collection we have selected over 150 objects for catalogue study. They will be exhibited to the general public at Harvard and Princeton and at the Seattle Museum. Among them are a number of masterworks, but we have not attempted to deal only with masterworks. Rather, our goal has been to arrange this material into contexts that will evoke the richly detailed fabric of Japanese civilization. We hope to account for the creation of masterworks by exploring the religious, social, intellectual, and purely aesthetic values that helped bring them about. We have tapped the enormous body of research in connoisseurship that has been done in Japan, and attempted to demonstrate that some aspects of Japanese art can be documented in the same kind of detail that is found, for example, in studies of Dutch seventeenth-century painting and the Florentine Renaissance.

The writing of this catalogue has taken nearly a year and a half—not nearly long enough to exhaust our curiosity and interest in the works—and literally dozens of people have contributed to it. Listed below by categories are those to whom we are most deeply indebted, but it is impossible to include every name. Above all, however, we are grateful to Kimiko and John Powers for sharing their collection so generously; for their material assistance; for their patience, good humor, and tolerance.

From Japan:

Tanaka Ichimatsu, member of the National Commission for the Protection of Cultural Properties, Cultural Affairs Agency, Tokyo, and one of Japan's most distinguished connoisseurs. Tanaka-san

consulted with us in Cambridge in April, 1969, and graciously contributed to the writing of entries 49, 81, and 134.

Shimada Shūjirō, Professor of Japanese Art, Princeton University, who participated in many stages of selection and cataloguing, and contributed entries 5–9, 25, 26, 32, 34, 35, 46, 47, 66, 67, and 98 on calligraphy. No aspect of this project has been more rewarding than the insights gained from Professor Shimada and the personal contact with this man who embodies so much that is luminous and meaningful in Japanese culture. Professor Shimada has been assisted in valuable ways by Shimizu Yoshiaki, a graduate student at Princeton.

Kurata Bunsaku, Suzuki Susumu, and Hayashiya Seizō from Tokyo—all scholars of the highest attainments in their field—who have generously assisted in judgments on individual works.

Nobuki Saburō and the staff of Kōdansha International, Limited, and Mrs. Maeda Mana, designer, who have given sympathetic and skilled assistance in producing the catalogue.

Princeton University:

Wen Fong, Professor of Chinese Art, who has generously encouraged this project.

Patrick J. Kelleher, Director of the Art Museum of Princeton University, who, in addition to Professor Shimada and his students, collaborated unstintingly.

Harvard University:

Agnes Mongan, Director of the Fogg Art Museum, and John Coolidge, former Director, who have offered constant encouragement and assistance.

Max Loehr, Abby Aldrich Rockefeller Professor of Oriental Art, who has been at all times helpful and sympathetic.

C. Adrian Rübel, long a supporter of the Oriental Department of the Fogg Museum, who has generously provided much of the research material used.

Usher P. Coolidge, Consultant, Oriental Department of the Fogg Museum, who assisted in the study of the ceramics and decorative arts.

Fumiko Cranston, chief research associate on this project. She, together with her husband, translated materials in entries 77, 103, 107, 112, 120, 123, 132, and 142. She has worked with the manuscript and been indispensable to the project in a great many ways. Our debt to Mrs. Cranston cannot be adequately expressed.

Edwin Cranston, Associate Professor of Japanese Literature, who helped in translations, especially in entry 107, and also assisted in other ways.

Matsubara Naoko, who undertook the delicate task of printing from an ancient wood-block for entry 60.

Mildred Frost, who loyally prepared the manuscript for publication.

Ellen Farrow, who patiently edited the manuscript.

Louise Cort, Assistant Curator, Oriental Department of the Fogg Museum, who skillfully wrote entries 90–94, 138–141, 150, 152, and 153, and assisted in the exhibition proper.

Other members of the staff of the Fogg and the Department of Fine Arts to whom we are indebted for hours of assistance: Suzannah Doeringer, Elena Drake, Ann Landreth, Ellen Thurman, Chang Cheng-mei, Aoki Michiko, Margaret Sevcenko, Mabel Regan, Monica Bethe (who helped on entry 63), Catherine Coté, Elizabeth Jones, Arthur Beale, Marjorie Cohn, Laurence Doherty and his staff.

Members of the Department of Far Eastern Languages and the Harvard-Yenching Institute who have assisted: Donald Shively, Itasaka Gen, Glen Baxter, Eugene Wu, George Potter and his staff. The following graduate students assisted in preparing individual entries:

Ahn Hwi-jun, 64; Albert Brewster, 145; Gina Lee Barnes, 109, 151; Phyllis Granoff, 31, 41; Horst Huber, 95; Laura Marin, 11, 42, 43; Ōyama Midori, 99, 108, 126, 149; Tamaki Ryōko, 78, 95, 143, 146; R. Elizabeth ten Grotenhuis, 36, 37; Stephen Wilkinson, 115

Museum of Fine Arts, Boston:
Jan Fontein; Money Hickman; Horioka Chimyō; Iguchi Yasuhiro

Freer Gallery, Washington, D.C.:
John A. Pope; Harold Stern; Thomas Lawton

Seattle Art Museum:
Richard E. Fuller; Henry Trubner

We have also shamelessly enlisted the help of travelers and visitors to the Fogg Museum, picking their brains without hesitation. Included among them are Steve Addiss, Mr. and Mrs. Joe D. Price, Peter Drucker, and Sylvan Barnett.

As a matter of record, all manuscripts have passed through my hands for initial editing; all entries were prepared by myself except those that are signed at the end by the initials of the writer. All errors in the catalogue are my responsibility.

JOHN ROSENFIELD
Cambridge, Massachusetts
June, 1970

CONTENTS

Japanese Buddhist Arts

The Ancient Epoch (500–1200 A.D.)

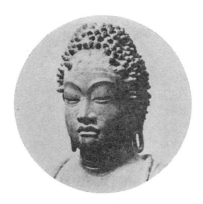

The Japanese, like countless millions of the Buddhist faithful throughout Asia, have lived in the historic shadow of an absolute event that defies history: the attainment of Sambodhi (Supreme Enlightenment) by the noble Indian sage Gautama Śākyamuni. Called the Buddha, he became a religious leader. Impelled by his compassion for all sentient beings, he preached the insights gained in his moment of Enlightenment. He felt he had resolved the dilemmas that trouble all mankind—the paradoxes of death in life, of poverty in wealth, of sanctity and damnation in being. Around Gautama a community of monkish followers developed in the early fifth century B.C., then a church that sent evangelists throughout Asia, and finally an artistic tradition that embodied its ideals.

In Japan until the dawn of its middle ages, both the glory and limitation of its arts lay in the fact that they were made chiefly in and for the Buddhist monasteries. From the seventh through the eleventh centuries, there is virtually no surviving work of painting and sculpture in Japan that is not Buddhist in inspiration, for Buddhism there enjoyed a prestige higher than in any other land of Asia, except Tibet. To this day, the strong imprint of the faith may be sensed in the character of the people, in their thought processes, ethical standards, and artistic values. When the creed was introduced from China and Korea in the sixth century, the social and intellectual development of the Japanese people was comparatively primitive. The new faith opened the path to spiritual experiences of the utmost sublimity, and it brought the technical equipment and conceptual modes of the highly evolved, urban civilization of China. The native Japanese religion, after an initial period of hostility, was obliged to coexist with the imported creed. Shamanistic and devoted to simple forms of nature worship, it was called Shintō, the Way of the Gods, to distinguish it from the Way of the Buddha.

As Japan came to identify itself as a Buddhist nation, the newly founded monasteries became centers of learning in the broadest sense of the word. Advanced architectural and engineering skills were needed to build impressive pagoda towers and image halls. Wood-block printing of holy texts was begun. The faith promoted the study of medicine, weaving and embroidery, ceramics, and even metallurgy. Buddhist monks were obliged to study Chinese and Sanskrit. The metaphysics and theology of the faith were demanding, subtle, and abstruse. The Japanese also began constructing formal, permanent capital cities

and palaces modeled on Chinese forms, the first in the Asuka district and the second near the modern city of Nara.

Buddhism was over a thousand years old when it first reached Japan, and its beliefs had evolved greatly from its beginnings as the puritan creed of a small group of ascetics in Gangetic India. It had become the universal doctrine of much of Asia with numerous sects and subsects. Historians usually distinguish three major stages in this evolution. The oldest is called the Lesser Vehicle (Hīnayāna) to stress the fact that it believed salvation to be open only to a small number of monks who had removed themselves from the temptations and distractions of daily life. It is also called by the name Theravada (School of the Elders), because it promoted the ideal of the arhat, the perfect saintly man who practices decades of severe self-discipline and avoidance of the world in order to attain salvation. The name is used in Ceylon, where this concept still flourishes.

The second stage of development is called the Greater Vehicle (Mahāyāna) for it offers salvation to laymen and monks alike in far greater numbers. It appeared in India in the early years of the Christian era, proclaiming the ideal of the Bodhisattva, a class of deities who vow to work for the salvation of all mankind. Mahāyāna also stressed that there are innumerable deities existing simultaneously, who, because of their compassion, are eager to help the faithful; this contrasts with the older creed that stresses the importance of the career of Śākyamuni and the concept that only one Buddha exists at a given time. The Greater Vehicle as it had been adapted to the spiritual needs of the Chinese and Koreans reached Japan in the sixth century A.D. It taught that the proper practice of the faith yielded fruits in the realms of matter as well as the spirit; wonder-working monks were said to be able to produce rain, cure illness, and defeat enemies. A close rapport between the faith and the apparatus of the state had developed. In Japan, the building of the giant bronze Buddha image at Tōdai-ji in the mid-eighth century marked the high point of state-supported Buddhism; and it was the threat to the independence of the throne that probably prompted Japanese courtiers to urge the building of a new seat of government free of the influence of the great Nara monasteries. In 794, the court was moved to the new Heian-kyō (Capital of Peace and Tranquillity), the site of modern Kyoto, where only two monasteries were permitted within the city proper. One was Tō-ji, the Eastern Temple, which still remains as one of the great monuments of the age; the other was Sai-ji, the Western Temple, which soon was lost in a fire. Both temples stood just behind the main South Gate to the city, the Rashōmon.

At this time, however, unmistakable traces of the third stage of Buddhist ideology were appearing in the arts and liturgy of East Asia. By the beginning of the ninth century, the new doctrine had swept through the region with a speed and enthusiasm comparable perhaps to that of Marxism in the twentieth century. This intellectual force was the Thunderbolt Vehicle (Vajrayāna), or Esoteric Buddhism, which had originated in different parts of India—at Nalanda in Bihar, for example; or at Vikramaśīla in Bengal; in Kashmir and the Swat valley; and at Khotan in the Tarim Basin. Missionaries had brought it to T'ang China, where Japanese pilgrims such as Kūkai (Kōbō Daishi) and Saichō (Dengyō Daishi) mastered it before returning home. Its emphasis was upon magic formulas and elaborate rituals handed

down from master to pupil in great secret. It believed in enormous pantheons, many of whose deities were thinly disguised Hindu gods, and thought the powers of the myriad deities could be invoked by charms and rituals. So complex were these pantheons that Esoteric Buddhist monks studied and wor_shiped schematic diagrams (*mandalas*), which outlined the interrelationships of the gods. Esoteric Bud_dhist rituals were extremely impressive, like the *goma* ceremony in which bonfires of inscribed sticks were burned before appropriate images in order to gain fulfillment of the inscribed prayers.

In Japan, the extraordinary social and artistic influence of Esoteric Buddhism lasted until the late tenth century, when the zeal of its monks began to wane. The Japanese then returned with renewed fervor to the worship of the Buddha Amitābha (Amida), who dwells in his Paradise in the west amid jeweled trees and fresh running springs, offering to the faithful a place of rebirth where Nirvāna could easily be attained. There are many other Buddhas and Paradises in Mahāyānaism, but that of Amitābha caught the imagination of the faithful. Generally speaking, Amidism became the most popular Buddhist cult in East Asia. The monk Genshin (Eshin Sōzu), who dwelled on Mount Hiei near Kyoto, published several treatises around the year 1000 describing the delights of the Western Paradise and the pains of Hell for those who lacked faith. His influential work marks the beginning of a new wave of temple building and image making which swept Japan until the aristocratic families that supported such efforts lost their power and fortunes in the political revolutions of the late twelfth century.

Throughout this ceaseless shifting of intellectual currents in eastern Buddhism, certain fundamental principles remained constant: the world as known to man's senses is basically false and delusory; an infinitely truer, richer, mightier realm lies beyond; the chief concerns of man's life must be internal, focused on his serenity and spiritual equipoise; man's ultimate goal, no matter how he reaches it, is the attainment of Nirvāna (*satori*), the transcendent state in which all psychic and physical ties to the world are broken and man is freed from endless rebirths. In the aesthetic makeup of Buddhist art, these values were also implicit. The great deities of the Buddhist pantheon were shown usually in a highly idealized manner, with no trace of human weakness or imperfection. They were youthful and elegant, belonging to a realm vastly finer than that of normal experience. Or else they were given superhuman ferocity, often with multiple heads and arms in order to demonstrate how vast and violent is their power in the name of righteousness.

Buddhist art in Japan was given a high degree of importance by the state as well as by the church. For centuries this tradition defined for the Japanese the most vital issues of life and afterlife, for as Kōbō Daishi stated, "art is what reveals to us the state of perfection." Throughout their long existence, Buddhist arts were motivated by an awareness of the inconceivable and invisible sources of all being in Buddhist metaphysics, a fact we should never ignore. This awareness is present in the atmosphere of mystery and inchoate darkness in the interior of temples; and it is present in the sense of an even grander and more inexpressible majesty that lies beyond the most splendid altar groups, the most exquisitely wrought mandalas. It is part of the rationale of the "imperfect" image in Zen painting. It is, in a sense, the root of aesthetic inspiration of all Buddhist art.

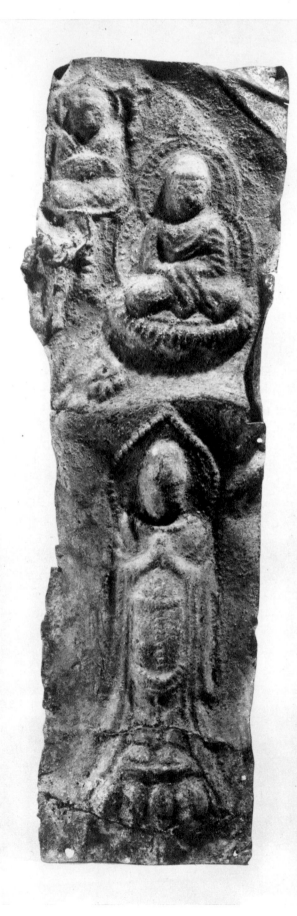

1. Standing Bodhisattva and two seated Buddhas

Hakuhō period (ca. 650)
Thin, embossed copper plate, with traces of gold leaf
H. 9 1/2 × 3 1/2 in. (24.1 × 8.9 cm.)

During the Sui and early T'ang dynasties in China, the Buddhist faith spread among all strata of society to an unprecedented degree. To meet the need for large quantities of images, the Chinese developed mass production techniques. For household shrines, flat clay tiles with images of the Buddhist pantheon were cast in molds and baked in low-fired kilns; also, thin sheets of copper were hammered over wood or metal matrices to produce images in low relief like this one. The clay tiles were painted, and the copper sheets were covered with gold leaf. These methods spread to Japanese centers of Buddhist sculpture in the Yamato region during the last half of the seventh century. Japanese sculptors, intrigued with Chinese technology in the arts, explored the more flexible, malleable media of the arts—dry lacquer (see No. 12), stucco, the lost wax method of bronze casting, and embossed copper. The last of these is called the *oshidashi* (literally, pushed out) technique, a term that appears as early as the eighth-century Hōryū-ji documents. There still exists a solid copper matrix from this period, a small figure of the seated Buddha that resembles a conventional sculpture in high relief; it is part of the Shōsō-in collection.

The sheet of copper shown here, among the older examples of the *oshidashi* technique, is the right-hand portion of a trinitarian group similar to No. 2 and No. 3, except that five or seven small seated Buddhas were originally placed over the canopy. The ensemble probably represented a Buddhist Paradise and signified one of the most fundamental Mahāyāna Buddhist conceptions—the existence at any moment of a host of Buddhas and Bodhisattvas, each having vowed to work for the salvation of the faithful and offering refuge in Paradise in the next life for those who earnestly wish it.

Two other fragments in this style are now in the Tokyo National Museum. They may all be dated from the mid-seventh century on the basis of the style of the Bodhisattva, gravely frontal and composed. The leaf-shaped halo and pendent scarves, which flare out in a swallowtail manner, are reminiscent of mid-sixth-century North Chi sculpture. A time lag of seventy to one hundred years in the relationship of Chinese and Japanese imagery is not unusual at this period, when the Japanese were tending to perfect and refine artistic methods from the mainland long after they had gone out of vogue there. By the beginning of the eighth century, however, the Japanese were much more up-to-date and by the beginning of the ninth, were developing their own techniques and stylistic traits.

Formerly in the collection of Tanaka Shōkō.
Published: Kuno Takeshi. *Kobijutsu*, no. 15 (November 1966), pl. 17.

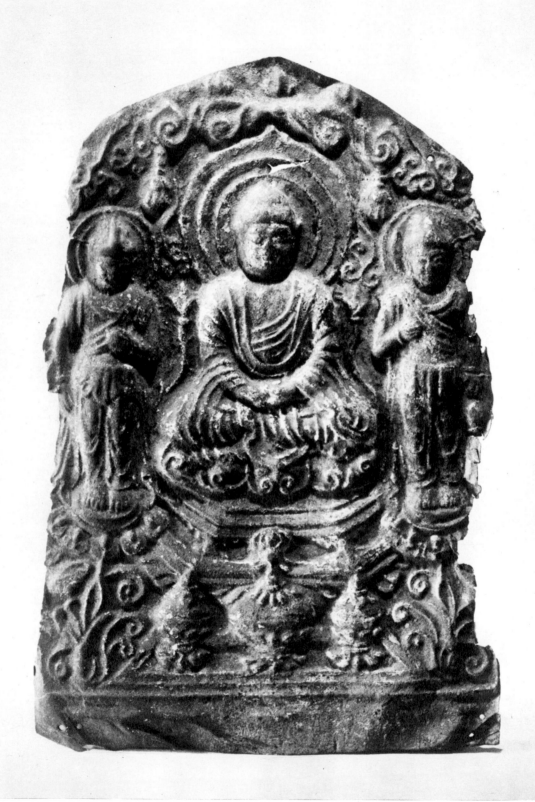

2. Amitābha (Amida) trinity

Hakuhō period (ca. 680–700)
Thin, embossed copper plate, with traces of gold leaf
H. 9 × 5 1/2 in. (22.9 × 14 cm.)

This embossed copper plate must originally have been nailed to the back wall of a small, portable household shrine. The Buddha sits in meditation, cross-legged on an elaborate octagonal throne. Two Bodhisattvas stand on lotus pedestals supported by long stems that emerge from a lotus plant with exaggerated tendrils and leaves. The florid, linear detailing is a quality that appeared in Chinese Buddhist arts as early as the 630s and 640s and in Korea slightly later. In Japan, a large number of cast clay tiles in this distinctive style have been found. Many were excavated at a ruined temple site in Mie Prefecture, the Natsumi-dera; one is in Tōshōdai-ji.

Before the figures are three offering bowls, the center one having a florid thunderbolt motif on its lid. The water vase in the hands of the Bodhisattva on the right probably establishes his identity as Avaloki-teśvara (Kannon) and, thus, the ensemble as a conventional trinity of Amitābha, Lord of the Western Paradise, the two Bodhisattvas being agents of his compassion. However, at this period, Mahāyāna Buddhist imagery was replete with Paradise scenes and trinitarian groups, often with few differences among them.

The composition is identical in many respects to one formerly in the Yasuda collection, the chief departure being the position of the canopy at the top. In this work, the canopy is close to the heads of the deities; in the other, it is higher, which suggests that separate matrices were used for the figures and canopy. We can assume that the workshops had matrices for the different parts of these compositions—canopies, individual deities—and combined them in a variety of ways.

Formerly in the collections of Tanaka Shōkō and Nakamura Masazane.
Published: Kuno Takeshi. *Kobijutsu*, no. 15 (November 1966). Color pl. 2.
Reference: *Tōshōdai-ji Ōkagami*, part 2. Tokyo, 1934. Pl. 37; Asahi Shimbun, ed. *Tempyō Chihō*. Tokyo, 1961. Pls. 261–264.

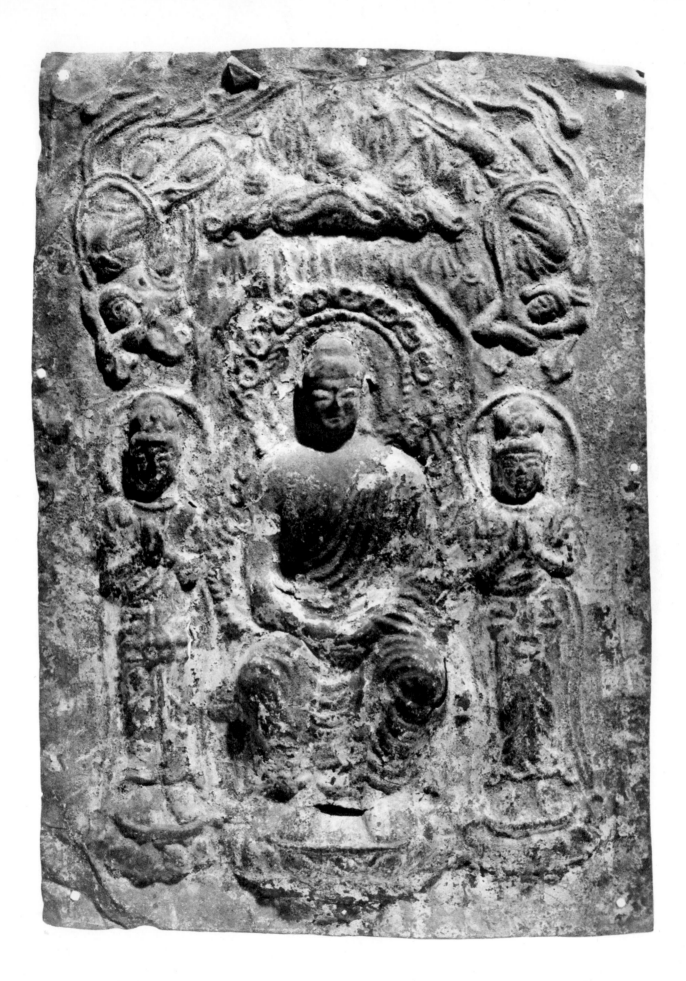

3. Buddhist trinity

Hakuhō period (ca. 680–700)
Thin, embossed copper plate, with large areas of gold leaf
H. 8 1/2 × 6 in. (21.8 × 15.3 cm.)

Flanked by two Bodhisattvas, with hand gestures of devotion, the Buddha sits stiffly erect in what is often called the European position. This pose differs strongly from those of the Buddha preaching or seated cross-legged in meditation. Endowing the image with a hieratic, regal presence, this pose became current in Indian Buddhist art during the late fifth century and spread rapidly to East Asia, where it exerted considerable appeal. At the Lung-men cave sanctuary near Lo-yang, the T'ang metropolis, a colossal image of Maitreya in this position was dedicated in 673; also seated in this position is the central Buddha in one of the major Paradise scenes in the wall paintings of the Kondō at Hōryū-ji, datable to around 710. The European position became quite current in Japan in the late seventh and eighth century. And then, like so many other traits of this period, it virtually faded from the repertory of Buddhist art—the pose of figures half cross-legged in meditation, for example, and the use of dry lacquer and stucco.

This thin copper relief is quite similar to the composition on clay tiles of the late seventh century from temples in the Asuka region—the Tachibana-dera, Minami Hokke-ji, or Tsubosaka-dera. This is most apparent in the two angels, flying downward and scattering flowers, their bodies bent and twisting around their own axes. It also resembles the well-known stone relief triad at Ishii-dera, Nara Prefecture, but it differs from all these examples in being more coarse in detail, with the figures somewhat fatter. This is probably due to the loss of surface refinement resulting from hammering the copper over the matrix. The copper here was so thin that it was stretched to the breaking point at the neck, head, and knees.

A plaque that must have been hammered over the very same matrix is part of a composition of several embossed plates now in the collection of Tōshōdai-ji, Nara.

Formerly in the collection of Koga Toranosuke.
Published: Kuno Takeshi. *Kobijutsu*, no. 15 (November 1966), pl. 22.
Reference: Asahi Shimbun, ed. *Tempyō Chihō*. Tokyo, 1961. Pl. 236; *Tōshōdai-ji Ōkagami*, part 2. Tokyo, 1934. Pl. 38.

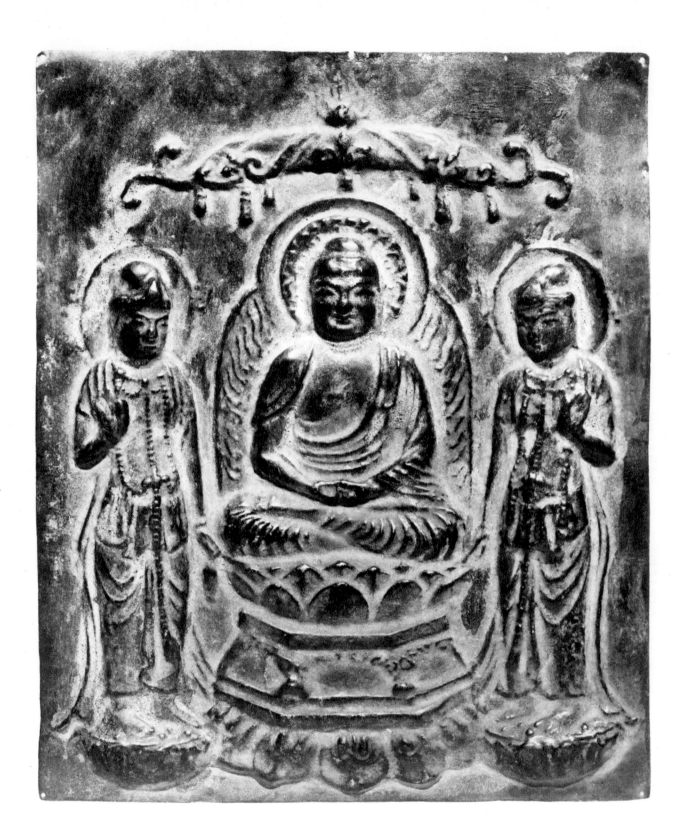

4. Amitābha (Amida) trinity

Hakuhō period (ca. 680–700)
Copper plate, with traces of gilding
H. 6 5/8 × 5 3/8 in. (16.8 × 13.6 cm.)

This is perhaps more advanced stylistically than the other two embossed copper Buddhist triads exhibited here (Nos. 2, 3). The two flanking Bodhisattva figures are turned slightly toward the center, no longer held by the rigid frontality of the earlier works; their scarves and strings of pearls are suspended in a more descriptive, sinuous manner. The Buddha is shown in the heavy, wide-faced style current in Chinese sculpture of the mid-T'ang period; and the octagonal pedestal is correspondingly massive.

Flanked by Bodhisattvas, the seated Buddha may be recognized as Amitābha by his hand gesture, the Midajō-in. The thumbs and the knuckles of the index fingers are pressed together, signifying the Buddha's entry into silent meditation and his possession of supreme insight. The mandorla (halo) around his body is filled with radiant flames. The Bodhisattva to the left holds the water vase identifying him as Avalokiteśvara (Kannon), while the other figure is Mahāsthāmaprāpta (Seishi).

The plaque is made of a relatively thick sheet of soft copper and thus has a more unified surface than the thinner, more friable sheets in Nos. 2 and 3. In this respect, it resembles the most elaborate example of repoussé copper work in Japan, the scene at the Hase-dera of the apparition of the stūpa from the *Lotus Sūtra*, datable to *ca.* 690–710.

散如来時庄嚴具於虛空中變成寶盖　庄嚴惡與一切諸宫殿等端嚴勢十前寺　嚴金剛圍山周迊圍遶其形猶如明淨椆　衆寶庄嚴无量龍王慈火執持寶樹圍遶　百普重於其盖中有菩提樹枝葉榮茂普　法界以无量庄嚴而庄嚴之見虛合那伽　山樹下與不可說佛剎微塵等大吉薩傾皆　悲具足普賢菩薩一切所行住善薩住所住　壞者又見一切世界諸王圍遶如来又見彼　佛神力自在又見一切諸句次弟世界成就　又見一切諸佛次弟世界又見普賢苦薩　一切佛所恭敬供養教化衆生又見　世界中悉有佛剎微塵等世界種種安　種庄嚴種種清淨種種劫種種如来出現于　世種種三世種種國土種種法界種種諸道　種種入法界種種虛空種種道場種種佛　種種諸佛庄嚴師子之座種種春屬村　種如来方便轉法輪種種如来春屬村　種種音聲海說種種脩多羅雲時彼女人目　開如是歡喜无量尒時妙德憧佛於大衆中　說循多羅名一切如来法輪妙音十佛世界　彼庭等備多羅以為眷屬時彼女人闻心

5. Segment of the *Kegon-kyō*

Nara period (ca. 744 A.D.)
From the Nigatsu-dō, Tōdai-ji, Nara
Segment of hand scroll mounted as kakemono; silver ink on deep indigo paper, with losses due to fire
H. 9 3/16 × 14 3/4 in. (23.3 × 37.5 cm.)

The unusually fine aesthetic quality of this manuscript suggests that it was dedicated by donors of the highest standing and wealth. Despite its burn damage and fading, it is one of the outstanding works of early Japanese calligraphy. The text is written with lustrous silver on deep blue paper and done in a Chinese style of the early T'ang period. The characters are firmly structured, their shapes stabilized and strengthened by prolonged horizontal strokes that act as either a central axis or the base of the structure. Delicate balances and harmony are created by combinations of thin lateral strokes and thick vertical ones and by the contrast of diagonal strokes, the left-hand ones being short and thin, and the right-hand ones long and thick.

This segment of a long manuscript came from the Nigatsu-dō of Tōdai-ji, the structure halfway up the verdant slopes, just to the north of the Daibutsu-den. The hall is the scene of a long series of rituals performed each February (*nigatsu*), when monks at Tōdai-ji undergo a period of severe austerities and withdraw from their normal duties. A set of sixty scrolls of manuscript of the *Kegon-kyō* had been stored in the Nigatsu-dō until the spring of 1667, when a fire broke out during the Omizu-tori ceremony and burned the building. Some of the manuscripts were salvaged even though they were partially burned. Most of the surviving scrolls were cut apart and dispersed, and only a few of the manuscripts were retained in the temple. The many fragments are known generally as the *Nigatsu-dō Yake-gyō* (Burned Sūtras) because of the conspicuous scars of fire damage along the top and bottom.

Tōdai-ji is the largest monastery ever built in Japan; it is also the headquarters of the Kegon sect, one of the six major schools of Japanese Buddhism that flourished during the Nara period. It is only natural that a sumptuous set of the *Kegon-kyō* be kept at the temple, for this sūtra is the doctrinal basis of the Kegon sect. It is presumed that such a set was donated to the temple in 744, when the annual ceremony of adoration of the sūtra (the Kegon-e) was first performed. A comparison of this manuscript with others of that time, especially the two sets of the *Tripitaka* executed according to the vows of the Empress Kōmyō in 740, makes it likely that this manuscript could indeed be one that was dedicated in 744. If true, this would make it the oldest example from Japan of a text copied on blue or purple paper in silver characters. The silver ink in the *Yake-gyō* is especially lustrous, and some scholars have speculated that it contains an additional metallic ingredient, perhaps platinum. This mode of sūtra decoration was introduced from T'ang China, and it included also a floral pattern on the outside of the cover and a picture of the Buddha preaching as a frontispiece inside the cover. There are many examples of this type of ornate text from the eighth century. The custom has continued into modern times, but an especially large number of copies on blue paper were made during the twelfth century, in the late Heian period.

The formal name of the sūtra in Sanskrit is the *Buddha-avatamsaka-mahāvaipulya-sūtra* (the *Expanded Sūtra of the Buddha Adorned with Garlands*); it was first translated into Chinese in 421 A.D. by the Indian missionary Buddhabhadra. Other translations were made in 695 and again in 798. The text of the *Yake-gyō* comes from the oldest of the three Chinese versions. This segment is from volume 53, the 40th chapter "Entry into the Realm of the Law," from the 10th fascicule. (S.S.)

Reference: *Yamato Bunka*, no. 50 (April 1969); Tanaka Kaidō. *Nihon Shakyō Sōkan*. Osaka, 1953; Nara National Museum catalogue. *Naracho Shakyō-ten* (1969).

6. Section of the *Lotus Sūtra*

Nara period (last half of the eighth century)
Section of hand scroll mounted as kakemono; gold ink on blue-violet paper
H. 10 × 20 in. (25.4 × 50.8 cm.)

This section of a long hand scroll contains twenty-eight lines of text from the "Chapter on the Encouragement of Samantabhadra Bodhisattva" ("Fugen Bosatsu Kanbatsu-bon") of the *Lotus Sūtra*. It may be identified as having once been part of a set of scrolls of the *Lotus* now called the Tōmyō-ji sutras, because four complete scrolls are owned by that temple in Nara. Nara period scrolls of this kind, in which the text is written in gold ink on blue-violet paper, are relatively rare; more commonly they were done in silver ink. The finest examples of the gold-character scrolls are two sets of the *Suvarna-prabhāsa-sūtra* now in Ryūkō-in and Saikoku-ji. Called the *Konkōmyō Saishō-ō-kyō* in Japanese, this was one of the most important of the early Mahāyāna sūtras; it supported the conception that the Buddhist faith could guarantee the safety and prosperity of the nation. Copies of the text were delivered at imperial order to the official state monasteries of the provincial temple system (*kokubun-ji*) in 742. They were probably prepared at the Kinjikyō-sho (Bureau of Gold-Character Sūtras), a branch of the official Bureau of Sūtra Copying. As such, they represented superb craftsmanship in every respect—in calligraphy, mounting, and storage boxes. The lustrous surface finish was probably achieved by polishing the gold ink with the tusk of a wild boar.

The Tōmyō-ji scrolls, which are in much better condition than the fragment shown here, also display a very high level of craftsmanship and calligraphy. And specialists have assumed that these may have been the texts of the *Lotus Sūtra* ordered for each official provincial nunnery after the completion of the *Konkōmyō-kyō* project. This may be correct, but there is no documentary evidence for it. And the Tōmyō-ji sūtras differ markedly in calligraphic style from those others and from the *Yake-gyō* (see No. 5), the highest standards of this type of work. These are not as sharp and vigorous in brushwork, the muscular ending of the strokes is remarkably reduced and the solid structure of the characters is loosened. The calligraphy, while falling short of the finest works of the Tempyō era in dynamism and sturdiness, is imbued with the quality of gentle intimacy. The characters are

written with care and regularity, but at times they fall into disarray, tending slightly towards the running style (*gyōsho*). The lateral strokes of the characters are slanted upwards on the right-hand side, a feature not common in the mid-eighth century. This can be seen as an anticipation of the calligraphy of the late Nara and early Heian periods, and hence this sūtra fragment may be dated to the second half of the eighth century.

The *Lotus Sūtra*, as it is called in the West, originated in India around the beginning of the Christian era and was called, in Sanskrit, the *Saddharma-pundarīka-sūtra*, (the *Sūtra of the Lotus of the True Law*) (in Japanese it is called the *Myōhō-renge-kyō* or the *Hokke-kyō* for short). It was translated six times from Sanskrit into Chinese, of which only three versions are extant. Among these, the one done by the brilliant Indian missionary Kumārajīva in 406 is the most widely used, and there is probably no more important and influential text in the entire Mahāyāna *Tripitaka*, the Buddhist canon. Apart from its theological significance, the *Lotus Sūtra* is unique for its rich literary flavor. It is enlivened with verbal scenes of spectacular miracles and imaginative settings. It relates, for example, how tens of thousands of Bodhisattvas emerged from the earth in response to a summons from the Buddha to see a Buddha of the past, Prabhūtaratna, and attend his sermon—proving thus that more than one fully enlightened Buddha may exist at one time.

The *Lotus Sūtra* is presented in the form of a sermon as given by Śākyamuni atop Vulture Peak, near Rājagriha, over forty years after he attained Enlightenment. Among the essential points of the *Lotus* is the notion that Śākyamuni, the historical Buddha, identifies himself with the Eternal Buddha who had achieved Enlightenment in the infinite past and who would remain permanently on Vulture Peak and continue to preach. Śākyamuni also states that his earlier teachings were designed to lead his followers to the Enlightenment of an arhat, one who devotes himself to monastic life and all of its restraints. But he says that in fact there is one and only one real vehicle leading to full Buddhahood, the doctrine of the *Lotus*

佛告普賢菩薩若有善男子善女人能成就
四法於如來滅後當得是法華經一者為諸
佛護念二者殖眾德本三者入正定聚四者
發救一切眾生之心善男子善女人如是成
就四法於如來滅後必得是經
介時普賢菩薩白佛言世尊於後五百歲濁
惡世中其有受持是經典者我當守護除其
衰患令得安隱使无伺求得其便者若魔若
魔子若魔女若魔民若為魔所著者若夜又
若羅刹若鳩槃荼若毗舍闍若吉蔗若富單
那若韋陀羅等諸惱人者皆不得便
是人若行若立讀誦此經我介時乘六牙白
象王與大菩薩眾俱詣其所而自現身供養
守護安慰其心亦為供養法華經故
是人若坐思惟此經介時我復乘白象王現
其人前其人若於法華經有所忘失一句一
偈我當教之與共讀誦還令通利介時受持
讀誦法華經者得見我身甚大歡喜轉復精
進以見我故即得三昧及陀羅尼名為旋陀
羅尼百千万億旋陀羅尼法音方便陀羅尼
得如是等陀羅尼
世尊若後世五百歲濁惡世中比丘比丘
尼優婆塞優婆夷求索者受持者讀誦者書
寫者欲修習是法華經於三七日中應一心
精進滿三七日已我當乘六牙白象與无量
菩薩而自圍遶以一切眾生所憙見身現其
人前而為說法示教利喜亦復與其陀羅尼
呪得是陀羅尼故无有非人能破壞者亦不

Sūtra itself. Through this, not only Bodhisattvas but also good men and sinful ones and even animals have the potentialities of Buddhahood within them and can realize it by this doctrine. The *Lotus* also introduces a new conception of Nirvāna. Nirvāna is not simply the state of absolute freedom from all kinds of suffering. It is identified with the nature of the Buddha himself, transcendent beyond any possibility of change or comparison with any other form of being, transcending any conception of existence and non-existence. Another significant feature of the sūtra is a blessing given to women. In earlier Buddhism, a woman was generally thought of as a sinful being who innately bore obstacles to Enlightenment and, consequently, was disqualified from Buddhahood. The *Lotus*, however, attests to a woman's eligibility for Buddhahood by relating the story of the daughter of a dragon king who was inspired by Mañjuśrī and who was given a certificate by the Buddha showing that she had indeed attained Buddhahood. This unusual blessing in favor of woman naturally drew countless female believers to the sūtra and its doctrines. (S.S.)

Reference: Tanaka Kaidō. *Nihon Shakyō Sōkan*. Tokyo, 1953. Color pl. 1, pp. 113–210.

7. Scroll of the *Astasāhasrikā-prajñāpāramitā-sūtra*, Vol. II

Nara period (ca. 740)
Hand scroll; ink on paper
H. 10 3/8 in. (26.3 cm.)

The calligraphy here, although marked to some extent by personal mannerisms, exhibits the fine discipline in the academic style current among the scribes of the Bureau of Sūtra Copying. The brush-work is very sharp and full of dynamic vigor; the lines have an angular and nervous quality owing to the conspicuous exposure of the brush tip, the heavy accent at the beginning of the strokes, and the bending of the hooked strokes. Particularly characteristic is the remarkable extension of diagonal strokes, which impart a twisting tension to the characters. Irregular arrangement of the horizontal strokes, in particular, at times impairs the integrity of form.

This sūtra, known as the *Maka Hannyaharamitsu-kyō* in Japan, is one of the major texts in the division of *prajñā* (wisdom) in the *Tripitaka*. It elucidates the great wisdom of the Bodhisattvas that enables them to transcend the impermanence of this world, and advance—if they wish—to Buddhahood. There are two Chinese translations of this sūtra, bearing exactly the same title, and both rendered by the same translator, Kumārajīva. The earlier version consisting of ninety chapters was made in 403, and only five years later, he rendered a compact version of twenty-nine chapters. The present scroll is the second chapter of the later version, which is usually distinguished by the abbreviated name of *Shōbon Hannya-kyō* ("The *Hannya-kyō* in Fewer Chapters").

At the end of this scroll is a postscript that reads:

The above sūtra was translated by An-sei-ko of the Later Han dynasty, the Crown Prince of Ansoku-koku. It is not listed in the catalogue of Fei Chang-fang.

The sixth year of the Tempyō Shōhō era, the third month, the first day. Collated by Kamikenu-no-kimi Tachimaro, Rank of Upper Junior Seventh Grade, Instructor at the National College.

The very virtuous monk of Gangō-ji, Shōei

The very virtuous monk, Ryōgō

The very virtuous monk, Sonnō

The graduate monk, Hōryū

The date of the sixth year of the Tempyō Shōhō era

(754) is not that of the execution of this manuscript, but that of the collation work done by the lay scholar Tachimaro under the supervision of the four monks. Similar postscripts with similar formulas containing names of other collators and supervisors and dates in 754 and 755 may be seen in many scrolls in the Shōsō-in Repository and in other collections. These are remnants from two sets of the *Tripitaka* dedicated by Lady Fujiwara and the Empress Kōmyō respectively in 740. The postscripts recording the act of collation were attached long after the original inscriptions that marked the donation by the eminent ladies. It is likely that by 754, a new set of the *Tripitaka*, a Chinese version with more scriptures and more accurate contents, had been brought into Japan, and that the older Japanese versions had to be collated with the new, more authoritative ones. The supervisors of the collation work were chiefly monks of Gangō-ji in Nara, one of the oldest and most sacred of the great monasteries of the capital; today it is but a shadow of its original grandeur. The scrolls with records of collation often carry seals of Gangō-ji, and are usually known as the Gangō-ji sūtras. The scroll shown here does not have the original votive inscription nor the seal of Gangō-ji; instead it bears two seals of Tōdai-ji, at the beginning and the end, which indicates that it had once been owned by that monastery. But because the monk supervising the collation, Shōei, was from Gangō-ji, and because of the general resemblance of this scroll to the Gangō-ji sūtras, the possibility is strong that this scroll also belonged to that group.

The postscript of this scroll poses some problems. An-sei-ko (An Shi-kao, in Chinese) is a famous figure, the crown prince of a country called An-hsi-kuo in Chinese, formerly identified as Parthia but recently reidentified as Bokhara in Central Asia. He abandoned his honored position in his native land to migrate to China, where he did a number of Chinese translations of Buddhist scriptures. Early Chinese catalogues of Buddhist scriptures do not list this sūtra as his work, and the authorship of Kumārajīva is a famous fact in Buddhist history. It is possible that the postscript,

摩訶般若波羅蜜釋提桓因品第二 三藏法師 闍那崛多譯

尒時釋提桓因與四萬天子俱在會中四天
王與二萬天子俱在會中娑婆世界主梵天
王與萬梵天俱在會中乃至淨居天衆無數
千種俱在會中是諸天衆業報光明以佛身
神力光故皆不復現尒時釋提桓因語須
菩提言是諸無數天衆皆共集會欲聽須菩
提說般若波羅蜜義菩薩云何住般若波羅
蜜須菩提語釋提桓因及諸天衆憍尸迦我
今當菜佛神力說般若波羅蜜若諸天子未
發阿耨多羅三藐三菩提心者今應當發若
人已入正位則不堪任發阿耨多羅三藐三
菩提心何以故已於生死作鄣隔故是人若
發阿耨多羅三藐三菩提心我亦隨喜終不
斷其功德所以者何上人應求上法今諸佛
讚須菩提言善哉善哉汝能如是勸樂諸菩
薩須菩提言世尊我當報佛恩如過去諸佛
及弟子教如來住空法中亦教學諸波羅蜜
如來學是法得阿耨多羅三藐三菩提世尊
我今亦當如是護念諸菩薩以我護念因緣

written on a separate sheet of paper, as are many others on scrolls of the Gangō-ji group, was erroneously attached to this one. Another problem is that of the indication under the title of the scroll that the translator was Sha-na-ko-ta (Jñānagupta, in Sanskrit); this, too, is in conflict with the authentic authorship. This misattribution may be the result of confusion of the two sūtras belonging to the same *prajñā* division of the *Tripitaka*, namely, the *Astasāhasrikā-prajñāpāramitā-sūtra* by Kumārajīva, and the *Vajracchedikā* rendered by Jñānagupta and Dharmagupta. Both texts are included in the larger, complete version translated in the seventh century by Hsüan-tsang, the *Mahā-prajñāpāramitā-sūtra* (see No. 32). These discrepancies, however they may be interpreted, do not affect the authenticity of this eighth-century manuscript but indicate the inaccuracies that beset the Buddhist tradition. (S.S.)

Reference: *Shōsō-in no Shoseki*. Tokyo, 1964. Pp. 27–34.

8. Manuscript of the *Mahāyāna-sūtrālamkāra*

Late Nara—early Heian period (798)
Hand scroll; ink on paper
H. approx. 9 1/2 in. (24.1 cm.)

The *Mahāyāna-sūtrālamkāra* is a work of the great Indian Buddhist theologian Asanga (Mujaku). Consisting of thirteen volumes, it is a treatise on the fundamental principles of Mahāyāna Buddhism. It was translated into Chinese in 633 by the Indian monk Prabhākaramitra and was soon included in the *Tripitaka*.

This scroll is the first of the thirteen volumes. At one time it was owned by the Kōki-ji temple in Kawachi (Osaka Prefecture), where the Monk Jiun later served (see No. 101). It was recorded in the *Kokyōdaibatsu* ("Colophons of Old Sūtra Manuscripts") by the nineteenth-century Japanese monk-scholar Tetsujō, the abbot of Chion-in. Most importantly, it bears a postscript with a late eighth-century date:

> The seventeenth year of the Enryaku era [798], the the fourth month, the twentieth day. The original donor, the Shami [student monk] Enmyō, supporter of Awano-dera.
> Successor in the Service, Monk Jorai; Monk Gongun, Ihokibe-no-muraji-Fukuhito.
> [signed] *The Sūtra maker* [Kyōshi] *Monk Shintetsu*

The inscription tells us that the making of the manuscript was initiated in 798 by Shami Enmyō and that Enmyō was succeeded (presumably after his death) by the monk Gongun, other monks, and a layman in finishing the manuscript. That such a succession took place is obvious from the scroll itself. The last eleven lines of the text and the title following it were surely written by a hand different from the preceding text (on the right), and the postscript is by still another hand. Generally, *sūtrālamkāra*s are not prepared by donors, except for the purpose of their own study. As a class of literature, they are designated as *lun* (in Chinese) or *ron* (in Japanese), that is, as treatises that analyze and interpret the meaning of a text. Such treatises would deal with one of three categories of Buddhist scriptures from Indian sources—*kyō*, sūtras giving the teachings of the Buddha; *ritsu*, the *vinaya* literature or the rules of monastic behavior, and *ronso*, the metaphysical discussions.

Hence, it is possible that the original vow of Enmyō had been to dedicate a number of Buddhist scriptures, possibly an entire set of the *Tripitaka*. Another sūtra scroll exists with a postscript similar to this one, but there are minor differences in the name of the sūtra maker and in the date.

Shami Enmyō may have been a member of the Ihokibe clan. The term *shami* designates a person who has accepted Buddhist discipline but who is not yet ordained as an officially registered monk. Unfortunately, nothing is known about the biography of Enmyō and his successors or about the history of Awano-dera.

The writing style of this scroll is very different from that of standard eighth-century sūtra scribes. The calligraphy here, although modeled after professional copyists of the time, is conspicuously disorderly in the brushwork, structure, and spacing of the characters. The work can hardly be ascribed to a professional and strictly trained scribe of the Shakyō-sho (Bureau of Sūtra Copying). It is not in the strict *kaisho* (block-character style), but is written as a whole in *gyōsho* (running style). The brushstrokes show little variation; the horizontal and diagonal strokes are shortened and lacking in tension and vitality. The placement and arrangement of characters in columns are particularly irregular. Not only is the spacing disorderly, but the basic rule of writing seventeen characters per column is frequently disregarded. There are many columns with either sixteen or eighteen characters. These features reflect the rapid deterioration of the academic style from the high standards of the mid-eighth century, a result of the reduction of personnel in the Bureau of Sūtra Copying. It was eventually abolished in the early ninth century after the Imperial Court moved to the Heian capital.

If the donor of this scroll was indeed a member of the Ihokibe clan, which did not hold a particularly high position in the government or Imperial Court, then this might help to explain the rather provincial style of calligraphy, which shows a lack of practiced exactitude. In contrast with the abundance of dated

量戍就依以菩薩種性亦尔一者為大菩
提因二者為大智因三者為大定因定者由
心住故四者為大義因成就无邊眾生故巳
廣分別性位次分別无性位偈曰

一向行惡行　普斷諸白法　无有解脫分　善少亦无因

二者普斷諸善法三者无解脫分善根四
者善根不具足畢竟无涅槃法者无因故彼
无畏得脫性此謂但求生死不樂涅槃人巳說
无性次說令入偈曰

廣演深大法　令信令極忍　究竟大菩提　二知二性勝

釋曰廣演深大法者為利他故謂无智者令
得大信巳大信者令成就擬忍能行不退巳
擬忍者令究竟成就无上菩提二知者謂諸
凡夫及諸聲聞若得如是彼諸二人則知自
性性德圓滿忍性家為殊勝問云何勝得曰
增長菩提樹　主療及滅苦　自他利為果　此勝知吉根

釋曰如是種性能增長廣功德大菩提樹
能得大藥能滅大菩提能得自他利樂以為大
果是故此性家為第一群如吉祥樹根善薩

種性亦尔　種性品究竟

大乘莊嚴經論卷第一

sūtras from other decades of the eighth century, work
from the late eighth and early ninth centuries is very
scarce. This sūtra, therefore, is a valuable and in-
formative example of the decline of mature, academic
calligraphy at the close of the Nara period. (S.S.)

detail

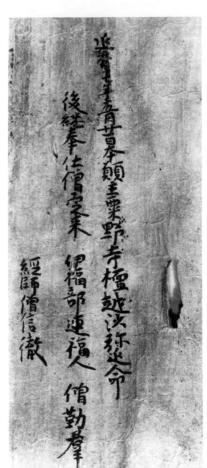

27

9. Collected commentaries on the *Mahāparinirvāna-sūtra*

Nara period (mid-eighth century)
Hand scroll; ink on paper
H. approx. 10 in. (25.4 cm.)

Because this work is annotated, the writing style differs slightly from that of the usual sūtra script. Each standard column contains sixteen characters, with the longest columns of commentary containing twenty or twenty-one smaller characters. The placement of the characters is not as strictly regular as that of the classic *Yake-gyō* (see No. 5), and the columns are not consistently straight. Although occasionally the structure of the characters loses equilibrium, most of them are written in energetic brushwork, generating tension and strength. This scroll is a good example of academic sūtra calligraphy of the mid-eighth century.

The text contains commentaries on a sermon delivered by the Buddha when he was approaching his *Mahāparinirvāna*, the state in which all illusions, suffering, and all possibilities of birth and death were permanently and exhaustively eliminated. The text of the sermon is called the *Mahāparinirvāna-sūtra* in Sanskrit; in Japanese it is called the *Daihatsu-nehan-gyō*, or the *Nehan-gyō* for short. In content, it represents a major step in the development of Mahāyāna thought from that of the *Lotus Sūtra*. It emphasizes that Buddha exists eternally despite the fact that Śākyamuni, the historical Buddha, entered Nirvāna. In addition, it stresses that every being in the cosmos, whether conscious or non-conscious, possesses potential Buddhahood. The original sūtra text had a complex history. Several Chinese translations were made, but some were lost. One of the current versions of the sūtra, translated by an Indian monk, Dharmaraksha in North China in 421, was recompiled shortly after that with the collaboration of the monks Hui-yen and Hui-kuan, and the famous lay scholar Hsieh Ling-yün of the Liu Sung dynasty in South China. Early in the sixth century, a team of monks headed by Pao-liang was ordered by the Emperor Wu-ti of the Liang dynasty to prepare an annotation to the revised version of the sūtra, known as the Southern Version. Commentaries by earlier writers were collected, excerpted, and rearranged in this new work, which consists of seventy-one volumes. They were finished in 509; the scroll shown here is part of the seventeenth volume, treating of chapter nine of the original sūtra: the distinction between right and wrong.

Ancient manuscripts of this annotated work of the *Nehan-gyō* are very rare. In the Shōgo-zō (Storage of Holy Words), the *Tripitaka* store of the Shōsō-in Repository at Nara, are nine scrolls of this commentary, which were originally included in the *Tripitaka* dedicated by the Empress Kōmyō on the first day of the fifth month in 740 (see No. 7). The present scroll, although it does not have any inscription indicating its origin, may be dated almost contemporary with the empress's *Tripitaka* on the basis of the close similarity of the calligraphic style. (S.S.)

Reference: Tanaka Kaidō. *Nihon Shakyō Sōkan*. Tokyo, 1953. Pl. 2, p. 127.

是已便入涅槃若有經律作是說者當知
即是魔之所說我亦不聽常翹一脚若為
法故聽行住坐卧又亦不聽服毒斷食五
執炎身繫縛手足殺害眾生方道呪術呵貝
鳥牙以為草屣儲畜種子草木有命著摩
訶楞伽若言世尊作如是說當知是為外
道眷屬非我弟子我唯聽食五種牛味及
油蜜等聽著草屣憍奢耶衣我說四大無
有壽命若有經律作是說者是名佛說
若有隨順佛所說者當知是等真我弟
子若有不隨佛所說者是魔眷屬若有
隨順佛經律者當知是人是大菩薩　案僧宗曰
第七用若九十五種道皆聽出家亦為亂律也智
秀曰此第十一謂佛聽畜不如法物及聽出家
亦為魔說也　善男子魔說佛說善別之相令
巳為汝廣宣分別　案智秀曰結上言也
世尊我今始知魔說佛說善別之相因是　案智秀曰讚嘆
得入佛法深義　佛讚迦葉善哉

10. Three model pagodas

Nara period (ca. 764–770)
Wood coated with gesso and originally colored
H. 8 1/2 × D. 3 3/4 in. (21.5 × 8.5 cm.)
Printed paper sheet
Overall dimensions: H. 2 3/8 × 18 5/16 in. (6 × 46.5 cm.); printed area 1 3/4 × 12 5/8 in. (4.5 × 32 cm.)

These miniature Buddhist pagodas, mass-produced on lathes, were part of a group of one million ordered by the retired Empress Kōken at a time when she was enmeshed in one of the most bitter and controversial disputes in the history of the Japanese imperial family. As works of art they bear none of the subtleties of personal expression found in painting or calligraphy, yet they are remarkable reflections of the spiritual and political atmosphere of the Nara period, and of the impact that Esoteric Buddhism was beginning to have. In each model pagoda, for example, a printed Buddhist charm closely related to the empress's difficulties was placed in a small chamber beneath the base of the spire. These charms, moreover, have long been considered the world's first certain and clearly attested examples of printing with blocks upon paper. However, a slightly older printed Buddhist text has recently been discovered at the Korean monastery of Pulkuk-sa in Kyongju, the former capital of United Silla.

The Empress Kōken came to the throne in 749. She was the daughter of the Emperor Shōmu and his consort Kōmyō, both extremely pious Buddhists. Shōmu was intimately involved in the building of Tōdai-ji and the bronze Daibutsu in Nara and in the scheme to set up state-supported monasteries and nunneries in each province of the nation. The Empress Kōmyō devoted herself to the expansion of Kōfuku-ji, the tutelary temple of the Fujiwara family, of which she was a member; it was she who gave much of the imperial treasure to the Shōsō-in Repository after Shōmu's death. Their daughter Kōken was pious in her own right, and in 758 she abdicated the throne to become a nun. Succeeding her was an infant emperor, Junnin. Controlling the bureaucracy and armed forces was a powerful member of the Fujiwara family, Nakamaro, who planned major governmental reforms and even an invasion of Silla. He was given the honorific title, Emi no Oshikatsu. The retired empress, however, fell under the sway of an eloquent and brilliant monk, Dōkyō, and a bitter rivalry broke out between Oshikatsu and the monk, and between Kōken and the young emperor.

In 762, Kōken entered the nunnery of Hokke-ji, near the Imperial Palace, and proclaimed her intention to rule as head of state. In 764, she sent an official to seize the state seal and other tokens of power from Junnin; open conflict on a limited scale broke out, and Oshikatsu was killed. In October of 764, Junnin was arrested and exiled, and Kōken resumed the throne under the new name of Shōtoku. It was during the trials of that year that she vowed to have the million pagodas built, and the project took around six years to complete. During that interval, she appointed

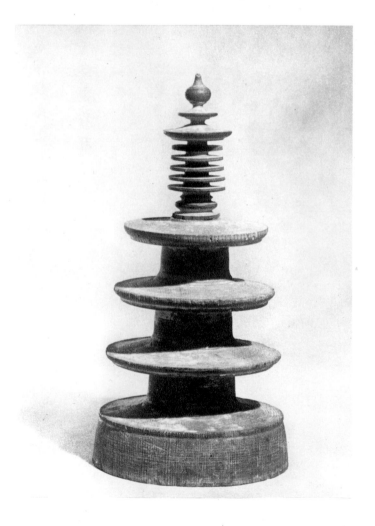

Dōkyō Minister of State and Master of Buddhist Meditation. She even planned to abdicate in his favor, and thereby convert Japan into virtually a theocratic state. However, the resistance of conservative courtiers continued. Upon the death of the empress in 770, Dōkyō lost his power, and plans were made to move the capital away from the oppressive influence of the Nara monasteries.

Kōken's intentions in ordering the one million small pagodas were based on a Buddhist sūtra, the *Mujōkō-darani-kyō*, which was translated into Chinese in Ch'ang-an in 705 by a Central Asian monk named, perhaps, Mitraśanta. Typical of early Esoteric Buddhist texts, it offers guidance to rulers who wish to expand and lengthen their government, to extinguish wrongdoing in their realm, to suppress treason and sworn enemies. It urges them to copy charms (*dhāranī*, or phrases of semimagical import) and install them in small stūpas. In one passage the text stipulated making ninety-nine thousand stūpas; in another it suggests over nine billion, nine hundred million. The empress ordered one million stupas, divided them into groups

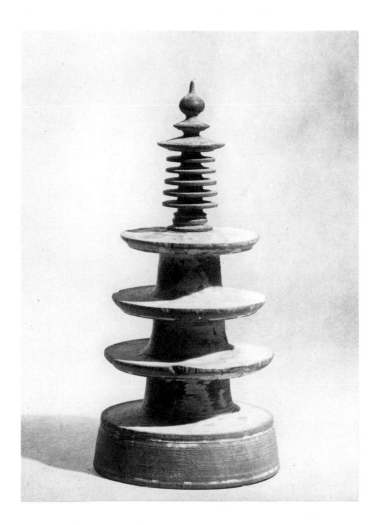
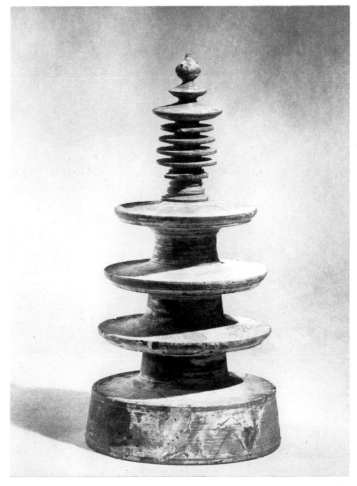

31

of one hundred thousand and donated them to ten great temples. In the Nara region, they were given to Kōfuku-ji, Gangō-ji, Yakushi-ji, Tōdai-ji, Saidai-ji, and Daian-ji; in the Yamato region, they were given to Hōryū-ji and Gufuku-ji. A set was given to Shitennō-ji in Naniwa (Osaka), and to Shūfuku-ji in Ōmi Province (Shiga Prefecture). In most places, special halls were built to enshrine them. Records of their donation are abundant, but today they are found only in Hōryū-ji, which has kept over forty-three thousand pagodas and over one thousand seven hundred printed charms.

In shape, the models are variations on the traditional three-story pagodas erected in Japanese temples, with the details and proportions modified for production on a lathe. The base and the three dishlike roofs are made of *hinoki* cypress; set into the third roof is the spire, made of harder wood like *katsura* (akin to redbud) or *mokkoku*. On the spire, the five thin discs represent the umbrella forms seen atop ancient Indian pagodas (stūpas), and above this is a modified jewel form set over a platelike pedestal. The models were all covered with a plasterlike gesso and then painted ultramarine or verdigris; some were vermilion-red, others yellow; most of the pigments, however, have flaked away. The three small pagodas exhibited here are the standard size; however, a pagoda twice this size with seven stories was made to mark each ten-thousandth unit; and for each hundred-thousandth, a pagoda was made three times as large

with thirteen stories. Examples of the larger pagodas may still be seen in Hōryū-ji.

The printed charms placed in the pagoda were of four kinds, each taken from the text of the *Mujōkō-darani-kyō*. Each of these three models contains its charm, somewhat rotted and eaten by insects. Scholars have debated whether they were printed from copper or wooden blocks. The bulk of the evidence suggests the latter, for the wear and fading of the type is considerable. As in the charm exhibited here, some of the characters were redrawn by hand; and in the Hōryū-ji collection are charms written entirely by hand.

The extravagance of the Empress Kōken's deed is very much in the spirit of the Indian religious imagination, in which fabulous numerical categories are common. Just as the Indian Emperor Aśoka is said to have built eighty-four thousand pagodas in honor of the Buddha, so the Chinese could duplicate in small gilt bronze replicas the legendary donations of Aśoka. In Japan, the custom of making wooden model pagodas was not limited to the Empress Kōken. The retired Emperor Shirakawa is recorded as having given 446,610 small stūpas and twenty-one larger ones in 1129; and there are records of similar donations into the Muromachi period.

Reference: Ishida Mosaku. *Nihon Buttō no Kenkyū*. Tokyo, 1969. No. 165; *Hōryū-ji Ōkagami*, vol. 7. Tokyo, 1933. Pls. 38–43; Mochizuki Shinkō, ed. *Bukkyō Daijiten*, vol. 5. Tokyo, 1933. Pp. 43–46.

11. Śākyamuni and three Kaśyapas, from an illustrated *Sūtra of Cause and Effect, Past and Present*

Nara period (ca. 750)
Section of a hand scroll mounted as a kakemono; color and ink on paper
H. 10 1/4 × 7 5/8 in. (26 × 18.5 cm.)

This small composition is taken from a long scroll relating the biography of the Buddha Śākyamuni. It shows three followers of a sect of Brahmans, called the Kaśyapas, inquiring of the Buddha how he had given off a miraculous emission of light. Śākyamuni had come to pass four nights in the hermitage of the Kaśyapas near Bodh-gayā, the place of his Enlightenment, and he performed a series of miracles that eventually convinced them that his religious authority exceeded their own. They became his loyal followers and thereby symbolized the submission of traditional Hindus to the new Law of the Buddhists.

This section was once part of a scroll belonging to the Masuda family, which has been cut apart and divided among many collections. The Masuda scroll in itself was one of four more or less complete ones illustrating this sūtra that remain from the eighth century. The four scrolls comprise one of the most important documents in the development of Asian narrative and landscape painting.

The title of the text, the *Kako-genzai-inga-kyō* (*Sūtra of Cause and Effect, Past and Present*), expresses the Indian conception that a person's good or evil deeds (his *karma*) produce good or bad conditions in his future lives. Hence, Śākyamuni, in previous incarnations, had done countless deeds of high merit, and his attainment of Enlightenment was in part the fulfillment of these deeds. The sūtra itself no longer exists in any Indian language; it was translated into Chinese by the Indian monk Gunabhadra, who died about 429. The text, four manuscript scrolls in length, must have been a popular one in China. It was illustrated there by placing narrative scenes in an upper register and the text in a lower one, thereby lengthening the whole to eight scrolls. Sadly enough, no ancient Chinese illustrated version of the text has been preserved.

There is evidence that the illustrated *Inga-kyō* was known in Japan as early as 735 and that it was faithfully copied by the Sūtra Copying Bureau of the imperial administration. That bureau had been established during the height of the official, governmental support of the Buddhist faith, and it was an elaborate atelier.

There is documentary evidence of at least nine different sets of illustrated scrolls of the *Inga-kyō* from the eighth century; none remains in its entirety. Of the scrolls that do remain, there are enough marked variations in style to indicate that they were done at different times or by different hands, and that probably more than one Chinese original served as model.

The Chinese scrolls seem to have possessed a high degree of sanctity. They were unique among their kind—combining text and illustrations in two registers—and the Japanese copyists remained unusually faithful to the originals, preserving Chinese modes of composition that were as much as two hundred years old. The size of the human figure in relation to the trees and rocks, for example, is symbolic and not objective; landscape forms serve more as ideographs, to identify a setting, than as aesthetic recreations of the experience of nature; rocks and trees are used primarily to separate one episode from another. The narrative method is a simple, didactic one, attempting to integrate no more than two events within a single frame; the action is brought into the foreground with little effort to establish a middle ground, and with only an occasional vista into deep space. The execution is direct and uncomplicated—a preliminary drawing in *sumi* ink followed by thin coats of bright, opaque pigments, and then by a final reinforcement of the composition with black outlines.

Together with the stylistic features of sixth-century painting, the *Inga-kyō* also reveal traits that are closer to the time of their creation. The figures and animals are rather normative in spirit, lacking the almost demonic vitality that so often appears in pre-T'ang figural arts; the costumes and hairstyles are those of the early T'ang period; and there are occasional advanced refinements in the realistic depiction of horses and rocks.

Technical analysis, however, does not reach the chief appeal of the early *Inga-kyō* paintings. Their very simplicity amplifies an air of elegant purity, which is so clearly apparent in this painting and missing in later versions of the same text (see Nos. 42, 43). Although the cutting apart of the Masuda scroll must be

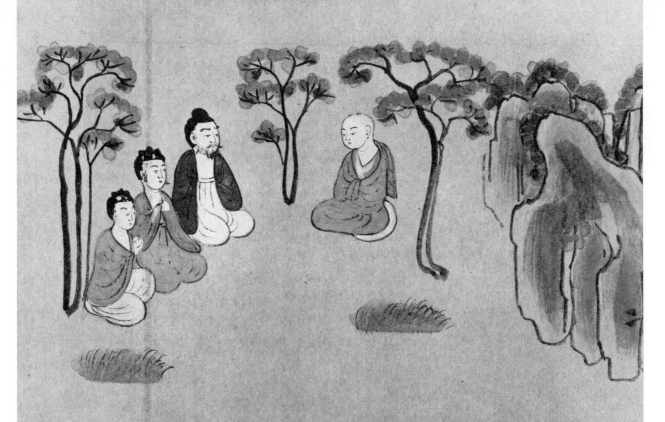

梵天王来下聽法故

道真也至第四夜大

德雖盛然故不如我

弟子言年少沙門神

其先于時迦葉語

提桓因来下聽法是

之事火佛言不也釋

詣佛所問沙門言汝

事火也重於明旦往

白師言年少沙門宅

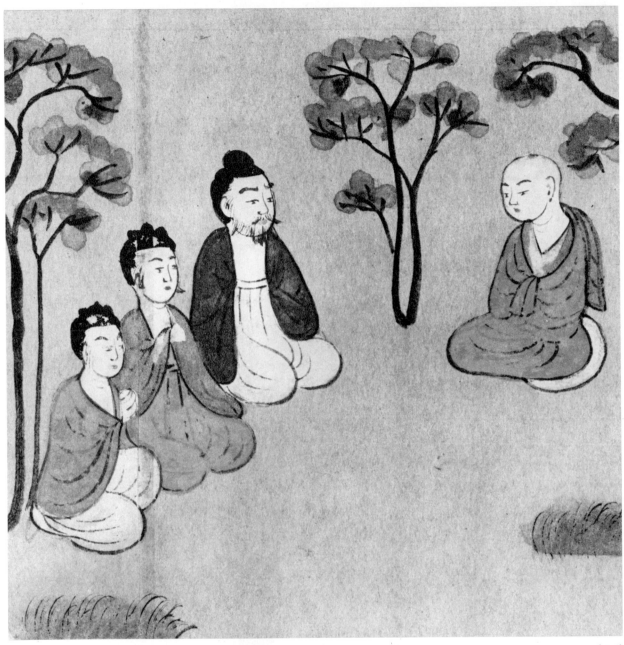

<div align="right">detail</div>

greatly regretted, something has been gained by the isolation of a composition as an aesthetic event. The paper is a darkened "yellow hemp" type. The calligraphy, in lines of eight characters each, is in itself of a very high order. It is a strict, disciplined T'ang style used particularly in Buddhist texts and also by the Nara Imperial Court. One character, reading "ear," was cut out from the seventh line of the text. The same character is missing in the next section of the scroll. This may have been done to make an amulet

for someone worried about his hearing. Other characters have been removed from the scroll, whose sanctity and curative powers must have been thought very powerful.

Formerly in the Masuda collection, Tokyo; Kōfuku-ji, Nara.
Published: Murase Miyeko in Shimada Shūjirō, ed., *Zaigai Hihō*, vol. I. Tokyo, 1969. No. 1; Kameda Tsutomu et al. *E-inga-kyō*. Nihon Emakimono Zenshū, vol. XVI. Tokyo, 1969. Pp. 59–60.

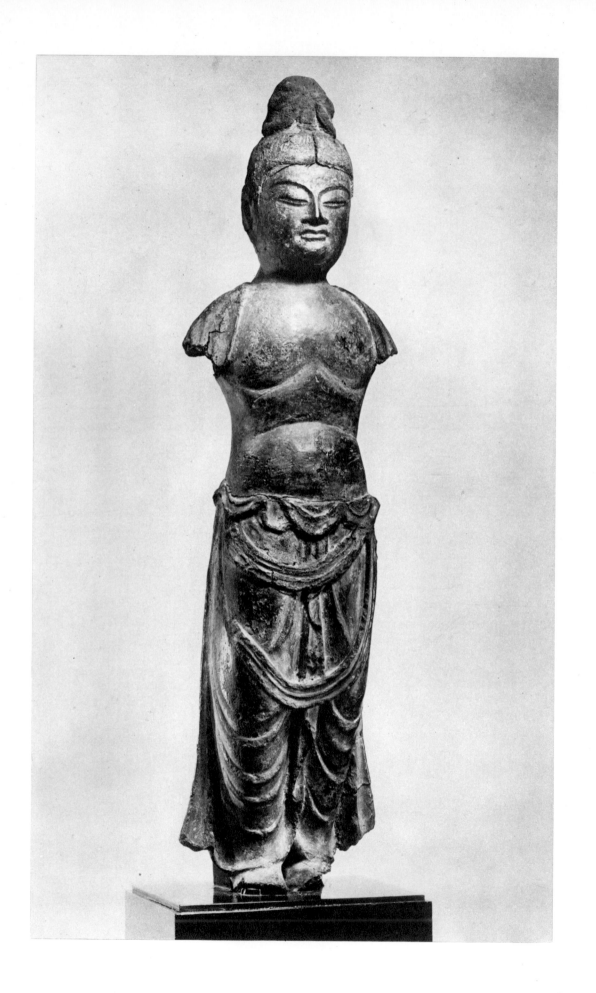

12. Standing Bodhisattva

Late Tempyō period (ca. 775)
Hollow dry lacquer, with traces of gold leaf
H. 21 in. (53.3 cm.)

Standing frontally with a slight suggestion of contrapposto, this small, sober image was probably an attendant Bodhisattva, one of two which flanked a central deity. In its aesthetic qualities, it bears the strong imprint of the method of its manufacture—the sense of volume swelling with an inner pneumatic pressure and the soft integration of the details of face and garment folds with the substance of the image itself.

It was made by the so-called hollow dry lacquer technique, a complex and difficult method that originated in China in the sixth century. Imported to Japan, the technique flourished almost exclusively in the eighth century in the Nara region, during the period of close contacts between China and the Japanese capital.

The figure is entirely hollow, and its outer shell is made of three or four layers of hemp cloth that were saturated with lacquer. The shell was probably made in two halves, front and back, which were sewn together. Each half was shaped over a clay mold that established the general form and volume of the inner void; slips of wood may have been inserted between the cloth lamina as reinforcement. When the lacquer dried and hardened, the clay was removed and the two halves joined. A smooth surface layer, made probably of powdered incense and lacquer, was applied and the figure then coated with gold leaf.

This process had appealed to the Chinese and then the Japanese for a number of reasons. First, it allowed the sculptor great flexibility in creating surface effects at a time when a variety of expressive media in the arts was being explored. Second, the dry lacquer images were extremely light in weight, but sturdy and insect resistant. Very large figures could be made this way, such as those remaining today in the Sangatsu-dō of Tōdai-ji, the Fukūkensaku Kannon, nearly twelve feet high, and the eleven-foot guardian figures. Third,

while the process was by no means simple or inexpensive, it had a great advantage over metal casting in that no bronze was used. In China especially, this reduced the temptation to marauders and bankrupt governments to seize an image for its intrinsic value for coinage or the making of weapons.

This work came from the celebrated collection of the Hara family, Yokohama, together with a statue similar in technique and scale now in the Freer Gallery, Washington, D.C. Both figures are posed with a slight contrapposto, this one casting its weight on its right hip, the Freer figure on its left, making it virtually certain that the two flanked a central deity in a trinitarian group.

A date in the last half of the eighth century for this work is securely based on stylistic grounds, for it is almost a perfect example of the transition between Tempyō and Heian styles, between the elegant, quasi-realistic style of clay and dry lacquer of the mid-eighth century, and the more sober, static, and volumetric manner of the early ninth. This figure belongs with a large group of images done in Nara in the last half of the eighth century: the solid wood sculptures of Daian-ji and Tōshōdai-ji and the rather small dry lacquer figures of attendant Bodhisattvas of the Dempō-dō in the Eastern Precinct of Hōryū-ji. This work and the Freer figure are among the smallest examples known today of hollow dry lacquer sculpture. But according to Kuno Takeshi, the records of the Nara temple of Saidai-ji indicate that a votive group in dry lacquer was made in 780, the main figures barely twelve inches high.

Formerly in the Hara collection, Yokohama; Morimoto collection, Tokyo.
Reference: Kuno Takeshi in *Kobijutsu*, no. 14 (August 1966); *Hōryū-ji Ōkagami*, vol. 8. Tokyo, 1924. Pls. 82–87.

13. Seated Amitābha (Amida)

Late Nara to early Heian period (ca. 800)
Wood-core dry lacquer, with traces of gold leaf
H. 11 5/8 in. (29.5 cm.)

In both style and material, this delicate figure belongs to the time of transition from Nara period to early Heian modes of sculpture. In its symmetry and idealization of form it retains the spirit of the classical, international Buddhist style; the full, brooding lips are faithful to the canon of Chinese Buddhist images of the mid-T'ang period. In addition, a touch of Nara period realism may be detected in the handling of the folds of the garment as it falls over the left arm and right ankle. Freedom and élan in the composition link it with such late Nara period works as the seated Buddhas of wood-core dry lacquer that were placed in the base of one of the pagodas of Saidai-ji, Nara. The Amitābha figure there is in the same pose as this one, and it is possible that this too was part of a set of the Buddhas of the Four Directions.

The sculptural techniques, however, are those of the early Heian period. The figure is built primarily of solid blocks of wood—three are visible on the bottom. Over the wood is a layer of hemp cloth and a finishing coat of lacquer. The lacquer is extremely thick over the upper arms, chest, and the folds of the robe hanging from the wrist. It is thin over the knees and feet. Indicative also of a date near the beginning of the Heian period is the assertive linear quality of the garment folds and the suggestion of the *hompa-shiki*, a method of modeling folds of cloth in which a sharp angle appears in the flat space between the folds.

Seated cross-legged, the Buddha holds his hands in a gesture of teaching, the emblem of his welcoming to Paradise even those who have sinned and broken the Buddhist commandments. (The fourth finger of the left hand, now missing, originally touched the thumb.) Amida images are found with nine such hand gestures, each symbolic of one of the nine stages of Paradise that are assigned to the nine levels of virtue (or lack of it) among men, ranging from saintly purity to gross evil. This gesture relates to the Gebon Chūshō, the middle level of the lowest stage of Paradise. Some of the hair curls have been lost; they were made of separate pieces of wood and lacquer and attached to the surface.

Published: Mayuyama Junkichi. *Japanese Art in the West.* Tokyo, 1966. No. 6; John Rosenfield. *Japanese Arts of the Heian Period.* New York, 1967. No. 10; *Oriental Art*, N.S., vol. XIV, no. 2. (Summer 1968).
Reference: *Saidai-ji Ōkagami*, part I. Tokyo, 1933. Pls. 20–24.

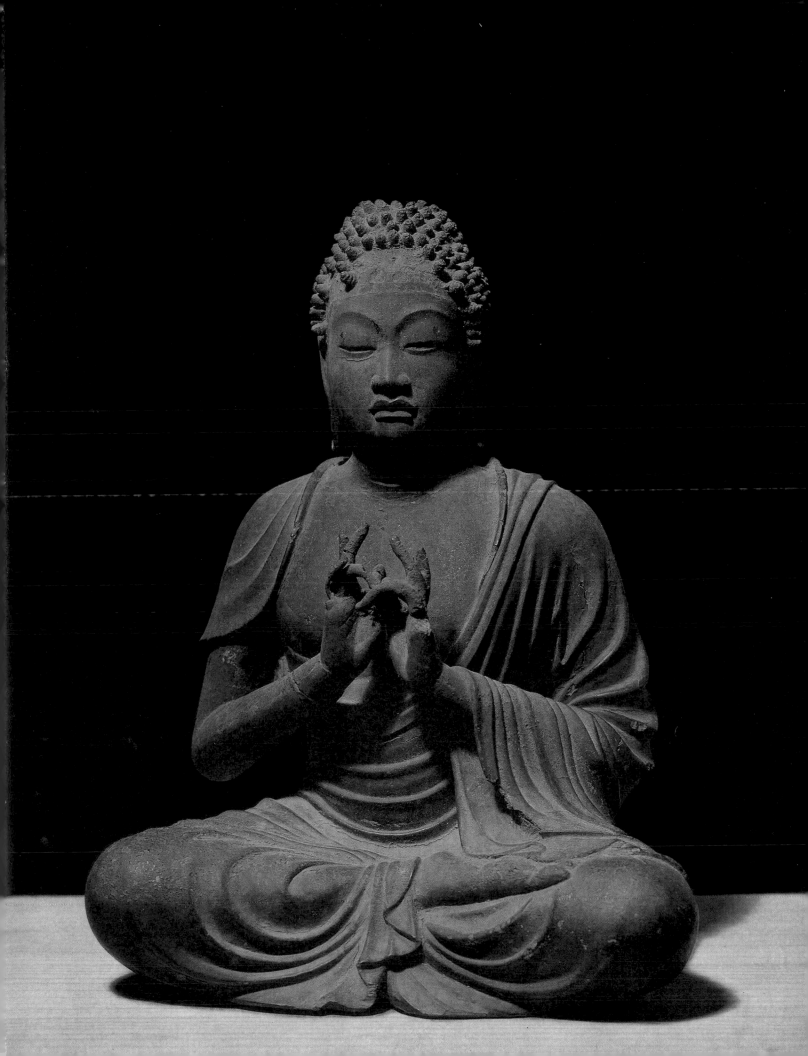

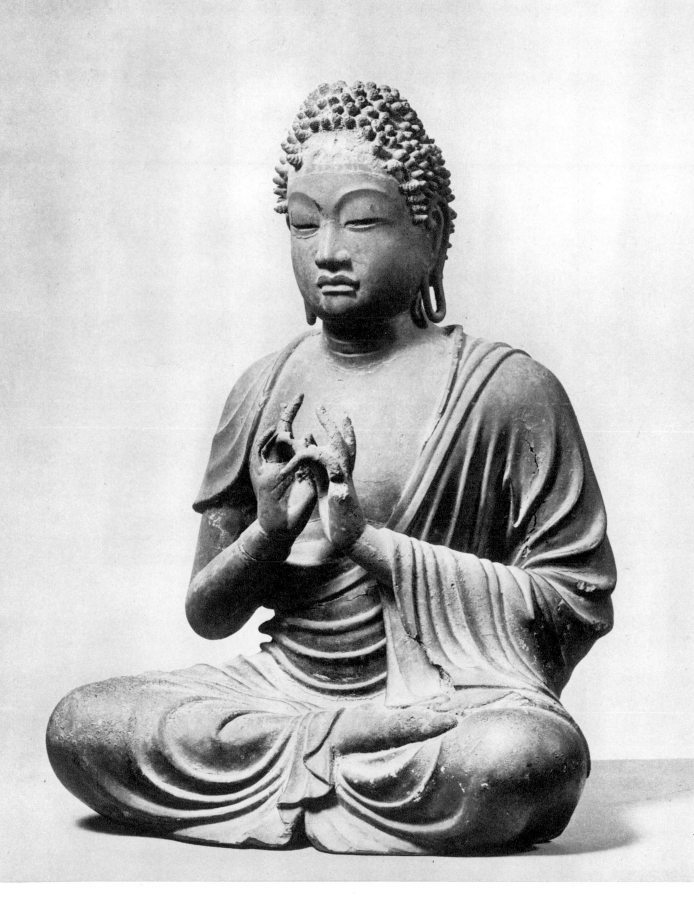

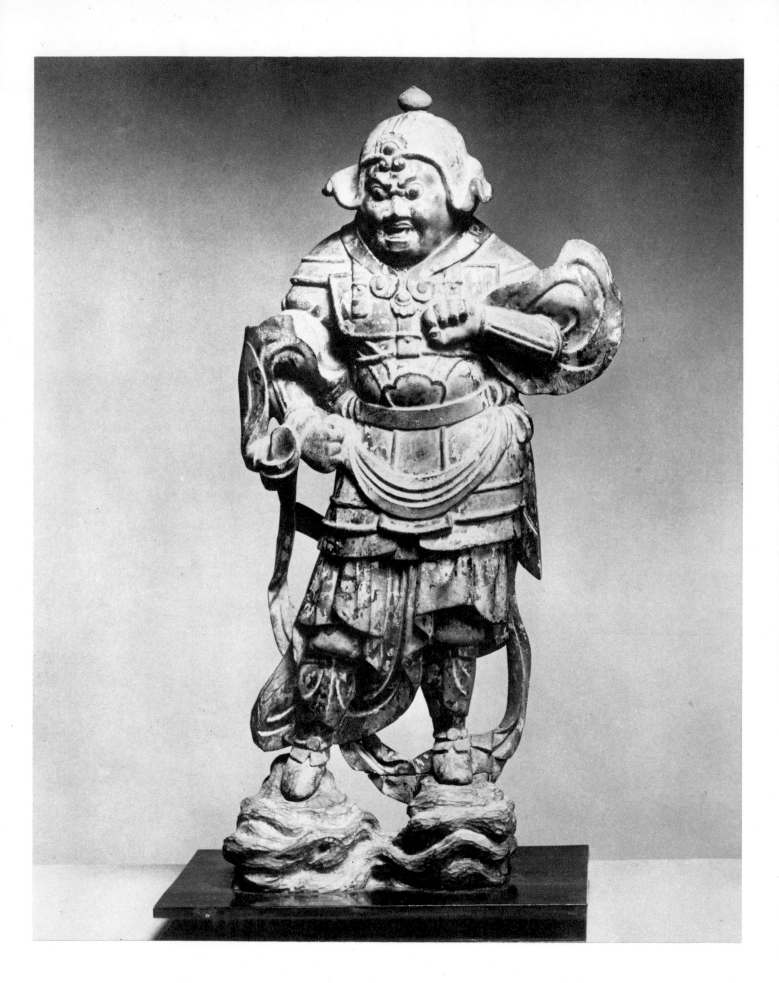

14. Divine General

Early Heian period (early tenth century)
Wood, with thin lacquer coat and remnants of gold leaf
H. 13 1/4 in. (33.6 cm.)

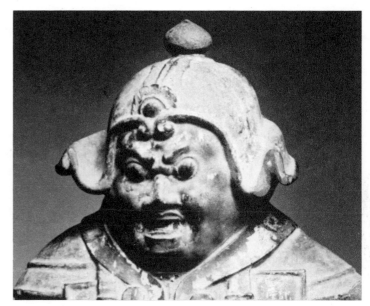

detail

This figure was one of a set of twelve guardian deities that were probably attached to the walls of a shrine enclosing a statue of the Healing Buddha, Yakushi. The Twelve Divine Generals (Jūni Shinshō) each personify a vow made by the Buddha Yakushi to heal mankind of its physical and spiritual woes.

The imagery is based on an ancient sūtra devoted to Yakushi and first translated into Chinese in 170 A.D. It lists the Buddha's Twelve Vows, which include goals such as causing all non-believers to find the path to Enlightenment and giving perfect purity to the life of all sentient beings. The Buddha also vows to cure all whose bodies are weak, to aid women to gain re-birth as men, to bring relief to those in prison and to those about to undergo capital punishment. He also vows to bring food and drink to those suffering hunger and thirst and to give garments and comfort to those who are poor. The Twelve Divine Generals, each of whom leads an army of seven thousand demons, pledge their assistance to the Buddha and pledge to protect all living beings who accept that holy text.

This image is said to have come from Kōfuku-ji, the great Fujiwara temple in Nara (see No. 58), and indeed, it fits well into the stylistic sequence of the many sets of guardian figures preserved there. Yakushi was widely worshiped at this temple; he was the *honzon* (main object of devotion) of the Eastern Kondō. From that hall, probably, has come a famous set of the Twelve Divine Generals carved in low relief on wood panels three feet high. Their dating, tentative at best, is thought to fall somewhere in the late tenth or early eleventh century. This figure is older and should be considered a prototype of the others, which are flatter in relief and more whimsical and humorous in spirit. This figure, in its thick neck and squat proportions, **is** closer to the tenth-century guardians that were installed in the Eastern Kondō.

Published: John Rosenfield. *Japanese Arts of the Heian Period*. New York, 1967. No. 70.
Reference: *Kōfuku-ji Ōkagami*, part one. Tokyo, 1932. Pls. 123–132; ibid., part two. Tokyo, 1933. Pls. 71–74.

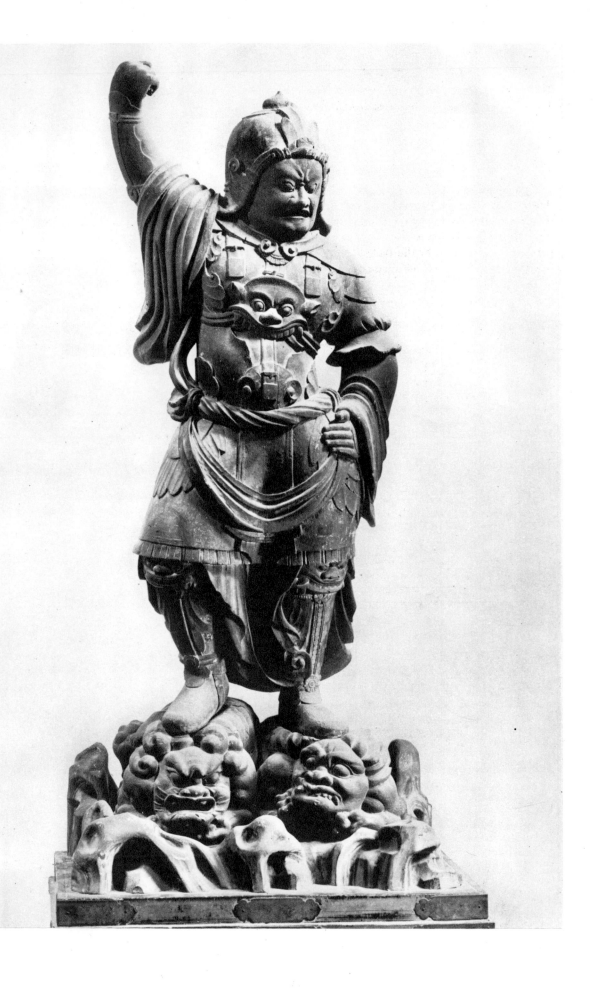

15. Divine Guardian King (Tennō)

Early Heian period (tenth century)
Wood, with darkened lacquer surface
Figure: H. 39 in. (99 cm.)

This burly figure belongs to a small but very distinct group of Buddhist sculptures localized chiefly in the region to the north and east of Kyoto. This is a stylistic "minigroup," a small, independent formal tradition within a much larger creative context. Datable to the ninth and tenth centuries, examples are scattered in such Esoteric Buddhist temples as Ishiyama-dera and Onjō-ji (Mii-dera), in Enryaku-ji as well as Daigo-ji. Stray works may also be seen in Nara at Reizan-ji and at Kōya-san. No sculptors' names are known, and the precise origins of these works are not certain; hence it is not entirely clear how so eccentric a style could have flourished in the very center of more orthodox Japanese sculptural traditions.

The style is distinguished by the use of solid woodblock construction, usually a single block for the core of the statue. The figural style is extremely squat; heads, hands, and feet are disproportionately large, the necks quite thick; assertive linear patterns are created by drapery folds and scarves. There is also a factual air about these images; each detail, from

fingernails to parts of armament and jewelry, is shown with almost exaggerated clarity. In the guardian figure exhibited here, this is especially apparent in the half-mask of the scowling lion ornamenting the chest armor. The style lasted for several generations at least, and seems, moreover, to have been partially revived in the sculptural renaissance of the early Kamakura period. Statues at the Kongōrin-ji, Shiga Prefecture, for example, datable to 1184 and 1212, recover much of this manner but with a far greater sense of movement. The early figures, such as this one, are quite static and are far removed from the mobile grace of classical T'ang sculpture that was still influential in Japan during those decades (see No. 14), In fact, this anticlassic spirit in the arts seems to stem from massive wooden figures of the late eighth century, such as the Yakushi statues at Jingo-ji and Shin Yakushi-ji, or such static guardian figures as those in Daian-ji, Nara.

It is possible that this statue was part of a set of four divine guardians of the four directions (Shitennō) placed at the corners of an altar platform (see No. 59), but his precise identity among the four is not certain. The Shitennō tended to take on the qualities of their most prominent member, Vaiśravana (Bishamon-ten), Guardian of the North, the direction of the greatest peril in Sino-Japanese cosmology. Bishamon in Japan became the object of an independent cult of his own as a giver of wealth and guardian of a district or town. He had those same functions in his earliest appearances in Indian Buddhist art under the name of Kubera. There, he was also considered as the King of the Yakshas, the animistic spirits who control rain and disease and the safety of travelers. These demigods, at once the victims and the agents of Kubera, are reflected here in the pair of eloquently carved demonic figures (*jaki*) beneath his feet, their faces contorted in anger, their bodies heavily muscled and powerful.

Reference: Uno Shigeki. *Ōmi Zōzō Meiki.* Kyoto. 1950. Pls. 16–20; S. Sakai. *Nihon Moku Chōkoku* (1929), pp. 137, 189; *Kōya-san.* Hihō, vol. 7. Pl. 198.

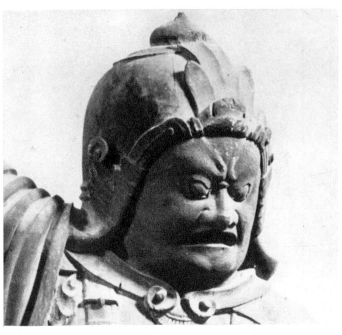

detail

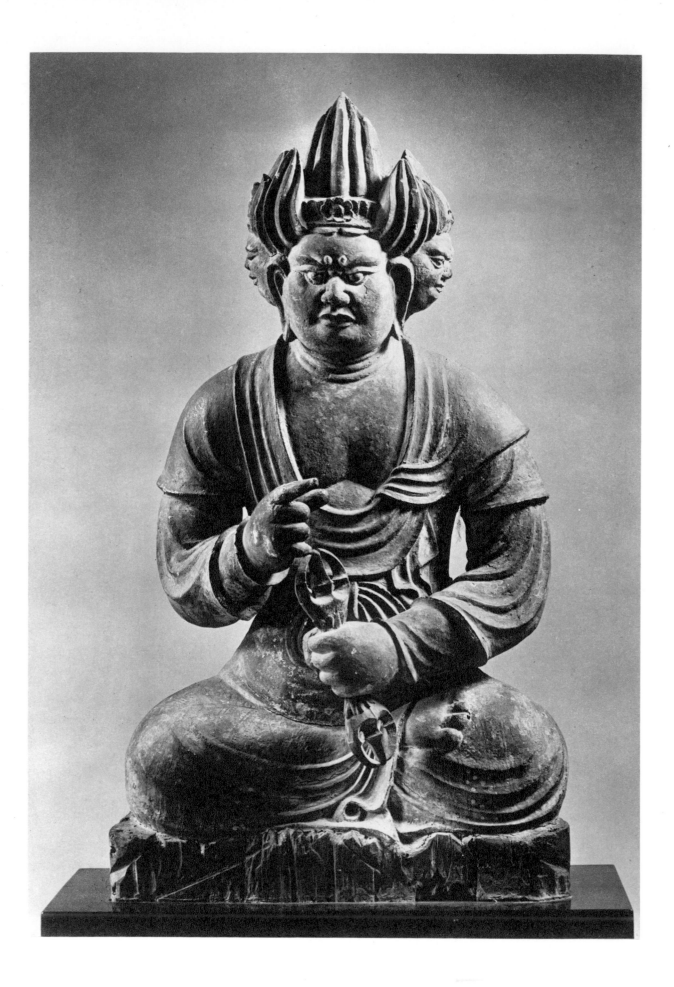

16. Seated Vidyārāja (Myō-ō)

Early Heian period (ca. 1000)
Wood, with coating of gesso and paint, and traces of gold
H. 15 3/8 in. (39 cm.)

This remarkable work of Esoteric Buddhist sculpture has a rustic flavor in its alertness and vigor, in the assertive, simplified sense of form. No precise parallels have been found for it, but among the patently provincial carvings from western Japan—Hiroshima, Okayama, and Shimane prefectures—and from the northeast as well, one can see faces as simplified as this and the same linear definition of the drapery folds. Also, the folded legs of this figure have been flattened so that the torso and lap are part of the same plane. This is a trait found in provincial Shintō sculpture in the same area and in Kyushu. Carved from a single block of wood, the figure is modeled more as a relief than as a three-dimensional sculpturesque form. The left foot, shown as though seen from above, and the out-turned ears add charming touches of naiveté.

One of the most unusual features of Japanese art is the manner in which Esoteric Buddhist imagery spread into the remotest parts of the land from the great workshops of Kyoto and Nara. The small sculpture ateliers that arose in distant monasteries lacked the accumulated technical skills and standards of the metropolitan centers, and their products often have the qualities of folk art so apparent here—fresh, original variations on more sophisticated forms. To be sure, some provincial sculptures are painfully inept; but in this case, there is a wholesome vitality and self-confidence.

The figure is as simplified iconographically as it is in style. He holds in his left hand a large, three-pronged thunderbolt (*vajra* or *kongō*), a primary emblem of Esoteric Buddhism which is often referred to as the Thunderbolt Vehicle (Vajrayāna). The deity is probably one of the Bright Kings (Vidyārājas), a large class of ferocious, enraged deities who project the fiery energy and militancy of the faith (see Nos. 19, 45, 56). But despite the demonic arrangement of three heads and the depiction of the flaming hair, this figure seems more like a stern uncle when compared with his truly frenzied counterparts in the Lecture Hall of Tō-ji in Kyoto, for example. Usually, when such Vidyārājas (Myō-ō) are shown with three heads

as here, they are given more than two arms to emphasize their superhuman powers. Instances do occur, however, in which Dai-itoku Myō-ō (Yamāntaka, the Bright King who vanquishes death) is depicted in a manner similar to this.

Published: John Rosenfield. *Japanese Arts of the Heian Period*. New York, 1967. Added entry C.
Reference: *Shinshū Daizōkyō Zuzō*, vol. III. Tokyo, 1932. P. 876; Kuno Takeshi. *Zoku Nihon no Chōkoku*, vol. I. Tokyo, 1964. No. 13; ibid., vol. V. Tokyo, 1964. Nos. 13, 19, 23.

detail

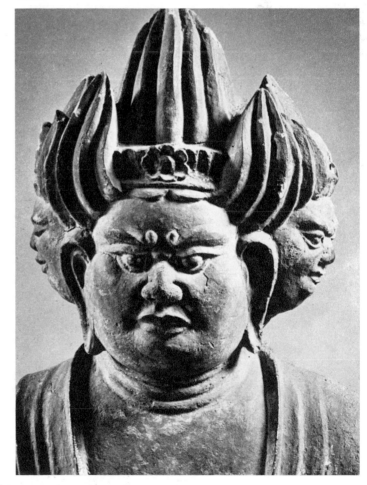

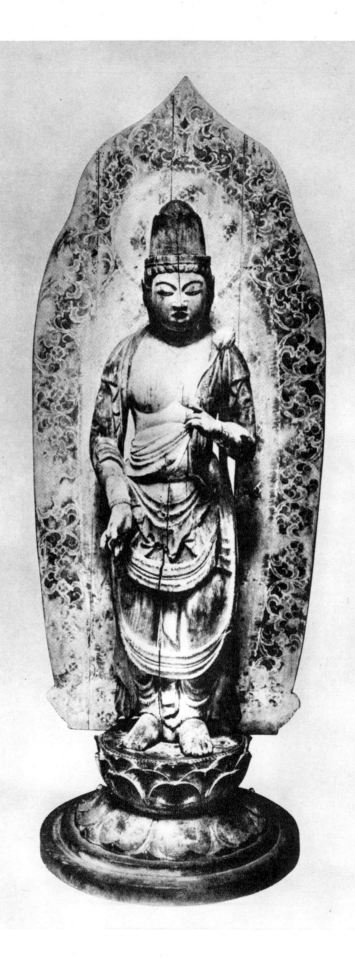

17. Standing Avalokiteśvara (Kannon)

Heian period (first half of the eleventh century)
Cypress wood, with traces of gesso and paint
H. 35 7/8 in. (91 cm.)

This standing Bodhisattva demonstrates many traits of a distinctively Japanese style of Buddhist sculpture that appeared in the first part of the Heian period—the static pose; the sense of the solidity of the wood; the sober, introspective expression of the face. To be sure, its prototypes are the graceful ninth-century wooden figures of Kannon in such temples as Kōgen-ji in Shiga Prefecture, Hokke-ji in Nara, and Dōmyō-ji in Osaka. In those, the search for ideal beauty and charm was part of the main current of Mahāyāna Buddhist imagery as devised in Guptan India—in the celebrated standing Avalokiteśvara from Sārnāth in the National Museum of India, for example—and transmitted through Central Asia and China. The supremely refined, elegant stone reliefs from the exterior of the pagoda of the Pao-ch'ing-ssu in Ch'ang-an most clearly manifest this style, which the Japanese knew well and emulated throughout the eighth and ninth centuries. But, during the ninth century, many factors arose to challenge the authority of that tradition. The severe persecutions of the Buddhist community in China in 845 upset its stability and its artistic progress. The development of Esoteric Buddhism in Japan called for aesthetic qualities somewhat at odds with the classic Mahāyāna tradition—the intense ferocity of some of the deities adapted from the Hindu pantheon (see Nos. 19, 31, 54) and the sense of mystic, uncanny power in others. The spread of the Buddhist faith into remote areas of Japan saw the development of simple, rustic styles of sculpture, which, in their rusticity, appealed to a native Japanese feeling for materials, especially wood.

Even though this statue remains within the general framework of the idealizing and elegant Mahāyāna style, it has become far more solid and somatic in nature. It is carved of a single block of *hinoki* cypress, with no hollowing out from the rear, and thus deep cracks have appeared in its surface as a result of the drying and shrinking of the wood. The scarves which cross the body fall in a regular and geometric pattern rather than twisting gracefully and realistically in the T'ang manner. Even though the left knee suggests a slight contrapposto, the figure is stolidly frontal in pose. Unfortunately, the two hands are later additions taken from an old but smaller figure, and thus not in harmony with the figure itself. The feet, too, are restorations.

The provenance of this statue is unknown, and the handsome flat board halo seems to have been made for a taller image; it belongs, however, to about the same period. Its simple floral pattern in gray and buff has been deftly restored. On stylistic grounds, this figure may be placed in the first half of the eleventh century, just before the perfection of the assembled wood-block construction and of the lighter, more lyrical spirit of Pure Land imagery (see Nos. 20, 27). It seems to fall between the date of the solid Kannon image in Yūnen-ji, Nara, dated 1069, and the Juntei Kannon in the Nara temple of Shin Yakushi-ji, dated 970.

Published: Kuno Takeshi. *Kantō Chōkoku no Kenkyū*. Tokyo, 1964. P. 319. No. 60 (shown without halo); John Rosenfield. *Japanese Arts of the Heian Period*. New York, 1967. No. 21.
Reference: *Nihon Chōkokushi Kiso Shiryō Shūsei*, vol. I. Tokyo, 1967. No. 7; ibid., vol. II. Tokyo, 1967. No. 20.

18. Processional mask

Heian period (ca. 1000 A.D.)
Paulownia wood, with traces of gesso and lacquer
H. 9 1/4 in (23.5 cm.)

This mask was originally part of a large set carved for a ritual known as the Mukae-kō (the Ceremony of Welcome), which was performed at temples of the Pure Land creed. The ceremony is said to have begun around the turn of the eleventh century and been started by the monk Genshin who revived the cult of Amida and the Western Paradise; monks and laymen dressed in their most resplendent robes and wearing these masks would enact the coming of Amitābha and his entourage of Bodhisattvas, musicians, and guardians to receive the souls of the dead. To the beating of drums and cymbals, and the plaintive wail of flutes and the chanting of prayers, these processions (*gyōdō*) would move slowly along a raised walk leading from an Amida hall into the forecourt of a temple. The courtyard would be filled with crowds of parishioners of all ages, from infants to aged grandparents, for whom the ceremony strengthened their belief in Amida's coming and filled their imagination with a vision of rebirth in Amida's Paradise—popular Buddhism's most precious reward to the faithful. The custom is still maintained at a number of temples. Perhaps the most hallowed performance takes place at Taima-dera, Nara Prefecture; it may also be seen at Nembutsu-ji, in the Saga district, west of Kyoto.

Carved of an extremely light but strong wood known as *kiri* (paulownia), this face has a grave, composed visage and a sense of sculptural form that link it in time to a group of processional masks at Tō-ji, Kyoto. Those were done late in the tenth century, and were used in a procession featuring Esoteric Buddhist deities, the Twelve Divine Guardians (see No. 31). The carving of such masks had been a major sideline of Japanese Buddhist sculpture from the time of the introduction of the faith from the Asian mainland. During the seventh and eighth centuries, dance pantomimes called *gigaku* and *bugaku* were performed at most of the major Nara temples. At the time of the dedication of the great bronze image of Tōdai-ji in 758, for example, a lavish performance of *gigaku* was staged in the courtyard before the Daibutsu-den. The masks used on that occasion have been preserved in the Shōsō-in collection and are important examples of Nara-period sculpture, strongly influenced by Chinese and Central Asian imagery and filled with expressive realism. Processional masks of this kind, however, are usually less inventive than the older dramatic types. They are more akin to conventional Buddhist religious sculpture, but, by the aesthetic criteria of such imagery, this mask must be judged a work of great presence and authority.

Published: John Rosenfield. *Japanese Arts of the Heian Period*. New York, 1967. No. 31b.
Reference: Kaneko Ryōun. *Nihon no Men*. Tokyo, 1966. Pls. 99–100; Asahi Shimbun, ed. *Tō-ji*. Tokyo, 1958. Pp. 57–63.

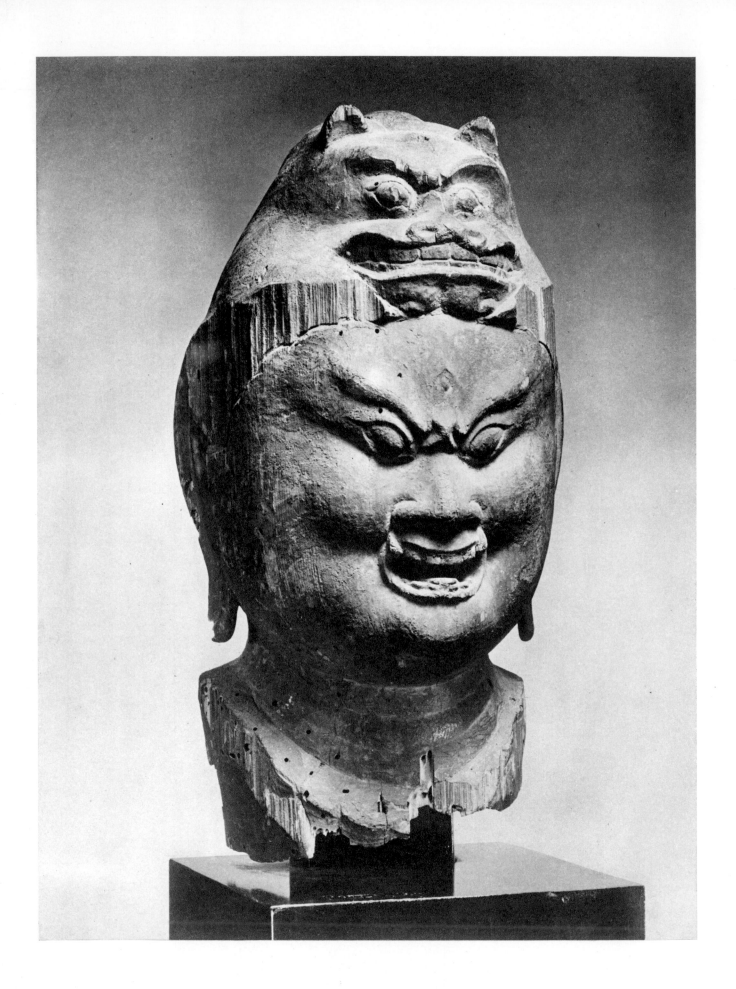

19. Head of Aizen Myō-ō

Late Heian period (ca. 1075–1100)
Joined wood-block construction, with traces of darkened lacquer
H. 13 1/2 in. (34.3 cm.)

Two contradictory aesthetic principles have been successfully combined in this head. It was intended to be wrathful and frightening, to suggest violent fury and destructive energies. Hence the brows are knotted and the mouth scowling; the menacing lion's head adds a demonic dimension. Despite those intentions, the face has a naive, almost boyish grace which reflects the dominant style of Buddhist sculpture of the period in which it was made—the generation that followed the great Kyoto master Jōchō (see No. 20) and refined his aesthetic and technical methods.

Comparison with a large number of pieces dating from the last half of the eleventh century enables us to place this head in its historical context. The most notable similarities, perhaps, appear in the delicate statue of Bishamon in the Kondō of Hōryū-ji, presented by the Emperor Shirakawa in 1078. A product of one of the metropolitan workshops of Kyoto, that figure has none of the ferocity associated with the guardian image but rather a sober, quiet self-possession and a slender physique. The handling of the volumes of the face is very similar to that of this head. Other analogies may be seen in a group of three statues of Fudō and two child attendants, dated 1094, in the Osaka temple of Takidani Fudō Myō-ō-ji.

Although only the head remains, this image has the considerable distinction of being one of the oldest statues in existence of Aizen, an Esoteric Buddhist deity. Knowledge of him was introduced into Japan early in the ninth century, but he was not included in the group of the Five Great Myō-ō often seen on Esoteric Buddhist altars. Instead he served as an independent object of worship within his own separate shrine, and like the Batō Kannon (see No. 54), his cult did not become popular until the Japanese middle ages. Thus most statues of Aizen date from the Kamakura period and later. Usually they were painted a deep red, crowned with the scowling lion, and given six arms holding a bow and arrow and other emblems such as the thunderbolt, bell, and lotus (see No. 56).

Placed before a lustrous, black-red circular halo, these figures are among the most frightening, awesome icons in Japanese art.

Aizen symbolizes one of the most fundamental Mahāyāna Buddhist conceptions: illusion and human passions are identical with Enlightenment, and the metaphysical grounds of all being permeate even that which can be called illusory and morally evil. His Sanskrit name is Rāgarāja or Mahārāga (literally the King of Passion or the Great Passion); but the passion is one sublimated to combat vulgar, profane love, to destroy egotism and greed. Like the other Myō-ō, however, Aizen was believed to possess general powers of assisting his devotees in danger, both spiritual and physical. The height of his popularity in Japan may have coincided with the Mongol invasions in the last half of the thirteenth century. There are records of local ceremonies held before his image to ward off that threat. In the seventh month of 1281, for example, the famous monk Eison of Saidai-ji in Nara led a seven-day ceremony for the preservation of the nation at the shrine of the War God Hachiman at Iwashimizu, the chief place of worship of that god for the Imperial Court and government at Kyoto. Over five hundred monks assembled from Nara and Kyoto for the recitation of incantations and prayers that the invaders' ships be burned and lost. At the climax of the ceremonies, Eison shot the arrow from his personal image of Aizen into the air in the western direction in order to focus divine forces in repelling the enemy.

Published: John Rosenfield. *Japanese Arts of the Heian Period.* New York, 1967. No. 4.
Reference: *Hōbōgirin*, 1st fascicule. Tokyo, 1929. Pp. 15–17; Wajima Yoshio. *Eison, Ninshō.* Jimbutsu Sōsho, vol. 30. Tokyo, 1959. Pp. 72–74; *Hōryū-ji Ōkagami*, vol. I. Tokyo, 1932. Pls. 93–94; *Nihon Chōkoku-shi Kiso Shiryo-shūsei.* Heian period, vol. 2. Tokyo, 1967. No. 27.

20. Head and torso of Bodhisattva

Late Heian period (mid-twelfth century)
Assembled wood-block construction; cypress wood
H. 20 7/8 in. (53 cm.)

The composed elegance of this figure and the subtle nuances of expression are characteristic of the aesthetic achievements of the Kyoto sculptors in the century following Jōchō. Trained by his father, who had served Fujiwara Michinaga in a number of sculptural projects, Jōchō became the outstanding master of religious sculpture of his day; his sole remaining work, however, is the Amitābha figure of the Phoenix Hall of the Byōdō-in, completed in 1053. It has the quality of cool, mathematical balance and reserve; and the sculptors who succeeded Jōchō in Kyoto treated his style as a classic to be preserved and perfected. He refined the techniques of constructing images of thin walls of wood, carefully glued and pegged, which enabled them to be light in weight even though large in scale, and to be made virtually by assembly-line methods.

As can be seen in this statue, the surface relief in the Jōchō style became low and geometrically refined, the facial expression dispassionate and detached. The imagery is pervaded by a sense of weightlessness, of ease and grace suited to the aristocratic atmosphere of Pure Land Buddhism. This figure is extremely close in style and spirit to the Bodhisattva images flanking the central Buddha at the lovely Sanzen-in, north of Kyoto among the foothills of Mount Hiei. Those two Bodhisattvas, which are dated 1148, are kneeling on lotus pedestals in the gesture of welcoming souls of the deceased to the salvation of Amitābha.

This work is also close in style to the well-known statue of the Bodhisattva Samantabhadra (Fugen) riding on his elephant, now in the Ōkura Museum, Tokyo, and datable to the mid-twelfth century as well. Both the Ōkura and Sanzen-in figures retain their original coating, of lacquer and paint in the case of the former, of gold leaf in the case of the latter. This figure also was once given a finishing coat that has completely disappeared, revealing in the plain wood the remarkable, basic skill of the sculptor.

This head and torso are made in only four units. The area of the head including the facial mask, ears, and hair is carved from one hollowed piece of wood. A small flat piece forms the back of the head. The front and sides of the torso are also carved from a single, large block of wood, and a flat plate closes it to form the back. The head and neck are inserted separately into the torso; the edge of the neck is carved in scallops to insure a tight, immovable fit with the torso.

Published: Mayuyama Junkichi. *Japanese Art in the West.* Tokyo, 1967. No. 36; John Rosenfield. *Japanese Arts of the Heian Period.* New York, 1967. No. 23.
Reference: *Nihon Chōkoku-shi Kisoshiryō Shūsei,* vol. III. Tokyo, 1967. No. 50; Kurata Bunsaku. *Butsuzō no Mikata.* Tokyo, 1965. Pp. 204–209; Sherwood Moran. "The Statue of Fugen Bosatsu, Ōkura Museum, Tokyo," *Arts Asiatiques,* VII. (1960), pp. 287–310.

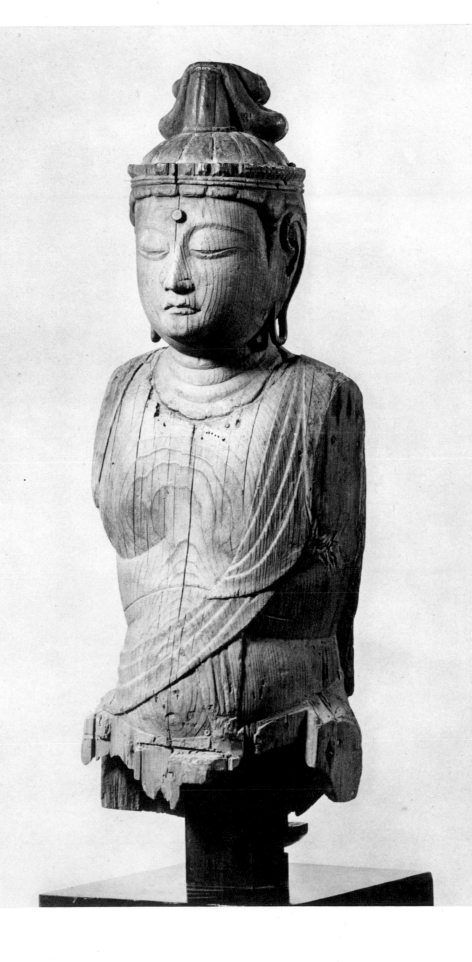

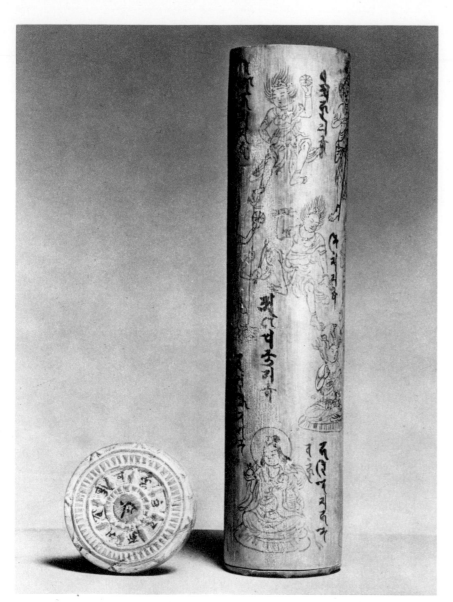

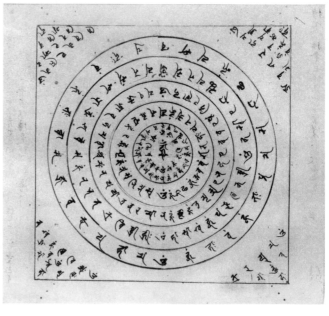

21. Wooden cylinder for Tantric ritual

Late Heian period (ca. 1150–1175)
Sendan cedar, with ink drawings
H. 9 1/4 in. (23.5 cm.); diam. 2 1/16 in. (5.28 cm.)

This small wooden cylinder served in an Esoteric Buddhist ritual called the Tembōrin-hō, "Turning the Wheel of the Law." It is a rare tangible relic of the ritual magic and incantations that gave Esoteric Buddhism its special appeal. The patron of such a ceremony inscribed on a piece of paper the goals he desired —safe childbirth, tranquillity for his city or nation, destruction of a hated enemy—and inserted it in the cylinder. A group of monks then placed the cylinder before the image of an appropriate deity such as Jizō, Fudō, Maitreya, or the Ichijikinrin Dainichi; with chanting and ringing of bells, incense was burned and a *goma* fire built. When the goal was the dispelling of an evil state of the spirit or when the suppliant wished to harm an enemy, the inserted paper would be removed and burned.

Based on a text first translated into Chinese by Amoghavajra, the influential Indian missionary active in the T'ang court, the ritual was introduced to Japan in the ninth century by the monks Kūkai and Ennin. It did not, however, become prominent until the twelfth and thirteenth centuries, when it was practiced especially by Shingon monks. For example, following the great fire of 1177, which destroyed twenty thousand homes and killed a thousand people in the Heian-kyō, the retired Emperor Goshirakawa ordered the ceremony performed for seven days in order to restore tranquillity.

A square piece of paper found in this tube bears the seal of Kōzan-ji, and writing appears on both sides. The obverse has a design of five concentric circles with Sanskrit characters representing various deities; on the reverse is a similar design together with the Sanskrit formula invoking the power of the deity Marīci, who guarded against the perils of war. It gives the name of Fujiwara Yasuie, a courtier of the "junior fifth rank, upper grade." In one corner is the notation that this design was copied at Mt. Kōya in 1205 from one used in a ceremony on the eleventh day of the eleventh month of 1175, to increase the good fortune of Yasuie (who died in 1210).

On the body of the cylinder are images of sixteen deities of protection and good fortune, shown in four registers, with the name of each written in vertical Sanskrit letters. The two upper registers are filled with ten Yakshas from the Indian tradition of tutelary guardians of specific locales or kinds of fortune. The first is none other than Viśvakarman, the Indian father of the arts; also shown are Manibhadra, Giver of Wealth; and the Virūpāksha, who is also Kōmokuten, one of the Four Deva Kings (Shitennō). On the next register are three Nāgarājas, led by Vāsuki, who is famous in Indian epic mythology as the serpent used in the churning of the ocean; on the lower register are three goddesses led by Hārītī, Goddess of Fertility.

The top and bottom lids of the cylinder are carved in low relief in the shape of the Buddhist Wheel of the Law, and on both sides of the lids are Sanskrit letters written in ink. The wood used is an aromatic form of cedar that is specifically prescribed in the ancient liturgical manuals under its old name, *kuremboku*. To make this delicate, thin-walled cylinder, a single block of wood was rounded and hollowed out. The images were then lightly scratched into the soft wood, and the drawing in *sumi* ink was rapidly and skillfully brushed on. As a finishing coat, a reddish, translucent pigment was added; over the centuries it has turned dark brown.

In a meticulous article from which much of this information was drawn, Yanagisawa Taka has shown that the style employed here belongs roughly to the third quarter of the twelfth century. She suggests that the cylinder may well have been kept at the Kajū-ji (Kanshū-ji) monastery near Uji and then given to the famous monk Myōe Shōnin of Kōzan-ji in 1214. A cylinder similar to this one but brightly colored in the style of the mid-thirteenth century has been preserved at Kōzan-ji, and there is a bronze cylinder with the same designs at Ninna-ji.

Published: Yanagisawa Taka in *Bijutsu Kenkyū*, no. 231 (November 1963), pp. 1–22; Yanagisawa Taka in Shimada Shūjiro, ed., *Zaigai Hihō*, vol. I. Tokyo, 1969. No. 33; John Rosenfield. *Japanese Arts of the Heian Period.* New York, 1967. No. 6.

22. Tile engraved with Buddhist text

Late Heian period (eleventh century)
Baked clay
H. 9 1/8 × 7 1/4 in. (23 × 18.2 cm.)

On this tile is a portion of the text of the holy *Lotus Sūtra*, engraved on both sides with a stylus when the clay was still soft. The entire sūtra was written this way on a large number of tiles, which were baked in a crude kiln, their surfaces scorched and irregularly colored. Ultimately, the tiles, together with religious implements—statues and altar fittings—and items of personal use—mirrors, combs, and cosmetic jars—were buried in tumuli called *kyōzuka* (sūtra mounds). These *kyōzuka* have been found throughout Japan, from northern Honshu to Kyushu, and usually in the neighborhood of a temple or Shintō shrine. The mounds are most numerous, however, in Kyushu, especially in Fukuoka Prefecture, from which this tile is said to have come.

The *kyōzuka* are the product of an extraordinary religious mania that swept Japan in the days of Fujiwara Michinaga, early in the eleventh century, and continued with varying degrees of fervor into the seventeenth. According to the doctrines of the Pure Land sects, Japan as a Buddhist country had, during the eleventh century, entered into the third stage of the history of the faith, that of the degenerate Mappō (End of the Law). Genshin, monk of Enryaku-ji and probably the most influential teacher of Pure Land doctrines in the mid-Heian period, stated that this new, disastrous era was actually to begin in 1042. Nichiren claimed that it had begun in 1050. Both men were calculating on the basis of the uncertain birthday of Śākyamuni, and accounts of the Mappō vary considerably in details.

It was a very ancient conception that the Buddhist Law, like any other phenomenon in the experience of mankind, was fallible and subject to decay. During the first stage of its history, that of the Shōbō (Correct Doctrine) immediately following the teaching of Śākyamuni, the Law was fully understood, and men attained Enlightenment through their own self-discipline and insight. That period lasted for five hundred years. During the second period, that of the Zōhō (the Counterfeit Law), the doctrines of the faith were understood and put into practice; but Enlightenment was not attained by men through their own efforts but through the grace of compassionate deities. That era had lasted for one thousand years. During the third stage, that of the Mappō (End of the Law), the teaching would remain; but men would neither understand it nor attain Enlightenment on earth. Only through rebirth in Amitābha's Paradise could they escape the pain of existence and attain Nirvāna; and the only text effective in this degenerate age was the *Lotus Sūtra*, which contained in essence the insight and wisdom of all other Buddhist sūtras. As this period progressed, however, even the teaching of the Law itself would disappear. And it was against this prospect that the sūtra mounds were filled with holy texts on permanent materials such as tiles and gilt-bronze plates, or with paper sūtra scrolls buried in solid containers (see Nos. 23, 24). Such objects were to remain until the time of the coming of the Buddhist messiah, Maitreya (Miroku), who would live among men, attain Enlightenment, and begin the cycle of the three stages of the faith once more. Then the buried objects would emerge from the earth of their own accord.

The earliest and perhaps most lavish of the sūtra mounds have been found on Mount Kimbu in the Yoshino district, Nara Prefecture, which was popularly believed to be the place where Maitreya would return to earth. There, in 1007, Fujiwara Michinaga, the mighty head of the Fujiwara clan and real ruler of the empire, buried fifteen sūtras (which he had copied himself) and several altar implements. And throughout that century, the store of objects placed in mounds on Kimbu-sen increased.

Thanks to the efforts of Kurata Osamu of the staff of the Tokyo National Museum, the full and almost unbelievable scope of enthusiasm for the sūtra mounds is coming to light. He has thus far documented over two hundred dated groups of remains from the *kyōzuka* and countless undated ones, showing that the concept of the End of the Law must have been one of the most pervasive elements in the world view of medieval Japan.

Apart from the fact that this tile came from Fukuoka Prefecture, there is no further dependable in-

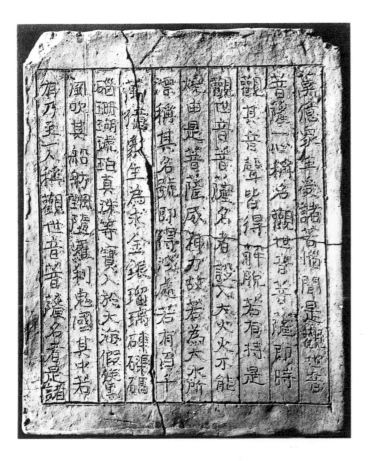

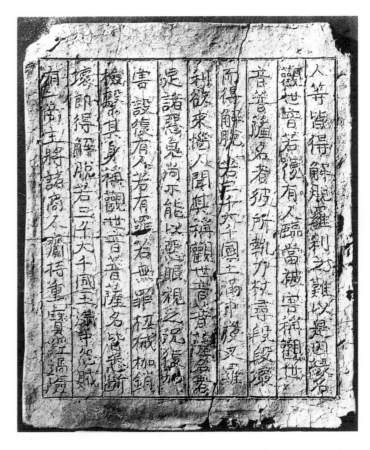

formation on its origin. In its clear, lucid script in the late Heian style, it resembles a sūtra tile from Yoshi-taku, Fukuoka city, but differs from it slightly in measurements.

Reference: *Objects Excavated from Sūtra Mounds*. Tokyo National Museum Illustrated Catalogue. Tokyo. 1967. Kurata Osamu's notes entitled "Kyōzuka-ron," *Museum*. 1963 to the present; Mainichi Shimbun, *Kokuhō*. The National Treasures of Japan, vol. II. Tokyo, 1964. Pp. 16–19 (in English).

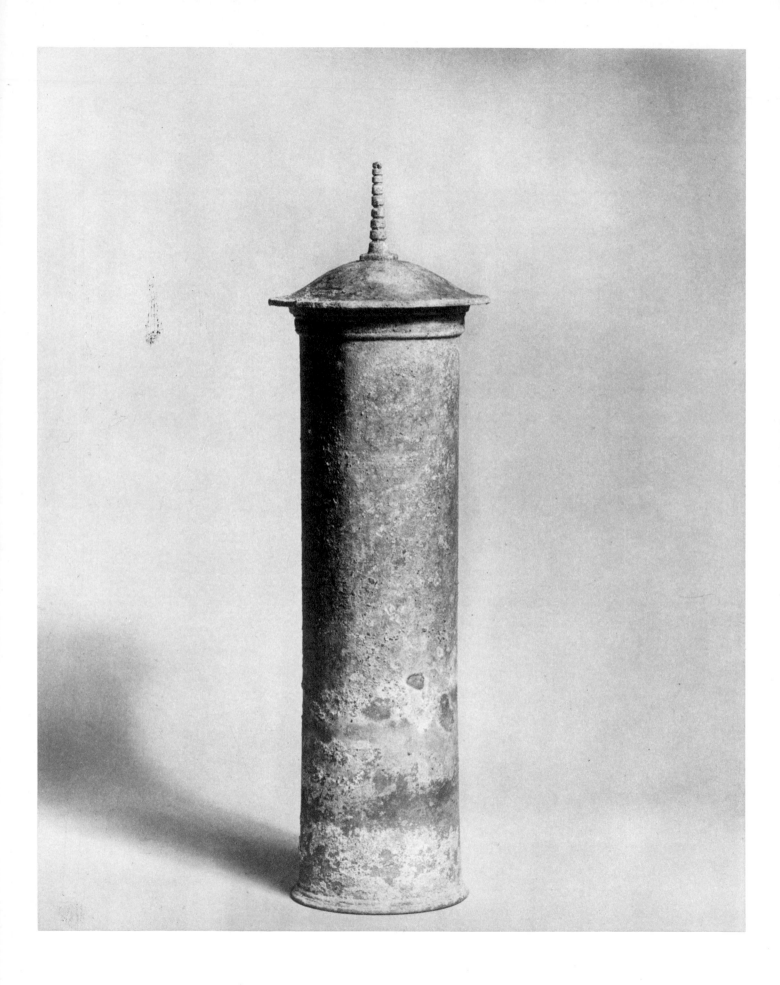

23. Sūtra container

Late Heian period (dated 1090); said to have come from Eiman-ji, Fukuoka Prefecture
Patinated bronze
H. 12 in. (30.5 cm.); diam. 2 7/8 in. (7.5 cm.)

The sūtra mounds of Eiman-ji, in Nogata city, Fukuoka, have yielded a rich hoard of objects, especially sūtra cases, many of which are dated. This case, the oldest of all those thought to have come from the mounds, has a date on its side showing the fourth year of the Kanji era (1090), the sixth month, and the third day. The inscription, which is lightly and crudely engraved in large characters, also states that the case held the eighth chapter of the *Nyohō (M)yō-renge-kyō* (*The Lotus of the True Law*). It uses the term *Nyohō* (lawful) instead of *Myōhō* (wonderful law) in the title, which is typical of the copies of that text made specifically to be buried in the earth.

This vessel possesses the tall, slender proportions and sense of inherent elegance usually seen in eleventh-century sūtra containers found in western Japan. It is very similar in proportions to ones found in Hirayama, Dazaifu, and Sankō-mura in Kyushu. The lid is capped with a spire divided into nine levels, resembling the finials of a pagoda. The bottom of the case was made of an old mirror, quite battered and worn, but decorated with designs of flying birds.

A date of 1090 places this case in the early stages of the main period of sūtra mound construction. To be sure, the custom can be traced back to Ennin (Jikaku Daishi), who in 833 dedicated copies of the *Lotus Sūtra* written on stone and placed in a small stone stūpa on Mount Hiei near the Heian capital. This was not, strictly speaking, a burial deposit. The first recorded instance of the burial of texts was that of 1007, when Fujiwara Michinaga began the donations to the mounds of Kimbu-sen, in the Yoshino area, which were steadily augmented until the 1250s. By the last half of the eleventh century, the custom had become nationwide.

Reference: *Objects Excavated from Sūtra Mounds*. Illustrated catalogue of the Tokyo National Museum. Tokyo, 1967. Pp. 143–144; Tokyo Imperial Museum, ed. *Kimbusen Kyōzuka Ibutsu no Kenkyū*. Tokyo, 1937; *Sekai Kōkogaku Taikei*, vol. IV. Tokyo, 1961. Pp. 149–156.

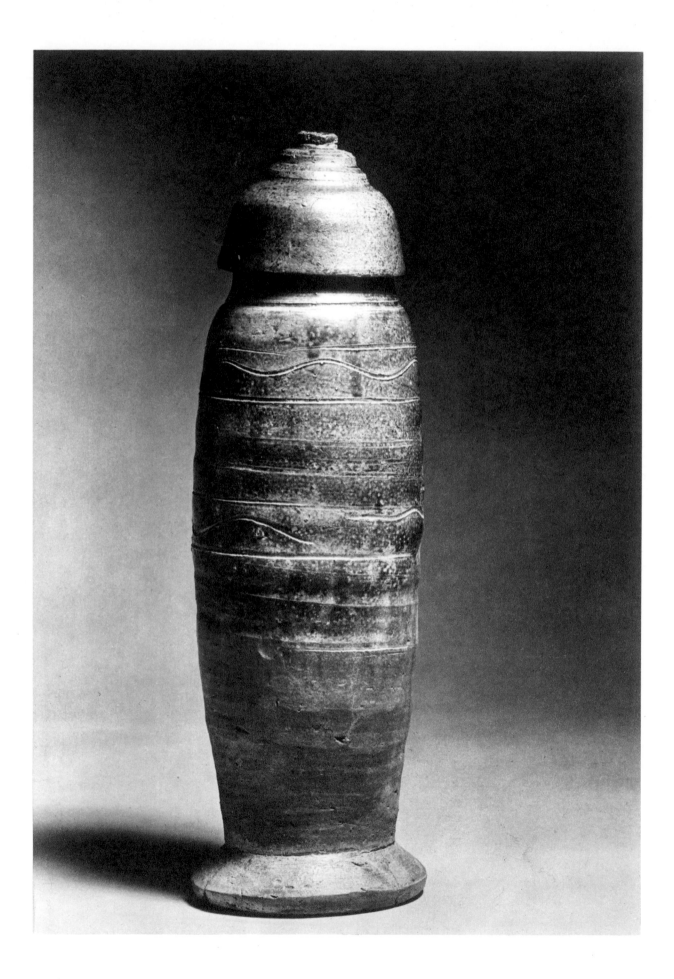

24. Sūtra container

Late Heian period (first half of the twelfth century); said to have come from Ōharano, Fukuoka
Brownish violet baked clay, with thin olive-brown glaze
H. 15 1/4 in. (38.5 cm.)

Unique to the sūtra mounds of Kyushu, pottery containers of this kind have only recently been unearthed. They are major additions to the history of Japanese ceramics, but the full implications of their discovery are not entirely clear. Some scholars believe that they were imported from China; others believe that they were made in Japan. If the latter is true, they indicate that the development of high-fired pottery took place in western Japan at the same time as it did in the main ceramic centers in the Nagoya area. In the Sanage kilns, on the outskirts of modern Nagoya city, one can trace the change during the eleventh century from utilitarian ash-glazed ware derived from Sue types to more ambitious vessels reflecting both Chinese inspiration and the effort to create an aristocratic ceramic art. In the Seto area nearby, production of glazed high-fired wares began also in the eleventh century but was interrupted by the political disturbances of the Gempei wars. Production was not resumed until the mid-thirteenth century, when it was strongly influenced by the ornate Chinese T'zu-chou wares, which were imported into Japan and Korea and emulated in both countries.

This sūtra container is quite similar to ones found elsewhere in Fukuoka Prefecture—at Dazaifu and Fukuoka city, and near Sue-machi. Those finds may be dated in the first half of the twelfth century on the basis of the objects buried with them. This vessel was formed by the coil method and given an erratic, somewhat asymmetrical profile. The strong, flaring foot is typical of this group of vessels, as is the loose-fitting cap. The other vessels also have the same thin, olive-brown glaze, made of feldspar, ash, and iron. Apart from the shape itself, which was specially intended for use in the sūtra mounds, in most respects this container resembles imported Chinese wares. The prominent undulations of the horizontal coils reflect

similar qualities in the baluster vases of the T'zu-chou type; the flaring foot may also be traced to the same source, along with the incision of a simple, linear design in the wet clay. The thin, transparent glaze is reminiscent of Chinese Yüeh wares, which have been excavated recently in Kyushu.

Containers similar to this one have been found in typical small sūtra mounds of western Japan, consisting of a chamber made of rough slabs of stone no more than three feet high. Usually, one ceramic and one metal sūtra case would be found inside, together with mirrors and beads, all tightly packed in chips of charcoal. The chamber, closed with a flat stone slab, would be covered with earth to a depth of three feet and a width of around ten. On the surface of the ground, marking the site, would be a small stone or ceramic pagoda, usually a *gorin-no-tō* (see No. 37). Most of these pagodas have long since disappeared, making the discovery of the mounds often a matter of chance.

The motives of the layman in dedicating holy texts in such a mound might have been rather general. He would, of course, have thought he was helping safeguard the Buddhist Law during the period of the Mappō, until the coming of Maitreya. He might have been hoping, by this meritorious deed, to insure rebirth in Amida's Paradise for himself or a deceased relative; he might also have been hoping to insure happiness and prosperity in his current life. The entire dedication would have been supervised by a local monk, who presided over the ceremonies at the time of the burial, and whose name often appears on the engraved metal cases.

Reference: *Objects Excavated from Sūtra Mounds*. Illustrated catalogue of the Tokyo National Museum. Tokyo, 1966. Pp. 141–156.

香瓔珞末香塗香燒香繒蓋...

作諸妓樂人中上供而供養之應持天寶而

以散之天上寶聚應以奉獻所以者何是人

歡喜說法須臾聞之即得究竟阿耨多羅三

猊三菩提故尒時世尊欲重宣此義而說偈

言

若欲住佛道　成就自然智　常當勤供養　受持法華者

其有欲疾得　一切種智慧　當受持是經　并供養持者

若有能受持　妙法華經者　當知佛所使　愍念諸眾生

諸有能受持　妙法華經者　捨於清淨土　愍眾故生此

當知如是人　自在所欲生　能於此惡世　廣說無上法

應以天華香　及天寶衣服　天上妙寶聚　供養說法者

吾滅後惡世　能持是經者　當合掌禮敬　如供養世尊

上饌眾甘美　及種種衣服　供養是佛子　冀得須臾聞

若能於後世　受持是經者　我遣在人中　行於如來事

若於一劫中　常懷不善心　作色而罵佛　獲無量重罪

其有讀誦持　是法華經者　須臾加惡言　其罪復過彼

一部道信一切下　八年戊月引人又牧昌寺

25. *Lotus Sūtra*, part of chapter ten

Late Heian period (early twelfth century)
Hand scroll; ink on paper with silver paint
H. 8 1/2 in. (21.6 cm.)

The scroll preserves approximately the first third of chapter ten, the "Hōshi-bon" ("The Preacher") from the *Lotus Sūtra*. The cover and end sections are missing. This chapter explains the merit attained by those who believe, read, preach, and copy the *Lotus Sūtra* in order to propagate its teaching. It furthermore proclaims that anyone who aids in spreading the doctrines of the *Lotus Sūtra* is the Buddha's messenger, and it promises them the fruits of future Buddhahood.

The text is written between lines drawn in silver ink on a paper that was originally white or cream in color. Ornamenting the paper are motifs of small birds and butterflies, together with plants and pine trees. The placement of these elements is entirely ornamental; there is no scenic arrangement of the trees and grass, no suggestion of consistent spatial depth. However, each design element creates a slight feeling of space around itself that greatly enriches the ornamental effect. The birds, moreover, impart a sense of life in their agile, subtle movements; and the silver paint flickers as it reflects the light.

This scroll belongs to a new type of decorated sūtra that dates from the late Heian period as a supplement to the older ornamented forms written in gold and silver on blue and purple paper. The new type is commonly called the *chōdori-kyō* ("butterfly-and-bird sūtras") because those two design elements are so conspicuous. Unlike the blue and purple sūtras, texts of this type have not been found in China. They are entirely a product of Japanese aristocratic culture of the Heian period, and the writing style as well shows a complete transformation into native Japanese modes. Although based on the academic manner of the Sūtra Copying Bureau of the Nara period, the brushwork lacks the vigor of the older style, and the composition of the characters lacks its solidity.

None of the *chōdori-kyō* bears a date or donor's name, making it difficult to determine the date of their production. But judging on the basis of the calligraphy, for which comparative materials exist, the oldest *chōdori-kyō* belong to the beginning of the twelfth century. This particular example may be compared with pages in the great collection of calligraphy of the first half of the twelfth century, the *Sanjūrokunin-shū*, chiefly in Nishi Hongan-ji in Kyoto. This text was probably transcribed by a professional sūtra calligrapher, but it is in the Japanese courtly style originated by Fujiwara Yukinari (or Kōzei) in the early eleventh century during the time of Fujiwara Michinaga and the writing of *The Tale of Genji*, marking the emergence of a genuinely native spirit in the arts. The calligraphy of Kōzei served as a model for twelfth-century sūtra writers, for the handling of the Chinese characters had a flavor unique to Japan. (S.S.)

Reference; *Shodō Zenshū*, vol. 12. Tokyo, 1954. Pls. 66–92; ibid., vol. 14. Tokyo, 1958. Pls. 102, 103; Tanaka Shinbi. *Nishi Hongan-ji-hon Sanjūrokunin-shū*. Tokyo, 1960. Pls. 36, 40, 45.

聲聞辟支佛以無漏智不能思惟知其限數
我等住阿惟越致地於是事中亦所不達世
尊如是諸世界無量無邊尒時佛告大菩薩
衆諸善男子今當分明宣語汝等是諸世界
若著微塵及不著者盡以為塵一塵一劫我
成佛已來復過於此百千万億那由他阿僧
祇劫自従是來我常在此娑婆世界說法教
化亦於餘處百千万億那由他阿僧祇國導
利衆生諸善男子於是中間我說燃燈佛等
又後言其入於涅槃如是皆以方便分別諸
善男子若有衆生來至我所我以佛眼觀其

26. *Lotus Sūtra*, chapter sixteen

Late Heian period (twelfth century)
Hand scroll; ink on paper with silver and red paint
H. 10 in. (25.4 cm.)

Although the cover and end sections are now lost, this scroll contains the entire chapter called the "Juryō-bon" ("Duration of Life"), which is the opening section of the sixth volume of the *Lotus Sūtra*. Its contents are the most significant of all twenty-eight chapters, for it proclaims that the historical Buddha is, in fact, the Eternal Buddha who had attained Enlightenment at a time infinitely remote in the past, and who, in the infinite future, will remain at the Vulture Peak and continue to preach. Thus the Buddha's life, his teaching, his compassion, and his will to save all beings are eternal.

The text is written on ornate paper very much in the manner of the previous example of the *chōdori-kyō* (No. 25), but the calligraphic style is more personal and eccentric. The variation of thick and thin strokes is extremely exaggerated, and the accents at the beginning and ending of a stroke are greatly mannered. Still, the brushwork is smooth and the structure of each character relaxed. The ornamentation, in silver ink, of the writing paper differs from that in No. 25 in that the tree and grass motifs are limited to the margins, whereas the birds and butterflies are restricted to the text field. Color had been deftly added to the plants, but has faded almost completely except for traces of red dots near the end of the scroll.

In transcribing the *Lotus Sūtra* during the eleventh century, there are many instances in which the main donor would enlist those who wished to be co-donors, and would assign one person to each one of the twenty-eight chapters of the text. Such a set of the *Lotus Sūtra* is called *ippon-gyō*. There were many instances of production of *ippon-gyō* among the court ladies of the late Heian period, since the sūtra, by guaranteeing Buddhahood for women, had special appeal for the ladies of the aristocracy. However, there are no examples of the *chōdori-kyō* having been made in this fashion, and it is likely that this scroll was simply the beginning section of this chapter. (S.S.)

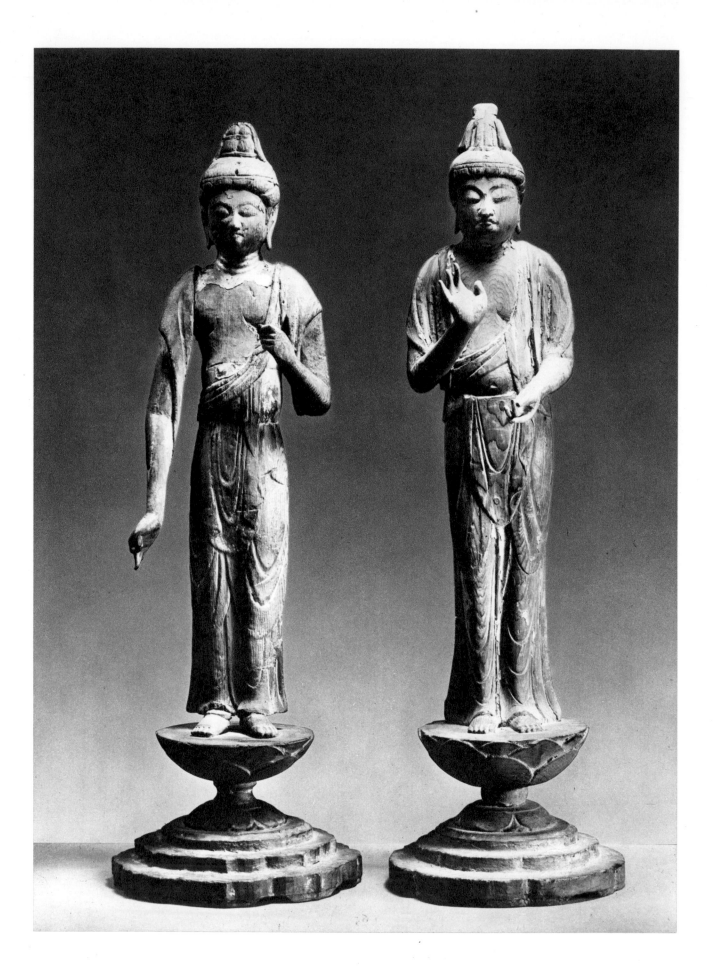

27. Standing images of Shō Kannon

Late Heian period (late twelfth century)
Cypress wood, with traces of gesso and gold paint
H. of figures 15 1/4 in. (38.7 cm.); H. of pedestals 3 3/4 in. (9.5 cm.)

These small, fragile images of Kannon are said to have come from Kōfuku-ji, the ancient Fujiwara family temple in Nara. Although carved under conditions that can only be characterized as mass production, they have the extraordinary presence, grace, and lively delicacy that is widely found in Buddhist imagery of the late twelfth century.

It is believed that a large altar or special hall designed for the installation of hundreds, if not a thousand, of such statues once stood within the Kōfuku-ji temple compound. Unfortunately, there is no historical record of this. However, large numbers of these statues emerged from the temple around 1890–1900 when it became desperately impoverished. Baron Masuda Takashi, for example, is said to have received seventy of them (including these two) in 1900, when he contributed to the reconstruction of the temple. Fifty examples are in the Fujita family collection, Osaka, and many others have left Japan.

The custom of dedicating images in vast numbers was widespread in the twelfth century, following the same time-honored Buddhist principle of multiplication that produced the Tibetan prayer wheel, the countless identical stone carvings of Yün-kang and Lung-mên in China, and the One Million Miniature Pagodas of the Japanese Empress Kōken (see No. 10). This is the concept that the spiritual merits of a deed are increased by its repetition, that a proper emblem of the power and majesty of a deity is the multiplica-tion of his attributes. By this principle, the Japanese Buddhists donated, in the twelfth century, literally thousands of identically illuminated manuscripts to such temples as Jingo-ji in Kyoto and Kongōbu-ji atop Mount Kōya; and there are records of many Sentai-dō (Halls of a Thousand Images). The chief and most familiar relic of a Sentai-dō still in existence is the Sanjūsangen-dō in Kyoto, reconstructed in the 1250s on the site of the hall founded in 1164 by the Emperor Goshirakawa.

There, an awesome array of one thousand nearly life-sized statues of the Thousand-armed Kannon stand on a stepped altar-platform over three hundred and fifty feet long, in the center of which is an eleven-foot-tall seated figure of the same deity. The sheer quantity and bristling complexity of that ensemble of images in Kyoto is one of the most sobering experiences of the irrational power of Asian imagery. The small, rather humble figures shown here are predecessors by three-quarters of a century or so, and are far more humane and accessible in spirit.

The forearms and hands are modern restorations, as are the feet and noses.

From the Masuda collection, Tokyo.
Published: John Rosenfield. *Japanese Arts of the Heian Period.* New York, 1967. No. 30.
Reference: *Catalogue of the Tenth Anniversary Exhibition,* Fujita Museum. Osaka, 1964. P. 18.

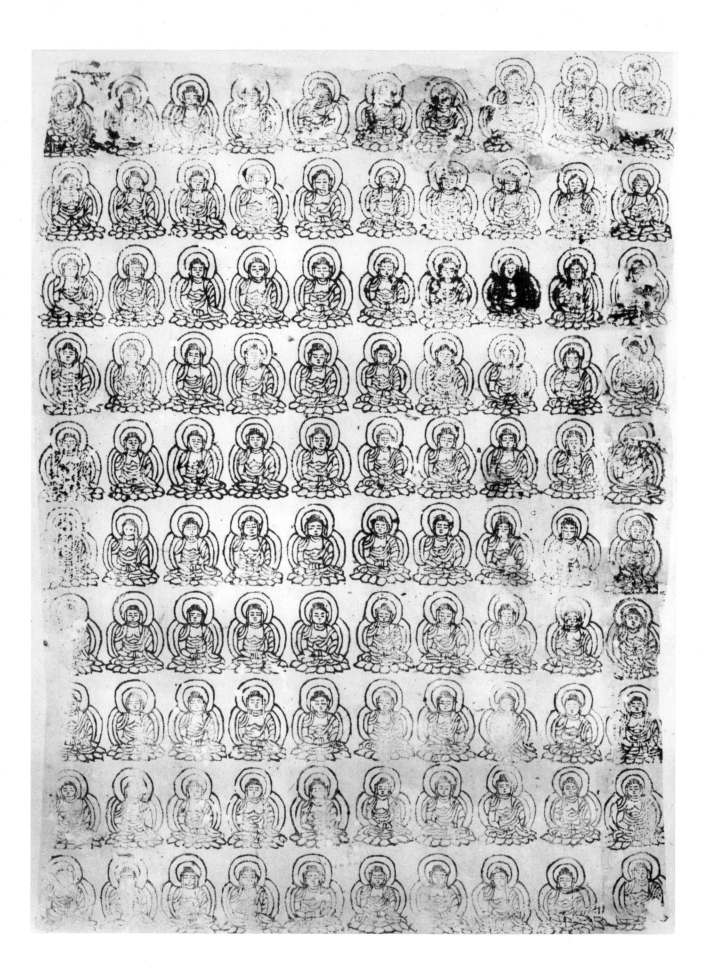

28. One hundred images of Amitābha (Amida)

Late Heian period (twelfth century)
From Jōruri-ji, Kyoto Prefecture
Ink on paper
H. 17 1/4 × 12 1/2 in. (44 × 31.6 cm.)

In both China and Japan, it was customary to place objects inside Buddhist statues in order to "enliven" them, to add to their symbolic content and relevance for the donors. Religious prints were commonly included. Perhaps the most celebrated instance is the wooden image of Śākyamuni brought from China by the pilgrim monk Chōnen in 987 and installed today in Seiryō-ji in the Saga district, Kyoto. At the time of the dedication in China, four wood-block prints were inserted along with carefully made cloth replicas of the human stomach and intestines, mirrors, beads, glass vessels, printed sūtras, and manuscript documents. The prints depict Śākyamuni preaching atop Vulture Peak and the Bodhisattvas Maitreya, Mañju-śrī, and Samantabhadra.

From many Japanese statues of the late Heian period have come wood-block prints; the oldest dated ones were found in a Bishamon figure in the Jōshin-in, Nara Prefecture, and inscribed 1162. The print exhibited here came from the Main Hall of Jōruri-ji, in the hills northwest of Nara. It was one of a large number of sheets found inside the central Amida statue when it was restored some years ago. The majority of the prints are like this one, with one hundred virtually identical images of Amida printed from a single block. In others, however, a stamp containing twelve images was used to build up the composition. This repetition of images was believed to be an effective method of accumulating religious merit. The prints were crudely executed, but the overall effect is an eloquent reflection of the religious fervor of the day.

Reference: Ishida Mosaku. *Kodai Hanga*, Nihon Hanga Bijutsu Zenshū, vol. I. Tokyo, 1961. Nos. 44–45; *Nihon Chōkokushi Kiso Shiryō Shūsei*, vol. I. Tokyo, 1967. No. 8; Gregory Henderson and Leon Hurvitz. "The Buddha of Seiryō-ji," *Artibus Asiae*, vol. XIX (1956), pp. 5–55.

29. Six stamped images of Mahāvairocana (Dainichi)

Late Heian period (twelfth century); said to have come from Enryaku-ji
Ink on paper; mounted as a kakemono
Each figure: H. 5 1/4 in. (13.5 cm.)

Six identical figures of this ornate Buddha seated in meditation have been stamped on a sheet of thin paper. The image is conceived with crisp, linear discipline of a high order. The information accompanying the sheet states that it came from within the statue of the chief object of worship (*honzon*) on Mount Hiei, overlooking Kyoto to the northeast. This presumably designates the statue of Yakushi enshrined in the Komponchū-dō, the main ceremonial hall of the great Tendai sanctuary of Enryaku-ji. The building was begun in 788 by the temple founder, Dengyō Daishi, enlarged by Chishō Daishi, burned in 931, and rebuilt. The history of this hall and its statues, which have been enshrined as secret images, is extremely complex, especially with the complete destruction of the sanctuary in 1571 by Oda Nobunaga, and it is not possible to confirm the attribution. Prints of other deities are said to come from the same statue, and an almost identical page of stamped images, now in the collection of Tōshōdai-ji, Nara, is supposed to have come from the Esoteric Buddhist temple of Negoro-ji, in Wakayama (see No. 144).

The deity is the Great Illuminator, Mahāvairocana (Dainichi), who combines the ornaments of a Bodhisattva with the highest theological status in the Buddhist pantheon. He is the noumenal source of all being, all other Buddhas, all elements of the universe. The same deity as the great bronze Daibutsu of Nara, he sits here in the position of deep meditation just as he appears in the center of one of the most important mandalas of Esoteric Buddhism, that of the Womb of Great Compassion, the Mahākarunāgarbha (Taizō-kai) Mandala. In that diagram, enframed by a blue lotus, the Buddhas of the Four Directions and the Four Great Bodhisattvas radiate from his body; beyond them are over 341 other major deities, who express the totality of the forces that control the physical and spiritual world.

Reference: Ishida Mosaku. *Kodai Hanga*. Nihon Hanga Zenshū, vol. I. Tokyo, 1961. Pls. 63, 110.

30. Esoteric Buddhist Bodhisattva

Late Heian period
Attributed to Takuma Tametō (active ca. *1131–1174)*
Album leaf mounted as a hanging scroll; ink and color on paper
H. 9 15/16 × 5 9/16 in. (25.3 × 14.2 cm.)

This small page with a delicately colored Bodhisattva holding an incense burner is one of ninety-five from a notebook illustrating the deities of the Kongō-kai mandala. The book was discovered in 1927 by a group of specialists from the Japanese Commission for the Protection of Cultural Properties at Ganjō-ji, a small temple in Kumamoto Prefecture, Kyushu. On both aesthetic and historical grounds, they recognized it immediately to be one of the most important additions to the history of Japanese art made in decades; and they took legal steps to register and protect the book. But before these could be completed, the book was sold, the pages cut apart and dispersed. Twelve pages are now in the Museum of the Yamato Bunka-kan; others are in the Mutō collection, the Tokyo National Museum, and the Tokyo Fine Arts University, for example, and at least five are known to be in the United States.

According to an inscription on the last page of the book now in the Mutō collection, dated 1532, the drawings were done by "the painter, Shōchi, whose lay name was Takuma Tametō, Governor of Bungo, whose ecclesiastical rank was Hōin [Seal of the Law]."

The name Takuma occurs prominently in traditional histories of Japanese art as that of a hereditary family of painters who were active for over five centuries. Such long, dynastic lines of artists are a peculiarity of Japanese culture; the Kanō, Tosa, or Kakiemon families are more recent and familiar examples of the same phenomenon. Most of the Takuma painters listed in records are little more than names, without credible examples of their work. However, the wall paintings at the Amida Hall of the Byōdō-in were supposedly done by Takuma Tamenari in 1053; Takuma Shōga, the son of Tametō, painted a brightly colored series of the Twelve Devas (Jūni-ten) in 1191, which are still preserved in Tō-ji (see No. 59); Takuma Chōga was an active Buddhist painter in the mid-thirteenth century for whom there are convincing attributions; and Takuma painters are known to have worked in the early fifteenth century in a manner reflecting the Zen tradition.

The main period of the family's history begins with Tametō, however, who actually became a Buddhist monk and spent many years on Kōya-san. These drawings are the most substantial work attributed to his hand; and while the attribution is by no means certain, Tanaka Ichimatsu has shown that the evidence tends more to confirm than to deny it. In any event, despite their repetitious nature, the drawings are superlative examples of Buddhist imagery in a somewhat informal vein. On stylistic grounds alone, they would be placed in the mid-twelfth century. In the disciplined drawing of the hands and drapery folds and in the expressively light touch of the brush, they show the highest level of professional skill.

Other colophons at the end of the book (also in the Mutō collection) indicate that it had been kept at Kōya-san, at the Kōdai-in, and had been given by a certain monk Chōson to one named Koshin. An inscription dated 1532 records its presentation to the Abbot of Ganjō-ji, where it remained for four centuries. Of particular interest is the fact that the mandala is not the conventional one of the Shingon sect, but rather of an offshoot called Shingi Shingon, which combined Pure Land Amidism with Esoteric Buddhism. The leader of this movement, the monk Kakuban, was active at Kōya-san at the same time Tametō lived there and was a vital figure in the religious life of the times. Kakuban was familiar, for example, with the monk Kakuyū (the celebrated Toba Sōjō, who was a teacher of Genshō and also a pioneer in the movement to unify the Buddhist faith by harmonizing its diverse schools [see No. 31, 41]); the Shingi Shingon sect is an outcome of that attempt at unification.

The deity on this page is identified by the inscription as the Tōnan'un-kongō (Thunderbolt of the Southeastern Cloud) and also as the Isho-kongō (Thunderbolt Produced by the Will, or Ishtavajra in Sanskrit). Below him is the indication that his distinctive color is black. This page may, in fact, be incomplete; it lacks the usual symbolic device that was used to represent the deity in the elaborate altar tables of Esoteric rituals, and the space for the Sanskrit seed letter is left unfilled. These appear on most of the other

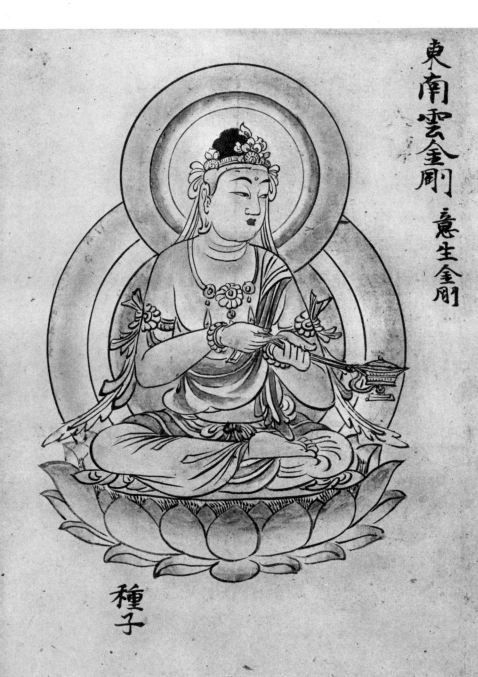

東南雲金剛
意生金剛

種子

黒色

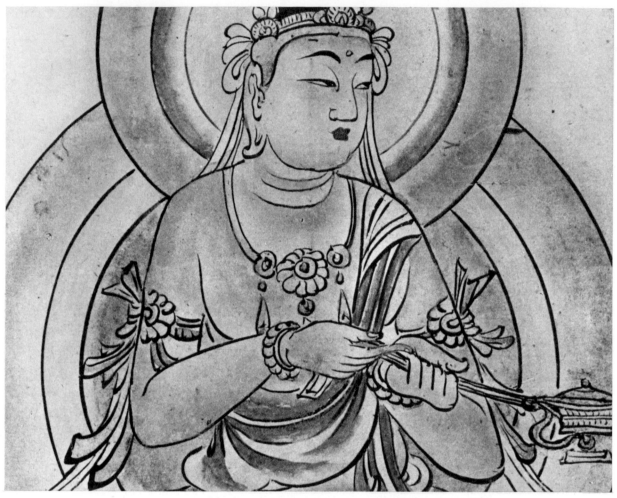

detail

pages, along with mantras, or prayer formulas, that were recited before the deity. The deity itself is an extremely abstract one, like so many of those in mandalas, and is found only in the rare products of the Shingi Shingon school.

Published: Tanaka Ichimatsu. "Kontai Butsuga-chō to Takuma Tametō," *Yamato Bunka*, XII (December 1963), pp. 28–37; Tanaka Ichimatsu. *Nihon Kaigashi-ronshū*. Tokyo, 1965. Pp. 100–121; John Rosenfield. *of Japanese Arts the Heian Period*. New York, 1967. No. 5d.

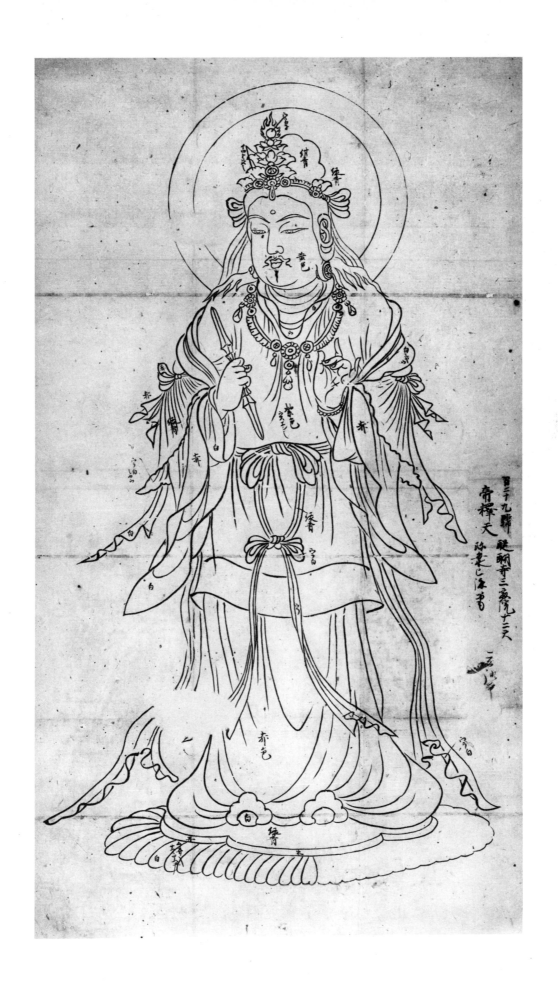

31. Indra (Taishaku-ten)

Late Heian to early Kamakura period
Monk Genshō (ca. 1145–1206), copied from a version by the monk Chinkai (1092–1153)
Hanging scroll; ink on paper
H. 36×19 1/2 in. (91.4×49.5 cm.)

Unfinished, uncolored drawings of this kind played a vital role in traditional Buddhist art. When made by a revered monk who was an authority on the complex details of symbolism, they were cherished and copied for centuries by professional painters or by student monks learning Buddhist iconography. Aesthetically, this drawing of Indra embodies the lyrical, relaxed flavor of late Heian Buddhist imagery, and its religious pedigree is especially impressive. It was made by Genshō, a monk-painter of the middle twelfth century, on the basis of one by Chinkai, an even more revered figure of two generations earlier. The inscription at the right reads:

> Number 129. Daigo-ji, Sambō-in. Jūni-ten. Taishaku-ten. Drawn by Chinkai Ikō. Genshō's version.

Genshō was a prolific artist. Large numbers of his iconographic drawings have been preserved: the oldest, dating from 1173, is a compilation of mandala figures now in the Gotō Museum, Tokyo. Intellectually, he was a member of a circle of monks working to unify Esoteric Buddhism, which had broken down into subsects and schools, each jealously guarding its own secret traditions. One of Genshō's teachers, the monk Kakuban, and one of his close associates, the celebrated Myōe Shōnin of Kōzan-ji, were among the leaders of this movement. They sought to eliminate the barriers between the different schools of Buddhism, especially as the breakdown of the Heian aristocratic order weakened the patronage and support of the traditional Buddhist temples. As a part of the effort, a number of iconographic encyclopedias were compiled in order to codify and systematize Buddhist symbolism. The most familiar, perhaps, are the *Besson Zakki* (see No. 41) and the *Kakuzen-shō*, which is 120 scrolls in length, completed around 1211 by the monk Kakuzen. Much of Genshō's production should be seen as a similar effort, although some of his drawings were also preliminary studies for a painting workshop.

A lifelong member of the Shingon sect, Genshō received his early religious training at Tō-ji in the

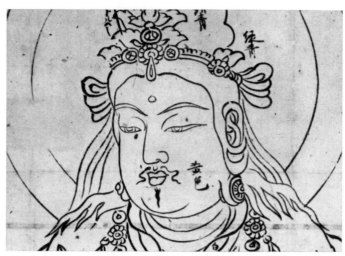

detail

Heian capital and later at Kanshū-ji, southeast of the town. He seems to have dwelled also at Daigo-ji, where this drawing probably originated. He ended his days on Mount Kōya, at the Getsujō-in, where he had numerous disciples and was honored with the title of Ajari (Ācārya in Sanskrit, designating a spiritual leader).

Chinkai, on whose work this drawing was based, is said to have painted a number of finished, colored works, the most familiar being "Monju Crossing the Sea," a National Treasure at the Kōdai-ji in Kyoto (see No. 44). He is also recorded as having restored the noble Tempyō painting of "Śākyamuni Preaching on the Vulture Peak" from the Sangatsū-dō, Tōdai-ji, now in the Museum of Fine Arts, Boston. Among Chinkai's numerous iconographic studies are the remains of a set of the Twelve Devas to which Genshō's drawing is clearly related. A copy of the set made in the thirteenth century is preserved at Kōzan-ji; and, interestingly, the drawing of Indra must have been missing at that time.

This standing figure of Indra is dressed in a full, flowing Chinese-style tunic and skirt. In his right hand he holds a thunderbolt, which is symbolic of his role in ancient Indian mythology as god of lightning, thunder, and rain, and as the heavenly archetype of

detail

detail

monarchs on earth. In the guise shown here he was part of a set of the Twelve Devas of Indian origin, the Jūni-ten, whose power was invoked in a Shingon ceremony intended to protect the nation and the emperor. Starting with Indra, they are: Agni, God of Fire; Yama, God of Death (see Nos. 48, 49); Rākshasa, God of Demons; Varuna, God of Waters; Vāyu, God of Wind; Vaiśravana, God of Wealth and Regent of the North (see Nos. 41, 59); Ishāna, a form of Śiva, God of Wealth and Protection; Brahmā, God of Sacred Indian Lore; Prthivī, God of the Earth; Sūrya, the Sun God; Candra, the Moon God.

Beginning in the ninth century, that great state ritual was performed at the Shingon-in within the Imperial Palace compound, usually on January 8 before members of the court and the civil administration. Images of the Twelve Devas together with the Five Vidyārāja (Myō-ō, see No. 45), either mounted on folding screens or as separate hanging scrolls, were set up as part of the ritual. The ceremony was also performed within the precincts of Shingon monasteries, especially Tō-ji. One of the oldest remaining sets of the Jūni-ten remains in Tō-ji, having been painted in 1127 to replace a set of a century earlier that had been lost in a fire. In those, the deities are brightly colored on silk and are each seated on a lotus

pedestal. No. 59 of this collection was copied after the figure of Bishamon-ten belonging to that set.

Another ancient set, also preserved at Tō-ji, shows the twelve gods standing in positions similar to Indra here. It was painted in 1191 by Takuma Shōga, the professional artist and son of Tametō (see No. 30). It shows more influence from contemporary Sung Buddhist painting than does this work of Genshō, rooted as it was on models fifty years older, before the resumption of close trade and religious contacts with the mainland.

Formerly in the Inō collection.
Published: Hirako Takurei. *Bukkyō Geijutsu no Kenkyū*. Tokyo, 1914. P. 529; *Kokuhō*, The National Treasures of Japan, vol. III. Tokyo, 1965. P. 5.
Reference: *Taishō Daizōkyō Zuzō*, vol. 7. Tokyo, 1933. Pp. 581–590; Doki Seiyō. *Genshō Ajari no Kenkyū*. Tokyo, 1943; Ishida Hisatoyo, in *Museum*, no. 210 (September 1968); Takata Osamu and Yanagisawa Taka. *Butsu-ga*. Genshoku Nihon no Bijutsu, vol. 7. Tokyo, 1969; John Rosenfield. *Japanese Arts of the Heian Period*. New York, 1967. No. 7; *Kokka*, no. 173 (September 1904).

大般若波羅蜜多經卷第五百八十一

第十一布施波羅蜜多分之四

三藏法師玄奘奉　詔譯

尒時舍利子白佛言世尊云何菩薩寂初發

心云何菩薩第二發心云何菩薩住不退地

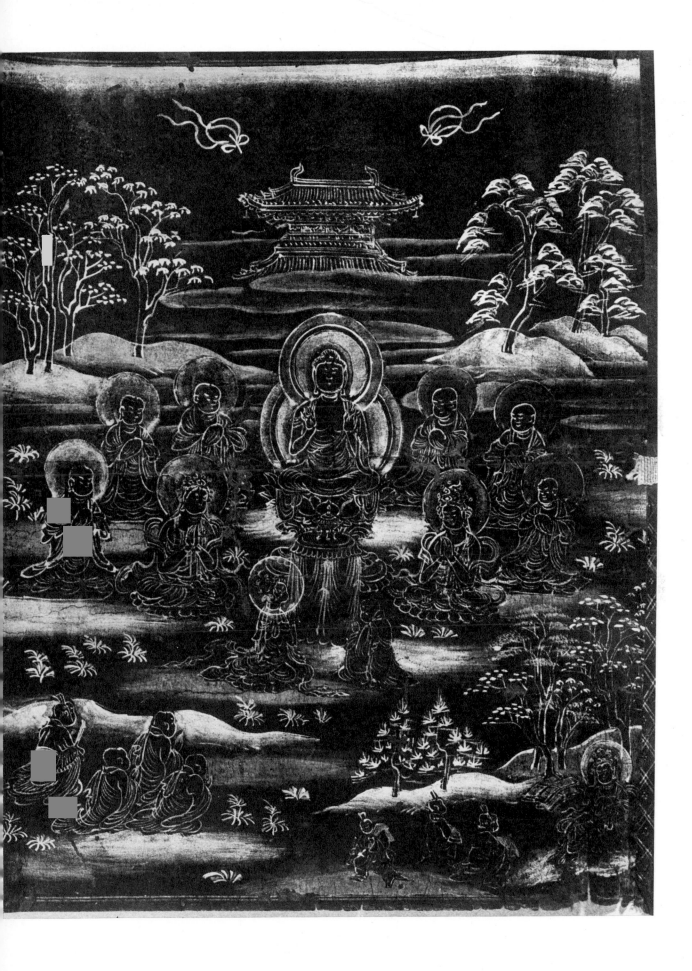

32. Śākyamuni preaching; frontispiece of an illuminated *Daihannya-kyō*

Late Heian period (ca. 1176)
Hand scroll; gold and silver ink on indigo paper
Frontispiece: H. 10 1/10 × 8 1/8 in. (25.6 × 20.7 cm.)

This is the frontispiece illustration of a decorated sūtra. In the center, Śākyamuni, with two round haloes behind him, is seated cross-legged on a lotus throne and attended by two Bodhisattvas and six disciples. Above him, rising from the mist, are the roofs of a two-storied temple hall. In the lower right corner another Bodhisattva is depicted in the act of giving alms to a few laymen, while a group of devotees kneel in prayer at the left. Flowers tied with ribbons fall from heaven onto the landscape. Painted in gold and silver inks on dark indigo paper, the scene has a sumptuous, visionary quality.

Decorated sūtras of this type were produced by professional ateliers specializing in such work and employing mass-production methods. They produced, for many temples throughout Japan, large sets of holy texts—this, for example, is number 582 from a set of six hundred scrolls of the *Daihannya-kyō*—and sets of the entire *Tripitaka* numbering in thousands of volumes. When a scroll such as this one is divorced from the original set and lacks an inscription or other historical document, it is difficult to determine its exact provenance. However, in format and style, it is very close to the now fragmented set of the *Daihannya-kyō* donated in 1176 by Fujiwara Hidehira at Chūson-ji, and this fragment may well have been a part of it.

Chūson-ji is located in Hiraizumi city in Iwate Prefecture in the northern part of Honshu. It was the tutelary temple of the local rulers of that remote region, a family bearing the name Fujiwara but only loosely connected to the main branch of the clan ruling in Kyoto. Enriched by the discovery of gold in the region and by the virtual independence of their rule, the northern Fujiwaras created a lavish sanctuary at Chūson-ji. The Amida Hall, with the popular name of Konjiki-dō (the Golden-colored Hall), remains today as one of the finest examples of late Heian architecture, sculpture, and lavish decoration; the ornamented sūtras of the entire *Tripitaka* donated between 1117 and 1176 by three generations of the family are among the finest and most ambitious of their kind. Over twenty-seven hundred scrolls still remain in the temple; 4,296 scrolls were transferred

in the late sixteenth century to Kongōbu-ji on Mount Kōya; and a large number have found their way into other temples and private collections.

Decorated sūtra scrolls with a frontispiece illustration are known to have existed in China since the T'ang dynasty. In Japan, the tradition can be traced back as early as the Nara period through examples such as the *Brahmajala-sūtra* (*Bonmo-kyō*) preserved in the Shōsō-in Repository, Nara. In the Heian period, as faith in the *Lotus Sūtra* and the cult of the Pure Land of Amitābha became increasingly prevalent, ornate sūtras in great numbers were commissioned by the aristocracy. As the indigenous styles of painting and calligraphy developed in sophistication and skill, the art of decorating Buddhist texts reached extraordinary heights, especially in such works as the sūtras donated in 1164 by the Taira family to the Itsukushima Shrine.

Among the various forms of decorating sūtra scrolls, the use of gold and/or silver ink on dark blue or purple paper was the most common. The oldest examples of such frontispiece decorations are of two types. One is a narrative type that combines an ensemble of scenes, each illustrating a specific passage of the text. An example can be seen in a set of *Lotus Sūtra* scrolls of the late tenth century at Enryaku-ji, Shiga Prefecture. The other is more hieratic and depicts Śākyamuni or another Buddhist deity giving a sermon in the center of the composition. An example of this type can be seen in a scroll of the *Hannya-kyō* done in the early eleventh century and now in Shinkō-in, Kyoto.

In terms of composition, the illustration shown here combines both narrative and hieratic modes, the narrative element being the gift of alms by the Bodhisattva at the lower right. Compared with the Enryaku-ji and Shinkō-in works, the space is more naturalistic, the contour lines and treatment of drapery folds are more dynamic and expressive, and there are great variations in thickness of the strokes. These features suggest that the painter was familiar with the more secular narrative paintings that had been developing at the end of the twelfth century, like the Bandainagon scrolls.

The text of which this scroll is part was one of the prime canonical sources for Mahāyāna Buddhism in East Asia, the opening sūtra in the Chinese *Tripitaka*. It is called the *Mahāprajñāpāramitā-sūtra* in Sanskrit; the *Daihannyaharamitsu-kyō*, or the *Daihannya-kyō* for short, in Japanese. Comprising the stately total of six hundred volumes, it contains the sermons of the Buddha at sixteen different meetings held at the Vulture Peak, near Rājagriha in India. A shorter version was translated into Chinese in the early fifth century; this version was done between 659 and 663 by Hsüan-tsang, who had gone to India to obtain Sanskrit texts. This scroll is the fourth part of the sermon of the Buddha at the eleventh meeting, where he expounded the merits of selfless charity.

In general, the teaching of the *Daihannya-kyō* is highly metaphysical. It explains that *prajñā*, "wisdom," is the highest of the six paths leading to Enlightenment. These are the six *pāramitās* (*roku-haramitsu*): charity, keeping of holy precepts, perseverance, assiduousness, meditation, and wisdom. The central doctrine of the sūtra is that of Absolute Truth—*śūnyatā* (*kū*), often translated in English as "void" or "emptiness." It puts forth the concept that all existence and all parts of existence have causes and that, in addition, since the causal factors are ever changing, there is no static existence. The combination of the terms *prajñā* and *pāramitā* means the perfection of wisdom; *prajñā* means not only knowledge of absolute truth but also that the truth had been embodied in the Buddha himself and that his words in turn are embodied in this sūtra. For this reason, the *Prajñāpāramitā-sūtra* was worshiped in its own right. When the Chinese monk Fa-hsien traveled in the Indian kingdom of Mathurā early in the fifth century, he saw Mahāyānists there give offerings to the sūtra, and this is the earliest recorded instance of the worship of a text as a deity.

In China in 663, shortly after Hsüan-tsang had completed his translation of the sūtra, the Emperor Kao-tsung made a ceremonial offering to it. This became the precedent for the *Daihannya-kyō* in Japan, a great ceremony in which the sūtra is worshiped and the text read aloud. The earliest extant copy of the text in Japan is dated 712; after the eighth century, the sūtra came into increasing prominence as a result of the belief that it was endowed with wisdom and had the power to cure, to ward off evil influences, and to protect the country. It was customary to read the entire sūtra in temples and at the Imperial Palace on behalf of the throne or the nation, whenever the emperor or his courtiers so proclaimed. In fact, the use of this sūtra at ceremonies became so frequent that monks would cut down on the reading of the entire text. They would pass the wooden boxes containing the scrolls from hand to hand believing this had the same effect as reciting the contents. In other instances, an octagonal, wooden revolving shrine for the text was provided so that worshipers, by rotating it like a Tibetan prayer wheel, could get the same blessing as they would have by actually reading the text. (S.S.)

Published: John Rosenfield. *Japanese Arts of the Heian Period*. New York, 1967. No. 34b.
Reference: special issue devoted to ornamented sūtras, *Yamato Bunka*, no. 50 (April 1969); Tanaka Kaidō. *Nihon Shakyō Sōkan*. Tokyo, 1953.

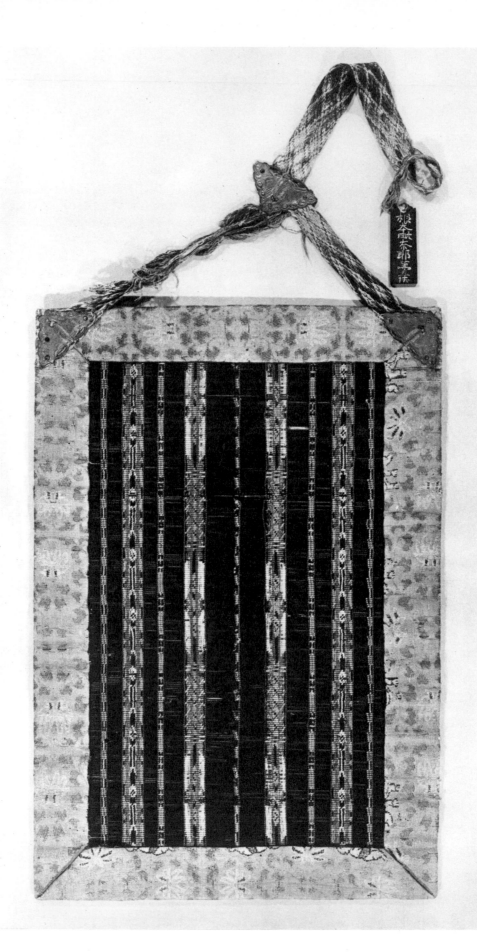

33. Sūtra wrapper

Late Heian period (last half of the twelfth century)
From Jingo-ji, Kyoto
Bamboo strips with silk brocade binding; remnants of mica; brass ornaments
H. 18 1/8 × 12 3/16 in. (46 × 31 cm.)

This wrapper for a group of ten sūtras came from the Kyoto temple of Jingo-ji, and it probably belonged to the vast set of the *Tripitaka* inscribed in gold on blue-violet paper and donated to the temple. According to tradition, the set was begun by the retired Emperor Toba who abdicated in 1123, and completed in 1185 by the retired Emperor Goshirakawa. Together with the Chūson-ji sūtras, it is one of the best known of the ornate sūtra sets of the Heian period because nearly twenty-four hundred scrolls were sold in 1879 to help finance essential repairs to the temple. Many have found their way to foreign collections.

The wrapper is made of thin bamboo sticks, which serve as a warp for the woven threads of yellow, dusty blue, green, and red silk that form long bands along its length. Framing the bamboo mat is a wide band of silk brocade with golden threads woven in with pale orange, green, and yellow. At one time there was a sheet of mica immediately beneath the bamboo, which added to the lustrous, ornamental effect and also helped protect the contents. The mica sheet was sandwiched against the bamboo by a sheet of green silk, which forms the outer cover when the wrapper is in use. Brass studs in the shape of butterflies serve to fix the tie ribbons of braided silk to the wrapper. At the end of the ribbon is a wooden tab with the name of the temple on one side. On the other side is the marking that this is the fifth wrapper of the *Kompon Binaya*, an abbreviation for the Vinaya of the Mūla Sarvāstivādin sect, the monastic regulations of one of the early, proto-Mahāyāna sects of India, which served as influential models of monkish behavior in China and Japan.

This lavishly made wrapper was only a small part of the elaborate respect, and even veneration, given to the holy Buddhist texts, the very embodiments of the Buddhist Law. The axles of the scrolls were sometimes made of aromatic woods like sandal, rosewood, or fine cedar; the ends of the rollers were ornamented with bronze or crystal. The tie-strings were made of beautifully woven silk cords. In some cases, each sūtra had its own individual storage box inlaid with sandal or cloves to perfume it. In other cases, sets of a single text would be stored in a special bookcase. For the most part, however, the large sets of texts were stored in sturdy, lacquered wooden boxes; within the boxes, they were kept in groups of ten in wrappers such as this.

The custom of making such wrappers in Japan may be traced back to the Nara period, and it was surely of continental origin. In the Shōsō-in Repository, for example, there is a beautifully preserved wrapper made especially for the *Suvarnaprabhāsa-sūtra*, which was to be distributed to an official state monastery, *kokubun-ji* (see No. 6); the name of the text and the date of 742 were woven in the threads over the bamboo. Hōryū-ji preserves the ancient, badly worn wrapper that once enclosed the commentaries that Prince Shōtoku wrote on the *Lotus Sūtra*; the same temple donated to the imperial household two wrappers of the early Kamakura period, similar in style to this one but not quite so ornate. On some of the Jingo-ji wrappers a date in the founding year of the Kyūan era (1145) has been discovered; but in all likelihood the wrappers were made continually during the period between the two retired emperors Toba and Goshirakawa when the *Tripitaka* was being donated.

Reference: Tanaka Kaidō. *Nihon Shakyō Sōkan.* Tokyo, 1953. Pp. 399–400; *Shōsō-in Hōmotsu,* vol. 2. Tokyo, 1960. Pls. 27–31; Tokyo National Museum catalogue, *Hōryū-ji Kennō-butsu Zuroku.* Tokyo, 1959. No. 41; *Hōryū-ji Ōkagami,* vol. X. Tokyo, 1933. Pl. 39.

34. The apparition of Samantabhadra (Fugen); frontispiece and text of the *Kan-Fugen-Bosatsu-Gyōbō-kyō*

Kamakura period (early thirteenth century)
Hand scroll; gold and silver ink on dark blue paper
Frontispiece: H. 10 1/8 in. (25.7 cm.)

The illustration shows the appearance of the Bodhisattva Samantabhadra before a monk who reads the *Lotus Sūtra*. The iconography is identical to that of the frontispiece of the *Muryōgi-kyō* (see No. 35), although the Bodhisattva here is followed by only two attendants. He is mounted on a lotus throne on the back of an elephant with six tusks; above him is a heavenly canopy depicted as if suspended in the air. The movement of the heavenly host toward the monk is indicated by the cloud trails behind them, like lines of force originating from deep in the background. Beneath the feet of the elephant and the Bodhisattvas are lotus flowers rising from the clouds.

Clear stylistic differences may be noted between this illustration and that of the *Muryōgi-kyō*. The principal figures in this composition are more diminutive in scale and more clearly established as part of the landscape scene. However, the greater realism in spatial effects here is contradicted by the schematic treatment of details; the precipice, for instance, is shown by more mannered brushwork; the rock configuration is represented by a series of slanted and lateral texture strokes conceived as mere convention. The lower half of the precipice appears to be flat, as does the small, amoeba-shaped islet below. The bands of mist that separate the small hills in the distance are done in severe straight lines.

The cover of this scroll, although somewhat damaged, is decorated with the conventional floral motif called *hōsōge*, the peonylike representation of the lotus flower. The title *Kan-Fugen-kyō* is written in the style of late Heian calligraphy in the rectangular label, which is depicted like a tablet standing on a lotus flower. The label is decorated on its outer margin by the crisp arabesque design, which is repeated on the outer margin of the cover. Also, in the upper and lower bars of the outer margins are designs of the magic Wheels of the Law (*kongōrin*), originally six in each bar but now nearly all effaced. The edge of the cover is decorated with a chain of diamond patterns rendered in parallel gold lines. The large floral motif is clearly outlined in gold against a silver ground, following the established convention

in sūtras on blue-violet paper decorated with gold pigments. Compared with the late Heian examples, however, the design of the present scroll shows a distinct linear quality. The stems, tendrils, buds, and flowers here appear even more sharply set against the silver ground, in contrast to the more tactile and much fuller flower designs of the late Heian sūtras. Noticeable also is the repeated pattern of the purely decorative tendrils, appearing somewhat harsh and flat, simulating the surface of an exuberant openwork metal plate. In the late Heian examples, the tendrils are still smaller and the petals much fuller and more descriptive, but in this design, the tendrils are enlarged, greatly abstracted, and the flowers are mechanically executed. The flowers appear to be dismembered and scattered in an ocean of tendrils.

The calligraphic style of the text is also markedly different from work of the late Heian period (see Nos. 25, 26), even from the style of the label on the cover. It had been the general practice in the eighth century that the title on the cover of a sūtra scroll was assigned to a better calligrapher than the scribe assigned to the text itself. This may explain the inconsistency here between the calligraphy on the cover and the text proper. The characters in the text, small and regularly spaced, are written in a restricted manner, taking for their model the academic sūtra writing style of the eighth century. But the vigor of brushwork and excellent craftsmanship of the scribes of the Sūtra Copying Bureau are completely absent here; moreover, the rich flavor of the aristocratic grace of late Heian calligraphy has also disappeared. The writing style and pictorial features of this scroll thus suggest a date of the early thirteenth century, when the afterglow of the Heian style was fading and the new Kamakura style was just arising.

The text itself was translated into Chinese three times, but only the last version, rendered by Dharmamitra between 424 and 441, is still extant. Called in Sanskrit the *Samantabhadra-bodhisattvadhyāna-caryā-dharma-sūtra* ("Sūtra on the Law of the Practice of Meditation on the Bodhisattva Samantabhadra"), its name in Japanese is *Kan-Fugen-Bosatsu-Gyōbō-kyō*,

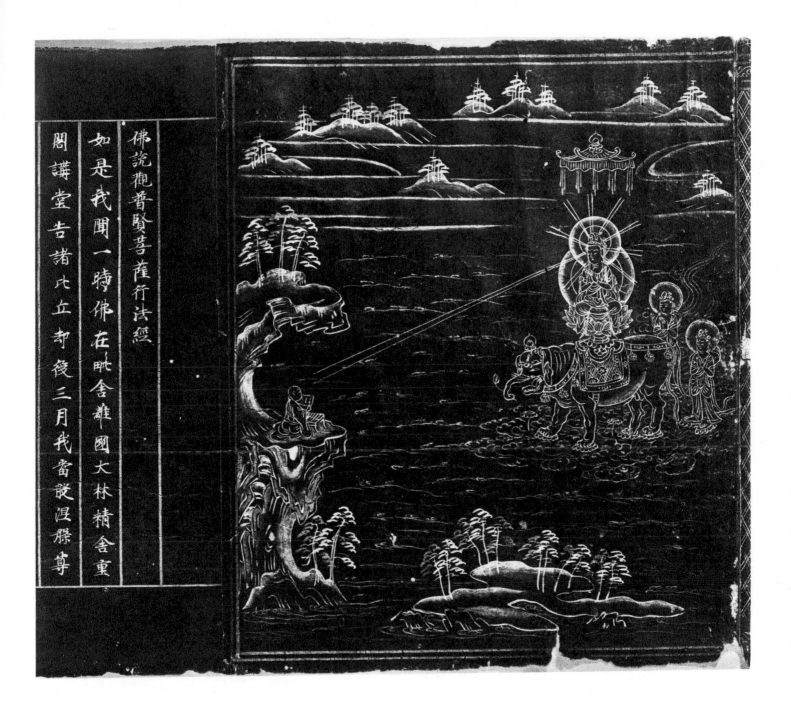

佛説觀普賢菩薩行法經

如是我聞一時佛在毗舍離國大林精舍重

閣講堂告諸比丘却後三月我當般涅槃尊

or the *Kan-Fugen-kyō* for short. The single volume contains the Buddha's sermons delivered, three months prior to his death, in the lecture hall of the Great Forest Monastery in Vaiśālī, in central India. In it, the Buddha expounds the meritorious virtues of meditation on Samantabhadra and he gives instructions on the rites of repentance and purification of the sins of the six organs of sense. The section on the meditation on Fugen Bosatsu is considered to be the counterpart to that in the "Chapter on the Encouragement of Fugen Bosatsu," the twenty-eighth and final chapter of the *Lotus Sūtra*. For this reason, the founder of the Tendai sect in China, Chi-i, joined this sūtra to the *Lotus* as the text that concludes the *Lotus*, just as he joined the *Amitartha-sūtra* (*Muryōgi-kyō*) as the opening sūtra. The three texts together form the "Three Books of the Lotus" upon which he developed much of the theology of the Tendai creed (S.S.)

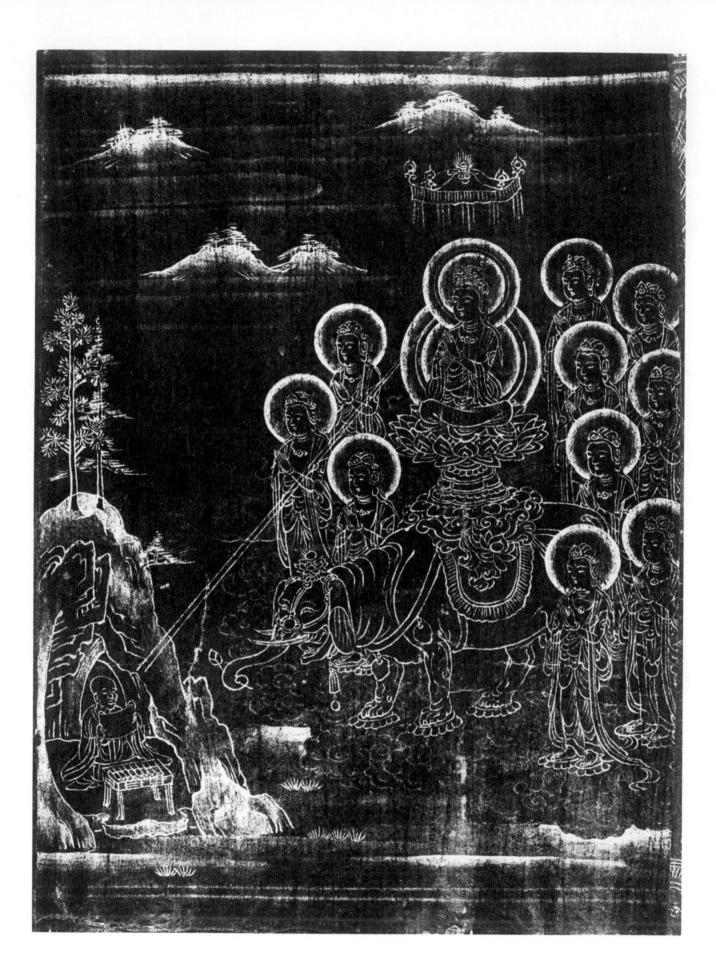

35. The appearance of Samantabhadra (Fugen); frontispiece of an illuminated sūtra (*Muryōgi-kyō*)

Kamakura period (early thirteenth century)
Hand scroll; gold and silver ink on paper
Frontispiece: H. 9 7/8 in. (25.1 cm.)

The frontispiece illustration of this scroll depicts a scene of the great Bodhisattva Samantabhadra mounted on an elephant and accompanied by an entourage of ten heavenly beings. From his forehead come two rays of light that extend down to a faithful preacher seated in a mountain cave and reading the *Lotus Sūtra*. The revelation takes place in an open landscape with stylized horizontal silver bands of mist separating three hillocks in the distance from the rest of the scene. Compared with the frontispiece illustration of the *Daihannya-kyō* of the late Heian period (No. 32), the handling of the mountain cave and the trees on top is more descriptive and naturalistic. It suggests a date early in the thirteenth century.

The text is the *Amitartha-sūtra*, which was translated into Chinese in 481 by the Indian monk, Dharmajatayasas. It consists of three chapters: the first explains virtuous deeds; the second is made up of the Buddha's sermons on the immeasurable meanings (*muryōgi*) of the one, true reality; and the third extols the virtues of preaching this sūtra. In the sixth century, the Chinese monk Chi-i, who founded the Tien-tai (or Tendai) sect, considered this text to be a preamble to the introductory chapter of the *Lotus Sūtra*, in which the term *muryōgi* is discussed. For this reason, the Tendai sect took the *Muryōgi-kyō* to be the opening portion of the *Lotus Sūtra*, with the *Kan-Fugen-kyō* (see No. 34) as the closing one. Therefore, it was customary to include both the *Muryōgi-kyō* and the *Kan-Fugen-kyō* together with the *Lotus Sūtra* to form the "Three Books of the Lotus" (the *Hokke-sambu*). The most eminent example of this combination are the scrolls donated by the Taira family to Itsukushima Shrine in 1164.

The scene depicted in this illustration bears no relationship whatsoever to the content of the *Amitartha-sūtra*. But since the Tendai sect considered Samantabhadra as the special patron and protector of the believers of the *Lotus Sūtra*, his image was placed at the beginning of the text that was held to be the preamble to the *Lotus* itself. The painting was based on the twenty-eighth and last chapter of the *Lotus*, entitled the "Fugen Bosatsu Kanbatsu-bon" ("Chapter on the Encouragement of Samantabhadra Bodhisattva"); from the mid-twelfth century onward such scenes were frequently depicted. One can be seen, for example, in the illuminated sūtras of Kunō-ji of 1141 and in the Taira scrolls at Itsukushima.

The ten figures accompanying Fugen Bosatsu in this illustration are a special, iconographic trait. They are Rakshasī (Rasetsunyo), females with superhuman powers taken from Indian mythology. Mentioned only in the seventh chapter of the *Lotus Sūtra*, their function is to guard and protect those who preach the sūtra. Although the *Lotus* itself does not identify these women with Fugen, their protective role is so similar to that of the Bodhisattva that the ten women and the main icon were joined into one motif, which appears in a handful of paintings of the late twelfth and early thirteenth centuries. In some of these, the Rasetsunyo wear Chinese costume and headgear, which suggests that the motif may have originated on the mainland. In others, they are dressed as Japanese court women. Of the Chinese type, the earliest example is a painting of the late Heian date at Rozan-ji, Kyoto; of the Japanese type, the earliest is the painting formerly in the Masuda collection, dated early in the Kamakura period.

This painting, which renders the Rasetsunyo in the guise of attendant Bodhisattvas, may be seen as a variant of the Chinese type. While the Rozan-ji painting depicts the ten Rasetsunyo as clearly identifiable with specific symbolic attributes, no such individual distinction is made in this version. The women are simply shown as a group of ten attendants to Fugen, thus indicating the flexibility of this iconography, which here resembles that of the attendant Bodhisattvas in the scenes of the Raigō of Amida, his coming to receive the souls of the dying. (S.S.)

Reference: special issue devoted to ornamental sūtras, *Yamato Bunka*, no. 50 (April 1969), pls. 22, 25.

Japanese Buddhist Arts

The Middle Ages (1200-1600 A.D.)

The Japanese middle ages began and ended in bloody civil strife. They began with the creation, in 1185, of a military government at Kamakura that imposed a loose, semifeudal political authority on the nation. They ended with the establishment at Edo, in 1603, of a military government with severe, centralized power, one that was more rigidly feudal in nature. In the arts, the four centuries of the middle ages saw even greater instability. At the beginning, there was a brilliant outburst of creativity in traditional Buddhist art and architecture, an attempt to rival the achievements of the Nara period. At the end, traditional Buddhist imagery had faded in importance; the visual arts were dominated by the aesthetic values of the Zen Buddhists, who looked to southern Sung China for inspiration, and a new style of decorative and genre arts had begun to appear.

The rise of the military government at Kamakura was the result of the gradual breakdown of the political order maintained for centuries by the Fujiwara family. The Fujiwara had ruled from the Heian capital; the head of the family had been in fact the chief minister of the land. His authority was exerted indirectly, through control of the imperial family and his ability to gain the support of the martial clans in the outlying provinces. In the eleventh century, at the height of Fujiwara power, a distinctly Japanese spirit in all the arts emerged, and political and trade contacts with China came virtually to a standstill. With the decline and fall of the great T'ang empire, Japan ceased looking to the mainland for models in statecraft, religion, and art; its own native styles of expression reached maturity. In literature, this maturity may be seen in the novels of Murasaki Shikibu and the court diaries of Sei Shōnagon and Izumi Shikibu; in Buddhist painting and sculpture, it is seen in the perfection of uniquely Japanese modes at the Byōdō-in, south of Kyoto. Similar achievements may be found in calligraphy, paper making, lacquer ware, embroidery, and metalwork. This was a metropolitan, urbane culture; the Heian capital was the center of Japanese civilization; its influences radiated out to the remote provinces.

The aesthetic unity of Heian period arts broke down during the second half of the twelfth century, however, as confederations of military clans fought violently with each other to replace the Fujiwara as the dominant power in the empire. The struggle claimed a fearful toll in lives, in homes, palaces, and temple buildings; it produced traumatic changes in the emotional life of the nation. Decade by decade

during the last half of the century, the air of aristocratic calm, abstraction, and delicacy in the arts gave way to one of greater militancy, vigor, and realism. The Minamoto family, led by the ruthless Yoritomo, established in 1185 the military regime (the *bakufu*, "curtain government") in the fishing village of Kamakura, south of modern Tokyo and far from the influence of the old Heian aristocracy. Civil war on a serious scale came to an end; almost immediately a major effort was begun in the home provinces to repair temples that had been burned in the struggles. Nara was the chief center of this activity, especially at the monasteries of Tōdai-ji and Kōfuku-ji, which supported large ateliers of sculptors and painters. Vast numbers of images were commissioned by the monks who led the restoration movement, and sculptors attempted to harmonize their work with the aesthetic features of the past. Above all, the strong realism found in some of the eighth-century sculptures of Nara appealed greatly to the taste of the time. From the sculpture workshop at Kōfuku-ji under the direction of the brothers Unkei and Kaikei came a number of remarkable carvings replete with descriptive detail comparable to the most extreme examples in the West—sculptures of Hellenistic Alexandria, of republican Rome, of the Florentine Renaissance.

The realism of thirteenth-century Japanese art was in close accord with the strong trend in the Buddhist church of the time to spread the faith among the masses. Realistic images of deities—their eyes of sparkling glass, their clothes and jewelry made of real silk and gold—were more easily understood and approached by the common folk. This theological movement was inspired both by the doctrine of compassion for all mankind and by the need to replace patronage of the fallen aristocracy with that of the populace at large. In contrast to the eighth-century bronze Daibutsu at Nara, built with state funds at the order of the Emperor Shōmu, the thirteenth-century bronze Daibutsu at Kamakura was financed by public subscription organized by an obscure evangelist monk. The older image symbolized the Esoteric Buddhist conception of a prime, creative principle in the universe, the Buddha Mahāvairocana; the Kamakura Daibutsu was Amitābha, Lord of the Western Paradise and chief object of devotion in the popular Pure Land cults. As Buddhist arts responded to the tastes of the Japanese masses, it emphasized deities who appealed to deeply rooted folk traditions—child gods such as the infant Shōtoku Taishi and Kōbō Daishi, for example, or the Bodhisattva Jizō, protector of women in childbirth, of children, of men about to enter battle.

Medieval Japanese culture was also affected by the reopening of large-scale contacts with China after two centuries of relative isolation. In popular Buddhism, for example, the cult of the Ten Kings of Hell was transplanted from China with great impact upon the Japanese masses. The heavy, baroque style of Sung temple sculpture and painting also made its appearance in Japan, primarily in the Kamakura region. In the reconstruction of the Great South Gate (Nandai-mon) of Tōdai-ji in Nara, a style current in the South China coastal region was employed. Misleadingly called the Indian style (*tenchiku-yō*), it was adopted in other parts of Japan as well. The most enduring form of mainland influence, however, was that of the Ch'an Buddhist sect. During the thirteenth century, scores of Japanese monks went to study in Ch'an monasteries in the region of Hangchou and Suchou, south of the Yangtze delta, and

returned to their homeland with a vision of the traditional arts of China strongly tinged with Ch'an Buddhist and neo-Confucian values. The newly imported doctrine, whose arts are discussed in greater detail below, grew slowly in its appeal to the Japanese. In the thirteenth century, it was limited chiefly to a few temples in Kyoto and Kamakura, but it had gained the sympathy of high-ranking samurai, who were attracted by its emphasis upon discipline and its respect for the everyday world.

The development of all the arts—whether secular or Buddhist—was continually affected by political disturbances. Chief of these was the threatened invasion of Japan by the Mongols, who had conquered both China and Korea during this period. The Mongol conquest had prompted a number of distinguished Chinese Buddhists to seek refuge in Japan; and the actual attempts to invade Japan in 1274 and 1281 along with the threat of other incursions became the overriding political reality for the last three decades of the century. After the successful defence of the nation, however, internal political instability continued to divert the energies of the ruling classes. Early in the fourteenth century, the Emperor Godaigo led a rebellion against the military regime, hoping to reestablish the imperial throne as the supreme governmental authority. The *bakufu* responded by approving another branch of the imperial family as the legitimate rulers. Godaigo was driven from Kyoto and established a court on Mount Yoshino, south of the Yamato plain. For most of the fourteenth century, there were two branches of the imperial family, each with its samurai supporters, claiming legitimacy—the southern one at Yoshino and the northern one in the Heian capital. Thus the era is called that of the Namboku-chō, of the contending northern and southern dynasties.

One of the leaders of the forces of the *bakufu*, the warrior Ashikaga Takauji, succeeded in establishing himself as shogun, the head of the military government. In 1338, he built a palace in the Muromachi district of Kyoto just north of the city boundary; the military regime thus returned to the old capital, and a new line of authority, that of the Ashikaga family, was founded. Takauji had come under the strong intellectual influence of the Zen Buddhist monk Musō Soseki, who hoped to establish the Zen faith as the state creed of Japan. With Takauji's support, Musō constructed temples in the Kyoto area and helped launch a series of trade and cultural missions to China, organized and staffed by the Zen clergy.

The sect became closely identified with the Ashikaga shoguns. Under their patronage and that of the imperial family, the vast Zen monasteries of Kyoto were constructed and became the major centers of Japanese cultural life. But the other traditional schools of art, both secular and Buddhist, remained active. The Tosa family in the fifteenth century became official painters to the Imperial Court and kept intact the *Yamato-e* style, with its sensitivities to brilliant colors and strong design patterns. Buddhist temple sculpture and painting were continually produced, usually by men who traced their artistic lineage back to the schools of Jōchō and Unkei and the Kose family. But because of the sheer brilliance of Zen ink painting of the fourteenth and fifteenth centuries, the other schools are often criticized for lack of originality and aesthetic vitality. Nonetheless, they maintained traditions that in the late sixteenth century would return to great eloquence and beauty, when the enthusiasm for Chinese-style ink painting had somewhat subsided.

Most of the leaders of the Ashikaga *bakufu*, after the consolidation of their power, were more effective as collectors of paintings and ceramics, and as poets and patrons of the theatre, than as governors. By the middle of the fifteenth century, a familiar social pattern reappeared, that of weakened central authority, of warfare and intrigue among the samurai families seeking political gain. The struggles, which lay waste to much of the city of Kyoto, continued for well over a hundred years, and came to a gradual end only with the appearance of three successive warlords of great personal ability—Oda Nobunaga, Toyotomi Hideyoshi, Tokugawa Ieyasu—whose achievements are described below.

Under the regimes of these three warriors, each of whom was an ambitious builder of castles and palaces, large-scale decorative arts became the overriding concern of the most talented artists. It is true that Hideyoshi and his family sponsored projects to reconstruct and refurbish the old Buddhist temples in the Kyoto and Nara region, and Hideyoshi built a giant Buddha image and temple in Kyoto to rival the Daibutsu of Kamakura and Nara, but even with such patronage, and even though a gifted artist like Hasegawa Tōhaku did traditional Buddhist painting, the ancient hieratic tradition in the arts had exhausted itself aesthetically. Japanese artists no longer channeled into it their deepest emotions. Even men of strong religious convictions, like Hon'ami Kōetsu or Shōkadō Shōjō, expressed themselves in other ways. The fading of the authority of the Buddhist arts in Japan had been a very long, slow, irreversible process. It was similar in many ways to the decline of Catholic influence in the art of France and Italy. By the 1860s the Japanese, French, and Italians stood in much the same position regarding the ancient religious tenets that had shaped their cultures so profoundly. The exhaustion of formal religious art was one of the most basic symptoms of the inability of the churches to respond to the challenge of new ideas and new circumstances of life.

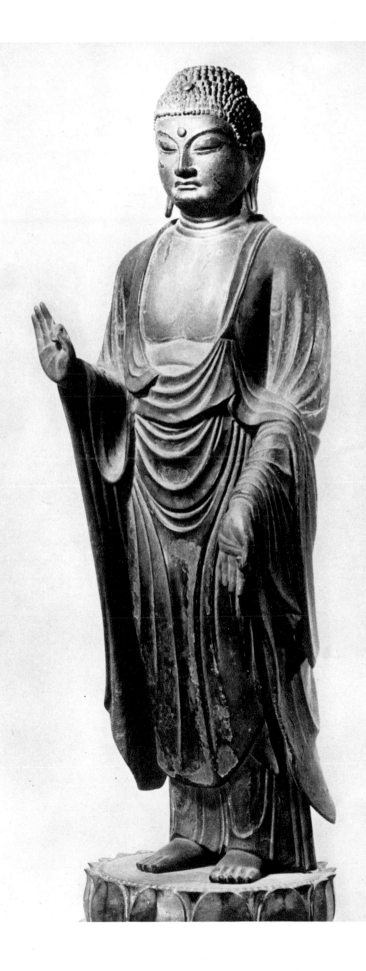

36. Standing Amitābha (Amida) Buddha

Early Kamakura period (ca. 1190–1200)
School of Kaikei (active ca. 1185–1220)
Assembled wood-block construction, with inlaid glass eyes
Figure only: H. 30 1/8 in. (76.5 cm.)

This grave, imposing statue of Amida was probably produced by the workshop of the Master Sculptor Kaikei. He and his older brother, Unkei, were the outstanding sculptors in the Kansai region during the reconstruction of the Nara temples and the spectacular revival of Buddhist art following the Gempei wars. The attribution to Kaikei is made on the basis of style alone; the interior walls of this image are inscribed with votive prayers, but neither the date nor the name of the sculptor is to be found. Usually this information was written on the wooden tenon that holds a figure on its pedestal. Here the feet and tenons are modern restorations, made in 1957, as are both hands and some replacements in the drapery.

Like the Jizō statue exhibited here (No. 37), a product of much the same artistic ambience, this image combines stylistic elements of the Heian period with innovations of the thirteenth century. And, again as in the Jizō figure, the conservative elements predominate. Archaic features include the sober and brooding expression of the face, the pronounced creases around the neck, and the symmetrical treatment of the garment folds over the thighs and lower torso. These are all characteristic of Buddha images of the early Heian period—the statues of Yakushi at Jingo-ji and Gangō-ji, for example. Such images were well known to the Kaikei school and must have served as inspiration for their efforts to revive traditional Buddhist arts and to revitalize the formulas of the Jōchō school (see No. 20). However, the folds of the robe as it falls over the two arms are an unmistakable symptom of the renewed interest in descriptive realism, which so intrigued sculptors at the beginning of the Kamakura period.

This statue is extremely close in style, material, and proportions to the nine standing Amida figures that are known to have been carved by Kaikei and installed in temples throughout western Japan. Among themselves, the statues differ considerably in details of garment folds, surface decoration, and nuances of facial expression. But all have the same general hand gestures, known collectively as the Raigō-in, symbols of welcome to souls reborn in the different sectors of the Western Paradise. The hands of this figure are modern, but careful, restorations, and the particular gesture symbolizes the salvation of those to be reborn in the lower sector of the upper level of Paradise (the Jōbon Geshō).

Kaikei, whose religious name was An-Amida-Butsu (the Peace of Amitābha) was a devoted believer in Amidism and strongly identified with the movement to spread this creed. He was closely associated with the venerable monk Shunjōbō Chōgen, who had led the campaign to reconstruct the burned Tōdai-ji and who is honored as the monastery's second founder. Chōgen commissioned many works of Kaikei and was also an Amidist, taking as his religious name the formula of devotion Namu-Amida-Butsu (Homage to the Buddha Amitābha). Kaikei's own sculptural style was ideally suited to express lyrical, visionary elements within this Mahāyāna faith, for his mature works have a romantic lyricism quite different from the more earthy and dynamic realism fostered by his brother Unkei and Unkei's many followers. Within the styles perfected by these two brothers, two main currents in Kamakura sculpture developed; the gentle idealism of Kaikei, best embodied, perhaps, in the celebrated standing image of Jizō in Tōdai-ji, came to be known as the An-Ami style. This statue actually predates Kaikei's maturity as a sculptor. It belongs to an earlier, more experimental phase in which he studied and incorporated elements from the past, but had not yet achieved his own distinctive manner. Its closest analogies are the Amida statues in Saihō-ji, Nara, and Henshokōkō-in, Wakayama, done in the 1190s.

Reference: Mōri Hisashi. *Busshi Kaikei-ron.* Tokyo, 1961. Pp. 131–143; Mōri Hisashi. *Unkei to Kamakura Chōkoku.* Nihon no Bijutsu, no. 11. Tokyo, 1964.

94

37. Jizō

Early Kamakura period (ca. 1200); repaired in 1655 and 1969
Joined wood-block construction; gesso and paint; inlaid crystal urna
H. of figure 27 1/4 in. (69 cm.); H. of figure and base 35 1/4 in. (89.5 cm.)

Seated in a slightly informal, half cross-legged position, this figure of Jizō is imbued with the combination of divine aloofness and humane compassion that is essential to his religious mission. Although he has the theological rank of Bodhisattva and is endowed with supermundane powers, Jizō is most often shown, as he is here, in the guise of a monk with shaved head and wearing none of the ornate jewelry characteristic of a Bodhisattva.

Stylistically, this statue demonstrates the transition between late Heian- and early Kamakura-period modes of expression. The head and torso are done in the highly idealized, geometric manner that originated centuries earlier in India and that predominated in Japanese work of the eleventh and twelfth centuries. The folds of the robe, however, are quite descriptive, especially as they drape over the edge of the lotus throne. Such realism is a trait adopted with great enthusiasm by sculptors in the Nara region during the great revival of Buddhist devotional art at the end of the Gempei wars. The facial mask of this figure also bears a distinctive stylistic trait of this era. The heavy T'ang-style lips, almost pouting in effect, contrast strongly with the thinner mouths of late Heian sculpture (see No. 20). This reflects renewed interest in the sculpture of the eighth century and an effort to emulate it.

An inscription on the bottom of the figure records that it was repaired in the beginning of the Meireki era (1655). It is also described as the main object of worship at the Jikō-ji in the Yamato area, a small temple no longer extant. That it was the main object of devotion of a temple is not surprising, for at the end of the Heian period, the Bodhisattva Jizō had emerged as an extremely popular deity. Today, of course, Jizō is among the most widely adored figures in Japanese Buddhism. His images in stone are seen in large numbers along country roads and near cemeteries. In the crowded city streets of Tokyo or Kyoto, shrines to Jizō are often seen inscribed *chōnai anzen*, (safety in the neighborhood). Jizō is thought to protect the weak, especially children. Women anticipating childbirth offer special devotions to him in hope

of safe delivery. Warriors and their families invoke his protection during battle; Jizō will also intervene on behalf of the souls of the dead who are reborn in each of the six stages of transmigration (*rokudō*). He will appear in Hell, where suffering is particularly intense (see No. 49); and also in the realms of hungry spirits, of animals, Ashuras (benevolent demons), and of mankind itself, and again in Paradise where the blessed faithful are reborn.

In his right hand here he carries a long staff, the *shakujō*. This was a standard item of monk's equipment by which they announced their presence when seeking alms and by which they frightened insects from their path as they walked. In his left hand is a small wooden staff with a jewel-shape head, the *Nyoi-hōju* (or Cintāmani in Sanskrit), emblem of the limitless power and resources by which Buddhist deities can work for the salvation of mankind. The jewel, incidentally, is divided into five layers, symbolic of the five types of wisdom in Esoteric Buddhism, the *gochi*.

Jizō's role in folk religion is remarkable, especially as he reached Japan essentially as an Esoteric Buddhist deity, without special prominence in the vast pantheon of that creed. The oldest traces of his worship in Japan are found in the Shōsō-in documents and in the record of a Jizō statue being erected in 747 in the Lecture Hall of Tōdai-ji as a subordinate figure. His Sanskrit name is Kshitigarbha, meaning Matrix of the Earth; his companion Bodhisattva is the Matrix of the Void, Kokūzō or Ākāśagarbha. They symbolize the role of these two elements in the physical and metaphysical makeup of the world. However, pre-Esoteric texts had also mentioned Jizō chiefly as a salvation deity, and he became increasingly fixed in the imagination of the common folk in both China and Japan. Tales of miraculous acts of salvation by Jizō may be read in Chinese documents found in Tun-huang and in the *Konjaku Monogatari*, a compilation of Japanese folklore made in the late Heian period.

Although the original sculptor of this statue is unknown, it is likely that it was produced in one of the Nara ateliers during the last two decades of the twelfth century. The face closely resembles, for example, that

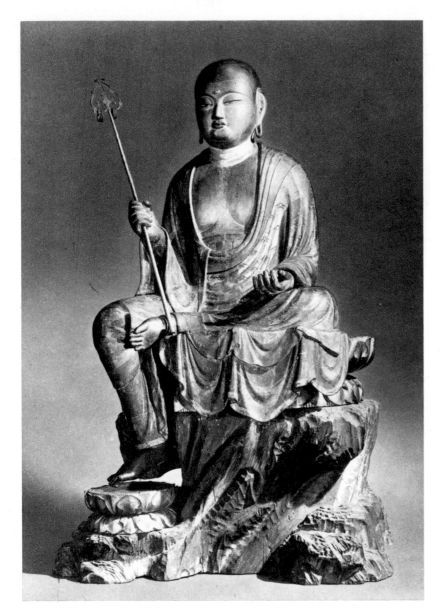

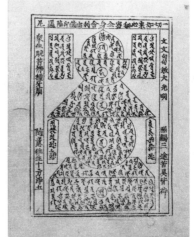

of Mañjuśrī in the Eastern Kondō of Kōfuku-ji, carved in 1196 by Jōkei, a prominent member of the Unkei school. The eyes here, however, are not inlaid with crystal; and the garment folds, realistic as they may be, have a strong, implicit geometric order. This piece should not be associated with the more adventurous or developed essays in realism by the Nara sculptors, such as the famous statue of Jizō by Kaikei in Tōdai-ji, dated 1209, because it is more conservative in spirit.

The repairs of 1655 were done by a master sculptor, Unkō, who listed himself as a disciple of Unkei. The repairs were chiefly internal; on the inside were pieces of rough wood fixed with a black pitch or tarlike substance to reinforce the joints. In 1969,

Iguchi Yasuhiro of Boston opened the statue and reglued the blocks, which had begun to shrink and separate. Inside the statue, he found a baked-clay tile, chocolate brown in color, in the shape of a *gorin-no-tō* (five-ring pagoda), with Siddham characters on the reverse and obverse faces. The script, slightly different from classical Sanskrit *devānagarī*, was used in eastern India during the ninth and tenth centuries and transmitted to China and Japan where it was preserved in Esoteric Buddhist circles. The *gorin-no-tō* itself is a characteristic pagoda form in Esoteric Buddhism, divided into five separate shapes that symbolize the five substances of which the universe is formed. At the bottom, the square element represents the earth. The

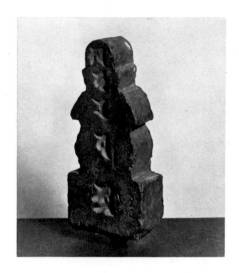
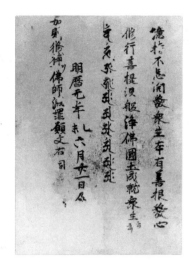
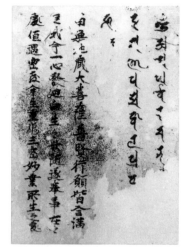

next part, which is round, symbolizes water; then a triangular shape stands for fire; a semicircle represents the air. At the top is a jewel, symbolizing the void or ether. The Sanskrit letters impressed on the sides are the *bīja* (or *shuji* in Japanese, meaning "seed letters"), which stand for the five elements. From bottom to top they read *A, Va, Ra, Ha, Kha*; the same characters appear on the reverse side with the addition of the *anusvāra* or nasal sound mark above each. The tile had originally been fixed upright in the center of the wooden bottom plate of the statue.

Also found inside the statue were approximately fifty sheets of paper bearing an identical wood-block print; they had been fused together, and, in many cases, damaged by insects. The main element of the block print design is the same *gorin-no-tō* as found in the tile, and large circles in the center of each element hold the same Sanskrit *shuji* (seed letters). Around these are other Sanskrit characters representing *dhāranī*, which are auspicious sounds to be recited in prayer. Along three of the borders are written prayers in Chinese. The one at the top reads, "The minds of all Buddhas are a mystic secret; their entire bodies are relics; the *Hōkyōin-darani* [one of three ritual formulas recited daily by devotees of the Esoteric sects] [brings safety and solace to the living and the dead]." On the right, the text reads, "The sentences and phrases [of the holy texts] give off great light; they illumine the three lowest stages of rebirth and destroy completely the suffering that attends them." The text to the left reads, "In sentient beings who are liberated from suffering, the seeds of Buddhahood shall sprout; through their own will [they shall] be reborn in the Pure Lands of the Ten Directions."

Included also among the objects found inside the statue are two manuscript pages which record the prayers and circumstances of the rededication. They begin with two lines of *dhāranī* written in Siddham characters, then the statement in Chinese characters: "Homage to the great Bodhisattva Jizō and to Fugen, [whose religious] deeds and vows have been completely fulfilled. I have now earnestly produced the spirit of merit-transference [to be] transmitted for generations of rebirths; I shall serve wherever I may be. I have encountered Esoteric teachings in this life and practice the lofty discipline of the Three Mysteries in this realm of existence to which I was born. I shall hold in my thoughts and shall not forget [my religious mission] to develop the roots of virtue inherent in all living beings. I shall produce a pious mind and practice religious austerities that I may attain Enlightenment, Nirvāna, the Pure Buddha-land, and [aid] sentient beings to attain perfection, and so forth."

Then follows a line of Siddham characters, and then two lines of Chinese: "On the twenty-first day of the sixth month of the founding year of the Meireki era [1655]. . . . This is a prayer that eradicates the sins of the sculptor who repaired this statue." The name, Unkō, is lost here but was recorded on the wooden plate that closed the inner aperture.

Published: Kuno Takeshi. *Kantō Chōkoku no Kenkyū*. Tokyo. 1964. Pp. 327–328; Kuno Takeshi in *Kobijutsu*, no. 5. (August 1964).

Reference: M. W. de Visser. "The Bodhisattva Ti-tsang (Jizō) in China and Japan," *Ostasiatische Zeitschrift*, II (1913), pp. 179–198, 266–305, 393–401; ibid., III (1914), pp. 61–92, 209–242; Manabe Kōsai. *Jizō Bosatsu no Kenkyū*. Kyoto, 1960.

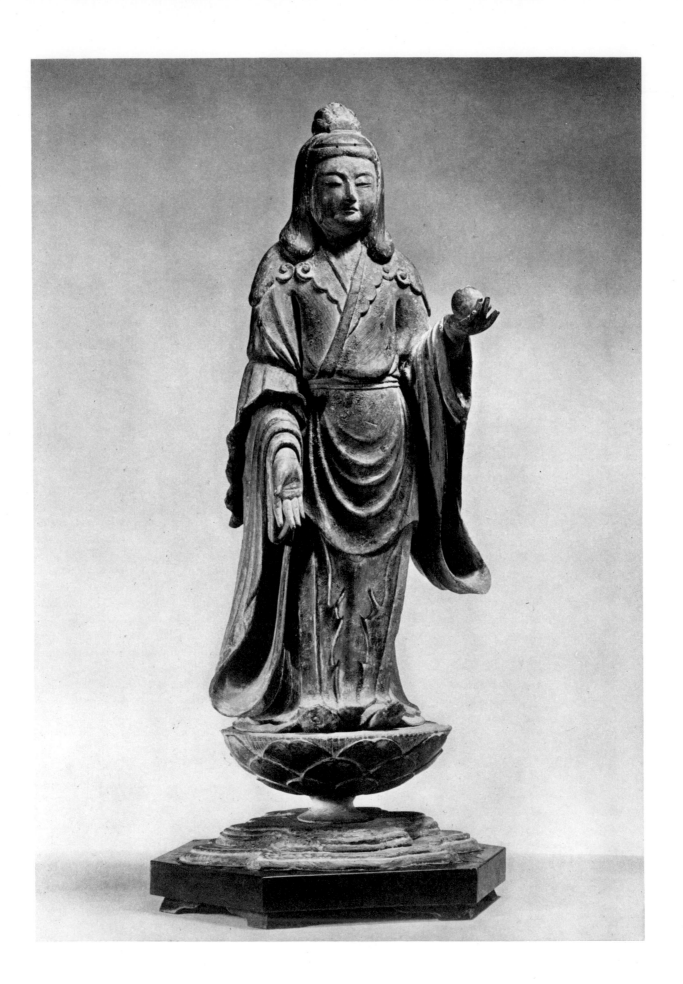

38. Kichijō-ten (Śrī-lakshmī)

Early Kamakura period (ca. 1200–1225)
Cypress wood, with traces of gesso and pigment; eyes made of glass
H. of figure 11 3/4 in. (29.8 cm.); H. with base 14 1/4 in. (36.2 cm.)

This delicate wooden image of the Goddess of Wealth and Beauty is one of a large number of small-scale votive statues produced in the early decades of the thirteenth century. This one, like the others, was originally painted and adorned with metal ornaments (holes for a metal crown can be seen over her forehead); and she was made to appear as lifelike as possible. The most famous and extravagantly ornate example of this kind is the statue of Kichijō-ten at Jōruri-ji in the hills above Nara, which was dedicated in 1212.

This statue seems close in style to the work of Tankei, son of Unkei and head of the Kyoto branch of the Kei school. He directed the vast sculptural works for the Renge-ō-in (Sanjūsangen-dō) in Kyoto—the thousand-and-one statues of Kannon and the twenty-eight attendant deities in the rear. He also carved small votive images like this one, especially a pair of standing Shintō deities at the commission of Myōe Shōnin, the revered abbot of Kōzan-ji, around 1225. This figure is not nearly as naturalistic as the Kōzan-ji ones, nor is it quite so thin and fragile; but the analogies in scale and spirit are striking.

The goddess stands with her right hand in the gesture of donation; the jewel in her left hand is the *Nyoi-hōju* (Cintāmani), the emblem of her possessing the power and means to aid her devotees. Kichijō-ten originated in India in ancient times where she was known by two names, Śrī and Lakshmī, and was worshiped widely by those seeking abundant wealth and beauty. She was also given a role as the embodiment of the good fortune and success of a ruling house, and she was considered the consort of the Hindu deity Vishnu. The cult of Śrī-lakshmī was absorbed into Buddhism and reached Japan from China as early as the eighth century. Courtiers of Nara were especially devoted to her. And to this day at Yakushi-ji, a ceremony has been preserved in which a fragile eighth-century painting of the goddess is exhibited for brief periods twice a year as citizens come before it to repent their failings and misdeeds. This statue within its own small shrine must also have served as the object of such a ritual.

The statue was made by the assembled wood-block method and is hollow inside. Tiny glass eyes were affixed inside the head. The lotus pedestal seems to be the original one.

Reference: Mōri Hisashi. *Unkei to Kamakura Chōkoku.* Nihon no Bijutsu, vol. 11. Tokyo, 1964. Pp. 64–67.

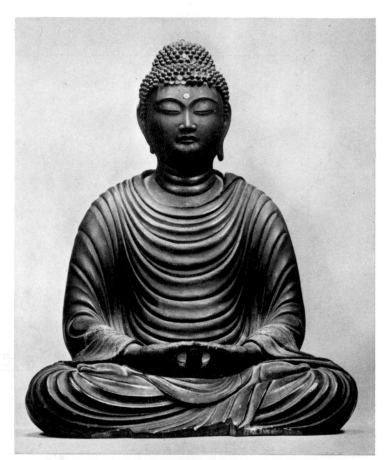

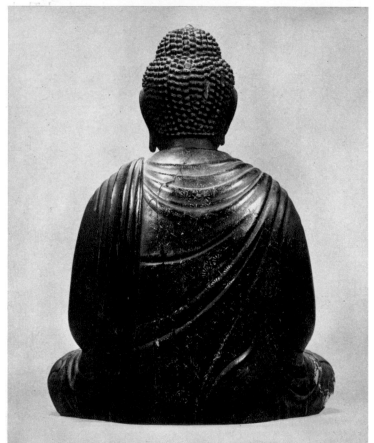

39. Seated Amitābha (Amida)

Kamakura period (thirteenth century)
Wood lightly lacquered, with cut gold (kirikane) *ornament; inlaid glass eyes and* urna
H. 12 1/2 in. (31.8 cm.)

An attempt to reconcile two conflicting formal principles is seen in this unusual statue, which is probably an experimental essay by a thirteenth-century sculptor. The strict symmetry and geometric order of the garment folds contrast markedly with the suggested softness of the robes and the fleshiness of the Buddha's face.

The symmetry, rigid frontality, and use of cut gold decoration (still visible on the back) must have been inspired by the celebrated statue of Chinese origin in Seiryō-ji in the Saga district west of Kyoto (see No. 28). It had been made in 985 at the Kai-yüan-ssu monastery in Shensi at the request of the Japanese pilgrim monk Chōnen, who wished a replica of a celebrated Indian statue there; he returned to Japan with the new statue two years later. In India, such images are known as the Udayana type, based on a group of legends dating back to the early centuries of the Christian era. These state that King Udayana of Kauśāmbī had his sculptor miraculously sent to the Paradise of the Thirty-three Devas to make a true image of the Buddha, who had gone there for three months to preach to his mother. Upon his return to earth, the Blessed One approved this image, made of precious sandalwood, as a suitable replica of himself. And at Kauśāmbī such a statue was kept for centuries and seen and copied by Chinese pilgrims. Images in this style, both seated and standing, are recognizable by the stern frontality of the posture and the symmetrical garment that covers both shoulders, and by the pronounced geometric pattern of folds, which often resemble flat bands.

During the thirteenth century, many replicas of the Seiryō-ji statue were made in Japan. The evangelical monk Eison of Saidai-ji ordered one in 1249. Another was made for Tōshōdai-ji around 1258, and at the time of the dedication, ten thousand persons offered donations to the temple. Indeed, like the imagery of Prince Shōtoku (see No. 50), these Udayana type statues played a prominent role in the movement to enlist the resources of the common people in the support of the Buddhist faith. A disciple of Eison, the monk Ninshō, seems to have brought enthusiasm for this kind of image to the Kantō area, for a fine example is enshrined at Gokuraku-ji, which he founded in Kamakura. Others are in Shimpuku-ji and Shōmyō-ji, both in Kamakura; the latter is dated 1308.

This figure is a rather free adaptation of the type; the surface of the wood is not left bare, as in the precise replicas of the Seiryō-ji statue, but is coated with lacquer. Moreover, the sculptor made no effort to retain the archaistic linear method of depicting the folds of the robe and the facial features. The face here is quite similar to those seen in the work of the Kei school in Kyoto during the second quarter of the thirteenth century. And, on the back, the sculptor abandoned completely the geometric formulas of the front and modeled the folds with unobtrusive realism. The *kirikane* pattern, however, is very much in the manner of the replicas of the Seiryō-ji Shaka statue, and the entire image may have been an effort to adapt a sacred type used exclusively for Śākyamuni to represent Amitābha, shown here in the position of deep meditation, the Midajō-in.

Published: Ishida Mosaku. *Bukkyō Bijutsu no Kihon*. Tokyo, 1967. P. 283.
Reference: Itō Nobuo and Kobayashi Takeshi. *Chūsei Jiin to Kamakura no Chōkoku*. Genshoku Nihon no Bijutsu, vol. 9. Tokyo, 1968. Pls. 43, 44; Asahi Shimbun, ed. *Kamakura no Bijutsu*. Tokyo, 1958. Nos. 138, 153; Miyama Susumu. *Kamakura no Chōkoku*. Tokyo, 1966. Pls. 52–56; Harold Ingholt. *Gandhāra Sculpture in Pakistan*. New York, 1957. No. 125; Benjamin Rowland, Jr. "A Note on the Invention of the Buddha Image," *Harvard Journal of Asiatic Studies*, vol. XI (1948), pp. 181ff; Alexander C. Soper. *Literary Evidence for Early Buddhist Art in China*. Ascona, 1959. Pp. 259–265.

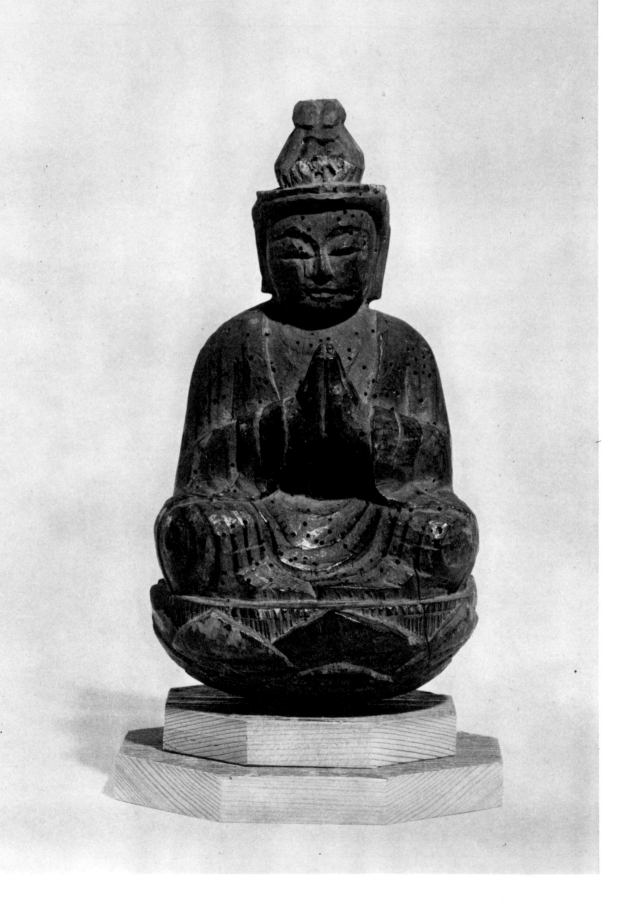

40. Seated Kannon in a gesture of prayer

Dated 1250 (Kamakura period)
Cedar, painted black over hair and eyebrows
Figure and lotus pedestal: H. 5 3/4 in. (14.6 cm.)

This tiny, humble image may well have been carved to fulfill a personal vow of the sculptor to make a large number of images of Kannon, perhaps as an act of repentance. His name was inscribed on the underside of the figure, along with the date 1250, but the name is no longer legible. The figure is done broadly and simply, as though it is roughed in, awaiting the final finish; the only detailed work is the vertical fluting on the lotus bud. For this reason, it reveals with unusual clarity the basic skill of the sculptor, his mastery of proportion and gesture and harmony of parts. The inscription seems entirely trustworthy, but if it were not, virtually the same date for the piece would be established by comparison with the small halo figures of the standing Śākyamuni image in Saidai-ji, dedicated in 1249 and copied from the famous Chinese image in Seiryō-ji, Kyoto.

Reference: Itō Nobuo and Kobayashi Takeshi. *Chūsei Jiin to Kamakura Chōkoku.* Genshoku Nihon no Bijutsu, vol. 9. Tokyo, 1968. Pl. 43.

41. Vaiśravana (Bishamon-ten) and Virūpākṣa (Kōmoku-ten)

Kamakura period (thirteenth century)
Section of a hand scroll mounted as a kakemono; ink on paper
H. 11 × 16 1/4 in. (27.9 × 41.2 cm.)

This is a small section from a very old copy of the *Besson Zakki* ("Notes of the Various Objects of Reverence"). An enormous encyclopedia of Buddhist liturgy and iconography, it was completed in the 1160s by the Ācārya Shinkaku and what must have been a large team of assistants. However, additions were made well after Shinkaku's death, which took place in 1180 or 1181.

Shinkaku was originally a Tendai monk but was converted to the Shingon creed by Chinkai (see No. 31) and others. After a period of twenty-five years in which he underwent great austerities in a remote mountain hermitage on Mount Kōmyō, he was received at the Shingon sanctuary on Mount Kōya in an exalted baptismal ceremony. There, dwelling in various subtemples, he remained for the rest of his life.

The list of Shinkaku's writings on iconography and liturgy is extremely long. The *Besson Zakki*, comprising a total of fifty-seven scroll-volumes, is his most famous work, but, in fact, is essentially a compendium of much older lore. The section from which this drawing was copied deals with the Four Divine Kings (Shitennō), the prayers and *dhāranī* that are addressed to them, and the types of incense to be burned before them. There are descriptions of famous statues, including the large ones in dry lacquer (now lost) that once flanked the Nara Daibutsu, and also of the Four Divine Kings (still extant) in the Lecture Hall of Tō-ji, Kyoto. There are also drawings of the lost statues of the Four Divine Kings in the chief temple devoted to their worship, the Shitennō-ji, Osaka. These two images are from a set of four that, unfortunately, are not identified. They could well have been paintings rather than statues, for they are conceived in an essentially pictorial manner.

The oldest extant version of the *Besson Zakki* is kept today in Ninna-ji, west of Kyoto. While reputed to be the original one, it may be a very early copy; two other complete versions are in Tō-ji. The date of this drawing is difficult to determine. It is very faithful in detail to the Ninna-ji version, differing only in the character of the line, which here is more calligraphic and structured. Sharply defined "nail-head" touches begin many of the brushstrokes and relate this drawing to the many narrative and iconographic scrolls from Kōzan-ji in the 1220s and 1230s.

The inscription at the right is a later addition, reading "Bishamon [and his] Five Princely Attendants" and listing the five by name.

Reference: *Taishō Shinshū Daizōkyō Zuzō*, vol. III. Tokyo, 1932. Pp. 577–578; Takata Osamu and Yanagisawa Taka. *Butsu-ga*. Genshoku Nihon no Bijutsu, vol. 7. Tokyo, 1969. Fig. 110.

為震動出大音聲令
時音釋聞地動響心
大獄喜雨目聞明骨
見先佛有此瑞應作
是念已從地涌出礼
菩薩是時有五百青
雀飛騰虛空谷繞菩
薩雜色瑞雲及以音
風而隨映佛今時音
靜以偈讚曰
菩薩足蹈亂地皆六種動
發大深遠音我聞眼開明
又見虛空中青雀繞菩薩
瑞雲煥鮮映香風甚清涼
此等諸瑞相悉同過去佛
以文知菩薩必定成已覺
於是菩薩即自思惟
過去諸佛以何為生
咸无上道即便自知

42. Śākyamuni before his Enlightenment; from an illustrated *Sūtra of Cause and Effect, Past and Present*

Kamakura period (last half of the thirteenth century)
Section of a hand scroll mounted as a kakemono; ink and color on paper
H. 10 1/2 × 15 3/4 in. (26.7 × 40 cm.)

This section and the one pictured in the next entry (No. 43) once belonged to the same scroll, a Kamakura period version of the sacred *Kako-genzai-inga-kyō* (see No. 11). That text, which recounted the life of Śākyamuni in this and one preceding existence, had been introduced to Japan from China, probably during the eighth century, when it was copied many times. During the Heian period, the *Inga-kyō* seems to have excited less interest; only two versions are known from that long era. But during the thirteenth century, during the great revival of the Nara temples and their arts, many new sets of the *Inga-kyō* were made.

This painting comes from the fifth scroll of a set of eight, and it treats of the events just preceding the Illumination of Śākyamuni. The prince is shown walking toward a clump of trees, and, as the text describes it, the earth is quaking in anticipation of his Enlightenment. Next he is shown with blue sparrows, five hundred according to the legend, circling his head in joy, while a perfumed wind is blowing. A sightless Nāgarāja regains his vision and kneels in thanks. The outcropping of rock at the left belongs properly to the next scene, where the Bodhisattva is shown half cross-legged in meditation in a mountain landscape, affirming his vow to attain Enlightenment for the sake of mankind.

Precisely the same scenes are in the eighth-century version of the *Inga-kyō* now in the collection of the Hōon-in, a subtemple of Daigo-ji near Kyoto. It is instructive to compare such examples of earlier and later treatments. These later copies, for instance, are as faithful to their eighth-century model as the models are to their Chinese prototypes, especially in composition and narrative method. However, thirteenth-century brush handling techniques dominate these later scrolls, in the rapidly painted outlines, the thin watercolorlike washes, and the chiaroscuro in the rock formations. In addition, the great advances made over archaic atmospheric and linear perspective were not to be denied, and the later scrolls are instinctively more realistic and dramatic in their narrative content. At the same time, they have lost completely the innocence, the composure, and the reserve of their ancient models.

This section is from the scroll that was once in the possession of the Matsunaga family; a virtually identical version is in the Shōri-ji, a temple in the Nagoya area. The two scrolls are so similar that one must have been copied from the other, or else from a common model of the same period now lost. Of the two, however, the Matsunaga scroll seems to be the older. Tanaka Ichimatsu estimates that it was done in the last half of the thirteenth century by a conservative, archaistic Buddhist painter who nonetheless was subject to the same contemporary influences from the mainland that had affected artists of such narrative scrolls as the *Kegon Engi*.

Formerly in the Matsunaga collection.
Published: Tanaka Ichimatsu in Kameda Tsutomu et al., *E-inga-kyō*. Nihon Emakimono Zenshū, vol. XVI. Tokyo, 1969. Pp. 62–64.

令者欲亂定意非清
淨心令更可去五不
相續時三天女變成
老姥頭自面皺齒落
垂延肉消骨立腹大
如鼓柱杖羸尒不眂
自復魔王既見如是
堅固心自思惟我昔
曾於雪山之中射摩
髑頭羅即便恐懼退
其善心而令不辭動

43. The daughters of Māra transformed into hags; from an illustrated *Sūtra of Cause and Effect, Past and Present*

Kamakura period (last half of the thirteenth century)
Section of a hand scroll mounted as a kakemono; ink and color on paper
H. 10 7/8 × 9 in. (27.6 × 22.9 cm.)

From the legendary biography of the Buddha just before his Enlightenment, this scene follows the preceding entry (No. 42) by eight events. In those, the Buddha-to-be has taken up his position of meditation, sitting on the sacred grass that was cut for him by Indra in disguise. Then Māra, the antagonist of Śākyamuni and the embodiment of evil, threatens him by ordering an arrow to be shot, which misses Śākyamuni and lands in a tree. Māra then sends his three beautiful daughters, dressed like Chinese court women, to distract the Bodhisattva. This tactic also fails, and the women are transformed into the ugly creatures shown here. The text beneath describes them as having pallid, wrinkled faces, falling teeth, sagging flesh with weakened bones, unable to walk without the support of a staff.

Their cruelly contorted faces show clearly the effects of the current of brutality that surged through popular Buddhist arts in the early middle ages (see No. 49). In the eighth-century version of this episode (in the Hōon-in scroll), the women are far less grotesque; and the rocks to the right are a modest device to divide the scene and are capped by tiny fernlike trees. Here the rocks have become a broad, flat plateau conceived clearly in three dimensions, and a sense of deep spacial recession extends behind the three hags.

The calligraphy style of the text below this section, and in No. 42, was also modeled on that of the Nara period, but the inner structure of the characters is remarkably more flaccid. The disciplined restraint of the classic T'ang style is no longer in effect.

Formerly in the Matsunaga collection.
Published: Tanaka Ichimatsu in Kameda Tsutomu et al., *E-inga-kyō*. Nihon Emakimono Zenshū, vol. XVI. Tokyo, 1969. Pp. 62–64.

44. Youthful Mañjuśrī (Monju) seated on his lion

Kamakura period (ca. 1300)
Hanging scroll; colors and cut gold (kirikane) *on silk*
H. 46 1/2 × 24 1/8 in. (118.1 × 61.3 cm.)

Mañjuśrī, the eternally youthful Bodhisattva, the embodiment of the wisdom of Mahāyāna Buddhism, here sits upon his striding lion with gold and blue-green fur. In Mañjuśrī's right hand is the sword with which he cleaves the clouds of ignorance; in his left is the stalk of the lotus blossom that supports a sūtra book, his emblem as Lord of Wisdom. He sits in the relaxed position familiar in Indian art, the *lalitāsana*, his right leg drawn up onto his seat, his left leg pendant, the foot resting on an ornate lotus pedestal.

This painting depicts an apparition of the Bodhisattva, rising above the clouds. The legends of the popular cult of Mañjuśrī repeat constantly how, in one guise or another, the Bodhisattva would reveal himself in response to the prayers of a devotee (see No. 64). The chief center of his worship in East Asia was the sanctuary atop the Five Pedestal Mountain (Wu-t'ai Shan) in Shansi Province, southwest of Peking. Pilgrims from throughout the Buddhist world would undergo great hardships to come to worship his images and pray for an appearance of the Bodhisattva "... in his dazzling brightness ... with his jadelike countenance, seated on his lion..." The images themselves were said to be faithful copies of the visions granted to the artists and monks.

This work belongs to a relatively large group of Japanese paintings of Mañjuśrī done in the thirteenth century, during the revival of the older forms of Mahāyānism. The center of that movement was the Nara region, whose monasteries were refurbished and reactivated by monks like Shunjōbō Chōgen of Tōdai-ji and Eison of Saidai-ji. Eison, for example, had images of Mañjuśrī installed in the two jails of Nara, and he held services before them for the sake of the souls of the prisoners. Early in the century, the monk Keinin of the Miwa Byōdō-ji rebuilt the Monju-in at Abe, near Sakurai city, where Mañjuśrī was said to have revealed himself; still remaining today is the giant wooden image of the Bodhisattva seated on his lion, one of the major works of the sculptor Kaikei (see No. 36).

The most celebrated painting of Mañjuśrī is preserved in the Kōdai-in of Daigo-ji, Kyoto, showing the Bodhisattva seated on his lion and accompanied by an entourage of four other figures. Called the Tokai (Sea-Crossing) Monju, it has been traditionally attributed to the monk Chinkai (see No. 31), who died in 1152. Chinkai may well have done an earlier version, but the Kōdai-in painting dates from the mid-thirteenth century and must be considered the main prototype for the Powers painting and the numerous others which resemble it. These paintings all have a strong Chinese flavor in the highly detailed drawing of the lion, the emphatic use of calligraphic ink outlines, and the color schemes of the rich dark reds and greens, which are heavier and more ornate than those favored by the Japanese during the Heian period.

The childlike roundness of the face and body of Mañjuśrī in this painting is a clear reflection of the tendency of the time to depict Buddhist deities as children (see No. 50). Somewhat earlier versions of the motif, the Kōdai-in painting or one in the Hōjū-in of Mount Kōya, show the Bodhisattva more upright and slender, less like an infant in his proportions. A date around 1300 for this painting is sanctioned by the severe geometry of the halo around the entire body and the one around the head; the cloud forms are extremely rigid and schematized, with strong contrasts of light and dark. There are many areas of cut gold (*kirikane*), which enhance the ornamental qualities of the work.

Published: Noma Seiroku in *Kobijutsu*, no. 11 (November 1965).
Reference: E. O. Reischauer. *Ennin's Diary*. New York, 1955. Pp. 226–266; Kōdansha, ed. *Kōya-san*. Hihō, vol. IV. Tokyo, 1966. Pl. 37.

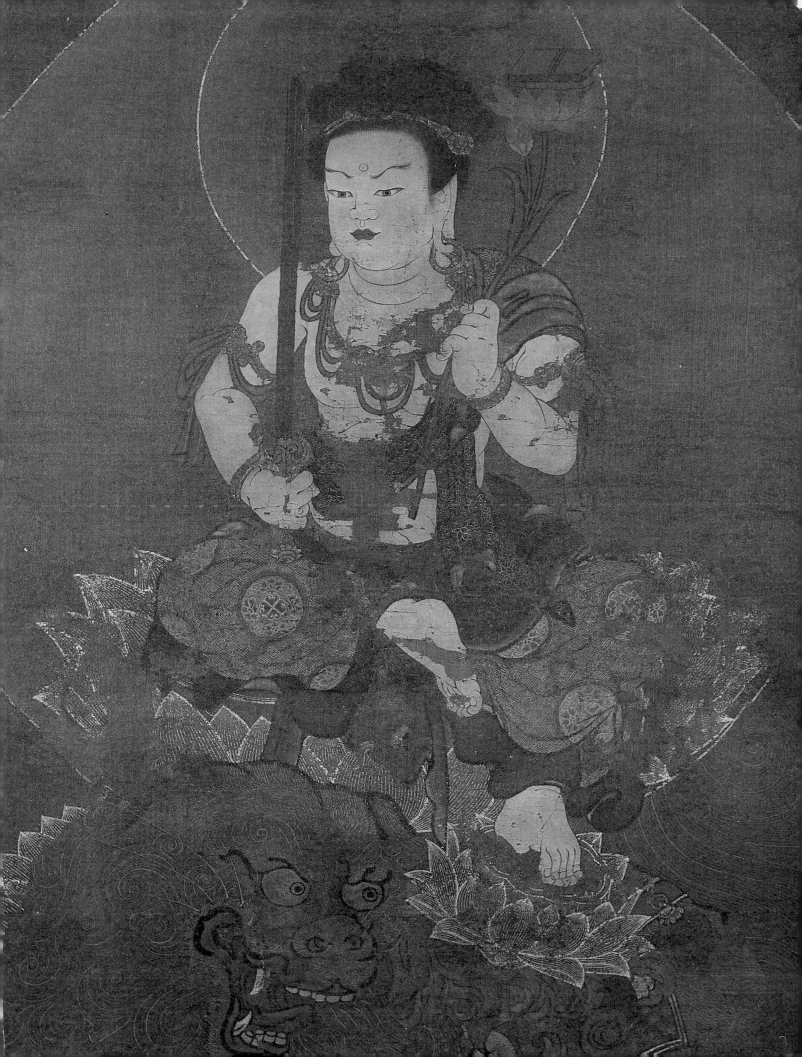

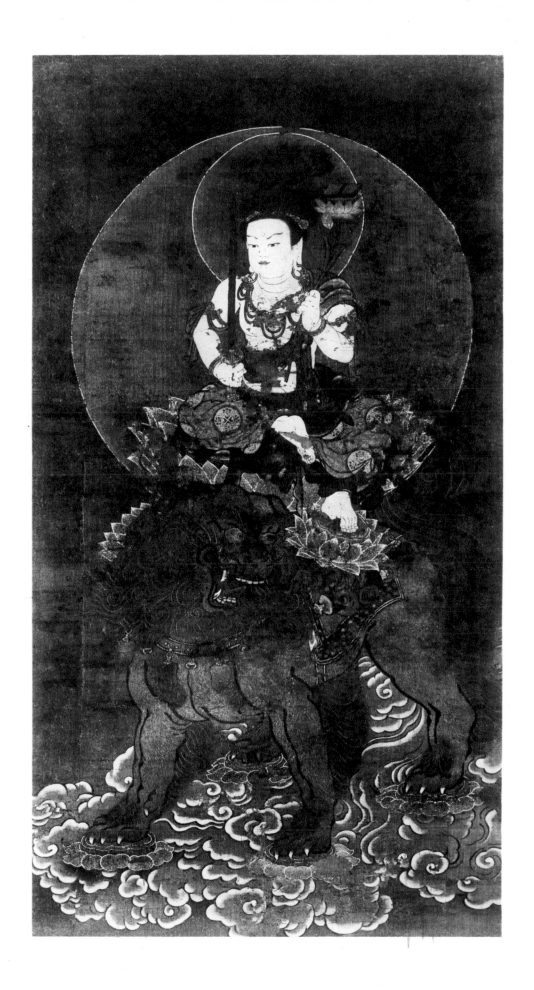

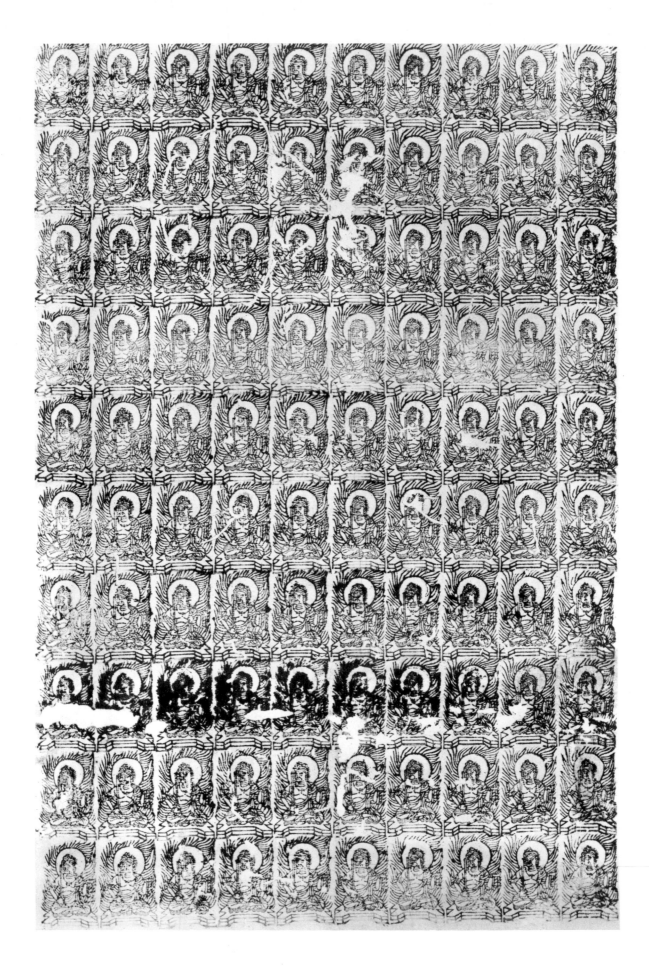

45. One hundred stamped images of Acala (Fudō)

Kamakura period (thirteenth century)
Ink on thin paper
H. 17 3/8 × 11 1/8 in. (42 × 28.2 cm.)

Overcrowded, pulsating with bristling energy, this sheet of one hundred tiny stamped images of Fudō is typical of those found inside Buddhist statues of the thirteenth century. Fudō, the Immovable One, is the most commonly depicted of the Esoteric Buddhist deities of the class of Vidyārājas, or Bright Kings (Myō-ō). These raging figures symbolize the ferocious energy of the Tathāgatas, their power to repel enemies and withstand temptations and to direct great physical and spiritual forces toward proper ends (see No. 19). Fudō sits here atop a stepped pedestal, representing a rocky crag. Like Mañjuśrī, he holds a sword in his right hand (see No. 44); in his left is the noose that he extends to those seeking his aid. Behind him is a swirling flame halo.

This set of one hundred images was made by two stamps, each having two almost identical images. There is no inscription or other data accompanying this sheet.

妙法蓮華經如來神力品第廿

尒時千世界微塵等菩薩摩訶薩從地涌出
者皆於佛前一心合掌瞻仰尊顏而白佛言
世尊我等於佛滅後世尊分身所在國土滅
度之處當廣說此經所以者何我等亦自欲
得是真淨大法受持讀誦解說書寫而供養
之尒時世尊於文殊師利等無量百千万億
舊住娑婆世界菩薩摩訶薩及諸比丘比丘
尼優婆塞優婆夷天龍夜叉乾闥婆阿脩羅
迦樓羅緊那羅摩睺羅伽人非人等一切眾
前現大神力出廣長舌上至梵世一切毛孔
放於無量無數色光皆悉遍照十方世界眾
寶樹下師子座上諸佛亦復如是出廣長舌
放於無量光釋迦牟尼佛及寶樹下諸佛現神
力時滿百千歲然後還攝舌相一時謦欬俱
共彈指是二音聲遍至十方諸佛世界地皆

46. Printed scroll of the *Lotus Sūtra*

Kamakura period (late thirteenth century)
Hand scroll; black ink, red paint, and gold and silver leaf on paper
H. 10 7/8 in. (27.6 cm.)

The sturdy, well-balanced structure of the printed characters belongs to the distinctive script style of the professional sūtra copyists active in Nara from the late twelfth century and well into the fourteenth. Bold and clearly printed, this style of writing is in close accord with the religious atmosphere of the new Buddhist sects that had risen in Japan during that period.

Of the religious reform movements of the early middle ages, the Pure Land creeds had penetrated most deeply into the untutored lower classes of Japanese society. With their easily understood and practical tenets, these creeds became the religion of the populace; consequently, there arose a greater demand for Buddhist scriptures than ever before. At the same time, printed editions of Buddhist scriptures were imported from Sung China, stimulating the Japanese to produce printed scriptures of their own in ever-increasing quantities. The printing of sūtras on a large scale had begun in China as early as the ninth century. The Japanese practiced it in the Heian period, but it became more common only when the Buddhist faith had become deeply rooted among the general public. Remarkably, the printing of Buddhist scriptures in Japan thrived in the Nara region, the home base of the old Buddhist sects. The Nara printing specialists retained their own independent style even after a handful of Chinese woodblock engravers and printers had arrived in Japan and influenced local printing with Sung and Yüan techniques.

The printed title of this scroll is that of the twenty-first chapter of the *Lotus Sūtra*, "The Divine Power of the Tathāgatas" ("Nyorai Jinrikibon"). This chapter falls within the seventh volume of the sūtra; however, the cover page of this scroll is labeled "Lotus Sūtra, Volume Three." This indicates that the scroll must have undergone alteration in the past. Probably it was originally a hand scroll as it is now, subsequently remounted as an *ori-hon*, a book accordian-folded for convenience in reading, and still later restored to its original scroll form. The present cover is likely to have been given to the scroll by mistake when it resumed its original form. The current backing paper, which is heavily but monotonously decorated with small squares of silver leaf, must have been put on during the last restoration. Both the text and cover have been cut down to about two-thirds of the original width.

The upper and lower margins are decorated with irregularly shaped cloud patterns done in such designs as *komasu* (small squares), *sunago* (sand), and *noge* (small rectangles), all cut from gold and silver leaf. The ornamental scheme relies on the traditional sūtra decorations of the twelfth century; compared with the elegant works of that period, the decorative elements here are more densely applied and lack variation in the distribution of patterns and in the rhythm of their spatial arrangement. Completely absent here are the illusionistic spatial effects seen in the Heian works. In those there is a contrast in the dense and sparse distribution of gold and silver leaf patterns and a contrast between the color of the paper and the silver and gold.

On the cover of this piece are patterns of mist and clouds rendered in silver and gold leaf and dust. Unlike the purely ornamental forms in the marginal spaces, these patterns have representational features that suggest the movement of a soft, trailing mist. Such use of gold or silver leaf for decoration was a new scheme, current from the late thirteenth to the early fourteenth centuries, applied mainly to sūtra covers. In this example, patterns of irregular round shapes were laid all over the surface and then mist was painted over them in gold paint. The art of decoration that combined abstract designs with the most simplified representational forms by the use of gold and silver alone continued throughout the Muromachi period. But gradually, the abstract patterns gave way to more representational forms, and the tradition of this art rose to its highest level in the thoroughly new style of painting in gold and silver of high aesthetic quality by the masterly hand of Sōtatsu. (see Nos. 105, 106).

又舍利弗極樂國土七重欄楯七重羅網七重
行樹皆是四寶周匝圍繞是故彼國名曰極樂
又舍利弗極樂國土有七寶池八功德水充滿
其中池底純以金沙布地四邊階道金銀琉璃
玻璃合成上有樓閣亦以金銀琉璃玻璃硨磲
赤珠碼碯而嚴飾之池中蓮華大如車輪青色
青光黃色黃光赤色赤光白色白光微妙香潔
舍利弗極樂國土成就如是功德莊嚴
復次舍利弗彼佛國土常作天樂黃金為地晝
夜六時雨天曼陀羅華其土眾生常以清旦各
以衣裓盛眾妙華供養他方十萬億佛即以食
時還到本國飯食經行舍利弗極樂國土成就
如是功德莊嚴
復次舍利弗彼國常有種種奇妙雜色之鳥
白鶴孔雀鸚鵡舍利迦陵頻伽共命之鳥是諸
眾鳥晝夜六時出和雅音其音演暢五根
五力七菩提分八聖道分如是等法其土眾生
聞是音已皆悉念佛念法念僧舍利弗汝
勿謂此鳥實是罪報所生所以者何彼佛國
土無三惡道舍利弗其佛國土尚無惡道
之名何況有實是諸眾鳥皆是阿彌陀佛欲
令法音宣流變化所作舍利弗彼佛國土微

風吹動諸寶行樹及寶羅網出微妙音譬如
百千種樂同時俱作聞是音者自然皆生念
佛念法念僧之心舍利弗其佛國土成就如
是功德莊嚴
舍利弗於汝意云何彼佛何故號阿彌陀舍
利弗彼佛光明無量照十方國無所障礙是
故號為阿彌陀又舍利弗彼佛壽命及其人
民無量無邊阿僧祇劫故名阿彌陀舍利弗
阿彌陀佛成佛已來於今十劫又舍利弗彼
佛有無量無邊聲聞弟子皆阿羅漢非是算
數之所能知諸菩薩眾亦復如是舍利弗彼
佛國土成就如是功德莊嚴

47. Section of embroidered sūtra, the *Sukhāvatī-vyūha (Amida-kyō)*

Kamakura period (late thirteenth century)
Section of a hand scroll mounted as a kakemono; printed ink and gold on colored silk, with colored embroidery
H. 12 1/8 × 19 3/8 in. (30.7 × 49.2 cm.)

The shorter *Sukhāvatī-vyūha* (literally, the Assemblage of the Land of Bliss), a sūtra of just one chapter, is one of the essential scriptures of the Pure Land creed in China and Japan. The sūtra elucidates the vow made by the compassionate Amitābha. He promises to protect and save those who believe in him and who meditate on him by welcoming them into his Pure Land of Extreme Pleasure in the West. It describes the joy of those reborn in Paradise at receiving his teaching, which leads them to attain Nirvāna. Composed in India, the sūtra was first translated into Chinese by the celebrated Central Asian missionary Kumārajīva from Kutcha in 402; it was also rendered into Chinese by Hsüan-tsang in 650, but under a different title. In Japan, it came to be known as the *Amida-kyō (Amitābha-sūtra)* and was included among the Three Sūtras of the Pure Land upon which are based the doctrines of the Jōdo and Jōdo Shin sects, the exclusive and absolute faith in Amida.

This is a fragment on two pieces of silk near the beginning of a decorated hand scroll of the *Amida-kyō*; the piece of silk on the right is a deep green, that on the left, a pale yellow. The original scroll was probably about five times as long and very likely was made of five pieces of silk in varying colors. Silk is an exceptional material for copying sūtras on and was probably chosen for the purpose of decoration by embroidery. The text was first printed; then rule lines were drawn in gold. The design of the lotus flowers and water was added, and embroidery was applied over the printed text and most of the floating lotus petals. In other examples of this technique, the embroidered characters change in color from one to the other or from line to line. There is no immediate clue to the exact dating of this work, but the calligraphic style of the printed text is very close to that of Buddhist scriptures printed in the Nara area late in the thirteenth century, the so-called Kasuga editions (see No. 46). The stylistic features of the pictorial design also point to this date.

Numerous manuscripts of this sūtra, decorated or undecorated, were made by ardent believers in Amida. Those embellished with embroidery are extremely rare, the work probably having been done by lay women or nuns as an act of personal piety. The Japanese art of ornamenting sūtra scrolls had reached an apex of accomplishment and technical sophistication in the twelfth century. It is best represented by two sets of exquisitely embellished scrolls of the *Lotus Sūtra*, those from the Kunō-ji temple now in the Tesshū-ji and Mutō collections and those presented to the Itsukushima Shrine in 1164 by the Taira family (or Heike). In the latter work, the motif of a lotus pond and drifting lotus petals was deployed on some of the covers, frontispiece illustrations, and along the margins above and below the text. The present scroll doubtlessly inherited the lotus design from such classical prototypes as the Taira family scrolls, but there are marked differences in both technique and conception in works separated by over a century. In the Heike scrolls, for instance, lotus petals are painted in a melodic arrangement and drift in an illusionistic space created by cloudlike clusters of tiny pieces of gold and silver leaf scattered in a random way in varying shapes and density on colored paper. In this fragment, the lotus pond is represented more naturalistically, the petals scattered with little rhythmic effect, lacking the evocative sense of space and lyrical mood. The brushwork here is not strong, and the symbolic meaning of the motif has been reduced by the addition of reeds and grasses, a sign of influence from Sung China. Such stylistic differences reflect the sweeping changes in all spheres of the political, social, and cultural life of Japan in the radical change from the order of the Heian aristocracy to that of Kamakura feudalism. (S. S.)

Reference: Nara National Museum, ed. *Shūbutsu.* Tokyo, 1964. No. 110.

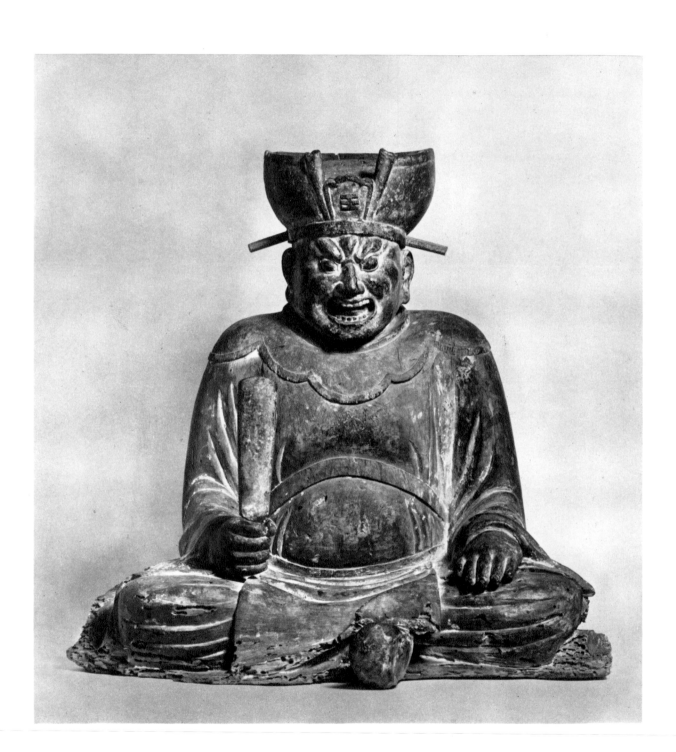

48. Seated Yama Rāja (Emma-ō)

Kamakura period (early thirteenth century)
Wood, with traces of gesso
H. 16 1/8 × 15 in. (41 × 38 cm.)

It is likely that this menacing figure was the center of an altar group forming the tribunal of the Ten Kings of Hell, a symbolic theme that played an important role in the popular Buddhism of the Japanese middle ages (see No. 49). Most familiar to students and travelers today is the set of figures carved in 1251 and installed in the Ennō-ji, Kamakura, across from the main gate of the Zen monastery of Kenchō-ji. There, in the darkened hall, the nearly life-sized group of the kings and their demonic attendants creates a threatening, ominous atmosphere. Those images were carved in a manner strongly influenced by the baroque, massive spirit of Chinese Sung sculpture and were once brightly colored; they must have created a great sense of fear of the ruthless justice and penalties decided by the court.

This smaller and more simplified image is probably older than the Ennō-ji group. Chinese influences are apparent only in the design of the cap, which bears a tab with the Chinese character reading *wang*, or king, and in the cut of the robe, with its scallop-edged yoke covering the shoulders. Stylistically, the figure possesses some inconsistencies that are difficult to explain. The body is squat, immobile and heavy. It is carved with plain surfaces with a minimum of detail, resembling late Heian Shintō statues. The face, however, is quite realistic and mobile in expression. It resembles faces in some of the early products of the Unkei school, especially the group of the Twelve Divine Generals (Jūni Shinshō) in the Tōkon-dō of Kōfuku-ji, datable to *ca.* 1207.

Reference: *Kōfuku-ji Ōkagami*, part 1. Tokyo, 1932. Pls. 81–93; Asahi Shimbun, ed. *Kamakura no Bijutsu.* Tokyo, 1958. Nos. 52–57.

49. Ten Kings of Hell and scenes of punishment

Namboku-chō (ca. 1350)
Two hanging scrolls; color and gold paint on rough silk
Each scroll: H. 63 1/4 × 54 5/8 in. (161.5 × 138.8 cm).

Although somewhat worn and damaged, these scrolls give a vivid account of medieval Japanese conceptions of the fate of the souls of the damned after death. During the early Kamakura period there arose a large body of imagery that released a strain of brutal, horrendous sadism in the arts. Prior to that time, Hell scenes had not been acceptable to Japanese taste, which demanded refinement and a sense of the ideal in public arts. However, detailed descriptions of Hell had appeared in early Indian Buddhist literature and in Chinese and Central Asian Buddhist painting in the T'ang period. Moreover, the most widely read Japanese account of the salvation of the soul, the *Ōjō-yōshū*, written by Genshin in 985, contained a lengthy account of the torments awaiting those who fail to accept the saving grace of Amitābha.

With the traumatic changes in Japanese life that accompanied the breakdown of the Heian aristocratic order, scenes of Hell suddenly came into vogue. The vogue was reinforced, moreover, by a strong wave of Chinese artistic and religious influence, in which a cult of the Kings of Hell was quite prominent. This cult had been codified in the ninth and tenth centuries. Most elements in the cult were of Indian origin, but many were from popular Taoism, which was integrated with Buddhism just as Japanese Shintō had been.

These two paintings, done about a century and a half after the importation of the cult to Japan, show a strong admixture of local intellectual and aesthetic elements. The rank of the Ten Kings, for example, is entirely Chinese in style and conception, but the placing of small Buddha images above them reflects Japanese practice. And in the Hell scenes, the native *Yamato-e* style is quite evident in the drawing of the figures and flames.

The ideology of the cult of the Ten Kings is thoroughly detailed here. It had been coordinated with the Buddhist funeral custom in which survivors hold services for the deceased on the seventh day after death and again on the second seventh day, the third seventh day, and so on until the forty-ninth day (the seventh seventh) when, for most, rebirth into the next stage of life is accomplished. However, in keeping with a pre-Buddhist Chinese form of ancestral devotion, services were also held a hundred days, one full year, and three full years after death; and this is reflected in the presence of the last three kings.

On the walls behind each king is a large ink landscape painting. The kings sit with impressive authority in front of attendants who are holding books. With one exception, each king sits at a desk with a writing brush, ink slab, and register. In a circle above each king sits the Buddhist deity who is the source of his authority—another instance of the concept of *honchi-suijaku* (see No. 58). Before each king, one or more of the unwilling accused are brought by fierce, horned demons, and a vast panorama of Hell extends below.

The brutality and sheer sadism are appalling. Old women are stripped and beaten; birds drink the blood from the crushed arms of a sinner; a naked child (actually, an aborted infant) tugs at the shirt of its mother who begins her penalties locked in a massive wooden stock. But amid this pitiless horror appear two saving figures, Kshitigarbha (Jizō, the "Harrower of Hell") on the left edge of the left scroll, and Avalokiteśvara (Kannon, almost effaced here) in the center of the right scroll—the only avenues of relief from suffering.

In the left scroll, the odd-numbered kings are shown from left to right.

1. Shinkō. The judge at the end of the first seven days. In the circle above him is Acala (Fudō Myō-ō, see No. 45). Before Shinkō, demons drag three cringing victims.

3. Sōtei. The judge at the end of the third week in Hell. In the circle above is Mañjuśrī (see No. 44). Before Sōtei is an old woman, half-disrobed, being dragged by the hair.

5. Emma. The king of the fifth week is Yama Rāja, the God of Death in ancient Indian Vedic literature (see No. 48). In the circle sits Kshitigarbha (Jizō, see No. 37), the Buddhist deity most prominently connected with this cult who is shown below again as the Harrower of Hell. Before Emma, a man is being forced by a demon to look in a mirror. In it

is depicted the murder of a Buddhist monk that was presumably his crime; above and below the murder scene are such animals as a horse, bull and rooster.

7. Taizan. King of the sacred Mount T'ai in Shantung, site of a pre-Buddhist Chinese cult of the dead. He rules at the all-important ceremony at the end of the seventh week, when the stage of rebirth for most of the dead is decided. In the circle is Bhaishajyaguru (Yakushi, see No. 14). Before Taizan, a victim in round, stone handcuffs is being struck with a sword.

9. Toshi. The judge of those who have passed a year in Hell. His Buddhist equivalent is Akshobhya (Akushu). The victim before Toshi is being held by the hair and struck with a club.

The Hell scenes below are not closely coordinated with the kings above. According to the four large inscriptions and several smaller ones, the scenes are of the Eight Hot Hells, as described by the *Ōjō-yōshū*. At the extreme right of the left scroll a handsome, half-draped woman sits atop a tree of thorns; below, a seminude man impales himself on the thorns as his passion drives him to reach her. To the left of this, three giant demons press against large rocks to squeeze, as in a vice, the victims inside, their blood spurting from the sides. This is labeled Shugō (Samghāta), the third of the Hot Hells, where mountains meet and crush sinners. Below, a nude woman is tied spread-eagled across two stakes, and demons are sawing her shoulder. To the left, demons are marking with

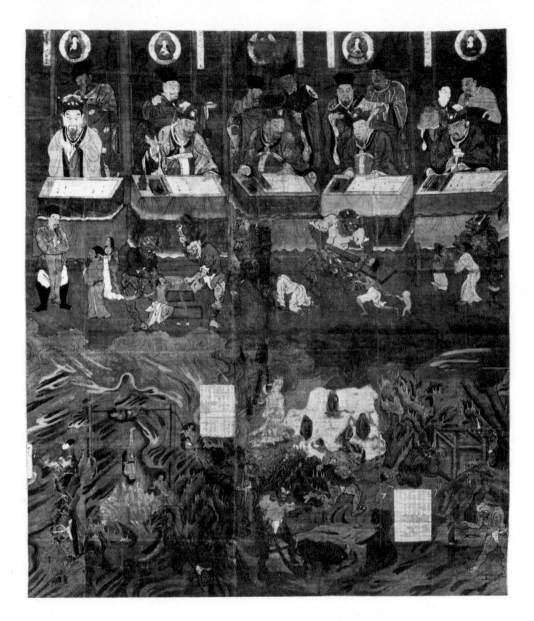

a carpenter's measure a woman outstretched on the ground, their saw lying beside her. Another demon drives a chisel against the chest of a man, and yet another holds body parts in a winnowing basket and shows them to a tiny child. Above them, two demons with clubs shaped like thunderbolts force people into a boiling cauldron.

Next comes a stream, labeled "Three Great Rivers," in which there are three frightful dragons (two are almost entirely effaced) with blood on their fangs. Huddled on the near bank are three victims facing the Datsu-i-ba, the Old Hag who takes away the clothing of the dead. Some garments hang on the limbs of a tree by the river. Beside the Hag stands the strange staff of the Fifth King of Hell, Yama, a tall pole with

a bowl at the top holding two heads. One head is scowling and demonic and the other benevolent and feminine, emblems of the fate of believers and non-believers. Finally, Jizō leads two partially dressed victims across the bridge and away from the terrors behind them.

In the right scroll, the even-numbered kings are arrayed from right to left.

2. Shokō. Judge of the second seven days. In the circle is the Buddha Śākyamuni. Before Shokō, a weeping man is tied by ropes to two stakes. A lawyer (present even in this kind of court) is talking to him, and the demon with halberd awaits instructions.

4. Gokan. King of the Five Officials, who are charged with recording the crimes of murder, rob-

detail detail

bery, lust, lying, and drunkenness. He judges at the end of the fourth week. Above is the Bodhisattva Samantabhadra (Fugen). Before Gokan, a woman is being locked by a demon into a heavy wooden stock, her child clinging to her shirt.

6. Hensei. King of Metamorphoses, who judges the sixth week. In the circle is Maitreya (Miroku). Before Hensei, a man is being flogged to his knees.

8. Byōdō. King of Impartiality, who judges those remaining in Hell for a hundred days. In the circle is Avalokiteśvara (Kannon). Before Byōdō, a victim's arms are being stretched over a stone as a demon crushes them with a mallet.

10. Godōtenrin. The Wheel-turning King of the Five Spheres of Existence, whose judgment comes three full years after death. Strongly Indic in concept, this king decides in which sphere a soul shall be re-born. In the circle is Amitābha. Before Godōtenrin a properly dressed man and woman are being inter-viewed by an attendant of the court, who stands in a respectful pose. For these two, the judgment is favorable.

In the Hell scenes below the tenth king is another version of the thorn tree. Here a handsome male courtier sits atop the tree while a half-draped woman with long hair struggles to reach him. Next is the awful Hell of Black Ropes (Kokujō, or Kālasūtra). Victims have heavy rocks tied to their backs; they are forced by demons onto a tightrope over a flaming pit and eventually fall into it because of the burden on their backs.

In the center of the right scroll appears Avalokiteś-vara facing a pond painted white and labeled "Eight Cold Hells." In it, the victims are frozen fast and afflicted by falling rocks. Next and to the right is a spiked mountain on which the victims are futilely climbing. Below this is a well or springhead from which blood flows through a spigot formed of the head of a monstrous bird. A demon kneels to catch the blood in a bowl. In the lower right corner, another demon seems to be forcing the blood into the mouth of a victim tied to the stake, holding his mouth open with tongs. In the lower center, a large demon is plowing a field of blood and flames with a green ox, while a demon beside him impales a small man with a spear.

In date, these two paintings seem to belong to the late Kamakura—Namboku-chō period. They are some-what rustic in spirit, when compared with such earlier versions as those in the Raigō-ji, Sakamoto city, or the Zenrin-ji paintings of Jizō and the Ten Kings. In those older works the Chinese influences are stronger and the execution somewhat more de-tailed. These scrolls seem to be close in style and symbolic details to the illustrated hand scroll of the *Ōjō-yōshū* in the Asata collection, datable to the late fourteenth century.

Published: Miya Tsuguo, in *Kobijutsu*, no. 23 (Sep-tember 1968), pp. 89-92.
Reference: *Kobijutsu*, no. 23 (September 1968), pp. 1-50; *Nihon Emakimono Zenshū*, vol. VI. Tokyo, 1960,

50. The infant Shōtoku Taishi

Muromachi period (early fourteenth century)
Assembled wood-block construction; paint over lacquer; inset glass eyes
H. 13 1/2 in. (34.2 cm.)

This doll-like statue would have been dressed in real clothes and treated almost as a living being. Popular Buddhism of the Japanese middle ages appealed to the simplest and most unsophisticated believers, and objects of devotion were made as tangible and comprehensible as possible. In addition to clothes, the statues were given jewelry and other realistic attributes; in some instances, human hair was attached. In this factual frame of mind, many images were carved nude (in varying degrees of frankness); one of the oldest and perhaps best known is the nude statue of Jizō at the Nara temple of Denkō-ji datable to around 1228. However, one can list nude images of Benzai-ten (Sarasvatī) and Amida, as well as unclothed portraits of Kōbō Daishi. The custom was particularly popular in the Kantō region, but during the thirteenth and fourteenth centuries, it was practiced throughout Japan.

During that same period, the cult of Shōtoku Taishi became in itself a major trait of popular Buddhism. He was considered a savior deity, an incarnation of the Guze Kannon (one of the thirty-three forms of Avalokiteśvara). For the ruling classes, during an age of political instability and great violence, Prince Shōtoku became also the ideal embodiment of a just government founded on Buddhist principles. As evidence of the popularity of his cult, the monk Eison of Saidai-ji led a mass ordination of 502 persons at the grave of Shōtoku in the Kawachi district; in 1258, he held a vast public ceremony at the grave. In 1285, the famous evangelist Ippen Shōnin also conducted a service there, which is shown in the scroll of his illustrated biography, the *Ippen Hijiri-e*.

The votive images of Shōtoku Taishi, both paintings and sculpture, depict him at different stages of his life. The major ones are as an infant, two years old, reciting his first prayer; as a youth of seven, holding an incense burner in filial devotion to the soul of his deceased father; as a young man of fourteen or sixteen years, also with the incense burner; as a government official holding the scepter of power; as a layman reciting a Buddhist text, the *Shōman-gyō*, seated at a desk before a group of courtiers.

Of all these, however, the infant figure was the most popular, for it responded to a deep current in Japanese character and folk customs that has always cherished child heroes. During the middle ages, Kōbō Daishi was also depicted and worshiped as a child, and child heroes like the Ken-no-gohō of the *Shigisan Engi* and the eight guardians of the Hase-dera Kannon appear frequently in the arts. Important as it is in Japan, such concern with divine children has been a characteristic of folk religions all over the world. In ancient Greece, it was manifested in the cults of the infants Hermes and Dionysus; in India, in the worship of the young Krishna and Balaram; and it appears in the folklore of Finland and Hungary. Cultural anthropologists and folklorists see this as evidence of an archetypal pattern in human psychology that seeks solace and hope from the promise of youth, which gives a religious outlet to the tenderness and love that many feel for children. In the Christian world, devotion to the infant Jesus reveals the same instinct among the masses of the faithful.

The cult of the infant Shōtoku did not appear in Japanese art and legend until the thirteenth century, when popular evangelization had reached major proportions. It was based, however, on an episode in his legendary biographies in which, at the age of two (in the year 575), he faced toward the east, placed his hands together in prayer, and recited the formula of homage to the Buddha—the *Nambutsu*. (For this reason, the statues depicting this event are often called Namubutsu, or Nambutsu, Taishi.) At that moment, a tiny vessel containing a relic of Śākyamuni appeared miraculously in the infant's hands. The relic, said in some texts to have been the Buddha's left eye, is believed to be the one enshrined in the Relic Hall (*shari-den*) attached to the Yumedono, the octagonal hall erected in memorial to Prince Shōtoku at Hōryū-ji.

Over fifty small wooden images of the two-year-old Shōtoku have been preserved, dating from the late thirteenth and early fourteenth centuries. They were made in all of the major Buddhist sculpture workshops of the time, and almost all of them show

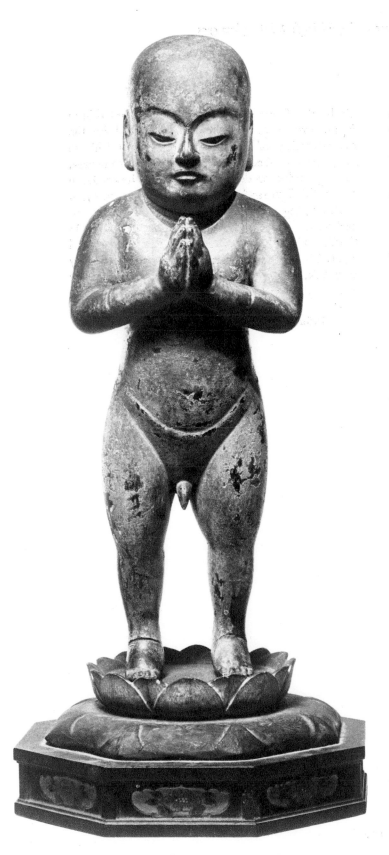

him nude to the waist wearing long pantaloons (*hakama*) and holding his hands in prayer. This figure is the oldest example of a nude image of Prince Shōtoku, and the aesthetic problems of depicting the chubby legs and belly of the child were obviously a novel challenge to the sculptor. The face and hands, however, are very close in spirit to those on the Namubutsu Taishi in the Atami Museum, dated 1328, and one dated 1320 in the Fujita collection, Tokyo.

Reference: Tanaka Shigehisa. *Shōtoku Taishi E-den to Sonzō no Kenkyū*. Tokyo, 1943; Ishida Mosaku, ed. *Shōtoku Taishi Kankei no Bijutsu*. Shōtoku Taishi Zenshū, vol. V. Tokyo, 1943; John Rosenfield. "The Sedgwick Statue of the Infant Shōtoku Taishi," *Archives of Asian Art*, XXII (1968–69). Pp. 56–77; *Kobijutsu*, No. 7 (1965); Carmen Blacker. "The Divine Boy in Japanese Buddhism," *Asian Folklore Studies*, vol. XXII (1963). Pp. 77–88.

51. Guardian lion

Late Kamakura period (fourteenth century)
Assembled wood-block construction; remnants of lacquer and gold leaf; inlaid glass eyes
H. 24 in. (62.5 cm.)

His legs rigid, his mouth open to roar, this lion was one of a pair used to guard, symbolically, the door to a Buddhist sanctuary or, more likely, a Shintō shrine. By the fourteenth century, such lion guardians had lost their primary identification with the Buddhist faith and were used universally. Even within the Imperial Palace, a pair was placed in the Seiryō-den, the private residence of the imperial family. According to *Kimpishō*, an account of court customs written by the Emperor Juntoku around 1219–1222, one of the lions had an open mouth, as does this figure, and was called *Shishi* (based on the Sanskrit word for lion, *simha*). The other had a horn on its head and held its mouth closed; it was called *Koma-inu* (dog of Koryo, the medieval Korean dynasty). The distinction between the two is not especially meaningful; in fact, they were symbolically of the same species, and the two names have been used interchangeably.

Strangely enough, the oldest Japanese examples of lion statuary do not date before the late Heian period, despite the symbolic importance of lions in Buddhism and the fact that the lion is the animal vehicle of Mañjuśrī, one of the most widely worshiped deities in the Buddhist pantheon (see Nos. 44, 64). In India, where it is indigenous, the lion was a suitable emblem for Śākyamuni. The Buddha was called the Lion of the Śākya clan, the Śākyasimha; his voice preaching the truth was likened to the roar of the lion in the forest, stirring all creatures with its authority. The Buddha mounted the lion throne when he preached; as the lion is the King of Beasts, the Buddha was King of Seers. Stone lions facing the four directions were placed atop the great edict pillars of the Buddhist Emperor Aśoka at Sārnāth and Sāñchī; on their heads rested the wheel, emblem of the Buddhist *dharma* or Law. Lions appealed greatly to the Buddhist community in China, and from the Six Dynasties and T'ang periods have come remarkable figures in stone, both freestanding and in relief. But in Japan, the lion was not an indigenous beast; it remained an alien creature whose imagery was supported entirely by imported examples. Not before the revival of Chinese influences in the thirteenth century did leonine forms come to play an important role in Japan. Two large stone lions were carved for the reconstruction of Tōdai-ji in 1196 by a Chinese sculptor who had come to Japan. One of these figures, although rather crude and blockish, is quite similar in pose to this figure and may be considered its prototype.

The dating of this statue is determined by comparison with the handsome pair of wooden lions in the Daihō Shrine, Shiga Prefecture, datable to around 1321. They are somewhat more realistic and lively than this, but otherwise close in the treatment of the mane and the facial expression.

Reference: *Kokuhō Zenshū*, nos. 625, 626.

52. Kongara Dōji

ca. *1350–1400*
Assembled wood-block construction; lacquered with traces of paint; inlaid glass eyes
H. 11 1/2 in. (29.2 cm.)

This tiny figure in a gesture of prayer probably faced a larger statue of Fudō, the Immovable One (see No. 45). As such he would be Kongara (or Kimkara in Sanskrit), meaning simply "servant" or "slave." He would be joined by the figure of Seitaka (No. 53), and the two are the most prominent of eight boyish attendants of Fudō. During the Japanese middle ages, popular interest grew in the miracle-working servants of the great deities, and their imagery became increasingly prominent.

This delicate statue is done with an extraordinary sense of unity in its movement; the body is bent in a single curving axis running from the head to the feet. Reinforcing the curve is the suggestion of the blowing wind in the direction of his robe, with the deeply undercut folds at his waist.

It is difficult to give this figure a precise date, but if indeed it was made together with No. 53, an attribution to the latter half of the fourteenth century seems reasonable.

Reference: Ishida Mosaku. *Bukkyō Bijutsu no Kihon.* Tokyo, 1967. Pp. 220–223.

53. Seitaka Dōji

ca. *1350–1400*
Assembled wood-block construction; lacquered and painted; inlaid glass eyes
H. 11 1/2 in. (29.2 cm.)

This figure was purchased together with No. 52. They are similar in scale and technique, and the two figures usually form a pair, flanking an image of Fudō. Nonetheless, there are distinct stylistic differences between them. Here the garment folds are carved in a much more detailed manner, and the body is more articulated, less unified in construction. The likelihood is, however, that they did indeed originally form a pair, but were produced by different members of the same sculpture workshop.

The name of this figure is Seitaka (Cetaka in Sanskrit, another word for "servant" or "slave"). He usually holds a rough stick in his right hand, and either shields his eyes with his left or holds a thunderbolt. The treatment of the head, clearly and graphically modeled, resembles that of the faces of the Twelve Divine Generals in the Kamakura temple of Kakuon-ji, dated in the eighteenth year of the Ōei era (1407).

Reference: Miyama Susumu. *Kamakura no Chōkoku.* Tokyo, 1969. Pls. 98–103.

54. Seated Batō Kannon

Late Kamakura period (1353)
Kakuen Busshi (1305–?)
Cypress wood, with traces of gesso and paint; inlaid glass eyes
H. 7 3/4 in. (19.7 cm.)

Bristling with a sense of radiant energy, this tiny image is a valuable document of the long survival of the realism of such early thirteenth-century masters as Unkei and Kaikei (see Nos. 36–39). Their overriding interest in expressive details is reflected here, a century and a half later, in the handling of the eyes inlaid with glass, the careful definition of the teeth and scowling lips, and the descriptive carving of the intricate folds of the skirt and pantaloons. The aesthetic integrity of this work has been preserved despite considerable damage. Missing from the space over the forehead is the small horse's protome usually found on images of Batō Kannon; also the two heads on the sides have been largely broken away. The deity originally had two arms whose hands joined together in a prayerlike gesture.

The image was made in the assembled wood-block technique; when taken apart for repairs recently, a lengthy inscription was discovered written in ink on the inner face of one of the blocks. It states the date of the work—the second year of the Bunna era (that is, 1352 in the reckoning of the so-called Yoshino dynasty). It also gives the name and age of the sculptor —the forty-eight-year-old Kakuen, a name not hitherto recorded. (A Kakuen of the previous century is known, an active disciple of Kaikei.)

Nothing is known historically of Kakuen, but since this work is clearly in the realistic tradition of the so-called Kei school, Kakuen may have been associated with two well-known proponents of that school, active in the mid-fourteenth century. They are Kōshun, who carved the familiar statue of Hachiman in the guise of a monk, now in the Boston Museum; and Kōshun's son Kōsei, whose statue of Yakushi in the Kimbusen-ji has many similarities to this image in the handling of the garments. Kōsei succeeded his father as director of the great sculpture workshop at Kōfuku-ji in Nara in direct line of succession from Unkei.

The interior inscription also tells that this image was made for the Nakayama-dera in a district called Kuzunuki. There are several Japanese temples with this name, which may also be pronounced Chūsan-ji;

the most likely possibility is the Nakayama-dera located in the hills of the Settsu region not far from Takarazuka city, between Kyoto and Kobe. It is one of the thirty-three temples in western Japan sacred to the worshipers of Kannon, who hope to make a pilgrimage to each temple during their lifetimes. While the district around the temple is not now known as Kuzunuki, that name was current in the region in antiquity; and the temple records reveal many acts of patronage and restoration throughout the fourteenth century.

The inscription identifies this as a statue of Batō (Horse-headed) Kannon and states that it was one of a set of six images of that deity dedicated together. The Six Kannon are a familiar grouping in Esoteric Buddhism related to the doctrine of the six worlds (*rokudō*) (see No. 37) through which the souls of living beings are thought to migrate. Loyal Buddhists insure the well-being of their departed ancestors by holding services before the six images of Kannon who preside over those realms in which those souls might dwell. The lowest level is that of Hell (see No. 49), and Buddhists there are protected by the Thousand-armed Kannon. The second realm is that of the Gaki (or Preta in Sanskrit), spirits condemned to hunger and thirst that can be assuaged only by the intervention of Kannon, here in the form of Shō Kannon (see No. 27). The third, presided over by the Horse-headed Kannon, is that of the animals in whose form a soul may also be reborn. The fourth is of the militant deities, the Ashuras, who help protect the faith; the Eleven-headed Kannon presides in this realm. The fifth is that of mankind, for whom the rather unfamiliar Juntei (or Cundī in Sanskrit) Kannon dwells; the sixth and highest is that of Paradise where Nyoirin Kannon presides (see No. 60).

That particular form of worship seems to have begun in the mid-Heian period. Fujiwara Michinaga, for example, is said to have installed an altar of the Six Kannon in the Hall of Yakushi within the vast grounds of his tutelary temple in Kyoto, the Hōjō-ji. His son Fujiwara Yorimichi, who built the famous Byōdō-in, also built a special hall for the Six Kannon

in 1041. In Esoteric Buddhist temples, however, such statues have frequently been treated as secret images and are never seen by their devotees.

The horse-headed form of Kannon is one of the most complex of all deities of Esoteric Buddhism, both in his historical origins and religious content. His Sanskrit name is Hayagrīva (literally, horse-necked), which is a familiar epithet of the great Hindu god Vishnu. Indeed, in the mingling of Hindu and Buddhist elements in Esoterism, Hayagrīva may be seen particularly as a Vaishnava form adapted to the use of the Buddhists. In Japan, he was mentioned in such early imported Esoteric texts as the *Mahāvairocana Sūtra*; but his worship did not become popular until the later middle ages, when he appealed to samurai and farmers as a protector of horses and cattle. For that same purpose, he is widely adored in Tibet and is frequently shown in Tibetan cult imagery. However, in the context of this statue, the religious value of the Batō Kannon was closer to that of the salvation deities and the popular concern for the afterlife.

Reference: R. R. van Gulik. *Hayagrīva*. Leiden, 1935; *Hōbōgirin*, 1st fascicule. Tokyo, 1929. Pp. 58–61; Mōri Hisashi. *Unkei to Kamakura Chōkoku*. Heibonsha Nihon no Bijutsu, vol. 25. Tokyo, 1964. Pp. 81–85; Itō Nobuo and Kobayashi Takeshi. *Chūsei Jiin to Kamakura Chōkoku*. Genshoku Nihon no Bijutsu, vol. 9. Tokyo, 1969. Pl. 57, pp. 212–225.

55. Karyōbinga

Muromachi period (ca. 1423)
Attributed to Chōyū Busshi (active ca. 1394–1427)
Cypress wood, coated with fabric and lacquer or gesso; painted
H. 17 1/8 in. (43.5 cm.)

The origins of this fabulous bird-woman with a bell-like cry lie in Indian mythology, where it is called the Kalavinka. Described in Buddhist texts as having the head and torso of a Bodhisattva and the body, wings, and legs of a bird, it sings the praise of the Buddhas with its pure voice. In accounts of the delights of the Western Paradise of Amitābha, it is said to play among the flowering trees, gilded palaces, and fresh flowing streams in the Pure Land where the faithful are reborn.

As an artistic motif in Japan, the Karyōbinga is found as early as the mid-eighth-century treasures of the Shōsō-in, on an inlaid lacquer box. But it appears frequently thereafter, most notably perhaps in the decorations of the celebrated Konjiki-dō, the highly ornate Amida Hall in Hiraizumi, northern Honshu, built by a provincial offshoot of the Fujiwara family. The bird-women appear on the plinth of the altar platform, shown in repoussée copper plates and in filigree hanging disks.

This example probably came from the halo of a large Buddhist image and must originally have had long wings on its back. Moreover, the skirt, blown by an imaginary swift-flowing wind, once extended several inches further out and ended in an enclosed semicircle, like a parenthesis. The surface of the skirt is now black lacquer; originally it must have been gilded with gold leaf, while the body and face were coated with gesso and paint. This figure closely resembles Karyōbinga figures in the Kamakura temple of Kaku-on-ji; they appear on the haloes of the two Bodhisattva attendants of the main votive statue there, the seated figure of the healing Buddha, Yakushi. The resemblance, in fact, is so strong that there can be little doubt that the halo figures were done by the same atelier if not by the same hand.

An inscription found inside one of the Kakuon-ji Bodhisattvas states that it was made in 1423 by the Buddhist master sculptor, Chōyū. Data concerning this man comes entirely from inscribed statues, from which it may be deduced that he was active in Kamakura between 1394 and 1427. He must have worked for a traditional-style Buddhist atelier in which especially strong influences from the mainland were focused, for there are many elements of Chinese-style cult imagery and portraiture in wood in the work of Chōyū and his predecessors. Rather little of the contemporary styles of Kyoto and Nara affected this essentially provincial atelier, except for such subordinate elements as the Karyōbinga bird shown here. The gentle, delicate realization of the features and body is faithful to the canons of Japanese Buddhist decorative arts. The baroque interplay of the swirling lines of the skirt and the twisting torso were derived from the plastic experiments of the Unkei school of the thirteenth century, which had established a branch at Kamakura.

Reference: Miyama Susumu. *Kamakura no Chōkoku*. Tokyo, 1966. Pls. 72–76, 98–103; Kuno Takeshi, ed. *Kantō Chōkoku no Kenkyū*. Tokyo, 1964. Pp. 256–257; Nara National Museum catalogue, *Muromachi Jidai no Butsu-zō*, no. 30. Nara, 1967; Asahi Shimbun, ed. *Kamakura no Bijutsu*. Tokyo, 1958. Pl. 24.

56. Seated Aizen Myō-ō

Muromachi period (fifteenth century)
Sandalwood, with light color and gold
H. 7 1/4 in. (18.4 cm.)

This work belongs to the very latest stages of Buddhist traditional art and was carved with the skill of a jeweler perhaps, rather than that of a sculptor. Nonetheless it is also extremely instructive concerning the difference between technical skill and intrinsic aesthetic content. A miracle of craftsmanship, it was carved of costly, imported sandalwood that was fine grained like ivory and allowed the most delicate surface detail. Because of its cost, sandalwood was reserved for images of special significance; by tradition, the first true image of the Buddha was carved in this material (see No. 39). The oldest sandalwood statue remaining in Japan is the small Nine-headed Kannon in Hōryū-ji, imported from China in 719 according to the temple records. That figure is extremely close to this one in the way the necklace and chains of jewels and armlets are carved in a high raised plane, and modeled so carefully that they appear to be made of metal and attached to the surface. The older work, however, retains a sense of rigid structure in the parts of the body, whereas here the anatomy is more realistic, the expression of the face is defined in minute detail, and an air of tension pervades the figure.

So traditional an object is difficult to date precisely. In proportion and features it seems to resemble most closely the Aizen image at Kairyūō-ji, Nara, dated to 1440. But works very similar in style were being made as late as the 1660s.

Reference: *Zōzō Meiki*. Tokyo, 1926. No. 148; *Kōya-san. Hihō*, vol. 7. Tokyo, 1968. Pl. 182.

57. The God of the Kasuga Wakamiya Shrine

Namboku-chō period (last half of the fourteenth century)
Hanging scroll; colors and gold on silk
H. 32 × 15 1/2 in. (85.3 × 39.6 cm.)

This vigorous young man stands in a billowing court robe with his feet apart, arms akimbo; he holds the ceremonial wand of a government official. Beneath his feet is a round pedestal, shaped like a lotus flower, and he towers supernaturally over a mountain crag. He is the Shintō god of the Wakamiya Shrine, built just south of the four main shrines of the Kasuga Taisha (see No. 58). His formal name is Ame-no-oshi-kumo-ne-no-mikoto, and he is the son of one of the mythical ancestors of the Fujiwara clan, Ame-no-koyane, the third of the main gods of the Kasuga Taisha. His religious value is vague but he appeared miraculously in 1003 to the Emperor Ichijō, who was coming to the Kasuga Taisha; the new deity was honored by the building of his shrine in 1135 by the Emperor Sutoku.

Despite the uncertainty of his religious value (recently Jean Herbert was unable to find a single worshiper who could identify the Kasuga Wakamiya), a festival in honor of the god, held each year from December sixteenth through the eighteenth, has been maintained over the centuries as one of the most dramatic rituals of the old Southern Capital. It is still performed and still graced by the presence of a member of the Fujiwara family. The American scholar Langdon Warner observed the festival in 1907, and described himself ". . . transported back fifteen centuries and more. The God (symbolized by a mirror) had been brought down to a temporary shrine in the middle of the night, and in front of it was a flat grass mound. . . . Huge iron baskets full of flaming pine and cedar knots blazed about the mound, and overhead the sky was purple-black and set with a million polished stars . . . all of a sudden, four figures came out of the shadow. They had on brown robes with long yellow trains and black Druidlike caps. Then there was the sound of shrill pipes and flutes and the solemn soft boom of a drum. . . . The four dancers stooped down, and rose, and stamped and swayed in rhythm— sometimes lifting their arms to the stars, sometimes lying prone on the sod. The dance is called 'Earth throughout the Ages' and I felt that I was watching the primeval rites of an elder people who knew and spoke with their Gods."

Although roughly of the same vintage as the Kasuga mandala (No. 58), with which it is closely linked in doctrine, this work is much more broadly and freely painted, and it seems to have come out of the native Japanese portrait tradition. Indeed, it resembles a number of paintings of Shōtoku Taishi of this era, done in similarly muted colors and with a strong emphasis upon outlines painted in ink. The calligraphic outline is one trait of late fourteenth-century painting; so also are the fine floral patterns on the sash and the gold areas along the undersides of the sleeves.

Votive paintings of the Kasuga Wakamiya are quite rare. Similar to this is one in the Freer Gallery in Washington, D.C.; it is better preserved but slightly younger in date.

Formerly in the Inoue collection.
Published: Ishida Mosaku, ed. *Taishi Kankei Geijutsu.* Shōtoku Taishi Zenshū, vol. 5. Tokyo, 1943. Pl. 3, p. 23 (where it is wrongly identified as a portrait of Shōtoku Taishi).
Reference: Shimada Shūjirō, ed. *Zaigai Hihō*, vol. I. Tokyo, 1969. Figs. 72–75; Theodore Bowie, ed. *Langdon Warner through his Letters.* Bloomington, Indiana, 1966. P. 25; Jean Herbert. *Shintō.* New York, 1967. P. 224; Kageyama Haruki. *Shintō Bijutsu no Kenkyū.* Kyoto, 1962. Pp. 91-99.

58. Kasuga mandala

Namboku-chō period (late fourteenth to early fifteenth century)
Hanging scroll; color and gold paint on silk
H. 31 × 13 3/8 in. (78.8 × 35 cm.)

The early morning sun, shown as a dark disc with an aureole of gold, rises above the distant Mount Ondai and the nearby Mikasa. The nocturnal setting, with pale light emanating from the sun and reflected in the gold areas of the hillsides, evokes a sense of mystic presence like that in nineteenth-century Romantic landscapes by Caspar David Friedrich and Arnold Böcklin.

This scroll is one of a large number of medieval paintings showing the great temple of Kōfuku-ji, Nara, in the foreground and its coordinate Shintō shrine, the Kasuga Taisha, in the background. The sensation of a bird's-eye view is created by the conventional Sino-Japanese linear perspective, in which parallel lines that are receding from the spectator seem to diverge, fanlike, in depth. Such compositions are called mandalas because they present, in a quasi-schematic manner, the relationship between the Shintō and Buddhist deities worshiped in a particular area. Many Kasuga mandalas actually show small Buddhist figures or Sanskrit "seed characters" above each of the shrines.

The shrine and temple were both constructed by the Fujiwara family when the capital at Nara was established in the eighth century. Four Shintō gods from eastern Japan were ceremonially installed in the Kasuga Shrine as *uji-kami*, "guardians of the fortunes of the family." The Kōfuku-ji, under Fujiwara patronage, excelled in richness and splendor all temples but the nearby Tōdai-ji, which was the official, state-supported monastery of the entire empire.

During the Heian period, the main deities of Kōfuku-ji and the Kasuga Shrine were linked together according to the doctrines of *honchi-suijaku*, by which Shintō deities were seen as emanations or avatars of Buddhist deities. The four principle deities of the shrine were linked with Shaka (Śākyamuni), Yakushi (Bhaishajyaguru), Jizō (Kshitigarbha), and the Eleven-headed Kannon (Avalokiteśvara) respectively. A fifth major shrine, that of the Kasuga Wakamiya (see No. 57) was added, and Monju (Mañjuśrī) was designated as his *honchi*. The *honchi-suijaku* concept was quite ancient, but there are no representations of the deities of the Kasuga Shrine and their Buddhist counterparts prior to 1184.

As the Fujiwara family fell from its eminence during the twelfth century, the Kasuga Shrine ceased to be identified primarily with that clan but, rather, was worshiped and supported by the populace at large. Donated by people in all parts of Japan, the thousands of tall stone lanterns that line its pathways testify to the numbers of citizens who sought the protection of the powerful deities of the shrine. Branches of the Kasuga Shrine were established throughout the nation, and worshipers of the Kasuga gods formed sodalities or associations called *Kasuga-kō* during the fourteenth century, particularly in the Nara-Kyoto-Kawachi area. Each *Kasuga-kō* possessed paintings, especially mandalas like this one, and statuary for its devotions. One of the few mandalas that is inscribed and dated indicates that it was done by a Buddhist monk-painter, probably in the painting atelier (*e-dokoro*) of Kōfuku-ji itself in 1300; the inscription was by the retired Emperor Kameyama.

Like many of the Kasuga mandalas, this picture minimizes the importance of Kōfuku-ji, which is represented here only by the two pagodas in the foreground. A dim pathway leads vertically up the center of the composition, through the forest of cryptomeria and autumnal maples and the herd of deer, which are the emblematic animals sacred to the shrine. The buildings are depicted with meticulous attention to detail and have been preserved very much as they appear in these mandalas. Shown are the two main *torii* (gates) along the pilgrims' path; the parking shed for the carts of the nobility stands by the second gate. The special preparation hall for the imperial envoy (*chakutō-den*) is also along the side of the path. A covered verandah encloses the entire *hongū* (Main Shrine), with its four tiny separate shrines of the four Kasuga gods. To the right is the shrine of Kasuga Wakamiya, with its *kagura-den* (Hall for Sacred Dances) directly in front.

The painting has suffered considerable damage, especially in the middle-ground forest area. Nonetheless, it retains the nocturnal lighting and power of

evocation that make the Kasuga mandalas among the most distinctive landscapes in traditional Sino-Japanese painting.

Reference: Nara National Museum, ed. *Suijaku no Bijutsu*. Tokyo, 1964. Pp. 1–34; *Kasuga Gongen Reigen-ki*. Nihon Emakimono Zenshū, vol. XVI. Tokyo, 1966; Kyoto National Museum catalogue, *Koezu*. Kyoto, 1968. Nos. 52–55.

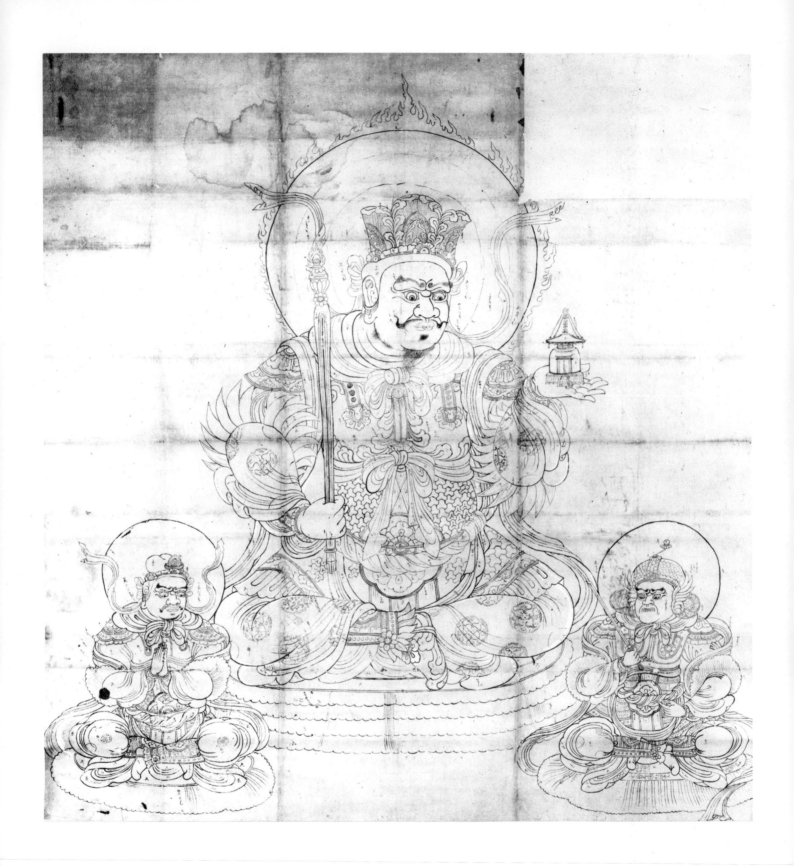

59. Vaiśravana (Bishamon-ten) and attendants

Muromachi period
Hanging scroll; ink on paper, with corrections in white paint
H. 51 1/4 × 47 1/4 in. (130.2 × 120 cm.)

Wearing a florid, Chinese-style costume, Bishamon sits here on a low matlike pedestal, holding in his left hand the miniature pagoda that is almost always an attribute of this deity. In his right hand is a regal mace, topped by a flaming Cintāmani jewel. Inscribed over all the composition are the names of colors, written in precise, cryptic abbreviations as instructions for a copyist.

This is a careful, full-scale copy of the painting of Vaiśravana in the Tō-ji monastery, Kyoto, that is part of a famous set of the Twelve Devas (Jūni-ten, see No. 31). Done in 1127, the Tō-ji paintings are brightly colored. In the Vaiśravana image, for example, the halos are deep vermilion, the chest armor of the god is ultramarine blue, his mail armor is gold, and the composition is enriched by fine, cut-gold patterns (*kirikane*).

The painting of the original set of the Jūni-ten was supervised by Kakunin, a professional monk-artist (*e-busshi*) who had been a teacher of Genshō (see No. 31). It was done to replace an older set, reputedly painted by Kōbō Daishi, that had been destroyed by fire. Thus this drawing, as a copy of a copy of probably an older copy, shows graphically the intense conservatism of traditional Buddhist art and the way in which sacred prototypes were repeated without major change. Indications that it is a late drawing can be sensed only in the subtlest nuances of line quality—which is here somewhat stiff and rigid—and a certain lack of organic unity in the anatomy of the figure.

In the upper left corner is an inscription which is largely effaced, written on the back of the paper:

Copy of the work of . . . ma
Tō-ji Treasure Storage
From the Twelve Devas
From the Hobodai(?)-in [a Tō-ji subtemple].

Reference: *Kokuhō*. The National Treasures of Japan, vol. III. Tokyo, 1965. No. 92.

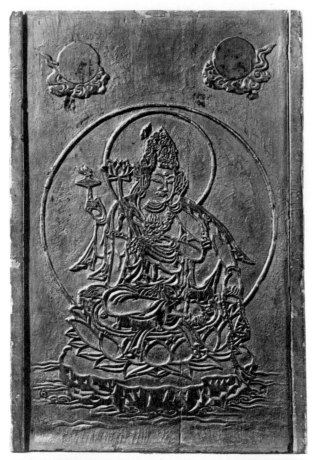

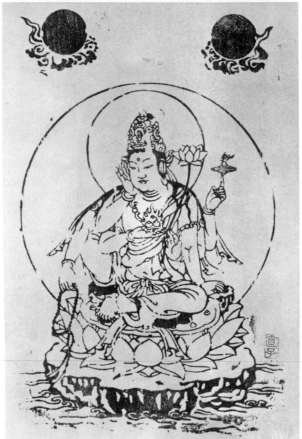

60. Wood-block and print of the Nyoirin Kannon

Muromachi period (1435)
From the Rokkaku-dō, Kyoto; new print, made by Matsubara Naoko
Wood-block; carved in relief and encrusted with dried ink
H. of block 18 3/8 × 10 7/8 in. (46.8 × 27.5 cm.).

Large wood-blocks of this kind were made for pilgrims and temple visitors. In this case, the temple is the famous Rokkaku-dō (Hexagonal Hall) in Kyoto, whose chief object of worship is a statue of the Nyoirin Kannon. The deity, like Jizō, (see No. 37), is an Esoteric Buddhist figure who became the object of great popular devotion, worshiped by laymen seeking relief from hardships and perils. He is also one of the six forms of Kannon who preside over the six stages of rebirth, a religious conception vital to those praying for the souls of the deceased. The Nyoirin Kannon is in the fifth of the six stages, which is the exalted realm of the Devas.

In two of his hands he bears the two emblems from which his name is derived: the wheel of the Buddhist Law (*Hōrin*) and the flaming jewel (*Nyoi-hōju*), symbolizing his supernatural ability to respond to the wishes of his devotees. In two other hands he holds the lotus, which is the constant attribute of Kannon, and a rosary; he touches a hand to his face in a pensive gesture, emblematic, probably, of the vow of the Bodhisattva to work for the salvation of mankind. He is posed in the especially relaxed "position of royal ease," called the *Mahārājalilāsana* in India, where it originated. Seated on a lotus pedestal atop a rocky crag, the deity meditates on the roiling sea before him; the sun and moon in the sky testify to the eternity of his presence and concern. Shown with a heavy, fleshy physique, the figure retains even at this late date the strong Chinese influence that often appears in images of the Nyoirin Kannon. Although one of the thirty-three distinct forms of Kannon worshiped in Japan, this type, by the Muromachi period, had become closely related to other forms— the White-robed Kannon (see No. 70), for example, and the Suigetsu (Water and Moon) Kannon. Some of them are distinctly feminine in appearance, but theologically this figure remains essentially neuter.

The wood-block has a large handle on the back and is inscribed in deep relief in the lacquer surface:

> The Rokkaku-dō; for the sake of all sentient beings.

The seventh year of Eikyō, the third month, the eighteenth day.

By popular tradition, as recorded in the *Zoku Kojidan*, the Rokkaku-dō was founded long before the city of Kyoto by Shōtoku Taishi (see No. 50), who had been searching in the area for timber to use in the building of Shitennō-ji, Naniwa. He had bathed in an inviting pool, then saw an image of the Nyoirin Kannon suspended miraculously from the branch of an oak tree. To enshrine the statue, he built a small hexagonal structure, the formal name of which was the Chōhō-ji, but it became popularly known as the Rokkaku-dō. Over the years, the temple shifted its location as it suffered from fire and earthquake. Today it stands in a rather unimposing compound near the corner of Karasuma Avenue and Sanjō; it has been deeply involved in the cultural history of the city. As the eighteenth of the thirty-three temples of western Japan sacred to Kannon, it is still visited by hordes of pilgrims and it was for such pilgrims, presumably, that the prints of the Nyoirin Kannon were made.

Dated wood-block prints from the Japanese middle ages are relatively rare. But, during the fifteenth century, the custom of making large-scale devotional prints of this kind became widespread, as did the printing of illustrated sūtras and reproductions of narrative scrolls. The print-makers' craft thus remained vital until the early Edo period, when it was used for popular, illustrated novels and theatrical and fashion prints, and expanded enormously with the rise of *ukiyo-e*.

Reference: Ishida Mosaku. *Kodai Hanga*, Nihon Hanga Bijutsu Zenshū, vol. I. Tokyo, 1961. Pp. 95–107; Ishida Mosaku (translated and adapted by Charles Terry). *Japanese Buddhist Prints*. Tokyo, 1964.

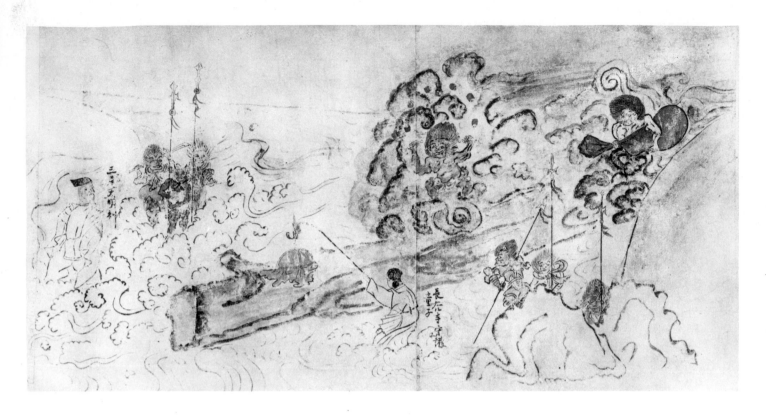

61. Illustrated scrolls of the *Hase-dera Engi*

Muromachi period (early fifteenth century)
Three long hand scrolls; color and ink on paper
Each scroll: H. 14 1/2 in. (36.8 cm.)

These three scrolls present the legendary history of the Hase-dera, a venerable monastery in Nara Prefecture founded in the late seventh century. Built on a picturesque hillside overlooking the highroad from Nara to Ise and the gorge of the Hatsuse (or Hase) River, the Hase-dera has suffered an unusual amount of damage from fire and earthquake. Few of its ancient buildings or objects remain intact. Nonetheless, it has always been a large and active sanctuary, one of the thirty-three temples in western Japan sacred to the Bodhisattva Kannon, and its halls are still filled with pilgrims and clouds of incense. The main object of devotion in the temple is a statue of the Eleven-headed Kannon over twenty-six feet high. The current statue dates from the sixteenth century, but it is based on an eighth-century original that had been carved from a wonder-working log of a camphor tree.

The history of the miraculous image and of the founding of the temple is told in the *Hase-dera Engi*, a text in Chinese characters (*kambun*) said to have been written by the scholar-courtier Sugawara Michizane (Kitano Tenjin) in 896. The attribution to Michizane is an important part of the tale itself—virtually equivalent to an attribution to John Milton or Dante—but it seems to be a pious fabrication. The *Engi* (an account of historical origins, with supernatural overtones) may well be a compilation of folktales and temple legends made long after Michizane's time.

The three scrolls shown here present the early portions of the story, but the scrolls themselves are no longer complete. Portions of both the text and illustrations have been lost; yet the main outline of the story is preserved. The first scroll, following an introductory section of the text, shows Michizane lodging at the temple and receiving a divine vision of its history, which demonstrates, of course, the

authenticity of this account. The next scene is a portion of the history of the first Hase-dera, which stood near the same site as the present temple. Following this was a long missing section that recounted the biography of the holy monk Tokudō, one of the leading clerics of the early eighth century and founder of the current temple; Tokudō then appears asking an old man of Hase village about the famous log of camphor wood that was nearby. The old man, in a technique similar to that of the movies, then recounts the former history of the log. The next scene, reproduced here, shows the log on the waters of Lake Biwa floating to shore. It is impelled by the Thunder and Wind Gods; demon guardians accompany it, as do a youth holding over it a canopy on a dragon-headed pole and an old man in a court costume and beard. The boy is labeled "Youth Protector of Hase-dera," and the old man is probably the Shintō god of the hillside site of the temple. Their presence here indicates that the log was predestined to come to Hase-dera, for the accompanying text dates the episode in the eleventh year of the Emperor Keitei, or 517 A.D. The next scene shows the log at the city of Ōtsu, where men are trying to split it, while fires break out in the town and people fall ill. After sixty-nine years, the log is brought to the Yamato region, and the next illustration shows it being pulled by men

accompanied by its supernatural host. It was taken first to the village of Yagi, where it caused further illness and death, and then to Hase where it was neglected until the time of Tokudō.

The second scroll opens with a scene of workers dragging the log up a steep slope to be used in making the image. Next is shown a horseman with his entourage, the powerful courtier Fujiwara Fusasaki, who had been assigned to assist Tokudō in his project of carving the image. Next Tokudō is shown in a building on his knees, praying in the direction of the sacred log in the foreground. Following this is a scene in which the log, now squared, is drawn with the image of the Bodhisattva, and services are held before the actual carving. Seated in stiff court costume before the log is a man labeled the Daibusshi, the Buddhist sculptor. The next major episode is reproduced here, in which a stone suitable to serve as a pedestal is being dug from the earth. The Youth Protector is shown in the foreground with a one-pronged thunderbolt; a demon with a dragon over his head is carrying away heavy rock; other demons assist; the Wind and Thunder Gods continue to protect the enterprise as the earth, with smoke and fire, yields the perfectly squared stone. Next, also illustrated here, is the completed statue, standing on its stone pedestal. Following this is the formal dedica-

149

tion ceremony, in the year 733, presided over by the famous monk Gyōgi Bosatsu, who had served as one of the chief advisers to the Emperor Shōmu in the project of building the Nara Daibutsu. Next, the eight great youthful guardians of Fudō (the Hachi Dai Dōji; see Nos. 52, 53) announce that they will also protect the worshipers of this temple and its image of Kannon. Then a supernatural ray of light falls near the Imperial Palace at Nara indicating to the Emperor Shōmu that the Hase-dera project has received divine sanction.

The third scroll depicts the activities of the monk Gyōgi at the temple. He is first shown inspecting the full array of statues installed around the Eleven-headed Kannon. These include the Four Divine Kings (Shitennō), Eight Dragon Kings, and the Eight Great Dōji. Further along is a scene of the construction under Gyōgi's supervision of a large temple hall. A huge bow and arrow device is being set in place on pillars to be triggered by a rope leading to a straw mat below. Other scenes include the inauguration of that hall in 747 and the visit paid by the Emperor Shōmu after his abdication.

The colophon on the third scroll gives no indication of the artist or date of this work. However, it is closely related to a more brightly colored version formerly in the Hayashi collection and datable to the

early fifteenth century. There are other versions—in the Tokugawa Museum, Nagoya; in the Seattle Museum, in the temple itself and in affiliated temples in Kamakura and Sakai—but these two appear to be earliest. Remarkably, there is no evidence that the tradition of the illustrated *Hase-dera Engi* began during the golden age of Japanese narrative scroll painting in the thirteenth century.

These scrolls seem to have been done by a rustic Buddhist artist, not a member of a professional atelier. Although they reflect in many ways the developments of sophisticated narrative painting, the actual execution of the painting is rather simple and direct; some of the landscape has elements reminiscent of the *Inga-kyō* scrolls (see Nos. 11, 42, 43); in parts, there is a simplicity like that of the *Ōtsu-e* (see No. 141), early examples of folk art.

Formerly in the Gejō collection.
Published: Miya Tsuguo in *Kobijutsu*, no. 15 (December 1966).
Reference: Richard Fuller. *Japanese Art in the Seattle Art Museum*. Seattle, 1960. Pl. 88; *Kokka*, no. 493 (December 1931); illustrated catalogue, *Tokugawa Bijutsu-kan*. Tokyo, 1964; *Dai Nihon Bukkyō Zensho*. vol. 118. Tokyo, 1913.

62. Mandala of the Ise shrines

Edo period (eighteenth century)
Two-panel screen; color on paper
H. 59 1/2 × 71 in. (151.1 × 180.3 cm.)

This maplike mandala, painted on a large screen, shows clearly the two main shrines of Ise, the most sacred of all Shintō sanctuaries, and their attached Buddhist temples. The composition is descended from the pictorial mandalas of the middle ages (see No. 58); but unlike them, this does not attempt to evoke the sense of mystery that such shrines instill in their devotees.

The pilgrims who have journeyed to Ise since remote antiquity have been deeply moved by their walk through the towering, millennial forests—of cypress, camphor, and cryptomeria—that surround the shrines. They have sensed an intuitive communion with nature in its benign and elemental power, in the cool, silent darkness of the forests and the crystal purity of the streams. The structures themselves are small but have been maintained with the utmost care, rebuilt in fact every twenty years. As seen today, their unpainted, smooth wood surfaces are joined and carpentered with a skill that transcends artifice. Pilgrims return from Ise with a profound sense of purification that is one of the most basic and enduring gifts of Shintō to its votaries. Their awareness of the ancient sources of national identity is strengthened, and they have experienced this identity in terms of the primacy and grandeur of nature.

Originally the great sanctuaries of Ise were the family shrines of the emperors, and pilgrimage there was a privilege and obligation of nobility. In the Muromachi period, however, with the impoverishment of the imperial household, worship at the shrines by commoners was encouraged by the Buddhist monks who were then active there. Religious associations (*kō*) were formed, like those for Amida worship and for the Kasuga Taisha, and group pilgrimages to Ise became an important feature in Japanese life. Income from tolls and sales of amulets helped support the sanctuary.

Mandalas of this kind, painted in a broad, almost cartoonlike style, are virtually a form of folk art similar to the so-called Nara *e-bon*. In their freshness and vitality the mandalas are almost completely innocent of the sophisticated refinements of the Kanō or Tosa ateliers and must have been made by a professional workshop, probably in Kyoto, with few social pretensions. Compositions similar to this one depict the Kiyomizu-dera, the Yasaka Shrine in Wakayama, Mount Fuji, and the Taga Shrine in Shiga Prefecture. Produced largely from the late Muromachi period through the first two centuries of the Edo period, scenes such as this were intended primarily for pilgrimage and votive associations. Those groups would periodically gather to offer devotion to the sanctuaries they had visited, using mandalas as a focus. A composition very similar to this one in the collection of the Mitsui Library, Tokyo, is inscribed as having belonged to a pilgrimage group known as the Sanei-kō. Some mandalas, however, have been kept at the sanctuaries themselves.

From right to left the composition is divided diagonally into three zones. At the far right is the Ise Outer Shrine (Gekū), dedicated to the goddess of cereals and sericulture, Toyouke-ō-mikami. Pilgrims approaching from Yamada city are shown in the lower right crossing the pontoon bridge over the Miyagawa; below them, others are washing in the stream. After crossing two other small bridges and passing a Buddhist temple to the right, the devotees enter the sacred *torii* (gate). There they encounter the Outer Stable, where horses donated to the god are cared for. Next is the *yojō-den*, a covered hall where ceremonies are performed in bad weather. The sanctum itself is enclosed by a stockade and consists of three thatched-roof structures, the center one being the shrine proper and the others, treasure-houses. Behind them is a two-storied gate, Buddhist style.

The next diagonal zone, which crosses the center line of the screen, represents the four miles separating the Outer and Inner Shrines. Within it one finds a small Nō stage, toll collectors, and amulet sellers; in the far distance is an open-air performance of shrine dancers. Directly beneath the darkened silver disc of the moon is a rock with three men gazing at it. This is one of the many rock shrines in the compound, and it represents Mount Miwa in the Yamato region (see No. 99). It is a symbol of the mother district of

the Japanese nation and of the Shintō shrine that nestles at the foot of the mountain.

At the lower center of the left panel is the large Uji bridge (270 feet long in reality), crossing the Isuzu River and marked at each end by *torii* (gates). Just above it is another of the *mitarashi*, places of water purification where pilgrims wash before praying. Above the Outer Stable are the shrines of two Shintō guardian deities, the Udaijin (Minister of the Right) and Sadaijin (Minister of the Left), shown as seated statues each in his own aedicule. The Ise Inner Shrine (Naikū) is dedicated to the Sun Goddess, Amaterasu-ō-mikami, ancestress of the imperial family. Here too, the main sanctum is flanked by two treasure-houses, set within a wooden stockade. Opposite the entry is the *yojō-den*, for ceremonies in bad weather. Above this are a number of subsidiary shrines, including one large rock with its own offering house at the very top of the composition. The mountain behind the Inner Shrine is Asama; at its foot is the Buddhist temple long affiliated with the shrine, the Kongōshō-ji.

In terms of the points of the compass, the composition is oriented with the east at the top, the west at the bottom. Comparing this picture with the condition of the shrines today, striking changes are apparent, although it is difficult to know how accurate the paintings are. Since the separation of the Shintō and Buddhist churches in 1868, the Buddhist elements have been eliminated. The style and spirit of the main shrine buildings have become more elegantly simple. They are now symmetrically arranged, their long axes facing the spectator, their thatched roofs now a simple gable form, no longer the hipped-gable type as shown here. Also, in the place of one stockade wall around each shrine, a large number of enclosure walls have been added. These old Ise mandalas, of which three are known today, are important documents for the development of Shintō architecture in the past two hundred years.

Reference: Nara National Museum, ed. *Suijaku no Bijutsu*. Tokyo, 1964. Nos. 87–89, pp. 72–73; Kyoto National Museum catalogue, *Koezu*. Kyoto, 1968. No. 440; Tange Kenzō, Kawazoe Noboru, and Watanabe Yoshio. *Ise, Prototype of Japanese Architecture*. Cambridge, Massachusetts, 1965.

63. Nō mask of the Okina (Old Man) type

Muromachi period (sixteenth century)
Cypress wood painted with flesh-colored gesso; eyebrows of cotton, beard of hemp fiber
H. 7 1/4 in. (17.5 cm.)

Okina, the fun-loving semidivine Old Man, is one of the major figures of the medieval Nō drama, but he originated in Japanese popular theatre of far greater antiquity. There are records of Okina plays performed in the mid-Heian period by wandering troupes of *sarugaku* minstrels. *Sarugaku* (literally, monkey music) was to be seen at fairs and temple festivals and, as described in early accounts, consisted of dancing midgets, puppetteers, jugglers, pantomimists, and humorous, satirical dancers making fun of monks and nuns and government officials.

As the Nō theatre was formed in the late fourteenth century, it absorbed and adapted many elements from popular entertainment, from *kyōgen* and *sarugaku* in particular, and the plays featuring Okina were given special prominence. Most Nō performances are begun with an Okina play, in which the Old Man, extending his arms and opening his fan, recites a prayer to invoke peace in the world, tranquillity in the land. During New Year's festivities and performances held on congratulatory occasions, this benediction is especially appropriate. The character of Okina is charged with great significance and, according to Donald Keene, " . . . performing this role, devoid though it is of emotion or special displays of technique, is considered so arduous as to shorten the life of the actor."

Okina masks from the older, folk theater were used in Nō without alteration. And so great is the force of tradition within Nō that the oldest Okina masks, dating from the twelfth century, have been copied for centuries, with only the slightest variations. The Okina mask, moreover, is simpler and less subtle than other types in Nō, but it is the only one having a movable chin. This is a trait of the more elaborate and ancient *bugaku* masks, of which the Okina form must be seen as a simpler, almost folkish version. In the early Okina masks, the technique of painting was similar to that used for *bugaku*; a relatively thin layer of colored plaster was used, but not to conceal the grain and texture of the wood.

Close dating of this particular mask is difficult, in view of the faithful repetition of the type over the centuries. It lacks, however, the shading at the edges, which was added after 1600 or so to suggest an antique appearance. The chisel marks on the reverse side are somewhat uneven, giving evidence either that the carver was rushed or that he was not highly trained. Nevertheless, this mask suggests a wider range of expression than the usual Okina type; depending on the angle of vision, the mask seems to laugh in surprise, chortle, or look sorrowfully introspective. Obviously it has been used repeatedly, for the paint on the edge has worn away with handling; the chin has been repainted, and the reverse side is darkened with the oils of human sweat.

Reference: Donald Keene and Kaneko Hiroshi. *Nō, the Classical Theater of Japan*. Tokyo, 1966; Shirasu Masako. *Nō Men*. Tokyo, 1965; Friedrich Perzynski. *Japanische Masken*. Berlin, 1925; Suzuki Keiun. *Nō no Men*. Tokyo, 1966.

Arts Related to the Zen Sect

Ink Painting (*suiboku-ga*)

Few forms of imagery are as simple technically as Japanese *suiboku-ga* (literally, "water-ink paint-ing"). Dark ink is applied with a soft hair brush to silk or paper, with an occasional touch of color added for accent. But, as with a flute or violin, such relatively simple materials allow the artist to achieve ex-tremely subtle effects and delicate nuances of personal expression.

For the Japanese, monochrome ink painting became a major, independent tradition relatively late in their history, but they adopted it with wholehearted fervor. Its development was linked with that of Zen Buddhism, for which it had a basic affinity. In keeping with the respect for austerity and simplicity within that sect, *suiboku-ga* was severely limited in expressive means. It contrasted sharply with Buddhist devotional art, with the gold patterns, artificial lines, and bright colors used to depict the great Mahāyāna deities in a sumptuous, highly idealized manner.

In China, ink painting had flourished for centuries without any special connection with the Ch'an (or Zen) creed. But in the thirteenth century, Ch'an monks in the Hangchou region began painting very actively as part of their spiritual discipline, and they did subjects deeply rooted in China's nature sym-bolism—birds, tigers and dragons, flowers, and landscapes. They also made portraits of great Ch'an teachers, devised their own variations on traditional Buddhist subjects, and illustrated the history and doctrines of the Ch'an sect.

Ink painting became a major artistic idiom in Japan centuries after it had developed in China. It is true that work in ink alone was done in Japanese Buddhist ateliers as early as the eighth century, but these were chiefly preliminary drawings or cartoons. While there is evidence from the Heian and Kama-kura periods for the existence of long-lost landscape screens in ink alone, monochrome ink painting did not really flourish until the fourteenth century, when the Zen sect became firmly established and con-tacts with the Chinese mainland resumed on a large scale. Throughout that century and the first half of the fifteenth, virtually all ink painting in Japan was done by Zen monks or by laymen under their in-fluence. True to the principles of Buddhist philosophy, these men sought in their work to subdue their identities, their sense of self or ego. Some monks would restrict themselves to painting a single theme for years at a time, each day repeating it as they would a prayer, and offering a picture occasionally to

a student or a layman. Other monks were more adventurous as artists, going as far as, by the middle of the fifteenth century, making large-scale screen paintings to provide a suitable atmosphere for meditation chambers and living quarters.

At the same time, ink painting within the Kyoto monasteries became somewhat professionalized. Certain monks—Minchō at Tōfuku-ji and Shūbun at Shōkoku-ji, for example—devoted most of their time to the arts. Shūbun, moreover, seems to have taught men from other monasteries who came to him as they might to another specialist for instruction in Buddhist theology. Stylistically, Japanese *suiboku* painters took as their models Chinese masters of the thirteenth and fourteenth centuries—Ch'an monks like Mu Ch'i, Yü Chien, and Yin-t'o-lo—or else their more famous contemporaries in secular life who worked in the Southern Sung Painting Academy—Ma Yüan, Hsia Kuei, and Liang K'ai. Also serving as models were less famous men of the Yüan period, such as Yen Hui or Hsüeh-ch'uang. Those Chinese models were all one or two centuries old, and the Japanese, as they had done often in the past, tended to perfect an artistic idiom long after it had gone out of fashion on the mainland.

That peculiar kind of archaism came to an end with the career of the remarkable monk-painter Sesshū. In 1468–69, while still young, he made a momentous trip to China and gained an accurate, up-to-date knowledge of painting there. He was a man of impressive talent and energy, in some ways similar to Michelangelo, active a generation later and half a world away. Sesshū injected into the rather idealized, romantic atmosphere of Japanese ink painting a sense of intellectual discipline, of rigorously schematic composition and strong individualism. And like Michelangelo, the impact of his personality and achievement remained strong for centuries, serving as a model and ideal for later generations.

By the early sixteenth century, the taste for *suiboku-ga* had spread wide among the community at large. Members of the Ashikaga family, who ruled Japan virtually as military dictators, had been deeply concerned with both Zen Buddhism and the renewed taste for imported art objects from the Chinese mainland. The first shogun, Takauji, painted modest devotional pictures and fell strongly under the influence of the Zen monk Musō Soseki. The third shogun, Yoshimitsu, collected Chinese paintings, and his suburban villa north of Kyoto, now known as the Kinkaku-ji (Golden Pavilion), was modeled on a hermitage built by Musō, the Saihō-ji. Yoshimochi, the fourth shogun, was an extremely accomplished ink painter. And Yoshimasa, the eighth, was a major force in the history of art. His artistic interests came ahead of politics, and during his long reign the country erupted in the first of a long series of violent civil conflicts.

Yoshimasa expanded the family collection of Chinese paintings and ceramics, and he formed a circle of connoisseurs and aesthetes at his villa in the Eastern Hills of Kyoto (the Higashiyama Palace). He patronized the Nō theatre and consulted numerous artistic advisers, among them Shūbun. It was during Yoshimasa's time that the tea ceremony became a central feature in Japanese culture—the ritualized drinking of tea in an environment of both refined simplicity and great beauty. Done under the leadership of a Zen monk, the ceremony had a sacerdotal air combined with the enjoyment of good fellowship and rare bowls and utensils, the cultivation of a feeling for sober, unadorned nature.

In the atmosphere of this new taste, Japanese ink painting gradually overshadowed the other traditional schools of art. Throughout the sixteenth century, the demand was so great that an increasing number of schools and subschools of *suiboku-ga* developed. A group of Zen painters worked in Kamakura, for example, led by the monk Kei Shoki. In the far northeast were the eccentric and prolific monk-painter Sesson and his followers. In the Nara region were semiamateur painters like Nara Kantei and Yamada Dōan. The mainstream of ink painting, however, remained in Kyoto and was occupied by painters of the Kanō school. Founded by Kanō Masanobu, one of the chief painter-advisers of the Shogun Yoshimasa, the members of that school tended to codify and consolidate the techniques and styles developed during the previous century. Connections between the Kanō school and the Zen monasteries were maintained over two centuries, and the Kanō artists perpetuated subjects that had risen in Zen circles. But the character of Kanō *suiboku-ga* became increasingly secular in spirit, just as Italian Renaissance painting for the Catholic Church gradually lost its basis in a genuinely votive, pious attitude. Moreover, by the middle of the sixteenth century, Kanō painters were doing genre themes of native Japanese life in bright color, laying the groundwork for the development of the highly decorative, large-scale screen paintings that so excited the patrons of the Momoyama and Edo periods.

The continuing appeal that ink painting had for both religious and secular circles in Japan created a demand that the Kanō ateliers alone could not fill. In the last decades of the sixteenth century, workshops came into being that painted more or less the same subjects in the same manner as did the Kanō school. The Kyoto atelier of Hasegawa Tōhaku claimed to be the legitimate successor to Sesshū; so also did Unkoku Tōgan, who actually won the lawsuit contesting the right to make this claim. Another rival to the Kanō painters was Kaihō Yūshō. He had studied under a Kanō master but set up his own independent atelier and gained the patronage of the most prestigious patrons. Although these variants of the Kanō school lasted for several generations, their main period of prosperity came to an end by the middle of the seventeenth century.

拘留孫佛を出し生ま時吉祥
長者之家に稻金毛師子而
姚雲中移り以文佛村爲兆
徳遊羅い之子生ま葵う葦
王而志海底惟を禹均求ん
廳之坐示生に利濟搭去
廣衣不露生許　慧極と

64. Mañjuśrī dressed in a robe of braided grass

Muromachi period (ca. 1425–1450)
Painter unknown; inscribed by Gukyoku Reisai (1363–1450)
Kakemono; color and ink on silk
H. 35 7/8 × 15 3/8 in. (91.1 × 39 cm.)

This young boy of sensuous, almost effeminate beauty represents an incarnation of Mañjuśrī, the Bodhisattva of Divine and Compassionate Wisdom, which is symbolized by the sūtra scroll he holds in his hand. Originating in the Zen Buddhist circles of Kyoto, this work demonstrates the willful reversal of the values of traditional Buddhist art that the Zen sect encouraged.

An instructive comparison of Zen and orthodox Buddhist representations of the same deity can be made between this work and No. 44. That painting of Mañjuśrī is only slightly older, but it comes from a traditional Buddhist atelier and shows him in his most familiar guise, a young "prince royal" lavishly adorned and mounted on a majestic lion. In this painting Mañjuśrī wears only a simple armlet of woven grass. The color scheme is subdued, going from tawny earth browns in his robe to the dark black of his hair and the warm tones of the silk. In its austerity, this painting reflects the ascetic, restrained temper of Zen taste.

The long hair falling to the shoulders is found in Bodhisattva imagery as early as the first century A.D. in India. Here, the hair is noticeably soft and natural. The hair is an important feature, for in inscriptions appearing on other versions of the Nawa Monju, it is described as hanging like dense clouds or like disheveled threads. The robe is worn in the manner of the soft, cotton garments of the monks of South Asia, covering the left shoulder and leaving the right one bare. Here, however, the garment is made of thick strands of braided grass and seems both uncomfortable and unwieldy.

The inscription was written by a learned monk, Gukyoku Reisai, who became abbot of the great Zen monastery of Tōfuku-ji, in the hills southeast of Kyoto. He was known for his intense devotion to Mañjuśrī and also as an artist and calligrapher; but his fame was overshadowed by that of his celebrated colleague, the monk-painter Kichizan Minchō. Both were active about the same time in Tōfuku-ji, and Minchō also illustrated the theme of Mañjuśrī in a braided grass robe. It is possible but not likely that

Reisai painted this work; his inscription, however, is written in an elegant, refined hand. Its meaning is scholarly and somewhat obscure:

> When the Buddha Krakucchanda [the fourth of the Buddhas of the past] was born in the world, the Auspicious One [Mañjuśrī] appeared at the home of a wealthy man riding upon his golden-haired lion. In the time of the Buddha Śākyamuni, he appeared as the son of the Brahman Bontoku seated on a jeweled lotus pedestal emerging from the bottom of the sea. For an incalculable period of time, [however], he has been unable to save living beings. Hence he rises [in this new form] wearing a grass robe, which does not reveal his entire body.
>
> [signed] *The aged Gukyoku*

The motif of Mañjuśrī in a grass robe (called in Japanese the Nawa, or Sōe, Monju) was common in Japanese Zen painting of the late fourteenth and early fifteenth centuries. Over a dozen examples from that period remain in Japan, and four major works are in the West (including this one). The Powers painting, however, along with several others in Japan, has been attributed to a certain Hsüeh Ch'ien, an obscure Chinese Ch'an monk who, like such other historical Chinese masters as Mu Ch'i, Yü Chien, and Yin-t'o-lo, lived chiefly in the esteem and memory of the Japanese and faded from memory in China. The Japanese know Hsüeh Ch'ien as a Yüan period master, skilled in painting Mañjuśrī and Avalokiteśvara (Kannon); he was so recorded in the late fifteenth-century Japanese connoisseur's manual, the *Kundaikan Sōchōki*. In Chinese Ch'an records, there is only evidence of a monk of roughly the same name (Ta-mei Hsüeh Ch'ien Shên) active in the monastery on Mount Ching near Hangchou, where Mu Ch'i and then Yü Chien lived and worked generations earlier. While Hsüeh Ch'ien may have been the painter of several works attributed to him in Japan, in all likelihood this one was done by a semiprofessional Japanese artist and inscribed by Reisai.

The motif of Mañjuśrī in a braided grass robe was

based on the legends of a vision of a Northern Sung official named Lü Hui-ch'ing, who had been an associate of the famous reformer Wang An-shih. He had come to worship on the spot in China most sacred to Mañjuśrī, the sanctuary of Wu-t'ai-shan. At the Central Terrace of the mountain, he was startled by a terrible thunderstorm, and from the clouds emerged a young boy. At first the boy resembled a blue dragon, but he was clothed in a robe made of braided grass and held a scripture before him. The boy asked Lü why he had come to the mountains in bad weather. Lü replied that he wanted to meet Mañjuśrī because he had found it difficult to understand certain Buddhist texts; the Bodhisattva could clear up these doubts. The boy then said that the truth of all the Buddhas is simple but that it had been obscured by endless texts and commentaries. Lü then chided him for criticizing the holy scriptures, whereupon the boy transformed himself into the traditional form of Mañjuśrī and disappeared in the clouds riding on a golden-haired lion. Realizing that he had actually seen Mañjuśrī and contradicted him, Lü bitterly regretted that the Bodhisattva had left him. Returning home, he burned incense day and night and prayed that the boy in the grass robe would reappear. He subsequently had a painting made of his vision.

That tale, which exists in at least two versions, is typical of the legends of Mañjuśrī at Wu-t'ai-shan; it also appealed greatly to the Ch'an Buddhists. Not only did it stress the fact that latter-day religious literature had obscured the essential truths of the faith, it also emphasized that even though appearances are deceptive, behind appearances is a profound unity, a fundamental First Principle. Things may alter in form—grow and blossom or decline and rot—but the underlying principle of being is unaltered. One thus cannot say that any one human experience is truer than another, for all experiences are equally close and equally far from the unknowable origins of being. The Bodhisattvas change their shape at will, but their mission of salvation remains constant, and no one form of the Bodhisattva is more sacred than another. Hence, at Wu-t'ai-shan, Mañjuśrī was thought to appear to those who need him as a royal prince, a beggar woman, a weak old man, even a donkey. This painting shows him in yet another permutation, an ascetic young boy dressed in the humblest robes, yet possessed of the highest wisdom and sanctity.

Formerly in the Makoshi collection, Tokyo.
Published: *Kokka*, no. 450 (May 1928); *Shina Meiga Hōkan* (The Pageant of Chinese Painting), vol. II. Tokyo, 1936. Pl. 408; Nakamura Tanio in Shimada Shūjirō, ed., *Zaigai Hihō*, vol. I. Tokyo, 1969. No. 77. Reference: *Kokka*, no. 410 (January 1925); *Kokka*, no. 126 (August 1900); *Seizansō Seishō* (illustrated catalogue of the Nezu collection), vol. I. Tokyo, 1939. Pl. 48.

65. The monk Ling-yün viewing a peach tree

Muromachi period (late fourteenth to early fifteenth century)
Inscribed by the monk Sokuan
Hanging scroll; ink on paper
H. 33 1/4 × 11 1/4 in. (84.5 × 28.5 cm.)

This must have been done by an amateur monk-painter, possibly Chinese. It was painted in the abbreviated, highly simplified style of such Southern Sung masters as Liang K'ai and Chih-weng, but this artist was unusually fond of detail. In the sandals and fishing pole, for example, he injected many more descriptive elements than the principle of maximum economy of means ordinarily allows. This picture is comparable to figure paintings by the Japanese monks Kaō, Mokuan, and even Josetsu, but in the work of those men one does not find the same brush handling as here, especially along the back and around the hat, where the rough calligraphic lines generate a strong sense of spatial depth. In the treatment of the feet and the black accents of the collar, this work shows some affinity to the style of the fourteenth-century Ch'an painter Yin-t'o-lo, but the composition is far less dynamic than his.

The theme is a familiar one in the didactic painting (*dōshaku-ga*) of the Zen tradition, the moment when the T'ang monk Ling-yün attained *satori* while gazing at a blooming peach tree (see No. 78, scene 2). In the upper left of the picture, a peach branch had originally been painted. Scholars who saw this painting in Japan years ago recall its presence. For some reason the branch was removed, but not without leaving a hazy outline.

Ling-yün had been a pupil of the Ch'an master Wei-shan, who encouraged his followers to cultivate immediate experience, to find salvation in simple, ordinary events. A fellow pupil of Ling-yün's was the monk Hsiang-yen, who attained *satori* upon hearing the sound of a rock striking bamboo (No. 78, scene 7). In Ling-yün's case, all questions in his mind about the inevitability of decay and death were resolved suddenly as he saw a peach tree in bloom. This was his moment of *satori*, and he composed a poem which is recorded in the *Ch'uan-t'eng-lu*, Vol. XI, and the *Wu-t'eng-hui-yüan*.

For thirty years
　　I searched for the sword.
Often I watched leaves fall
　　And branches send forth shoots.
But from the moment
　　I saw peaches bloom,
No further doubts.

At the top of this painting is an inscription based on Ling-yün's poem. It was composed by a monk who used one seal reading "Sokuan" and another reading "Zenyo gisho" ("playful signature in the fullness of Zen"). Sokuan corresponds to the name of an abbot of Tōfuku-ji in Kyoto, Sokuan Reichi, who died in 1419. He was one of the nineteen distinguished men who inscribed the famous painting by Josetsu showing a fool attempting to catch a catfish in a gourd. This seal, however, is different from any known to have been used by the abbot, and it is possible that the inscription was done by another monk with the same name—not an uncommon occurrence in Japan where the same monastic names were often used by men unknown to each other.

Written from left to right, the poem may be translated:

At first sight of the peach blossoms
　　No further doubts.
As before, my eyebrows
　　Extend over my eyes.
Since I fade [as do the blossoms]
　　What need to complain and complain.
The earth is broad, the heavens high.
　　I know myself.

Reference: *Tōfuku-ji-shi.* Kyoto, 1930; *Zenshū Jiten.* Tokyo, 1915. P. 1119.

地厚天高我自知
謝卻何如重饒舌
依然眼上帶雙眉
一見桃花便不疑

66. Calligraphy scroll

Muromachi period (mid-fifteenth century)
Ikkyū Sōjun (1394–1481)
Kakemono; ink on paper
H. 51 1/2 × 13 3/4 in. (130.9 × 34.9 cm.)

The eight large characters written in Ikkyū's vigorous running style may be translated, "The First Patriarch, the Great Master Bodhidharma" (Shoso Bodaidaruma Daishi)—a simple reference to the legendary founder of the Ch'an sect in China (see No. 102). In contrast to the other work of Ikkyū exhibited here (No. 66), this calligraphy is considerably more restrained. It lacks the thrust of spiritual energy expressed by the untrammeled brushwork in the other scroll, which is a serious personal treatise on Zen. Here, in writing the name of the revered First Patriarch, Ikkyū contained his own energies to some extent, but not completely so. In principle, an Enlightened monk such as Ikkyū stood on an equal footing with the Buddha, Bodhidharma, and other ancient masters, and was thus free to imbue his writing with the distinct imprint of his own spirit.

According to the certificate that accompanies it, this calligraphy was written by Ikkyū and given to the famous monk Murata Jukō as a certificate of Jukō's having attained Enlightenment. The document, which is dated in 1785, further states that Jukō had the work mounted and kept in his collection. There is no definite proof of the authenticity of the certificate. The calligraphy itself is not signed, but it does bear Ikkyū's seal and is unmistakably in his hand. Moreover, Jukō was a member of the small circle of Ikkyū's close followers at Daitoku-ji. He studied the ritual serving of tea with Ikkyū and later became the tea master of the Shogun Ashikaga Yoshimasa. Jukō is regarded as one of the patriarchs of the tea tradition in Japan. The document also records that according to the instructions of Sen no Rikyū, the outstanding tea master of the late sixteenth century, the scroll was hung in a tea house built especially tall to harmonize with its unusual length. It also states that Rikyū refused to sit in the place of honor at the

ceremony in which it was displayed, leaving the seat open in honor of Jukō. The scroll later passed through the hands of families closely connected with the Japanese tea customs. And whether or not the certificate of its origins is accurate, this scroll has long been celebrated in these circles as a precious relic of both Jukō and Ikkyū.

Calligraphy of this kind, in which a single line of script fills a narrow format, is unknown in China. It seems to have developed in Japan; an early example in the Zen style is a scroll of four characters, "Shaka Nyorai" (Śākyamuni the Tathāgata), written by the second abbot of Daitoku-ji, Tettō Gikō in the mid-fourteenth century. This custom, however, seems to have been an adaptation of the trait in Japanese Pure Land Buddhism of inscribing boldly and prominently the formula of devotion to Amitābha, "Namu Amida Butsu," in six Chinese characters. Two other examples of Ikkyū's writing in this manner may be seen in the Shinju-an, the subtemple of Daitoku-ji that was founded in his honor; and Ikkyū probably modeled these one-line calligraphies on the work of Tettō. In later years, Daitoku-ji monks such as Takuan Shūhō (see No. 77) and Kōgetsu Sōgan chose this as a favored format for their own writing. It was even adopted by Chinese Zen masters who came to Japan as refugees after the fall of the Ming dynasty, especially Yin-yüan Lung-chu (Ingen Ryūki, see No. 100) and his disciples, who founded the monastery o Mampuku-ji. (S.S.)

Formerly in the Inui, Masuda, and Ogawa collections. Published: exhibition catalogue published by the Mainichi Shimbun, *Suiboku-ga Kokuhō-ten Zuroku*. Tokyo, 1957. Pl. 163; exhibition catalogue of the Museum of the Yamato Bunka-kan, *Ikkyū Ōshō-ten*. Nara, 1963. No. 35; *Yamato Bunka*, vol. 41 (August 1964). Pl. 17B. Reference: *Sadō meiki kan*, vol. V. Tokyo, 1965. Pl. 15.

67. Calligraphy scroll

Dated the twenty-first day of the twelfth month, 1457
Ikkyū Sōjun (1394–1481)
Kakemono; ink on paper
H. 47 7/8 × 14 in. (121.5 × 35.5 cm.)

Rough, bold, and full of vigor, this calligraphic
work reveals the fiery passion of the extraordinary
Zen monk Ikkyū Sōjun. It is in praise of a Chinese
monk of the thirteenth century, Hsü-tang Chih-yü,
who had served in the Hangchou region in a number
of monasteries where many Japanese monks had gone
to study. He exerted a profound influence on latter-day
Zen in Japan. He was often depicted, for example, by
the monk Hakuin (see No. 102), and Ikkyū actually
considered himself a reincarnation of Hsü-tang; two
well-known portraits of Ikkyū show him as Hsü-tang,
inscribed by Ikkyū as though they were his own image.
The verse here is cryptic and obscure and refers to
doctrinal matters:

> Old Hsü-tang revitalized the school of
> (Ts'ao-)Tung [Sōtō],
> Eliminating and destroying that which would
> bring disaster to posterity.
> Clear and distinct are the Host and Guest.
> The Three Essentials are apparent in the
> yellow flowers of the double nine
> [the ninth day of the ninth month].

I composed this verse concerning Hsü-tang's assist-
ance to the Sōtō school; the first year of the Chō-
roku era [1457], the winter solstice day. [Written
by] the Man of the Mad Cloud, Sōjun.
 Seal of Ikkyū

Ikkyū is one of the most absorbing and contradictory
personalities of fifteenth-century Japan. He was born
on New Year's Day, 1394, and was the son of the
reigning Emperor Gokomatsu. He was never openly
acknowledged as an imperial prince, however, and
his mother was forced to leave the palace. She sent
him at the age of six to a Zen monastery, where he
began his training in Zen discipline and scholarship.
At the age of eleven he had mastered the ancient
Mahāyāna Buddhist text *Vimalakīrti-nirdeśa-sūtra*, which
celebrates the wisdom and virtue of laymen; at the
age of fifteen he had mastered composition in Chinese
verse. During his twenties, he became a wandering

167

monk until he was finally admitted as a disciple by Kasō Sōdon, a Zen master who belonged to the Daitoku-ji branch of the Rinzai school and who was known for the severity of his discipline. It was Kasō who gave him the name Ikkyū, meaning "a rest" or "a pause" between the realm of the material world and that of the monastery. At the age of twenty-seven, after many trials and hardships of training under Kasō, Ikkyū attained Enlightenment. By tradition, this occurred late on a summer night as he was sitting in meditation in a small boat on Lake Biwa; heavy rain clouds passed overhead; the silence was broken by the cawing of crows; he cried out in wonder.

Ikkyū was strongly dissatisfied with the Zen sect of his time, which thrived under the patronage of the Ashikaga shogunal government and the powerful feudal lords. The arts and letters flourished, but within the monasteries, much of the spiritual vigor that marked the high achievements of Zen in the fourteenth century was being lost. Ikkyū rebelled against the clerical hierarchy of the Zen sect and the stultifying atmosphere of the temples, and he resisted appointment to a leading position in one of the large temple compounds. For a monk he was eccentric in his behavior, and was frequently seen in wine shops and brothels. He claimed that in his profligacy he attained a sanctity far greater than hypocritical monks whose failings were those of the spirit. His poems are filled with boasting and attacks on other monks; they are collected under the title *Kyōun-shū* (The Mad Cloud Collection). Through more than half of his career as a Zen monk he drifted from one small hermitage to another, training only a handful of disciples. In 1474, however, in response to an imperial summons, Ikkyū assumed the abbacy of Daitoku-ji, which had lost its major buildings in the fires of the Ōnin Rebellion (1476–1477). Only a handful of monks remained there, and Ikkyū was thought to be the sole monk able to reconstruct the vast monastery. Then, in 1481, when the rebuilding was nearly completed, Ikkyū died at the age of eighty-eight.

Despite his anger against the complacent monks of his age, Ikkyū revered outstanding Zen masters of the past, as this poem suggests. His reference to Hsü-tang revitalizing the Ts'ao-tung (Sōtō) school of Zen is too complex an issue to explore here, other than to say that Hsü-tang was an associate of the more famous Wu-chün in the effort to restore the Ch'an sect in South China in the late twelfth and early thirteenth centuries. The "host" and "guest" mentioned in the verse refer to a well-known essay of Lin-chi (Rinzai) explaining the proper relationship between a master and his disciples, especially at the time of *mondō* (questions and answers between the two). The "three essentials" refer to another quotation from Lin-chi, suggesting, perhaps, the metaphysical entities of substance, quality, and activity; while the "yellow flowers of the double nine" are based on a commentary on the three essentials by a Zen monk of the Sung dynasty, Fen-yang Hsi-chao. (S.S.)

Reference: *Yamato Bunka*, vol. 41 (August 1964), special issue devoted to Ikkyū; Donald Keene. "The Portrait of Ikkyū," *Archives of Asian Art*, XX (1966–1967), pp. 54–65.

68. The Three Laughers of Tiger Valley

Muromachi period
Bunsei (active mid-fifteenth century)
Ink on paper
H. 22 3/8 × 12 1/2 in. (56.8 × 31.75 cm.)

This important early example of Japanese ink painting shows three famous, eccentric old men turning toward each other in an outburst of spontaneous laughter. The Buddhist monk Hui-yüan on the left, dressed in a robe of large patches, just violated his solemn vow never to leave the Hermitage of the Eastern Grove, which he founded on the verdant slopes of Mount Lu. Unintentionally, while seeing off two friends who had come to visit, he crossed a bridge over the stream that marked the outer boundary of the monastery. At that moment, the three men heard the sudden roar of a tiger. Startled, they realized Hui-yüan's vow had been broken and responded with wild laughter to the irony of the event, for the spiritual purity of a man is in no way governed by artificial boundaries.

This painting is probably the oldest extant version of the allegorical three laughers theme, which is filled with the philosophic overtones that strongly attracted artists and patrons of the Zen sect. In the lower right corner is a seal in red ink reading "Bunsei," which appears in a credible form on only a half-dozen other pictures. The general style and character of those works indicate that a man calling himself Bunsei probably studied with Shūbun, who seems to have trained an entire generation of monk-artists in his lyrical, highly idealized style (see No. 69). Because of the scanty information, however, it is extremely difficult to write biographies of such men. It is even hard to discover to what extent they were subject to serious monastic discipline and to what extent they were fulfilling, within monastery grounds, a Chinese ideal of the creative, semiprofessional artist, the Wên-jên (Bunjin).

Of the six paintings thought to be by the one man, Bunsei, two are romantic landscapes, of which the Boston Museum of Fine Arts has an outstanding example. Two are portraits of monks associated with Daitoku-ji, Abbot Yōsō Sō-i, dated 1452, and the Chinese monk Yang-ch'i, whose portrait was inscribed by Yōsō. The sixth painting, dated 1457, shows the Indian sage Vimalakīrti. Now in the Museum of the Yamato Bunka-kan in Nara, it is one of the masterpieces of Japanese ink painting, with its decisive, angular brushstrokes and vivid characterization of the face. A landscape painting in the National Museum of Korea in Seoul bears a "Bunsei" seal; similar to it are a pair of landscapes in Japan, with the same seal. Those Korean "Bunsei" works are quite different in style from the group defined here and will not be discussed.

Compared to the other Bunsei paintings, the "Three Laughers" shows signs of having been slightly washed or else faded; the inky darks have lost some of their intensity. Nonetheless, the painting captures the essential spirit of the subject. The old men are shown slightly off-balance, as though shocked by the impact of their new insight. The drawing of the bodies is not incisively descriptive or structural but dissolves into a softly independent play of lines and patterns. Only the carefully painted faces convey the psychological intensity of the moment. The somewhat wavering quality of the outlines and the uncertain drawing of the sleeves suggest that they may have been copied from another painting now lost or unknown. The possibility that an earlier work was the model for this one is reinforced by another painting of the three laughers in the Asano collection. It is perhaps two decades later in date but so close to this one in composition, pose, and details of the figures that the two must be linked, most likely by another picture from which both were derived. The Asano painting is inscribed by four separate men, one of whom is well-known in Kyoto Zen circles, the monk, Moku'un Ryūtaku.

The inscriptions on the Asano painting are of special value in interpreting the symbolic significance of the three laughers theme. That of Moku'un Ryūtaku reads as follows:

> [A man in a] Taoist hat [and a man in] Confucian shoes in the style of [the] Chin [dynasty]
> Visit the Master of Solitude [Hui-yüan] as, in the city, the water clocks [of the night] let fall their last drop.
> At the verdant face of [Mount] Wu-lao the three men first laugh,

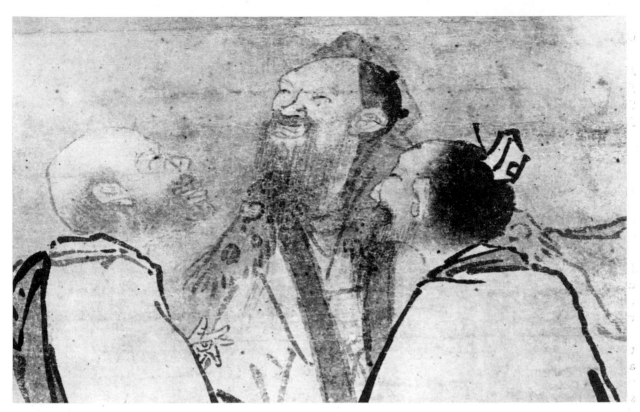

detail

[Realizing that] together they have silently crossed the bridge.

The central figure, wearing a leopard-skin cape, is T'ao Yüan-ming, a name familiar to all students of Chinese poetry. Born to a family with traditions of Confucian public service, T'ao gradually found himself unable to perform official duties. He turned instead to a life of near poverty, dwelling near Mount Lu as a semi-recluse, cultivating chrysanthemums, drinking a great deal, and writing. Shown at the right n̲/the painting is a Taoist priest named Lu Hsiu-ching who was a wonder-worker also living near Mount Lu in the early fifth century.

Hui-yüan is one of the outstanding figures in the early history of Buddhism in China, occupying a position roughly analogous to that of his contemporary, Saint Jerome, in the history of Christianity. Hui-yüan succeeded in translating Indian Mahāyānism into terms easily understood by cultivated Chinese, expressing himself largely in traditional Chinese literary language. He had originally been a disciple of the great fourth-century Buddhist translator and evangelist T'ao-an. Hui-yüan carried on an extensive correspondence with the Indian missionary, Kumārajīva, in China. When Hui-yüan joined the Tung-lin monastery on Mount Lu

around 384, he vowed never to leave its borders, never to return to the lay world of passions and dust, a fact particularly stressed in his traditional biographies, which also claim that he never violated his vow.

The theme of the three laughers contradicts that fundamental aspect of Hui-yüan's biography. The subject flourished in Chinese Ch'an paintings of the Southern Sung period, which exalted spontaneity and freedom of the spirit, the relaxation of the rules of monasticism and liturgy, and the essential unity of high religions. Iconologically, it is the same genre as is the theme of the "three tasters of vinegar" (three creeds responding to the same reality) or the "three religions" (personified by Confucius, Lao-tzu, and the Buddha), which are commonly encountered in Japanese ink painting of the fifteenth century.

Published: Tanaka Ichimatsu in *Kokka*, no. 668 (November 1947); Suzuki Daisetsu. *Zen and Japanese Culture*, rev. ed. New York, 1959. Pl. 30; Watanabe Hajime. *Higashiyama Suiboku-ga no Kenkyū*. Tokyo, 1948; Matsushita Takaaki, ed. *Suiboku-ga*. Nihon no Bijutsu, no. 13 (1967), fig. 53.

69. Landscape with distant mountains

Muromachi period (mid-fifteenth century)
Shōkei Ten'yū (active 1440–1460)
Sumi ink, with pale brown and blue-green color on paper
H. 31 1/2 × 14 1/4 in. (79.9 × 36.1 cm.)

This landscape is divided into two starkly separated units, the foreground island and the mountains in the background. They are joined compositionally by an expanse of water, suggested by the two boats in the middle ground. The relative emptiness of that area adds a somewhat romantic aura, a sense of distance, loneliness, and separation. This sophisticated mode of composition appeared in China in the fourteenth century, in the work of Ni Tsan in particular, but also in that of Wu Chen and Wang Fu.

In Japan it appeared in the 1450s and 1460s as a distinct part of the expressive language of the painters active in Kyoto under the tutelage of Shūbun. The works that come from there, the first fully developed school of Japanese ink painting, frequently have neither seal nor signature, and are not easily attributed to a given artist. Some, moreover, have misleading seals added by connoisseurs of later periods. In others the seals are authentic but nonetheless offer little more than tantalizing clues to the identity and character of the artists.

Bunsei (see No. 68) was a member of the group; so also was Gakuō, perhaps younger by one generation and well known in the United States through paintings attributed to him in the Baltimore Museum and the Freer Gallery in Washington, D.C. Included for a while were Soga Dasoku and Bokkei, both of the Shinju-an of Daitoku-ji and both connected with the monk Ikkyū (see Nos. 66, 67). The master Oguri Sōtan seems to have been Shūbun's successor as the leader of the group, but from his brush not one certifiable work has survived.

The painter of this landscape was unquestionably a member of the circle and one of the most sensitive. At the lower right corner is a seal reading "Shōkei" (Pine Valley), a cryptic name held by several Zen monks of the era. To his same hand can be attributed five other important paintings, and in three of them he used a second seal reading "Ten'yū" (Divine Leisure). The name Shōkei is found in *The History of This Nation's Painting* (the *Honchō Gashi*), written in 1678 by Kanō Einō on the basis of the records of his father, Sanraku. There Shōkei is described as the painter of an image of Kannon in ink, as having studied the work of Mu Ch'i, and as a descendant of the Takuma family (see No. 30). The Takuma connection is of special interest, for it is further evidence that this ancient family dynasty of semiprofessional Buddhist painters had transferred their loyalties to the new style of ink painting cultivated in the Zen monasteries. Whether Shōkei himself was a monk or a layman or what the dates of his birth and death were or what his personal background was are questions for which there are as yet no answers.

Remarkable stylistic consistency appears in many of the landscapes of Shōkei, Bunsei, and Gakuō. The basic furniture of their scenes—rocks and gnarled pine trees and mountain peaks—came chiefly from the Southern Sung Academy masters so widely admired in Japan, Ma Yüan and Hsia Kuei. But the painting technique was considerably less calligraphic and disciplined, somehow more impressionistic, nervous and fine-textured. Above all, the emotional tenor of these works is lyrical and slightly melancholy, strikingly different from the more conservative manner of the Southern Sung models.

In this painting, Shōkei unified the foreground and distant mountains by means of a carefully contrived, two-dimensional design. He applied the principle of repetition and parallelism as strictly as would a Poussin or a Cézanne. The shapes of the mountain peaks are echoed among each other and in the foreground rocks. The sandy beaches and bands of mist set up a distinct, pulsating rhythm of horizontal bands.

Originally, the format of the composition must have been much taller. Landscape hanging scrolls from Zen circles of this era all have room above for poetic commentaries; here the text must have been lost. The work also has been extensively but carefully repaired, and much of the original aesthetic integrity is intact.

Formerly in the collection of the Dan family.
Published: Kanazawa Hiroshi in Shimada Shūjirō, ed. *Zaigai Hihō*, vol. I. Tokyo, 1969. No. 84; Tanaka Ichimatsu in *Kokka*, no. 695 (1950); Tanaka Ichimatsu. *Nihon Kaigashi Ronshū*. Tokyo, 1961. Pp. 327–329, fig. 193; *Kokka*, no. 66 (1895).

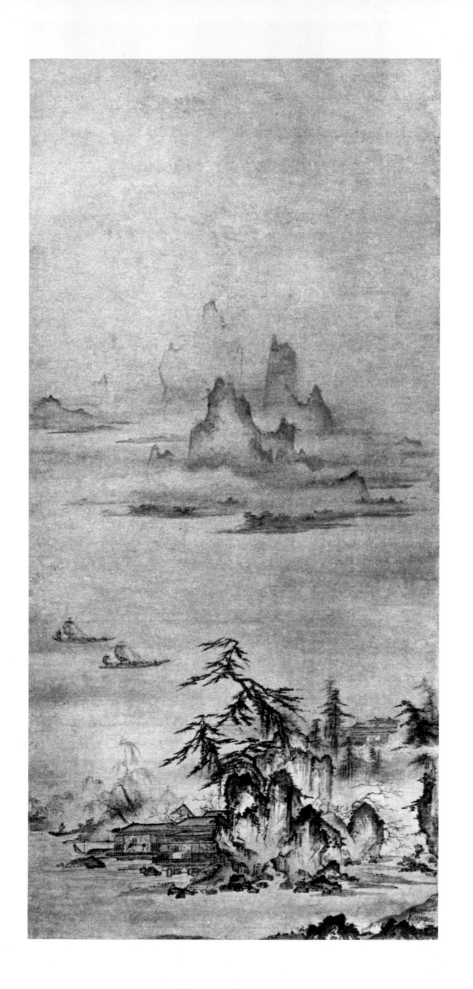

70. Kannon in a white robe (Byakue Kannon)

Muromachi period (early sixteenth century)
Ink on paper
H. 35 3/4 × 13 7/8 in. (91.2 × 35.3 cm.)

Although this painting has neither seal nor inscription, it can be identified on the basis of stylistic features. Leaning back on the left arm, Kannon (Avalokiteśvara) sits in a loose, relaxed pose. The head is bent forward, and the eyes are gazing pensively downward. The pale lines that define the robe and hair form patterns of sinuous decorative curves, which are stylized and lyrical. The painting is damaged and has faded considerably. The rocks have been largely repainted over the original forms, but the body and head of the Kannon seem to have been left untouched.

The motif of the white-robed Kannon was extremely popular during the rise and flowering of Zen ink painting in Japan. Sixty-four paintings of the theme, for example, are recorded in the connoisseur's sketchbook of Kanō Tan'yū (see No. 80) and attributed to such outstanding masters as Mu Ch'i, Kaō, Minchō, Shūbun, Sesshū, Kei Shoki, and Bunrin Isshi. Variations in pose and composition are evident in the sixty-four examples because there were no rigid iconographic rules for this motif.

Like the youthful Mañjuśrī in a grass robe (see No. 64), this Kannon is a variation on a traditional Buddhist theme that developed in Ch'an circles in South China in the early thirteenth century. It is an example of the Ch'an tendency to reject hieratic images as objects of worship and liturgy in favor of more informally composed works that were "objects of appreciation."

The most celebrated early version of the theme is the large silk kakemono by Mu Ch'i, now in Daitoku-ji but originally part of the collection of Yoshimasa, the eighth Ashikaga shogun. Together with other, less renowned paintings from the mainland, that work was carefully studied by Japanese artists of the fifteenth century, both Zen monks and laymen. They used the motif of the white-robed Kannon in memorials to the dead and as *dōshaku-ga*, paintings that pose philosophical questions.

There are indications that the motif was formed from several older and more orthodox Buddhist conceptions that left their traces in Ch'an tradition. The closest prototype is the Suigetsu Kannon (Avaloki-

teśvara by moonlit waters), which originated in the Hua-yen (Kegon) sect. Found as early as the late T'ang paintings of Tun-huang, the Suigetsu Kannon became a dominant Buddhist theme in the Sung and Yüan periods, especially in wood sculpture. The deity was carved in a position of relaxed ease atop a rocky crag, which symbolized the legendary island south of India, Mount Potala, the seat of Avalokiteśvara on earth. In paintings, the rocks were usually shown rising out of turbulent waters, and the deity often approached by the child Sudāna (Zenzai Dōji) in his search for Enlightenment. That motif was taken from an episode in the *Gandavyūha* of the Avatamsaka literature. The moon reflected in the water was an emblem of the insubstantiality of the phenomenal world, which the deity ponders.

The white-robed Kannon also resembles closely the simplified forms of the widely adored Nyoirin Kannon (Avalokiteśvara with the jewel and wheel with which he fulfills his vows to assist mankind); the Yōryū Kannon (with the green willow, Chinese emblem of femininity and natural grace); and the Takimi Kannon (meditating before a thundering waterfall). All those aspects of the one great deity were combined to give the white-robed Kannon its archetypal appeal to the religious perceptions of the Japanese.

This painting of Kannon is a valuable addition to the body of Muromachi period paintings of the subject. That its position is relatively late in the tradition is indicated by the underlying naturalism and relaxation of the body pose, by the softness and sweetness of the face, and by the stylized treatment of the robe and hair. While exact parallels in a single painting are lacking, there are close resemblances to versions of the theme with the Shūhō seal (*ca.* 1525) and to one by Kinka Sanjin (early sixteenth century).

Reference: Matsushita Takaaki. *Muromachi Suiboku-ga*. Tokyo, 1960. Nos. 78, 100.

71. Two herons in a lotus pond

Muromachi period
Kinkei Dōjin, or Ryōbin (active early sixteenth century)
Hanging scroll; ink on paper
H. 38 × 15 5/8 in. (96.5 × 39.7 cm.)

This is thought to have originally been part of a set of hanging scrolls showing herons in a lotus pond at different times of the year. Only two of the set are known today: this one, a summer scene with the lotuses in full bloom, and one in the Rockefeller collection in which the lotuses are dried and withered.

The painter, Ryōbin or Kinkei Dōjin, is a shadowy figure in the history of Japanese *suiboku-ga*. Documentary sources state only that he closely studied the art of Shūbun; that he modeled himself after Mu Ch'i; and that he excelled in painting human figures, flowers, and birds. The suggested date of early sixteenth century for Kinkei is supported by the stylistic features of his few remaining works. This one is dominated by the abstract, geometric rigidity that appeared in Japanese ink painting late in the fifteenth century. The two herons—one cleverly foreshortened, the other in strict profile—are highly schematized; the accented lines of the legs and reeds are as carefully arranged as a composition by Mondrian.

The scroll in the Rockefeller collection is far more spontaneously and freely painted. The seals and paper, however, are identical to this one, and it is thought that either the artist was experimenting with a variety of styles or else the works were by different but closely connected men—a father and son, or master painter and disciple. The stylistic discrepancy does not affect the chronology of Kinkei. His oeuvre, meager as it is, establishes him in the company of several lesser-known *suiboku* painters of birds and flowers—Keisō, Eison, and Kagai Rosetsu.

Lotus plants and waterfowl as a major pictorial theme had originated in China during the Northern Sung period in an offshoot of the realistic nature studies cherished in court circles. According to James Cahill, a school of minor professional artists specializing in lotus paintings developed in the verdant region along the Yangtze delta, Kiangsu and Chekiang provinces, with which the Japanese had especially close contacts. During the Muromachi period, many of those paintings—in bright color on silk and crowded with detail—reached Japan. Some remain today in such temples as the Chion-in and the Hompō-ji in Kyoto. The spontaneous, brightly colored style was emulated by some Japanese artists, a certain Genchū of the early sixteenth century in particular. However, the lotus and waterfowl motif was taken into the artistic repertory of the Zen monk-painters and done frequently in plain ink. Along with the well-known lotus paintings in the Boston Museum with the seal of Sessō Tōyō, these paintings by Kinkei Dōjin are among the very oldest remaining Japanese essays in the idiom; and they are of great interest to Japanese specialists.

It is unlikely that the lotus and waterfowl motif had a precise iconographic significance, but its poetic and symbolic overtones greatly appealed to Japanese Zen Buddhists. With some consistency, screen paintings of this theme are found in hermitages of the Zen sect—at Daitoku-ji, for instance, they are attributed to both Kanō Shōei and Soga Nichokuan. Lotus plants, their roots in the mud and their stalks emerging from the waters, were a Buddhist emblem of sanctity and purity of primordial significance. So also were waterfowl, such as swans and geese, symbols of the transmigrant soul, the mobile and insubstantial ego. Thus the pioneer Zen master Dōgen could write the following poem on the basis of a passage in the *Diamond Sūtra* that states, "The mind must operate without abiding anywhere."

Coming, going, the waterfowl
Leaves not a trace
Nor does it need a guide.

Published: Yonezawa Yoshiho in *Kokka*, no. 847 (October 1962).
Reference: *Koga Bikō*, p. 761; *Fusō Gajin-den*; James Cahill. *Chinese Painting, XI-XIV Centuries*. New York, 1962. P. 28; Matsushita Takaaki. *Muromachi Suiboku-ga*. Tokyo, 1960. No. 63; Tanaka Ichimatsu in *Kokka*, no. 679 (October 1948).

72. Chinese-style landscape

Muromachi period (first half of the sixteenth century)
Kōboku
Six-panel folding screen; ink on paper
H. 50 3/4 × 132 in. (128.9 × 335.2 cm.)

The artist of this screen is identified as Kōboku by the seal in the upper right corner of the last panel. He was probably a follower of the monk-painter Kei Shoki in Kamakura in the early sixteenth century and this landscape is an excellent example of the great changes in composition and technique which were produced by the stylistic revolution of the last quarter of the fifteenth century. As can be seen in the works of Sesshū after his return from China, or in those of Geiami and Kei Shoki, a sense of muscular energy was injected into the idealized, almost romantic manner perfected in mid-century by Shūbun and his followers

(see Nos. 68, 69). In this painting by Kōboku, the hardening of style may be seen in the schematic, yet almost tormented, twisting of the mountains on the left three panels, coupled with the assertive, linear rendering of architectural forms.

Kōboku's biography appears in only a few cryptic references in the *Koga Bikō*, which states that he worked in the manner of Chūan Shinkō, who lived in Kenchō-ji in Kamakura and was probably Kei Shoki's painting master. It also records that Kōboku's style reflects that of Kei Shoki and his follower Kōetsu, whose known paintings clearly agree in style with this

screen. All this serves to locate Kōboku in eastern Japan, if not Kamakura, and to place him in that generation in which the heroic, highly disciplined landscape compositions of Sesshū and Kei Shoki hardened into something more mannered and fragmentary but still exhibiting a sense of grandeur.

The surviving evidence indicates that panoramic screen painting of that kind began to flourish in the mid-fifteenth century in Japan. The usual subjects were the four seasons or the eight views of the area of the Hsiao and Hsiang rivers south of Tung-t'ing lake, favorite themes of Southern Sung landscape painters. The Kōboku screen was probably the left-hand screen of a pair showing the four seasons, for it is incomplete compositionally. At the extreme left is a winter landscape seen relatively near at hand. At the extreme right, in the middle ground, is a small peninsula with a pavilion overlooking the distant mountains and the tiny moon in the sky. Comparing this with other paired screens of the Shūbun school, the composition of the missing screen would join the peninsula and the

line of distant mountains in its own extreme left panel. At the far right would be a landform similar to the winter scene here and equally in the foreground, the entire overall composition having a kind of anchor at either end. In contrast to the Shūbun style, however, Kōboku's consistently strong contrast of light and dark and his strong outlines tend to weaken the sense of a unifying atmosphere. The landscape breaks down into a sequence of independent scenes linked together in composition but not in an intrinsic unity. In its various parts, the work was done with masterful skill, most notably in the thatched roofs in the foreground, the island in the middle-ground, and the alternating light and dark silhouettes of the distant, bladelike mountains.

Reference: Matsushita Takaaki. *Muromachi Suiboku-ga*. Tokyo, 1960. Nos. 87–97; *Koga Bikō*, p. 813.

73. Mountain village

Late Muromachi period (mid-sixteenth century)
Hanging scroll; sumi ink and light color on paper
H. 17 1/8 × 11 in. (43.5 × 27.9 cm.)

Bearing neither attribution nor seal, this modest landscape may be considered an offshoot of the main ink landscape styles of the sixteenth century. It lacks the vigorous, angular composition of the Kanō painters, as well as their more sophisticated handling of brush and ink. Instead, the relationship of the human figures to the tiny buildings is quite unsophisticated, as are the simplified brushstrokes used in the tree leaves. The sense of genial, relaxed intimacy in this painting is further enhanced by the absence of mist and deep perspective. Thus this painting may be from the hand of one of the numerous semiprofessional artists of the sixteenth century—Sesshū's disciple Sōen, for example, but more likely someone active around the 1530s or 1540s.

One of the most distinctive traits of this painting is the handling of the small stream that winds beside the mountain path; the water patterns are quite abstract —not at all unlike those used in Japanese lacquer designs and by decorative painters such as Kōrin.

Since the painting is done on heavy paper, rather like that used for sliding doors, there is the possibility that this was cut out from a larger scene. The composition, however, seems complete, and it is likely that it was one of a set of the Eight Views of Hsiao-hsiang, the motif usually labeled "Clearing in a Mountain Village after Rain."

Reference: Matsushita Takaaki. *Suiboku-ga*, Nihon no Bijutsu, no. 13 (May 1967), nos. 91, 92, 121.

detail

74. Three Taoist immortals

Muromachi period (mid-sixteenth century)
Kanō school
Six-panel folding screen; ink on paper
H. 61 1/2 × 127 1/2 in. (156.2 × 322.6 cm.)

This loosely structured composition portrays three figures taken from Taoist mythology: two men stand on the shore watching the wonder-worker Ch'in-kao (Kinkō) riding a carp that rises into the mist above the water. These figures are among the Taoist equivalents of the Buddhist arhats (sages), semimythical and semi-historical immortals (Hsien-jên or Sennin), who are supernatural protectors of the faith. Themes of this kind came to Japan among the many paintings of Southern Sung and Yüan origin imported during the fifteenth century. Even though the Taoist immortals have no connection whatsoever with traditional Buddhism, they were accepted into Zen iconography as part of the synthesis of Buddhist, Confucian, and Taoist ideology which the sect encouraged.

Like the arhats, the Hsien-jên are many, and the identities of individual figures are rather vague. Ch'in-kao (Kinkō), who is shown here, is one of the most frequently depicted of all. According to legend, he lived in the fourth century B.C., was famous for his skill on the lute, and was an accomplished painter of fish. One day, the King of the Fishes, a great carp, came to him and offered to take him on tour through the fish world. Ch'in-kao agreed and rode on the back of the carp. After two months, he returned, to the rejoicing of over ten thousand spectators who had been waiting for him. He urged them never again to kill fishes, then dived into the river to disappear forever. In this painting, he is shown at the beginning of his miraculous trip. The two other figures are probably immortals as well, for the details of their costume are common in images of the Hsien-jên. The first man, for example, wears a leafy collar and a leafy belt from which a gourd is hanging; the second man wears a large sword on his back and carries a shield.

The theme of Ch'in-kao riding the carp was popular in the sixteenth century, with well-known examples being attributed to Motonobu and Sesson. This particular screen has been attributed to Geiami, one of the members of the distinguished Ami family that advised the Shogun Yoshimasa in matters of Chinese art. In all likelihood, however, it is a Kanō school piece of the third quarter of the sixteenth century. Faithfully close to the style of Motonobu are the tree trunks, grass, and bamboo; but a later date is attested to by the scattered unstructured composition and the outlines of the rocks, whose simple contours resemble to some extent those employed by Kaihō Yūshō, for example, and Kanō Sanraku—masters of the Momoyama era.

Published: Mayuyama Junkichi. *Japanese Art in the West.* Tokyo, 1966.

75. Landscape painting

Muromachi period (third quarter of the sixteenth century)
Attributed to Kanō Yukinobu, or Utanosuke (ca. 1513–1575)
Ink on paper
H. 39 3/8 × 17 1/2 in. (100 × 44.5 cm.)

The suggestion of a mist-filled atmosphere and the bosky contours of the foliage do not dispel the artificiality of the composition, which approaches that of Seurat or Juan Gris. Underlying the irregular and ambiguous forms of nature there is a sense of a geometric, two-dimensional design, particularly noticeable in the edge of the cliff, the thrust of the foreground rock, and the banks of the lake.

The style of this painting is ultimately based on the brooding, loosely brushed manner of Hsia Kuei, and the subject is poetic and evocative—probably one of the Eight Views of Hsiao-hsiang. After some 150 years of evolution, Japanese ink landscape painting occasionally produced such a degree of geometric rigidity. None the less, the painting is pervaded by a sense of grand sobriety and dignity appropriate to the Kanō school of the late sixteenth century, and it is valuable as an unambiguous document of the style.

Yukinobu was the younger brother of the celebrated Kanō Motonobu, the inventive and gifted master of ink painting who led his atelier to a position of unrivalled prestige in the eyes of the shogunal court. Yukinobu was a man of lesser talent, however; and even though there are a number of paintings which have been attributed to him, his main role seems to have been in assisting his brother. The attribution to Yukinobu is based on the seals (which seem quite fresh, however) in the lower left. One reads "Moin,"

which was Yukinobu's honorific name. The attribution to Yukinobu was attested to by Kanō Tsunenobu (1636–1713), who signed the painting's storage box and impressed his seal on it, and probably recorded the painting with a sketch similar to those made by his uncle Kanō Tan'yū (see No. 80). According to the inscription on the outer box, there was also a written certificate by Isen'in (Kanō Naganobu, 1775–1828), but this has disappeared. The painting has been very carefully repaired and restored in modern times and the surface of the upper third of the sky seems to have been completely renewed.

While the evidence connecting this work to Yukinobu is far from conclusive, the style and technique of the painting are entirely those of the Kanō school of the mid-sixteenth century. There are direct quotations from Motonobu's screen paintings in the Reiun-in of Myōshin-ji, such as the foreshortened thatched roof of the house, the silhouetted patterns of the tree leaves and branches, and the giant rock formation in the foreground; in every case, the technique is more direct and coarse than Motonobu's. The seals do not inspire confidence, and Yukinobu's oeuvre is still rather a mystery, but the painting surely came from the artistic circle in which he was active.

Reference: *Koga Bikō*, p. 1602

76. Yawning Hotei (Pu-tai)

Late Muromachi period (last half of the sixteenth century)
Seal of Yamada Dōan (died ca. 1573)
Hanging scroll; ink on paper
H. 32 5/8 × 15 in. (82.9 × 38.1 cm.)

detail

This painting reveals the inventive brushwork of amateur painters in the Zen *suiboku* tradition during the decline of that tradition in the monasteries themselves. The lines defining the shoulder and sleeves of the monk's robes are willfully nondescriptive—perhaps they could be called antidescriptive. And the image becomes a tour de force in the counterpoint between the recognizable aspects of the image and the arbitrary formulations of the lines.

The painting has been considerably cut down; only a fraction of the cloth sack of Hotei remains in the lower left. The paper has darkened, and there is repainting on the tassels of the monk's belt and at the bottom edge of the paper. The seal, reading "Yamada-shi Dōan" (Dōan of the Yamada Family), may not be entirely trustworthy. And yet, as is sometimes the case, a questionable seal relates to the approximate origins of the work. Yamada Dōan was a samurai of substantial wealth and prestige who lived in Yamato Province not far from Nara; he is said to have had his own castle at Yamada. His biography is known only in the barest outlines, for he lived during the height of civil disturbances and rebellion at the end of the Ashikaga *bakufu*. But among the data assembled by Wakimoto in the journal *Gasetsu* is clear evidence of his being an active patron of traditional Buddhism. He contributed to the restoration of the head of the Daibutsu of Tōdai-ji; he contributed a fine stone lantern to the Kasuga Shrine (see No. 58); he seems also to have been a sculptor and donated a Buddhist image to Kōfuku-ji. Chiefly, however, he must have been an enthusiastic amateur painter in the Zen tradition. He is said to have studied the styles of Sesshū and Shūbun and Sung Chinese painting as well.

The attribution of this painting to Yamada Dōan is based on the seal and on a certificate in the storage box signed by Kanō Seisen, who died in 1848. However, the problem of determining authentic paintings by Dōan is particularly severe, owing to the fact that at least two other men, who were close relatives, also used Dōan's seals. In all likelihood, Dōan was the center of a circle of amateurs who worked in much the same style, and this painting may possibly have come from that circle. It does not closely resemble the few works that Japanese connoisseurs have accepted as genuinely by Dōan, such as his remarkable portrait of Lin-chi carrying a pine seedling. This painting is somewhat less sophisticated and accomplished in brushwork, and anticipates some of the simpler essays in *Zenga* of the seventeenth century.

The subject of Hotei was a favorite one in the Zen painting in which Dōan and his followers were trained. Today, Hotei is known to Japanese children as one of the Seven Gods of Good Fortune, for he has entered the realm of Japanese popular religion and folk customs. Originally, however, he was part of the same strata of Chinese Ch'an traditions in which Han-shan and Shih-tê originated, based on legendary accounts that were so overlain with metaphysical and popular interpretations that the historical content became almost unrecognizable. It is believed that Hotei originally was a Chinese monk with the religious name Ch'i-tz'u in the region of Ssu-ming (modern Ningpo). His personal name is unknown, and he had no permanent home save one Ch'an temple, Yüeh-lin-ssu, where he stayed for three years and where he

187

died. Instead, he mostly wandered from village to village, living on alms and playing the role of the genial, holy fool. All accounts of him describe his huge, white belly, which he left uncovered, and his big hemp cloth bag into which he would put part of the alms he had been given, or even rocks and pieces of wood. The bag was so prominent that his nickname became Pu-tai (Hotei in Japanese), "hemp bag", which is also, however, a euphemism for big belly. Although he is said to have been invariably joyous, laughing, and dancing, and often followed by children, he was the author of an ode to Maitreya, the Buddha of the Future, which in some accounts is said to have been written just before he died:

Maitreya, Oh True Maitreya!
You divide your body into hundreds of
 thousands of forms,
Thus manifesting yourself to men
 of this world.
But they do not recognize you!

In China after he died, it became widely held that he had, in fact, been an incarnation of Maitreya. In popular Chinese Buddhism, Pu-tai is commonly worshiped as Maitreya and is so named; in Japan, his origin in Zen legends has been remembered, and he retains his name, Hotei. In both countries, he became a folk deity, the embodiment of earthly prosperity, of a relaxed and uninhibited approach to life, a protector of children. This is an archetypal role in many popular religions, akin to Manibhadra and Ganeśa in India, and even to Santa Claus in the West —the fat, jovial, emblem of abundance.

Reference: *Gasetsu*, no. 10 (October 1937); ibid., no. 11 (November 1937); Suzuki Daisetsu, in *Eastern Buddhist*, VI (March 1935), pp. 32–331; Ferdinand Lessing. *Yung-ho-kung*. Sino-Swedish Expedition, publication 18. Stockholm, 1942.

77. Flowering plum branch

Ming period (1461)
Painted by Chiu Huai (dates unknown); inscribed by four Japanese monks (ca. 1635–1640)
Hanging scroll; ink on paper
H. 43 5/8 × 11 1/8 in. (111 × 26.1 cm.)

This Chinese painting of a flowering plum branch was more than one hundred fifty years old when four Japanese Zen monks inscribed on it poems in praise of the plum. Each of the four men served as abbot of Daitoku-ji; each was honored and deeply respected in his day; and when they wrote these poems, they must have been at a solemn gathering, perhaps a tea ceremony, or guests of the owner of the painting.

The poem that is in the upper left was signed "Dōminishi," with seals that read "Gyokushitsu Sōhaku." The oldest of the four monks, Gyokushitsu was the one-hundred-forty-eighth abbot of Daitoku-ji and died in 1641.

> The four seasons are like spring.
> Even in the ninety days of summer I imagine
> I see a bit of snow and the plum's crooked shape.
> In the dark I smell its fragrance
> Carried by the breeze.

Below this on the left is the poem signed "Tanshi Sūsō," with seals reading "Shūhō" and "Takuan." Takuan was the one-hundred-fifty-fourth abbot of the monastery, an artist, and a man of vast influence (see Nos. 78 and 95). He and Gyokushitsu had both been sent into exile in the remote northeast for their role in resisting efforts of the Edo *bakufu* to control monastic affairs. They returned to Daitoku-ji in 1636.

> Oh! The flowers open, then fall;
> The world prospers, then declines.
> Yet in a picture
> Things do not wither;
> Inexhaustible,
> Like this plum.
> The tip of the painting brush,
> Charged with the color of spring,
> Makes branches that last ten thousand years.

In the lower left corner, the poem is signed "Kesshin-shi," and has a seal reading "Sōgan." This monk was Kōgetsu Sōgan, a close friend of Takuan and a celebrated calligrapher. The son of a tea master, he too was expert in that art, and became the one-hundred-fifty-seventh abbot of the monastery.

> A noble plum
> Sends forth branches
> In many directions.
> Some grow by the river,
> Others by the lake.
> People long to climb the branches
> To inhale the pure fragrance.
> The guests, seated,
> All discuss this picture.

In the lower right corner, the poem is signed "Kozan Jitsumu-sō." The seals read "Ten'yū" and Shōkō," the name of the one-hundred-seventieth abbot of Daitoku-ji. The youngest of the four monks, Ten'yū linked his poem with that of Kōgetsu by using the same opening phrase, and he used the characters of the square seal of the Chinese painter as the text of his last line.

> A tree with the whiteness of snow,
> Pendant branches, luxuriant with blossoms;
> Roots entrusted to the hidden depths,
> Its pure spirit
> Embraces heaven and earth.

Along the middle right edge is the inscription of the Chinese painter.

> Chiu Huai painted this in the Southern
> Pavilion . . . while retired, on the
> eighth day of the tenth month in 1461.

The top seal reads "Chiu Huai," the bottom one "Ch'ien-k'un ch'ing-i," as in the last line of Ten'yū's poem. The name Chiu Huai has not yet been found in accounts of Ming artists. His picture is a relatively simple but skillful essay in plum blossom painting, which had become a highly codified, virtually independent idiom in Chinese art. The plum, as the

first tree to flower in springtime, blooming even in the snow, was an emblem of hope, of purity, of the spiritual aspirations of poets and painters. Ch'an Buddhists often painted it; in Japan, probably the oldest example of an ink painting of a blossoming plum branch belongs to the Rikkyoku-an, a sub-temple of Tōfuku-ji. Inscribed by the thirteenth-century monk Hakuun Egyō, it was used as one of two scrolls flanking a painting of Śākyamuni.

On the old storage box of this painting is written the notation that it had been done in the manner of Yang Pu-chih, a Chinese specialist in plum painting, active in the mid-twelfth century. Actually, the picture is closer in manner to Wang Mien, who lived until 1415 and apparently painted only pictures of this kind. Wang's style is reflected in a considerable number of fifteenth-century Chinese plum paintings preserved in Japan; one dated 1446, for example, by Ch'en Hsien-chang, and another of the same era by Liu Shih-ju are both now in the collection of the Tokyo National Museum.

Reference: *Daitoku-ji*. Hihō, vol. ll. Tokyo, 1968. Pls. 301-303; *Zendera to Sekitei*. Genshoku Nihon Bijutsu, vol. 10. Tokyo, 1967. Pl. 22; Osvald Sirén. *Chinese Painting*. Vol. VI. New York, 1958. Pls.118-119; Tokyo National Museum catalogue, *Chūgoku Minshin Bijutsu-ten Mokuroku*. Tokyo, 1963. Nos. 69, 70.

78. Spiritual exercises of Zen (Ch'an) monks

Early Edo period
Hasegawa Sakon (active first half of the seventeenth century); inscriptions by Takuan Shūhō (1573–1645)
Two six-panel folding screens; sumi ink on paper, with washes of pale gold ink
Each screen: H. 58 1/2 × 138 in. (148.3 × 350.6 cm.)

These twelve episodes portray Chinese monks of the eighth and ninth centuries personifying several of the fundamental aspects of Zen (Ch'an) Buddhism. As "paintings which explain the path [to Enlightenment]" (*dōshaku-ga*), the screens are part of the strenuous efforts made in the early seventeenth century to restore the shattered fortunes and ideals of the Zen sect. The artist, Hasegawa Sakon, was the third son of the celebrated Hasegawa Tōhaku (who did a similar set of paintings in Nanzen-ji); the inscriptions are by Takuan, one of the most influential Buddhist leaders of his day (see Nos. 77, 95).

Sakon and Takuan have placed the patriarchs of Ch'an Buddhism in allegorical arrangements similar to Raphael's compositions for the Stanza della Segnatura at the Vatican, which show, for example, the Fathers of the Church discussing the nature of the Holy Sacrament in the presence of the Trinity. In historical terms the twelve episodes demonstrate the apostolic legitimacy of the Lin-chi (Rinzai) school of Ch'an Buddhism. Philosophically, they point out the fundamental inability of man to express in words the nature of ultimate reality, and they show the wisdom and folly of the great men of the past. Some episodes are strictly historical, others are related to the Zen *kōans*, sayings of old masters that were used as subjects for meditation and instruction. The episodes are based on a number of different textual sources, the chief ones being the *Wu-mên-kuan* (*Mumonkan* of 1228), compiled by the Chinese monk Hui-k'ai, and a Japanese collection, the *Keitoku Dentōroku* of 1333. The significance of these episodes is explained by the inscriptions written by Takuan, who discussed them in groups of two.

In the upper left corner of the first screen (1) is the famous episode in which Hui-nêng (Enō, 638–713) escaped in the dead of night in a boat, clutching the monk's robe that had been given to him by the Fifth Ch'an Patriarch Hung-jên (Gu'nin, died *ca.* 675; see Nos. 95, 96). Hui-nêng, originally an illiterate peddler of firewood, had become a disciple of the patriarch and contested with another young monk the right to succeed him. It was said that the patriarch favored Hui-nêng and secretly gave the robe as the emblem of this

right. Then, fearing for the young man's safety at the hands of his rivals, the patriarch urged Hui-nêng to flee and actually ferried him across the Yangtze. From there, Hui-nêng went on to establish a flourishing school of Ch'an in South China, and the division of the sect into northern and southern branches began. The painting of that theme by Motonobu in the Daisen-in undoubtedly served as the model for Hasegawa Sakon, who, however, eliminated the figure of the ferryman, the temple structures, and the mountains in the background of the Motonobu version.

The figure below looking backwards (2) is the monk Ling-yün (Reiun, died 729), who was said to have attained Enlightenment upon looking at a peach tree in blossom (see No. 65). The inscription above the boat refers cryptically to both scenes and may be roughly interpreted as:

> Enlightenment [Bodhi] has no tree.
> It would be an error to expect it in a peach blossom.
> Discard whatever is held in the hands [as an external aid to Enlightenment],
> For the monk is clothed in the universe itself.

The first line is a quotation from Hui-nêng, who composed a poem criticizing the verse of his competitor which began "The body is the Bodhi tree . . ." (see No. 96).

The next two scenes are interpreted by Takuan as showing delusion and folly. The figure holding a bowl and staff (3) is Tê-shan (Tokuzan, 780–865), the distinguished teacher who helped preserve Ch'an after the violent anti-Buddhist persecution of the Emperor Wu-tsun in 845. In the *Wu-mên-kuan*, Tê-shan is described as having entered a dining hall with his bowl, and a young monk reprimanded him saying that the dinner drum had not yet sounded. The young monk related this to another student, who said that this indicated Tê-shan had not reached ultimate wisdom. Tê-shan learned of this opinion, and the next day gave lectures of surpassing insight; the sceptics were then convinced he had indeed attained *satori*.

detail detail

Next appears the episode (4) in which the eighth-century monk Shih-kung (Sekkyō) is threatening a young student San-ping (Sampei) who has come to him with a question. Once a famous hunter, Shih-kung had been converted to Ch'an by the famous Ma-tsu (Baso). Even though Shih-kung became a master in his own right, he kept his bow and arrows to challenge young students. When San-ping approached him with a question, Shih-kung cried out, "Watch out for my arrow!" The young man then bared his chest and said, "Yours is the arrow that kills. Where is the arrow that resuscitates?" Shih-kung was overcome, broke the bow and arrows, and never used them again.

Takuan's comments on those two scenes are broadly translated:

> Tê-shan holds out his rice bowl,
> Shih-kung draws his bow.
> Although the rivers and the valleys may differ,
> The clouds and the moon are the same.

The implication is that Tê-shan had been vain in proving his wisdom, just as Shih-kung had ostentatiously challenged his disciples. Both had thus made distinctions between wisdom and folly, peace and non-peace. Although things in this world appear to be different, the wise man makes no distinctions, for ultimate reality is not divisible. Sakon's composition of Shih-kung and San-ping is directly modeled on the Daisen-in screen attributed to Motonobu, but Sakon executed his lines much more fluently and rapidly, and his figures are more visually unified.

At the upper right (5) is the wise monk Tê-ch'eng (Tokusei), who insisted on working as a humble ferryman even though he was a master of Ch'an precepts. The ordinary people who dealt with him knew nothing of his attainments and called him simply Ch'uan-tzu (Sensu) or Boatman. One day a Ch'an monk, a stranger to Tê-ch'eng, came to his boat, and he asked, "In what temple do you live?" The stranger, Chia-shan (Kassan) then replied, "What has likeness has no abiding place, and what has abiding place has no likeness." To which Tê-ch'eng replied, "There is no likeness, yet of what is there no likeness?" and then added, "A word that can be uttered is like a stake to which you fasten a donkey for a thousand years." When Chia-shan started to reply, Tê-ch'eng took his oar and pushed the monk into the water. At that moment, Chia-shan attained Enlightenment.

An episode familiar to all adepts of Ch'an Buddhism (scene 6) begins the *Wu-mên-kuan*. The monk Chao-chou (Joshū), deeply revered by later generations for the paradoxical wit of his sayings, was once asked by a student whether or not the Buddha-nature exists in a dog. To this he replied *Wu* (*Mu*),

194

detail

"negation," which was to say neither yes nor no but to refer back to the ancient concept of the unknowable, inconceivable void at the heart of existence. In principle, the Buddhists believe that all sentient beings are endowed with the essential virtue of the Buddha, but to affirm this rationally is an error. "Has a dog Buddha-nature? If you say yes or no, you lose your own Buddha-nature."

Takuan's comment on those two scenes is especially subtle:

> Ch'uan-tzu searched for the fierce fire [of Enlightenment] in water;
> The Old One understood him especially well.
> Because [Chao-chou] bequeathed to us the perplexing problem of affirming or denying existence [he himself believed only in the Absolute which is beyond existence],
> It has become harder to avoid the question of good and evil in humanity.

Takuan seems to have chosen the first episode as the most fitting expression of the problem, common to both, that the products of the human mind (words, images, symbols) are at once inadequate for dealing with ultimate reality and yet inescapably part of that reality and the only means available to suggest it.

On the second screen, the figure with the broom in the upper left (7) is the ninth-century monk Hsiang-yen (Kyōgen), who played a prominent role in the development of Ch'an Buddhism in South China. While still a student, he was given a *kōan* by his master Wei-shan (Isan) dealing with the nature of his own existence before his birth. Deeply disturbed because he could not answer, Hsiang-yen burned all his books and set himself routine chores in a humble, isolated hut, all the while pondering Wei-shan's question. One day, while sweeping the ground, he brushed a rock against a bamboo, which made such a resonant sound that his mind was instantly raised to *satori* and the doubts raised by the question resolved.

Below him to the left (scene 8) and holding a knife in his hand is the monk Chü-chih (Gutei, active in the ninth century). His method of teaching was called "one-finger Ch'an," because he would raise his finger in silence whenever anyone spoke to him of important matters. A boy attendant began to imitate the habit, and Chü-chih seized him and cut off his finger. Although the boy was frightened and in pain, Chü-chih gained his attention and raised his own finger again, whereupon the boy attained Enlightenment. The *Wu-mên-kuan* itself criticizes Chü-chih, saying that Enlightenment has nothing to do with a finger and that he cheapened the teaching method by making it so

195

detail

The sword is a metaphor for the mind and will of man and is especially significant in the light of Takuan's many essays on the relationship between Zen and swordsmanship. In his treatise "The Sword of Taia," for example, he states, "The art of the sword . . . consists in not vying for victory, not testing strength, not moving one step forward or backward. . . . When one penetrates as far as where heaven and earth have not been separated, where the *yin* and the *yang* have not differentiated themselves, one is then said to have attained proficiency [in the art]. . . . When killing is the order, [the sword] kills; when giving life is the order, it gives life. While killing there is no thought of killing, while giving life there is no thought of giving life; for in the killing or in the giving of life, no Self is asserted." In that sense, the killing of the cat served to instruct the young beyond moral judgment. The existence of the cat could neither be affirmed nor denied, as indicated by Chao-chou's placing his sandals on his head—a paradoxical reply to an unanswerable question.

The figure squatting and leaning over his chopsticks (11) is Lan-tsan (Raisan, active in the late eighth century), a celebrated monk who had retired deep in the forests on Mount Hêng in Hunan Province. The Emperor Tê-tsung nonetheless wished to honor him and sent a messenger with an invitation to visit the Imperial Palace. When the messenger arrived, Lan-tsan was roasting sweet potatoes over a poor and humble fire of burning cow chips. Lan-tsan ignored the messenger and did not even look up from his chore. Moreover, as the story is told, Lan-tsan even refused the messenger the courtesy of cleaning his nose, which continued to drip during their interview. Sakon treated this episode, like many of the others on these screens, with a minimum of detail, eliminating the messenger and the landscape setting which appear in other paintings of the story, but depicting the monk with a remarkable sense of gesture and concentration.

At the extreme right (12), Sakon's narrative method is so simplified that the meaning is not clear until Takuan's commentary is read. Then the man seated in meditation before a tree may be identified as T'ien-

evident. Concerning those two scenes, Takuan's commentary states:

> Attaining Enlightenment upon hearing the sound;
> The one-finger Ch'an.
> Cut it off and see where it falls.

Seated on a rock and gazing at a tiny bird is the monk Chia-shan (Kassan) who appears in scene 5 attaining Enlightenment in the water. Here a tiny bird, impressed by the steadfastness of Chia-shan's meditation, brought him a flower as a tribute. Rather than being pleased, Chia-chan said that meditation cannot be the proper path to Enlightenment as long as a mere bird can fathom its depth.

The next episode (10) is one of the most basic of all emblems of Ch'an thought, the killing of a cat by Nanchüan (Nansen, 748–834). It is explained in No. 104 below.

Takuan's commentary on those two episodes is, roughly:

> The praise of a bird bringing a flower;
> The bloody decapitation of a cat.
> What is here is what is not here;
> Do not misuse, therefore, the sword in your hand.

jan of Tan-hsia, the willful monk who burned a wooden statue of the Buddha in order to warm himself. He did this while stopping at a temple in Ch'ang-an, and the shrine attendant asked how he dared to burn a statue of the Blessed One. Tan-hsia replied that he was searching for holy relics in the ashes. The attendant then asked how he could obtain relics by burning a wooden statue. And Tan-hsia replied, "If there are no relics to be found, may I have the other Buddha statues for my fire?" That episode, famous in legendary history of the Zen sect, often served as a subject of debate and discussion on the sanctity of holy images and religious implements. In a Chinese commentary, a monk defended Tan-hsia, saying, "When cold, we sit around the hearth with burning fire. Was he then at fault or not? When hot, we go to the bamboo grove by the stream."

Takuan's commentary on the two scenes begins with a pun based on an old Chinese proverb, "Although scraps of gold are precious, they are harmful if they get in the eyes." Takuan's text reads:

> Though scraps of gold are precious.
> They are worth less than one potato.
> Seeing the burning statue of the Buddha,
> He enters *samādhi* [the meditation that leads to Enlightenment].

Sakon is a somewhat obscure figure in the history of early Edo art, even though he was the third son and chief successor to the brilliant Hasegawa Tōhaku, who founded his own school of ink painting in Kyoto. In the twelve episodes illustrating these two screens, Sakon is shown to be faithful to his father's style of figure painting in *suiboku*. The extreme orientation toward earlier styles reflects the fact that father and son both claimed to be artistic descendants of Sesshū in the fifth and sixth generations respectively. Actually, there is less influence of Sesshū and more of early Kanō painting to be seen in both men's work, but Sesshū's name was the most celebrated at the time (see No. 80). There was also a group of artists, led by Unkoku Tōgan, who contested with the Hasegawa school for the right to be considered the legitimate successors of that towering figure.

An interesting fact emerges from investigation of other works of Sakon. He seems to have been strongly influenced by his contemporary Sōtatsu (see Nos. 105–107); in fact, Sakon is recorded in the *Koga Bikō* as having been closely involved with Sōtatsu's school of decorative painting.

Both screens bear a square-shaped seal in red reading "Hasegawa," a round one which is undecipherable, and a vase-shaped seal of Kanō Shōei that is a late addition and a forgery. Takuan's signature reads, "The blind monk who is nameless as grass added this inscription afterwards."

Published: Shimada Shūjirō, ed. *Zaigai Hihō*, vol. II. Tokyo, 1969. No. 8; Mayuyama Junkichi. *Japanese Art in the West*. Tokyo, 1966. Pl. 172; Doi Tsuguyoshi in *Kobijutsu*, no. 14 (August 1966). Reference: Heinrich Dumoulin and Ruth Fuller Sasaki. *The Development of Chinese Zen after the Sixth Patriarch in the Light of the Mumonkan*. New York, 1953; Suzuki Daisetsu. *Zen and Japanese Culture*, rev. ed. New York, 1959.

79. Two tigers

Early Edo period (first half of the seventeenth century)
Kanō school
Four hanging scrolls; ink on paper
Each scroll: H. 70 1/2 × 54 in. (179 × 137.2 cm.)

This bold composition of two tigers in a bamboo grove was probably once part of a screen-wall (*fusuma*) in an apartment of a Zen monastery. It entered the Powers collection along with a raging dragon (not exhibited but illustrated here) that also extends over four panels. Both works have been removed from their screen panels and remounted as hanging scrolls; both were extensively retouched and repaired.

Having ancient and profound significance in Chinese nature symbolism, tigers and dragons were admitted into Japanese Zen imagery as emblems of those forces of nature and the human spirit that were mastered by the power of Buddhist insight. In early Chinese and Japanese Zen paintings there are many scenes of both tigers and dragons being tamed by Buddhist arhats (sages); and Chinese ink paintings of these animals, by the Southern Sung masters Mu Ch'i and Ch'en-jung

for example, were widely admired in the collection of the Ashikaga shoguns. The animals came to be painted on the walls of monastic dwelling chambers, perhaps as a challenge to the residents or as emblems of the mysteries that the monk must penetrate.

The motifs spread from Zen circles into the secular world and appealed especially to the military classes, tigers, along with leopards, serving as symbols of strength and virility. By the early Edo period, the motifs of the tiger and the dragon had become extremely popular and, because of their Chinese origins, were cultivated by the Kanō school, the chief exponent of the Chinese manner. Kanō paintings of these themes are quite abundant; they are difficult to attribute to a single artist because they were often done as workshop productions, based on copybook models of older versions. In the Powers paintings, for example, elements can be detected from the style of Motonobu's later years—the 1550s—in the technique of painting grass, bamboo, leaves and rocks. There are also traces of the style of Motonobu's son Shōei, and of Eitoku, his grandson.

Striking resemblance is found in the drawing of these tigers to those attributed to Kanō Tan'yū (see No. 80) in the smaller Abbot's Residence of the Kyoto monastery of Nanzen-ji. Done presumably be-

tween 1636–1638 by Tan'yū and several assistants, the tigers are in bright color on gold leaf and are executed with great detail. Nonetheless, they have much the same monumentality and quiet dignity as the tigers have in the Powers collection. Both compositions, though, may have been derived from the tiger paintings on the wooden doors and screen walls in the Entry Building (*genkan*) to the main residence of the Nagoya Castle. These are of the very highest quality, imbued with a sense of intense energy, and were done by at least two master painters. They have never been given definitive attribution, but they most likely came from the workshop of the little-known Kanō Kōi,

Tan'yū's teacher, who was active in the first quarter of the seventeenth century.

Confirmation of the estimate that the Powers tigers and dragons probably belong to the time of Tan'yū's early maturity may be found in the close resemblance of the dragons to one painted by Tan'yū around 1657 on the ceiling of the *hattō* of Myōshin-ji in Kyoto.

Formerly in the collection of Hara Sankei.
Reference: *Shōhekiga Zenshū, Paintings in the Nanzen-ji Hōjō*, vol. V. Tokyo, 1968; ibid., *Paintings in Nagoya Castle*, vol. IV. Tokyo, 1967; ibid., *Paintings in the Myōshin-ji Tenkyū-in*, vol. II. Tokyo, 1967.

4.b.

25.b.

25.c.

80. Connoisseur's sketches

Early Edo period (ca. 1661–1674)
Kanō Tan'yū
Approximately 250 sketches mounted in an album; ink and color on paper
Varying sizes; most sketches are 5 3/4 in. (14.5 cm.) wide

When Kanō Tan'yū died in 1674, he was the patriarch of the Edo branch of the Kanō family and the chief official painter (Goyō Eshi) to the military government in the new Eastern Capital. Laden with honors from both the Buddhist church and the Imperial Court, he had become the guardian of the traditional style of ink painting that had been perfected in Zen circles in the fifteenth century—by Shūbun and Sesshū, for example—and then turned into a professional artist's idiom by his Kanō ancestors of the sixteenth century (Masanobu, Motonobu, and their immediate followers).

Tan'yū often gave judgments on the quality, authenticity, and monetary value of paintings brought to his studio near the Kajibashi Gate of the Edo Castle. During the last decades of his life, he kept a pictorial diary of the work that passed through his studio. Together with a disciple or assistant, he would make hasty sketches and notes (as many as ninety per day) on thin

Mino paper that he kept at his side. After his death, three large chests filled with these drawings were discovered among his effects.

At that point, the history of the drawings is unclear, but some scholars think they were sold by Tan'yū's grandson Morimichi, who was a chronic gambler in the game of *go* and may have used the drawings to pay off his debts. In any case, they were dispersed, but not until they had been loosely classified by subject matter, with sketches of a single subject kept together. Some, like the Powers drawings, have been mounted in albums, others in hand scroll form, and still others mounted as hanging scrolls. To give some idea of the quantity of this material, a cursory check reveals that thirty-nine scrolls and four albums are listed in the Kyoto Museum inventory, five scrolls in the Tokyo Museum, and three scrolls and two albums in the Ōkura collection. Others are in the hands of the Tokyo Fine Arts University and the Iwasaki and Hira-

28.b.

52.b. 69.a.

fuku families. Seven other scrolls are in a private collection in Cambridge, Massachusetts.

The sheer bulk of the drawings has, in a way, prevented them from receiving the attention they deserve. It would take years to study them thoroughly, and the handwriting is often exceedingly hard to decipher. The drawings, however, are a precious window into the world of painting as seen by the leading conservative master of his day. They give the names of the traditional artists who were esteemed, the major collectors, and sometimes the prices that were paid. Seals and inscriptions are carefully recorded. We come to know of many important works that have been lost, but we also find in the sketches the record of paintings that are well-known today. Some of the sketches were intended as preliminary studies for screens and scrolls to be produced by Tan'yū's atelier; others were detailed instructions for drawing hats or shoes and the like.

Often, the drawings have little aesthetic value; in several cases, enough time and thought was given to produce minor masterpieces. Many of the sketches bear Tan'yū's seal, either his intimate personal name "Morinobu" in a gourd shape, or "Seimei." It is possible that the sketches were intended as a permanent record and thus were themselves certified as genuine by Tan'yū.

The sketches in the Powers album are grouped by

subject matter in roughly the following order, from front to back:

Zen ink painting themes, such as Tu Fu on a donkey, the Tasting of Vinegar, Han-shan and Shih-tê, Hotei, Chinese-style genre studies, and hunting scenes.

Original sketches of Japanese costumes and landscape.

Traditional Buddhist images, such as the trinity of Śākyamuni, Samantabhadra, and Mañjuśrī.

Nature themes, such as carp fish, clam shells, lotuses, mice, pheasants and quail; a few of these are done in a precisely descriptive manner that anticipates the naturalism of the Maruyama-Shijō school in the next century.

Buddhist studies, mixed Zen and traditional themes such as Vimalakīrti, Shōki, Kitano Tenjin, Mañjuśrī in various guises, Śākyamuni returning from his mountain austerities, Avalokiteśvara in a white robe.

The sketches illustrated here are numbered according to the page of the album. A translation of Tan'yū's notes is included.

4.b. The sleeping Hotei [see No. 76]. On the twenty-third day of the tenth month, sixth year

69.b.

71.a.

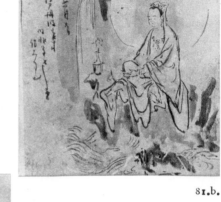

81.b.

of Kambun [1666], this picture by Sesshū came to me through the good offices of Lord Gyobu of Mito. Although uncertain of its authenticity, I returned word that it was cheap at 150 momme.

25.c. Three baby hawks. [No inscription; seal in red "Seimei."]

25.b. Horned owl. [No inscription; no seal.]

28.b. Peafowl in profile. [Seal in red "Seimei."] On the fourteenth day, second month, same year [unspecified], this picture was shown to me by Musa Denzaemon. I decided that the picture might be by Kaō.

52.b. Mañjuśrī in a grass robe [see No. 64]. On the eleventh day, third month, same year [1671], this picture was shown to me by Nihei. I sent word that it might be a work of Sekkan [Hsüeh Ch'ien].

69.a. Standing Śākyamuni. On the fourteenth day, eleventh month, this picture was shown to me by Nihei. It is said to be the work of Kei Shoki. I said it might be judged to be his work.

69.b. Standing Śākyamuni. Twelfth month, same year [unspecified], this picture was shown to me by Torozaemon.

71.a. Seated Śākyamuni. [Seal in red "Mori-

nobu."] On the sixteenth day, same month [year unspecified], this picture belonging to Yoshida Mataemon was brought to me by Tozaemon. It is said to have been painted by Sesshū at the request of the Abbot of the Jisso-ji monastery, but I do not consider it to be genuine.

81.b. Kannon [Avalokiteśvara] in a white robe [see No. 70]. On the twentieth day, third month, same year [unspecified], this picture came from Lord Abe of Tamba. I sent word that it was the genuine work of Minchō, and splendid even for him.

The translations were adapted from a manuscript by Honda Masajirō now in the Powers collection.

Formerly in the collection of Frances Fisher Wood, New York.
References: *Bijutsu Kenkyū*, no. 4 (April 1932) and no. 8 (August 1932); *Toei*, vol. 13 (1937). Woodblock reproductions in *Shūchin Gachō* (pictorial album of assembled marvels). Edo, 1802.

81. Twelve landscapes

Early Edo period (ca. 1675)
Kusumi Morikage (active in the last half of the seventeenth century)
Ink on silk, mounted on two six-panel folding screens of paper covered with gold leaf
Each painting: H. 39 3/4 × 16 1/2 in. (101 × 42 cm.)

For a man of such evident talent, Kusumi Morikage is an unusually obscure figure in the history of Edo painting. A large number of his works have survived but few are dated or inscribed; neither the date of his birth nor of his death is clear; and it is difficult to outline his stylistic and intellectual development. Apart from Morikage, other names found in his inscriptions and seals include Jūzan, Mugesai, Itchin-ō, and Bōin. A native of the Kaga region along the Japan Sea, he was a student and disciple of Kanō Tan'yū (see No. 80) and recognized as a man of outstanding promise. His wife, moreover, is said to have been a relative of Tan'yū. But Morikage left Tan'yū's studio to become an independent artist. The reason often suggested is that Tan'yū inadvertently affixed his own seal to a painting of Morikage's; but probably, the two men were incompatible in temperament. Morikage seems to have been retiring and unworldly while Tan'yū was the opposite, gregarious and eager for status and honors. After the break, Morikage seems to have moved to Kanazawa and then to Kyoto where he spent the rest of his long life—he may have lived into his eighties. He was a devotee of the tea ceremony; there is record of his having spent three years in Kanazawa, his home district, serving the daimyo of Kaga. Works by him have been found in that area in considerable number. One tradition claims that he did paintings for the Kutani porcelain ware produced there, but this has not been proven.

Typical of painters of his day, Morikage worked in a variety of styles. He did Japanese historical scenes in the Tosa manner, and he was attracted to genre painting. Perhaps his most celebrated work is in this genre, a folding screen in the Asō collection showing a peasant's family relaxed on the ground beneath a trellis of calabash gourds. Most of his works, however, are pure landscapes in the manner seen here, rooted in the classics of the past. In these twelve paintings on silk, the furniture of the landscape was taken largely from the traditional style of Ma Yüan and Hsia Kuei as interpreted by Sesshū and the early Kanō masters—rustic footbridges, pines and willows in dramatic silhouette, thin peaks rising through mist,

a sage meditating before a waterfall, fishnets spread out to dry over poles on the beach. There are quotations from the same two Chinese masters in the handling of the brush and in composition as well. But other Chinese sources are reflected, for example, in the horizontal dot strokes of Mi Fei and Kao K'o-kung and in the Yüan period compositional devices such as the lowered horizon and division of the landscape into units separated by empty stretches of water (see No. 69). A set of twelve paintings suggests that Morikage intended to paint scenes of the twelve months and four seasons. This was a favorite theme of his, but here scenes seem to have been chosen to display his virtuoso skills.

Japanese critics often praise the profundity of Morikage's loyalty to the past and the authenticity of his work in the Southern Sung–Muromachi manner; and they claim that he exceeds any contemporary Kanō painter in the emotional resonance of his work. They also recognize that his landscapes have a peculiarly scenic quality, as though they are windows into nature, and that this anticipates the spatial experiments of Maruyama Ōkyo and his school in the mid-eighteenth century. Morikage is both enigmatic and prophetic. The influence of his Kanō training is clearly evident here, especially in the snowy landscape. But in the deformation and imbalances of conventional rocks and the simplified fluency of his style, he seems also to anticipate such rebellious figures as Rosetsu and Shōhaku (see Nos. 82–88).

These twelve compositions are mounted on paper screens covered with gold leaf. The decorative effect and intense brightness of the gold seem to clash with the soft atmospheric flavor of the ink paintings. However, it should be noted that old publications discuss a pair of screens by Morikage in the Yamamoto collection, Tokyo, in which he painted a variety of compositions in this same style directly on the screens and then had gold leaf applied around them.

Formerly in the Masuda collection.
Published: *Kokka*, no. 184 (September 1905), p. 71; ibid., no. 186 (November 1905); ibid., no. 205 (October 1908).

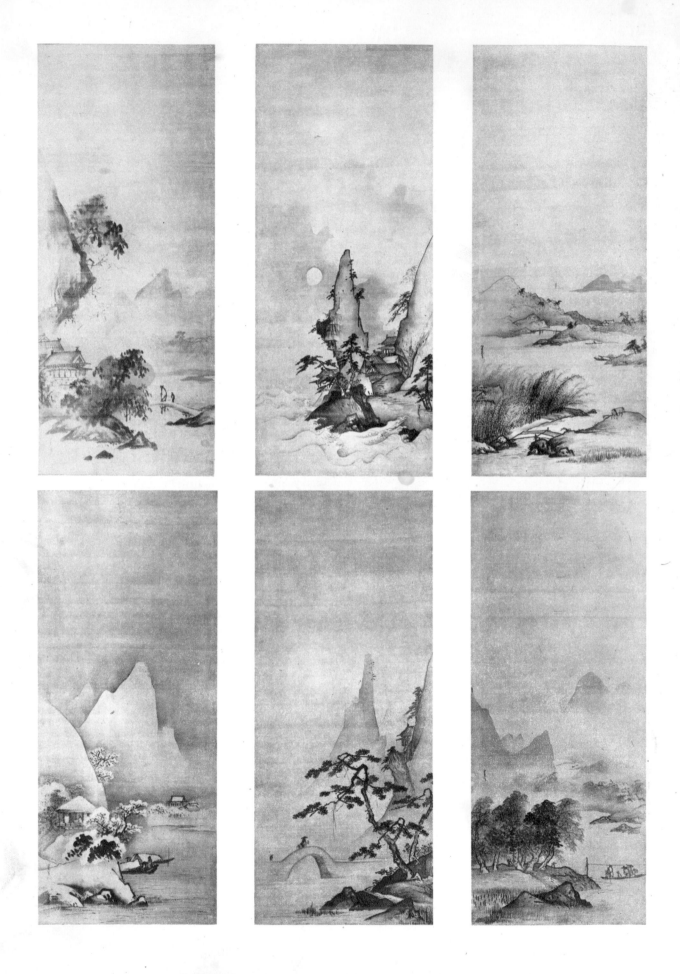

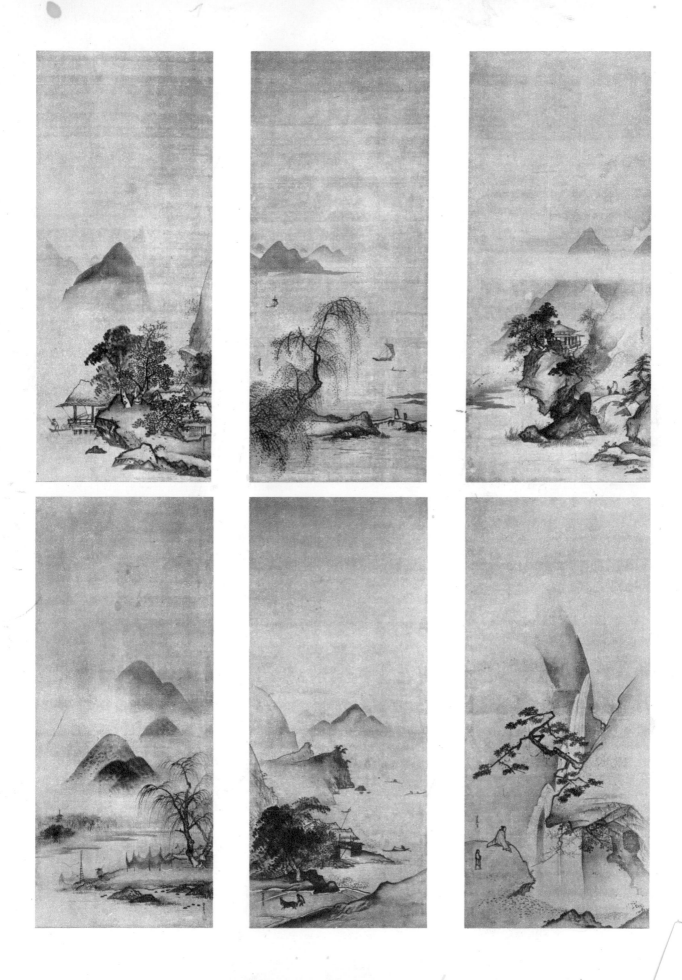

82. Scene from the *Tales of Ise*

Mid-Edo period (ca. 1760)
Soga Shōhaku (1730–1781)
Six-panel folding screen; ink and faded color on paper, and flecks of gold leaf
W. 140 in. (355.6 cm.)

This is an early work by one of the most eccentric and individualistic masters of the Edo period, Soga Shōhaku. Typical of an artist who had not attained the full maturity of his style, this ambitious composition shows several painting techniques imperfectly synthesized. But as a scene of visionary fantasy, it gives clear testimony to Shōhaku's extraordinary natural gifts as a painter. The moon silhouetted against dark clouds suggests an eerie light. Bands of mist rise from the ground, engulf the hills and housetop, and create a sense of isolation, of a normal world transfigured into a dreamlike setting. In the painting of the house to the left, the exaggerated wood texture and eccentric calligraphy are personal traits that appear often in his later work; they may have originally stemmed from such painters as Sansetsu or Matabei, whose work could readily be seen. The two figures, however, are done in a strongly linear manner that ultimately harks back to the courtly *Yamato-e* of the late Heian–early Kamakura periods. Shōhaku thus used an antique figural style to depict persons of an antique era, but in the trees in the foreground his brushwork shows a distinctive personal invention done with remarkable clarity and lyrical power.

Originally this screen was much more brightly colored. Traces of blue-green leaves appear near the house; yellow-brown was used in the brushwood fence, in the foreground grass, and in the house. Bright red oxide of lead was painted on the maple leaves and on the undergarments of the children. The colors were fugitive, however. All but the red have faded almost completely away, and the red of the maple leaves has become diffuse, the outlines lost.

The subject is taken from the twenty-third story of the *Tales of Ise*, which describes a boy and girl who used to play together beside a well. As they grew up, they were determined to marry one another. Her father wanted her to wed another man, and the boy sent this poem to the girl:

My height that we measured
At the well curb
Has, it seems,

Passed the old mark
Since last I saw you.

The girl replied:

The hair parted in the middle
That I measured against yours
Now hangs below my shoulders.
For whom shall it be put up,
If not for you?

Finally they married, but in time the husband became tired of his wife and began seeing a woman who lived in the Kawachi region. Despite this, however, his wife remained faithful and affectionate. Gradually she was restored to his esteem, and he ceased visiting the woman in Kawachi. This simple story is typical of the *Tales of Ise*—intimate, highly personal, with little dramatic action; an exploration of the nuances of human relationships that served as a prototype for the more extended, subtler treatments in *The Tale of Genji*. Shōhaku selected the opening phase of the story, in which the children are identified as playing by the well. The boy, in typical dress of the Edo period, wears the same clothes as the girl but may be distinguished from her by his harsh, angular profile. Shōhaku has shown the couple not as infants but as nearly adult, and he has imbued the entire composition with a poetic aura that is entirely in keeping with the mood of the original story. It is probable, however, that this is the left-hand half of a pair of screens. The arrangement of figures and empty space suggests that another screen completed the composition, and Shōhaku normally painted screens in pairs. If this were indeed the case, he would have probably taken another scene from the *Tales of Ise*, one that contrasted with this episode and thereby added to the literary content.

In terms of art criticism, Soga Shōhaku is one of the most challenging figures in Japanese art. This is a mild and lyrical painting, but Shōhaku often stretched the limits of propriety and good taste in both style and the interpretation of themes. Ernest Fenollosa,

the pioneer American historian and critic of Japanese art, dismissed him as a man like Buson who made crazy perversions of old Chinese forms. But Fenollosa's close friend Sturgis Bigelow was enthusiastic about Shōhaku and brought back to Boston, at considerable cost, a large number of scrolls and screens by this painter. Shōhaku was an eccentric who worked at a time when eccentricity was becoming rampant in Japanese cultural circles; and he was personally acquainted with or must have known indirectly the work of such innovative and unconventional men as Ike no Taiga, Buson, Rosetsu, Hakuin, and Jakuchū. But none deviated so consistently and so far from the established norms of painting as did Shōhaku.

Because he was something of an outsider in the established cultural circles of his time, the records of his career are sparse; his biography is unclear and embellished by tales that may or may not be apocryphal. Until recently, for example, it was thought that he came from Ise. Some important works by Shōhaku are found in that region; but evidence has been uncovered suggesting that he came from Kyoto, that his family name was Miura, and that the family were merchants who owned a store named the "Tambaya" or "Tangoya." He is said to have studied with a little-known Kanō school painter from the Ōmi region named Takata Keihō and to have become essentially a Kyoto artist. There are many tales that suggest that he was arrogant, vainglorious, and overbearing and that he was nervous and impetuous. One story describes his watching Ike no Taiga at work and jumping up with impatience with Taiga's slowness; another tells of friendly intimacy with Taiga, their visiting and feasting together on fancy hand-cut noodles. Of Maruyama Ōkyo, the most popular Kyoto painter of the day, he is reputed to have said, "If you are looking for a [true] painting, come to me; if you are looking for [mere] drawings, go to Ōkyo."

In this lyrical early composition, his eccentricities are prominent only in such details as the house. But in the intensity of the experience he has created, one senses the presence of an artist driven or inspired by emotive forces deeply rooted in his personality.

Reference: Tsuji Nobuo in *Kokka*, no. 905 (August 1967); Helen McCullough. *Tales of Ise*. Tokyo, 1968; Money L. Hickman in Shimada Shūjirō, ed., *Zaigai Hihō*, vol. II. Tokyo, 1969. No. 71; *Nihonga Taisei*, vol. 15 (1932), pls. 51–73.

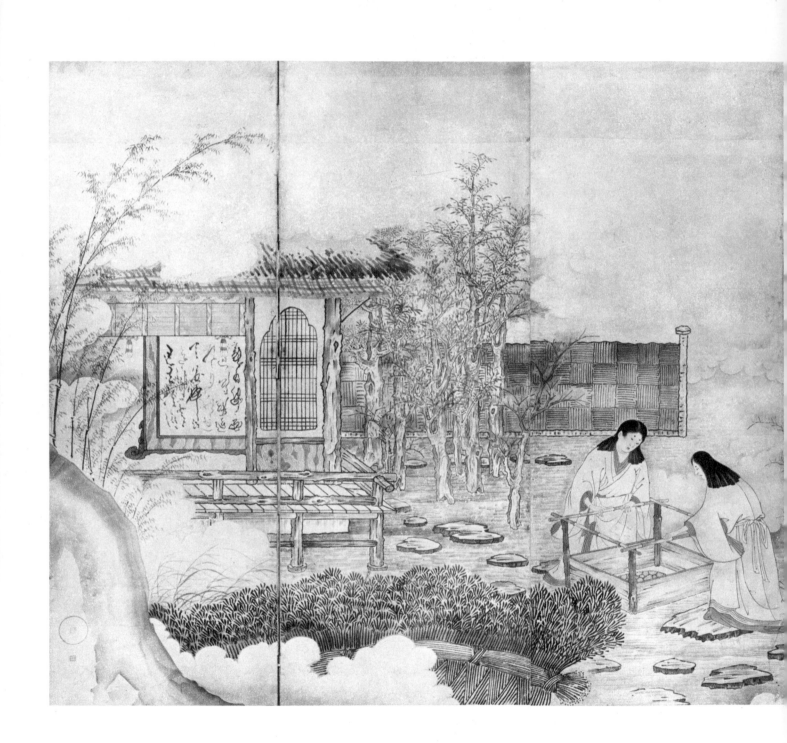

83. Two cranes

Mid-Edo period (ca. 1770–1780)
Soga Shōhaku (1730–1781)
Hanging scroll; ink on paper
H. 16 3/8 × 23 1/2 in. (41.6 × 59.7 cm.)

Almost all major painters of the Edo period received training in the Kanō style or were deeply familiar with it; it served as the common academic training ground for aspiring youths. Shōhaku had studied briefly with a Kanō painter, and the influence of that style occasionally reappeared in his work. This modest composition dates from the middle of his short career, when he had achieved a mature style; and at first glance, it seems to be an almost pure Kanō exercise. With great economy of means, he attempted to show the two birds reaching with their beaks toward insects on the ground. Yet the quality of the ink handling betrays Shōhaku's distinctive style. A heavy wash defines the body, neck, and head of the farther bird; the tail feathers are painted boldly and rather generally; the wash that establishes the rear of the nearer bird seems slightly hasty and unstudied. In short, he practiced the Kanō formula for depicting the essential aspects of a bird in the simplest possible manner, but he imbued the composition with a rough vigor that transcends the niceties of well-established formulas.

The painting is signed "The descendant of Kawatsu Saburō Sukeyasu, Soga Shōhaku." Here again Shōhaku has linked himself with a celebrated figure of the past, a Kamakura period warrior who was murdered by a relative. His two sons attempted without success to avenge him, losing their own lives in the process. The tragic story of the Soga brothers was one of the most popular of all themes in Edo poetry and theater. It is puzzling that Shōhaku would have linked his name to such ill-fated persons in his efforts to establish an artistic pedigree; it is possible that his intention here was ironic or even humorous.

84. Mount Fuji and Miho no Matsubara

Mid-Edo period (ca. 1760–1770)
Soga Shōhaku (1730–1781)
Two six-panel folding screens; ink and gold and red pigment on paper
Each screen: H. 67 3/4 × 148 7/8 in. (172 × 378 cm.)

Mount Fuji and its eight peaks have been transmuted into a group of pure, almost geometric cones rising from the beach called Miho no Matsubara along Suruga Bay. Shōhaku, like other painters of this era, evoked the sanctity of this mountain by accentuating its symmetrical, almost ideal shape in sharp contrast to the naturalistic forms of the rocky headlands, reefs, and trees. Within the panoramic sweep, moreover, Shōhaku has evoked a surreal, dreamlike atmosphere. In no sense of the word is this landscape a true, topographic account of the region; it is, rather, a mixture of familiar geographic symbols and the painter's creative fantasy. The clouds, which are done in pale *sumi* with washes of gold, are given a bubble shape like those in his *Ise Monogatari* (*Tales of Ise*) painting (No. 82), a shape that is repeated in the rocks and in the rainbow.

The rainbow and Mount Fuji are the main foci of the composition; the one, of course, ephemeral, the other eternal. The rainbow is foreshortened and so enhances the illusion of deep pictorial space that it is difficult to escape the conclusion that Shōhaku had come under the spell of Western spatial concepts, as had Taiga and Ōkyo, his contemporaries in Kyoto. They also painted panoramic scenes of this sort. The

sense of permanence and stability of the sacred mountain is enhanced by many suggestions of small motions around it. A fog bank rolls in from the left; a flight of waterfowl, crossing in front of the fog, settles down on the beach. Coastal ships are blown to the right, their sails taut in the wind. Most of the trees have been painted in free, loose washes and with rapid black accents that give them a quality of heightened animation. Above all this, the mountain looms in a strong, unbroken cadence.

This remarkable interpretation of Mount Fuji may be seen as a reflection of the growing veneration of the mountain during the Edo period. An ancient trait of Japanese folk religion had been the worship of great mountains and especially this sublimely proportioned peak. But a new cult called the Jikkō-kyō (the Religion of Practical Conduct) was founded in the early Edo period by a mystic visionary, Hasegawa Kakugyō, who conceived of Mount Fuji as the center of all creation, the earthly dwelling of the three parent deities of the Japanese nation as described in the *Kojiki*. Essentially a new religion, it combined Shintō nature worship with Buddhist mountain asceticism (see Nos. 117, 123); it also had very strong nationalistic overtones, strengthening the veneration

212

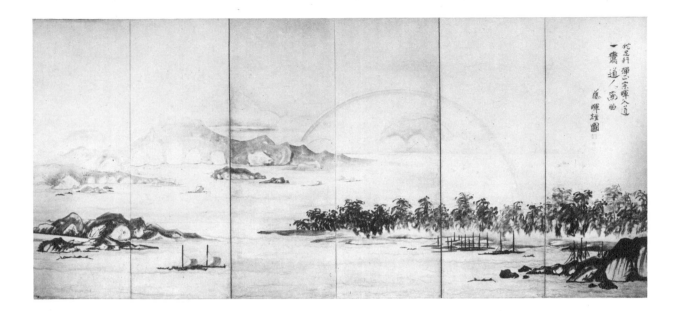

to be given the Japanese imperial family as another manifestation of the founding deities, who are absolute and eternal. The religion flourished during the seventeenth and eighteenth centuries; mass pilgrimages to climb the mountain were organized throughout the country by over eight hundred votive associations, the Fuji-kō, like those for visiting the Ise, Kumano, and Kasuga shrines. In this sense, Shōhaku's painting might be seen as a more secular, illusionistic version of the older landscape mandalas (see Nos. 58, 62), but there is no data in the biography of Shōhaku to connect him with the cult. There are, however, numerous paintings of Mount Fuji attributed to him, of which this is the most monumental in scale.

On the basis of both the seals and style, this painting seems to be a relatively early work of Shōhaku, done while he was in his thirties. It reveals something of his debt to Muromachi period ink painting as well as to the contemporary styles of Ōkyo and *Bunjin-ga*. One might assume that Shōhaku had carefully studied Sesshū's techniques in such works as the loosely brushed "short" landscape scroll in the Asano collection; also it would be tempting to think that Shōhaku had seen Sesshū's panoramic landscape of Ama no Hashidate, for the handling of trees is rather similar. One can sense the influence of other early ink paintings in Shōhaku's handling of the boats and sandbars—a panoramic view attributed to Nōami of much the same region, the Miho no Matsubara beach, for example, and some of the paintings of Sesson.

It is impossible to know precisely which antique works Shōhaku had studied, but his debt to the past is proclaimed in the inscription at the extreme right here, in which he states that he followed the true artistic creed of Soga Dasoku, a monk-painter associated with Ikkyū (see No. 66) in the mid-fifteenth century. Dasoku's biography and the full makeup of his oeuvre are especially difficult to define today, even though a number of superb scroll and screen paintings at the Shinju-an and elsewhere in Daitoku-ji can be attributed to him. Nonetheless, his work exerted such an appeal in Kyoto that a loosely defined Soga school of ink painting seems to have existed throughout the sixteenth and seventeenth centuries. It was not so prominent as the Kanō or Hasegawa schools, but two outstanding members did screen paintings in Daitoku-ji that were widely admired, Chokuan and his son Nichokuan. Shōhaku seems to have had access to the subtemples of Daitoku-ji and to have appropriated to himself the lineage of Dasoku and his Soga school followers, for this was a time when an ambitious Japanese artist was obliged to present his credentials of membership in a long established artistic tradition. Just as the painters of the Unkoku school claimed to be the descendants of Sesshū, so Shōhaku claimed he was the descendant of Dasoku in the tenth generation.

Published: Suzuki Susumu. *Ōkyo to Goshun*. Nihon no Bijutsu, no. 39 (August 1969), p. 31; Mizuo Hiroshi. *Kokka*, no. 882 (September 1965); Tsuji Nobuo. *Kisō no Keifu*. Tokyo, 1970. Pl. 34.

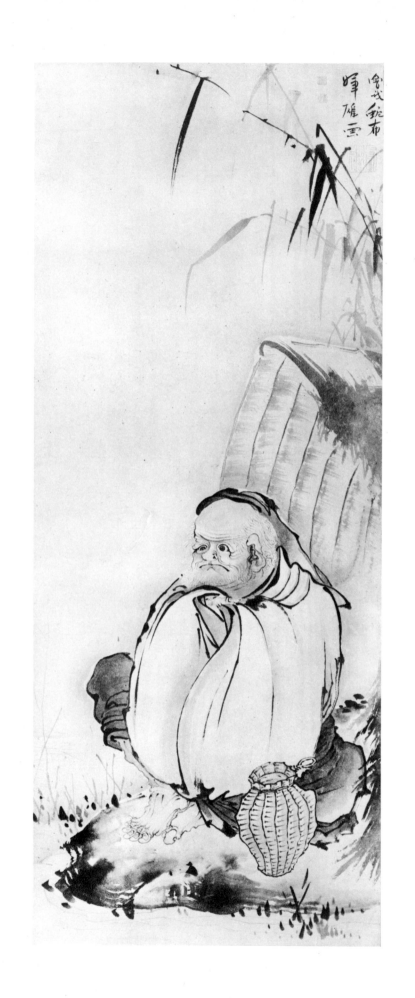

85. The General T'ai Kung-wang (Tai Kōbō) as a recluse

Mid-Edo period (ca. 1770)
Soga Shōhaku (1730–1781)
Hanging scroll; ink on paper
H. 52 1/8 × 20 in. (132.4 × 50.8 cm.)

Soga Shōhaku's mature style of figure painting is shown in this aged hermit sitting in front of a reed hut. Special attention was given to the gnarled feet and ears and to the asymmetric basket, distorted by lumps and protrusions in the sides. The handling of the basket is a recurring feature in Shōhaku's painting and reveals much of the artistic character of the man —his love of complex, fustian detail, of eccentric variations of normal forms. Compared with the rest of Shōhaku's oeuvre, however, this is a rather gentle, lyrical work, not nearly so charged with eccentricity and emotion as are many others. The orchestration of the ink washes is especially subtle, ranging from the soft, pale areas of the face to the free-flowing darks of the riverbank and the crisply painted, fine lines of the face and beard. The work possesses a mood of lucidity and composure.

The subject is taken from Chinese mythology, and depicts a celebrated warrior and governmental adviser of the twelfth century B.C., who had once served the tyrannical last ruler of the Shang dynasty. Known by a number of names, as a general he was called Chiang Tsu-ya. He quit the service of the infamous Shang emperor and became a hermit along the banks of a river, fishing with a straight pin baited with a grain of rice rather than with a hook. The fish hooked themselves because he was a man of such great virtue. He next became associated with another major figure in Chinese history, the revered Wen Wang, Duke of Chou and father of the founder of the Chou dynasty. One day, as the duke was about to leave on a hunt, he was told by a soothsayer that he would catch not a normal quarry but the teacher of a prince. The duke came upon the hermit and took him back to the palace where for twenty years he served as adviser to the Chou regime and led its armies against his former masters; and the old recluse was given the name T'ai Kung-wang (Tai Kōbō, Whom the Grandfather Desired). Many legends developed around this figure, the chief one being that he became a wizard who could control the spirits of the unseen universe. In later Chinese folklore T'ai Kung-wang became extremely popular, and to this day his name is written on doors to frighten away evil spirits. He has also served as a patron deity of fishermen.

The theme often appears in Edo paintings, but its precise significance for Shōhaku is yet unclear. Kaihō Yūshō painted it in Myōshin-ji, for example; and for Zen Buddhists Tai Kōbō must have had the same status as the Chinese Sennin (see No. 74), Taoist figures of supernatural powers. Hakuin made a painting of the old hermit fishing by his hut and inscribed it with a poem that gives a metaphysical interpretation to the conflict between the Shang and Chou states, likening the Shang to a mouse and the Chou to a dragon. For Shōhaku, however, the old hermit may have been little more than a congenial Chinese figure, an emblem of good fortune.

Reference: Takeuchi Naoji. *Hakuin*. Tokyo, 1966. No. 161; Kurt Brasch. *Zenga*. Tokyo, 1961. No. 99.

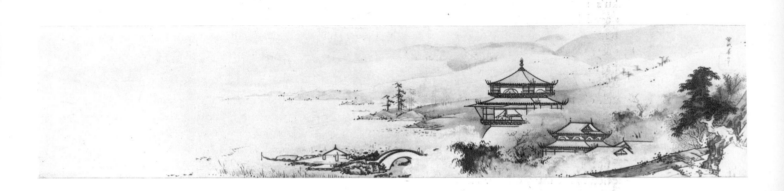

86. Horizontal landscape

Mid-Edo period (ca. *1770–1780*)
Soga Shōhaku (1730–1781)
Hanging scroll; ink on paper
H. 9 3/8 × 43 1/2 in. (23.7 × 110.5 cm.)

Shōhaku in his later years did a large number of ink landscapes in the style of this painting. The tranquillity of their mood and the impeccable control of the ink values should not disguise the fact that, essentially, they are highly innovative. A first glance at this painting, for example, seems to show the elements of Muromachi idealistic *suiboku-ga* still intact. The trees in the foreground are painted somewhat in the manner of Sesson, especially the gnarled and distorted trunk of the large oak. The architecture is handled with the strong, simplified outlines of Sesshū, while the rolling hills are reminiscent of Sōami. True to the canons of early Muromachi ink painting, no distracting color has been added. However, each of the antique stylistic elements has been reduced here to an especially lucid, conceptual clarity. The spatial effects are almost Western in their sense of pictorial depth, the influence perhaps of the style of Ōkyo and his school—which Shōhaku may have disliked but could not escape. Lacking here certainly are the tightly struc-

tured two-dimensional patterns of light and dark in Muromachi *suiboku-ga*, which strengthen the sense of integrity of the picture plane. Here, the light-dark patterns are open and essentially illusionistic, and the painting lacks the abstraction and metaphysical overtones of the older style.

Reference: Tsuji Nobuo. *Kisō no Keifu*. Tokyo, 1970. Pl. 30; *Nihonga Taisei*, vol. 15. Tokyo, 1932. Pl. 59.

detail

87. Mount Fuji

Mid-Edo period
Nagasawa Rosetsu (1754–1799)
Hanging scroll; ink and color on silk
H. 39 3/4 × 18 7/8 in. (101.1 × 48 cm.)

In this view of fog-shrouded Mount Fuji, a bold line from a broad brush, unmodulated and uninterrupted, defines the trunk of a stunted tree leaning across the foreground. The horizon line is extremely low, creating a spacial sensation very much in the spirit of Western painting. The leaves and branches of the foreground tree are also shown with a kind of atmospheric perspective that suggests illusionistic depth.

This unusual combination of Mount Fuji, emblem of Japanese national self-consciousness (see No. 84), and Western concepts of pictorial space reflects the fact that the artist, Nagasawa Rosetsu, had worked in the studio of Maruyama Ōkyo, whose interest in Western art was profound. Rosetsu, however, was also a contemporary and a kindred spirit of Soga Shōhaku and Itō Jakuchū, eccentric painters who were unable to find a niche in the clearly defined schools of Japanese painting. Rosetsu, emotionally, was probably the most turbulent and aggressive of the three.

Rosetsu was born to the Uesugi family, low-ranking samurai in Tamba Province (modern Hyōgo Prefecture); but he seems to have been adopted by a more prosperous family, the Nagasawa, in the Yodo fief, south of Kyoto. Details of his early life are sketchy and unclear, but he moved to Kyoto and, during his twenties, became a student of Maruyama Ōkyo. His talent was great, and he quickly distinguished himself. In 1782, he was ranked in the *Heian Jimbutsu-shi* as fourth among the artists of Kyoto, just beneath Buson (Nos. 119–122). Ranked above them were Jakuchū and Ōkyo. In temperament, however, Rosetsu and Ōkyo were radically opposed, the latter being more dignified and composed. A tale, perhaps apocryphal, describes a violent argument that caused Rosetsu to quit the older man's circle. He brought for correction by Ōkyo a painting the master himself had done earlier as a model; Ōkyo criticized it and suggested improvements, whereupon Rosetsu ridiculed him. This incident may be true, but despite their differences, the two men occasionally collaborated until Ōkyo's death in 1795. In his early thirties Rosetsu helped Ōkyo carry out a series of commissions for screen and wall paintings in Buddhist temples in the southern part of Kii Province (modern Wakayama Prefecture). He traveled widely and established a strong reputation in that region. He helped Ōkyo carry out a commission for paintings in the Summer Palace of the Imperial Compound in Kyoto, together with artists of the Kanō and Tosa schools.

Rosetsu must have been intemperate by nature. He devoted himself energetically to swimming, swordsmanship, horseback riding, and music, as well as painting. He is even reputed to have had a passion for spinning tops and to have lost the sight of one eye while doing this. During a memorial ceremony after the death of Ōkyo, he is said to have violently abused Ōkyo's pupil Goshun when the latter, a younger man whom Rosetsu fancied to be his rival, took the seat of highest honor in the gathering. And Rosetsu died at the early age of forty-six in Osaka. One account states that by his arrogant behavior Rosetsu had enraged a craftsman in the employ of the Lord of Aki, whom he was to serve briefly. In a fit of jealousy, the craftsman had Rosetsu poisoned. Another account states that Rosetsu took his own life. These tales cannot all be true, but a pattern of eccentric, turbulent behavior emerges from them that is reflected in some of Rosetsu's more extreme, subjective paintings. Among these are the grotesque "Old Woman of the Mountains" (*Yama-uba*), which was given to the Itsukushima Shrine in 1797, and some of his extravagantly imaginative landscape screens.

This painting, while calm and reflective in spirit, nonetheless shows great boldness in the painting of the main tree trunk. It seems to date from the middle of Rosetsu's career, and it is signed "Rosetsu Sha-i." The seals in red are "Nagasawa" and "Gyo," or "fish," which was a highly personal symbol (see No. 88).

Reference: Tsuji Nobuo. *Kisō no Keifu*. Tokyo, 1970. Pp. 107–118; Suzuki Susumu. *Ōkyo to Goshun*. Nihon no Bijutsu, no. 39. Tokyo, 1969; *Kokka*, no. 860 (November 1963).

88. Owl in the moonlight

Mid-Edo period
Nagasawa Rosetsu (1754–1799)
Hanging scroll; ink and color on paper
H. 51 3/8 × 19 1/4 in. (130.5 × 48.9 cm.)

In this simplified composition, much in the spirit of *Zenga*, an owl sits on the ridge of a thatched roof beneath the disc of the moon. Pale red maple leaves on the roof add a color note to the restrained ink washes. This theme was much favored by Zen monk painters (see No. 97); it was painted by Rosetsu with crisp control of the ink accents along the top of the roof and the owl's head and eyes.

Beneath Rosetsu's signature is the large, distinctive seal that appears on many of his works, reading "Gyo," or "fish." Its origin, according to legend, was a dream of Rosetsu's in which he saw a fish locked in the ice of a frozen stream on a cold winter morning, unable to escape. But as the sun rose and the ice melted, the fish gained its freedom and joyfully swam about. Rosetsu likened the condition of the fish to his own, as a pupil of Ōkyo, oppressed by having to serve the older man; the dream encouraged him to seek his independence.

This seal was broken in 1792, the upper right corner of the waving outline being lost; hence this picture of an owl may be dated prior to that time. During the decade before his death, Rosetsu was active in showing his work in Kyoto in what may have been the forerunners of art exhibitions of the modern era. According to Rosetsu's friend, the Bunjin artist Minagawa Kien, each autumn and fall a large competitive showing of works by Kyoto artists would be held, sometimes in a large restaurant. Artists tried to capture the fancy of the public by creating novel themes and techniques, and Kien stated that Rosetsu was particularly active in these shows. The owl in the moonlight theme appealed to Rosetsu. He painted it several times; the Cleveland Museum of Art recently acquired a version extremely close to this one in conception and execution.

Published: *Sekai Bijutsu Zenshū*, vol. 10. Tokyo, 1965. Pl. 37.

89. Snowy landscape

Late Edo period (1826)
Tani Bunchō (1763–1840)
Hanging scroll; ink on silk
H. 48 3/4 × 23 1/8 in. (123.6 × 58.7 cm.)

Tani Bunchō was a member of the Bunjin school, its leading master in Edo. Temperamentally, he was eclectic and sympathetic to a broad range of artistic trends. In this work, he employed a Bunjin type of composition based on Ming Chinese prototypes. The execution, however, suggests much of the fantasy and inventive spirit of Shōhaku or Rosetsu. Bunchō must have used stiff brushes or even sticks to create the bristling, erratic line quality seen here. He established illogical dislocations of pictorial space; and the trees, in comparison to the scale of the middle-ground village, are unimaginably large. However, in the control of the tonality of the ink washes to suggest the darkening sky and the whiteness of the snow, Bunchō reveals a sophisticated mastery of ink painting analogous to that of Shōhaku and Rosetsu.

This work is dated in 1826, when Bunchō was sixty-three years old and entering into the last major phase of his career. He fell more into the convivial life style of the Bunjin, painting for his own pleasure or for his friends, and working in a broad, relaxed manner, producing pictures at a prodigious rate. He was surrounded by numerous students and disciples; over one hundred men are known to have studied under him, the most famous being Watanabe Kazan, Takahisa Aigai, and Tachihara Kyōsho.

Bunchō's position as the leading artist of his day in Edo was reinforced by the fact that he moved in politically prominent circles. His father was a poet in the service of the Tayasu family, descendants of the Tokugawa shogun, Yoshimune. When a young man, moreover, Bunchō was taken under the protection of Matsudaira Sadanobu, who belonged to the Tayasu family but had been adopted by the house of Matsudaira. For many years Sadanobu had been one of the most influential Elders, or advisers, of the *bakufu*, virtually the prime minister of the realm. Sadanobu was a rigid Confucian of the Chu Hsi school, a moralist who established an orthodox interpretation of Confucianism that was enforced throughout Japan. Doctrines at variance with his, like those of Ogyū Sorai or the Wang Yang-ming school (see Nos. 113 and 127), were severely repressed. In 1790, Sadanobu

also established the censorship of many classes of publications, especially in the realm of *ukiyo* literature and art, in order to suppress pornography and political dissent. About this time, there appeared to be danger of Russian incursions on Japanese territory, and he ordered defenses prepared along the Sagami and Izu coasts. The young Bunchō accompanied the Elder on inspection tours and made sketches of the scenery. And he did illustrations for a famous antiquarian study published by Sadanobu, the *Shūko Jusshu*.

In his artistic training, Bunchō experimented among the rich array of styles possible in his day. He began with the Kanō school, studying with Katō Bunrei; he also worked in the Chen Nan-pin manner of bird-and-flower painting. From Shiba Kōkan (see No. 146) he took instruction in Western-style arts, which deeply impressed him, and some of his most original and powerful works are in that manner— objective landscape drawings and even copper engravings. He also studied the Tosa and Kōrin styles, but *Bunjin-ga* became his main interest. Within this style, however, he was also eclectic, and one finds a great range of elements. He made careful studies of Chinese painting, but one can find traces of the influence of Buson, of Mokubei, and Chikuden. During his years of maturity, he seemed to turn from one manner to another—from Kanō to Unkoku to Western to Ming Chinese and the other variations of *Bunjin-ga*.

He was a serious theorist and art historian, and published a number of books—an album of famous mountains in 1804, for example, and a history of Japanese painting, the *Honchō Gasan*. For this reason, it is all the more ironic that eccentricity of the kind found in this painting had such an appeal for Bunchō. One of his most celebrated works is a view of Mount Hiko done in 1815, which uses the lateral dots of the Sung master Mi Fei to define mountain forms that seem to be exploding. He was a facile, intellectual artist striving for the effects of eccentricity but lacking the necessary personal and psychological dislocations.

Reference: *Nangashū*, vol 4. Tokyo, 1910; *Nanga Ju-taika-shū*. Tokyo, 1909.

Arts Related to the Zen Sect

Ceramics of the Tea Ceremony

"The tea ceremony," said Sen no Rikyū, one of its principal formulators, "is nothing more than boiling water, making tea, and drinking it." Indeed, *cha-no-yu*, usually translated as "tea ceremony," means literally "boiling water for tea." Yet, despite Rikyū's contention, this simple procedure lay at the heart of an elaborate ritual, which, for some two centuries, shaped the aesthetic life of nobility, warriors, and wealthy merchants alike.

If the tea ceremony can be said to have been formalized as *cha-no-yu* during the latter part of the fifteenth century, especially during the years of Ashikaga Yoshimasa's retirement in the Ginkaku pavilion on Higashiyama, tea drinking itself was not new to Japan at that time. The *Nihonkōki* relates that the Emperor Saga was served tea during a visit to a temple in the early summer of 815; his response was to order the planting of tea bushes throughout the home provinces. During this early period, tea drinking was associated with religious ceremonies or enjoyed as a solitary diversion of the nobility, who would play the *biwa* and compose poetry as they sipped boiled tea. The monk Eisai is credited with introducing powered green tea, or *matcha*, upon his return from Sung China in 1168. That powdered tea, prepared by whipping with a bamboo whisk, was the form around which the tea ceremony would center. Such tea became a mainstay of Zen meditation, but during the Muromachi period it was also taken up by the Kyoto nobility. They featured tea drinking in lavish parties, which also included wine, gambling, and dancing girls.

Meanwhile, as tea cultivation became increasingly widespread, tea also gained in popularity among the townspeople. Monks spread the custom among their parishioners, and vendors appeared on the Kyoto streets calling "*Ippuku issen!*", "a sip for a sen." But, whereas tea drinking for the nobility was the occasion for a party, among the lower classes it formed a focal point, in informal gatherings, for social unity.

These two traditions met in—of all unlikely places—Yoshimasa's villa on Higashiyama in the 1470s. Against the background of a capital ravaged by endless internecine wars, Yoshimasa retired to the tranquillity of his retreat to spend his time collecting precious Chinese paintings and ceramics. One of his tutors in these matters was the monk Murata Jukō, who is considered the founder of the tea

ceremony in its refined, semireligious form. Jukō grew up in Nara, where he was familiar with tea drinking among the lower classes; as a priest he entered the Kyoto temple Daitoku-ji, noted for its long and influential association with the tea ceremony beginning with Ikkyū. Under Yoshimasa's patronage, Jukō reschooled the Kyoto aristocracy in the form of drinking tea: he moved the ceremony out of the spacious hall into a tiny, four-and-one-half-mat room, reducing the number of participants to less than half a dozen. In this quiet setting he developed the aesthetic of *wabi*, "lonely seclusion." *Wabi*, embodying images of transiency, of decay, of the sincere man aware "of the cold winter wind on his skin," contained an implicit exhortation to open all one's senses to the poignant experience of the fleeting moment. To the Kyoto nobility, who had seen much of their world in ruins, the intellectual starkness of the *wabi* aesthetics offered the solace of ritualized simplicity.

Jukō's followers expanded the concept of *wabi*, which had its roots in Zen spiritual austerity and the actual poverty of the war-torn country. The monk Takeno Jōō (1502–1555) lived in a temple in the flourishing mercantile port of Sakai, and he took the tea ceremony directly to the newly established merchant classes in Sakai, Kyoto, and Nara. Although Jōō forsook the social heights of Higashiyama, he brought even greater refinement to *wabi* tea, preferring a three- or two-and-one-half-mat room. One of his followers wrote, "The spirit of Jōō's *wabi* tea ceremony is the same as that of the poem by [the medieval poet] Teika:

> As far as the eye can see,
> No cherry blossom,
> No crimson leaf:
> A thatched hut by an inlet,
> This autumn evening.

The form of the tea ceremony required a variety of utensils: an iron kettle to boil the water; a pottery or lacquer tea caddy, a pottery bowl, pottery containers for fresh and waste water, and a bamboo tea scoop, whisk, and dipper. In addition, the alcove of the tea hut was customarily decorated with a hanging scroll of painting or calligraphy and a container of flowers. Many tea masters also designed their own hut and surrounding garden. The tea ceremony aesthetic revolved around the selection of these various elements for their harmony with each other and their appropriateness to the season, the occasion, even the time of day. In Shukō's time, the Higashiyama nobles chose from among their collection of precious pottery from Sung, Yüan, and Ming China; but by Jōō's day, those imported wares were not only exceedingly rare but also costly beyond reach of the merchants who were Jōō's disciples. Jōō is responsible for awakening interest in the native ware from such kilns as Seto, Shigaraki, and Bizen. He called such pottery *midate ōyōhin*, "discovered practical ware"; searching for them among the inexpensive pots in the marketplace brought a new element of competition to the tea ceremony as practiced by the merchants, and they delighted in it.

226

From such a family of wealthy Sakai merchants came Sen no Rikyū, best remembered for his service as tea master to both Nobunaga and Hideyoshi. He committed suicide apparently at Hideyoshi's command. For the military men of that period, the tea ceremony was a means to demonstrate their newly acquired social status. Hideyoshi is known for having ordered a complete set of tea utensils in gold and using them to serve New Year's tea to the emperor. His infamous campaign in Korea is often called the "Teabowl War," because so many of his commanders seized the opportunity to bring back Korean potters and start their own kilns for tea ceramics. Against Hideyoshi's brash taste, Rikyū preached the doctrine of simplicity: "The true spirit of tea resides in the grass hut." But under Rikyū's successor and disciple, Furuta Oribe (1544–1615), who was both warrior and tea master, the style of tea utensils became increasingly flamboyant and rough. Oribe moved from seeking out "discovered ware" to actively patronizing Japanese kilns, and his taste for softly shaped, brightly glazed ware exemplifies the exuberance of the late Momoyama style. This custom of ordering ware was continued in the early Edo period by Kobori Enshū (1579–1647). He was acquainted with Rikyū and studied with Oribe while still a young man, and for a while he studied at the Daitoku-ji. Enshū had a penchant for classification, and he is responsible by and large for the complex network of categories and rules that still govern the tea ceremony. Enshū established as his epitome of good taste the elegant, rich, "beautiful *wabi*." In a sense, with him, the tea ceremony returned full circle to the sumptuousness of its origins in refined Chinese ware.

With each tea master the harmony of tea utensils developed in a characteristic manner that can be clearly identified by the careful records of tea ceremonies kept by participants. From these "tea diaries" one can learn about the location, the guests, the featured utensils of the ceremonies, even the comments made about those utensils by the guests. One can reenter the world of the tea hut wherein the ceremony was at once the simple act of boiling water and making tea for a friend and the ultimate revelation of one's aesthetic spirit. (L. C.)

90. Large jar

Latter half of the Muromachi period (fifteenth to sixteenth century)
Shigaraki kilns, Shiga Prefecture
Stoneware
H. 18 3/8 in. (47 cm.); diam. of mouth 5 1/4–5 1/2 in. (13.5–14 cm.); diam. of foot 6 in. (15.4 cm.)

This massive, completely unadorned jar exemplifies Japanese pottery of the middle ages just as the refined, technically accomplished Sue ware *hiraka* (No. 152) represents the ceramics of the Nara period. The dramatic contrast between these two pieces reflects fundamental changes in the production and use of ceramics. In the Heian period, lacquer and metal wares replaced Sue pottery as serving and ceremonial utensils, and ceramics virtually disappeared from the lives of the nobility. However, as actual economic and political power shifted from the capital to provincial manors, a new group of consumers for pottery appeared—farmers. Expansion of farming production on the manors was based upon new techniques of fertilizing, presoaking seeds to hasten germination before planting, and storing seed grains over the winter. All those techniques demanded pottery, specifically large jars with wide or narrow mouths. Thus the kiln sites where Sue ware was rapidly dying out turned to the production of such large jars; and, by the late eleventh century, when demand exceeded the capacity of those few centralized kilns, other extinct Sue sites were revived and new kiln regions developed.

Despite this continuity at the Sue kiln sites, the techniques of medieval wares were basically different. Coil construction almost totally replaced the wheel as the most efficient way to produce large jars. The quality of clay and the structure of the kiln were determined by the necessity of month-long firing to produce a dense, heavy, impervious stoneware body that did not need glaze. All these changes were oriented toward efficient production rather than toward the aesthetic qualities of the pot, and those kilns that attempted to continue Sue-type refinements inevitably failed. By the late medieval period, certain regional kiln centers became dominant, for they possessed the essential instinct for economy and were favored by

natural circumstances, including high-quality local clay, abundant firewood, and access to water transportation. Those sites, known as the "six old kilns"— Seto, Tokoname, Shigaraki, Echizen, Bizen, and Tamba—all continue in production to the present day.

One of those major medieval kilns, Shigaraki lies equidistant between Kyoto and Nara in the former Ōmi Province, a major rice producing region in the middle ages. This jar is an example of Shigaraki's most typical and abundant ware, like that of all medieval kilns, the so-called seed jar (*tane tsubo*). It features a small mouth that is easily sealed for storage and a heavy, nonporous stoneware body providing protection against humidity, insects, and rodents. The asymmetrical silhouette of this jar, characteristic of all medieval pots, results from the difficulty of controlling shape in the coiling method. The jar was coiled in four stages and set aside to harden before each new stage was added; the junctures of the stages are still apparent at three levels on the lower, center, and upper body, the neck having been formed as part of the last layer. Yet, precisely because of this somewhat incoherent form, the strongest impression is not of line but of volume, the very quality on which the usefulness of the pot depended.

The matte finish of the body suggests that the pot was fired far back in a tunnel kiln, away from direct exposure to the flames. As a result, the thick crust of ash which fell on the surface did not reach a temperature high enough to fuse and form a natural glaze, except for a few streaks of dull olive gray on the face. Instead, the bare suface of the clay displays a delicate range of coloration from beige-pink through salmon to muted rose, suggesting the reason why tea masters often characterized Shigaraki clay as having the color of cherry blossoms. (L. C.)

91. Large tea jar

Late Muromachi period (sixteenth century)
Shigaraki kilns, Shiga Prefecture
Stoneware
H. 21 1/2 in. (54.6 cm.); diam. of mouth 6 1/2 in. (16.5 cm.); diam. of foot 7 1/2 in. (19 cm.)

In the production of large seed jars at the Shigaraki kilns from the thirteenth through the sixteenth centuries, the potters had no time for fine finishing or glazing, and their chief customers, the farmers, had no need of them. But it was precisely this straightforward, unelaborate aspect of the pottery that appealed to tea masters, who adopted the jars as storage vessels for tea leaves. In this role, Shigaraki jars not only preserved the fragrance and freshness of the tea over a long time but were in accord with the aesthetics of *wabi* tea. Using the vocabulary of *wabi*, the fifteenth-century tea master Jukō praised jars from Shigaraki and Bizen for seeming *hiekareta*, "chilled and withered." In contrast to the gorgeously glazed Chinese ceramics then in use in Yoshimasa's circle, the beauty of the unpretentious native ware was wholly the result of chance events in the kiln, where long exposure to flame, smoke, and ash during firing subtly mottled and pigmented the surface of the unglazed body. Coloration included bright spots of "scorch," crusts of gray ash, and sheens or rivulets of accidental ash glaze ranging in color from pale yellow-green to brilliant blue-green. In this idea of "kiln accidents" and "kiln change," the tea master recognized similarity between the potter's helplessness to control the kiln effects and the spirit of humility cultivated in the tea ceremony.

Nonetheless, once the potters became aware of the tea masters' interest in their pots, they began paying more attention to design. This jar, for example, much more than No. 90, shows a marked influence of urban taste in the controlled shape of the body, although the ridges indicating the successive levels of coiling are still visible. The neck, in particular, was amenable to refinement and was finished on the wheel with a crisply turned-out rim. This sort of jar might have been put on display in the tea room; such a usage is recorded in the *Matsuya Kaiki* tea diary for the second day of the eleventh month of 1578 at a tea hut within the Tōdai-ji in Nara.

Although not intentionally glazed, the surface of this jar sparkles with a thin coating of melted feldspar from the clay itself. The even-hued reddish brown body is sprinkled with unfused crystals of feldspar, called *ishi-haze* or "stars," which are a trademark of Shigaraki. On the face of the jar, a light olive green accidental glaze has formed. In contrast to No. 90, the "kiln effects" on this jar are typical of the ware fired in large, stable, oxidizing step-kilns rather than Sue-type tunnel kilns, where conditions were more variable. Step-kilns were introduced to Shigaraki as production of tea jars became a major enterprise. Throughout the Edo period Shigaraki maintained a monopolistic right to supply tea jars to the nearby tea-growing center at Uji, and Shigaraki jars—many finely glazed—became a familiar feature of tea stores throughout the country. (L. C.)

92. Tea jar

Late Muromachi period (sixteenth century)
Bizen kilns, Okayama Prefecture
Stoneware
H. 17 in. (43 cm.); diam. of mouth 6 in. (15.3 cm.); diam. of foot 7 1/2 in. (19 cm.)

Large jars from the kilns at Bizen, like those from Shigaraki, were used as storage vessels for leaf tea from an early date. The oldest dated Bizen jar bears an inscription stating that it was made in 1363 for a certain temple. The medieval kilns at Bizen developed from a strong Sue ware tradition, and facing south on the Inland Sea with easy access to water transport, they became the principle supplier of storage jars for southern Honshu and northern Kyushu.

But the popularity of Bizen tea jars depended as much on aesthetic as upon economic factors. Beginning in the early Muromachi period, so-called Luson jars, saké storage jars from southeast China, entered Japan via the Philippine trade routes. Not only did those jars exemplify "discovered practical ware" but they also retained the exotic, so-called Namban ("Southern Barbarian") flavor of foreign goods. Tea ceremony diaries of the sixteenth century show that the best grades of tea were stored in such foreign jars, while lesser grades were relegated to jars from Shigaraki, Seto, and Bizen. The native kilns were not slow in imitating the Luson jar, with its straight, high neck, four ears for fastening a lid, and thin brown glaze over the upper body. In such imitations, Bizen benefited from the natural color of its iron-rich clay, a deep,

lustrous purple-brown. This color resulted from the predominant use of "field clay" dug from the bottoms of paddies and dry fields, and heavy with organic impurities. Not only tea jars but various other tea ceramics from Bizen attained a wide reputation for their accordance with the Namban taste.

Every feature of this jar shows the influence of such taste. The body is quite thinly potted in a well-controlled, consciously elegant shape. Horizontal grooves indicate that the wheel was used for careful finishing and they evoke the exaggerated finger ridges found on Luson jars. The bands of coarse combing on the shoulder, in straight lines and wave pattern, derive from a Sue tradition at Bizen, but such ornamentation also appears on the foreign ware. Overlying the shoulder and neck is a mottled yellow-brown glaze with drips so even as to suggest intentional application after the fashion of some Luson pieces. The large, straight, somewhat inverted neck is also a feature of the Chinese jars. Jars of the type pictured here, produced at Bizen from the late Muromachi through the early Edo period, mark the end of "discovered wares"; these jars were made with full consciousness of the requirements of their consumers, the urban tea masters. (L. C.)

93. Small jar

Momoyama to early Edo period
Echizen kilns, Fukui Prefecture
Stoneware, with heavy natural ash glaze
H. 10 3/4 in. (27.3 cm.); diam. of mouth 3 5/8–4 3/4 in. (9–12 cm.); diam. of foot 5 1/8 in. (13 cm.)

As one of the "six old kilns," Echizen was the major pottery center in the Hokuriku region, on the Japan Sea coast north of Kyoto, during the middle ages. Sue ware kilns were already established in the area by the sixth century, although the gradualness of their development reflected their distance from the cultural center of the Yamato plain. At Echizen, Sue ware did not reach a peak of production until the late Nara and early Heian periods, when such ware was already declining in the home provinces. Echizen Sue was strongly influenced by techniques and styles of the Sue kilns in the home provinces, and this influence continued into the middle ages when the kilns turned to making large pots, jars, and bowls for the farmers of the region. Evidence of the transmission of techniques from the great kiln area at Tokoname on the peninsula southeast of Nagoya shows clearly on the early medieval Echizen ware, yet Echizen remained among the smaller of the "six old kilns," numbering only some eighty kiln sites in four hundred years of medieval pottery production.

Along with the standard medieval ware—large storage pots and mixing bowls—Echizen produced a characteristic small jar that often had a pouring spout and ears. Probably such jars served as kitchen storage vessels for oil, pickles, bean paste, and other staples; but tea masters also adopted them as containers for fresh water (*mizusashi*) in the tea ceremony, frequently fitting them with a plain black lacquer lid and giving them the whimsical nickname *uzukumaru*, or "crouching down pot."

This pot might well have served both as kitchen storage container and *mizusashi*. Distortion of the neck when something fell against it in the kiln did not reduce the usefulness of the pot to the farmer and, indeed, heightened its appeal for the tea master. The entire face of the pot is mantled by a glistening natural ash glaze, shot through with flecks of amber brown and milky blue. The unglazed surfaces display the reddish tint and shiny "skin" indicative of firing in the oxidizing step-kiln, which was introduced to Echizen in the Momoyama period. The constricted body with its high shoulders and weakly defined neck has lost the generous roundness of No. 94. Both technically and aesthetically, this piece has a slightly later date than No. 94; it belongs to the final days of medieval Echizen, before the introduction of modern kilns eliminated the marvelous accidents of glaze and coloration produced in the smoky, drafty tunnel kilns. (L.C.)

Reference: Narasaki Shōichi et al. *Hokuriku no Kotō.* Gotō Museum (Tokyo) and Tokugawa Museum (Nagoya), 1967.

94. Small jar

Momoyama period
Echizen kilns, Fukui Prefecture
Stoneware, with natural ash glaze
H. 8 7/8 in. (22.5 cm.); diam. of mouth 4 11/16 in. (12 cm.); diam. of foot 5 1/2 in. (14 cm.)

Numerous jars from the medieval kilns bear incised freehand markings on their shoulders commonly referred to as "kiln marks." Nevertheless, the significance of those markings has not been satisfactorily explained. Clearly recognizable kiln marks did not come into use until the sixteenth century, when they accompanied the introduction of large-scale communal kilns (so-called great kilns), for which some sort of identification of the various participating potters' work was essential. To the marks on pots that obviously predate the era of the great kilns various theories have accorded religious rather than practical significance. Possibly they are charms or magic formulas related to ritual purification of the pots before firing (even today Japanese potters usually make a small offering to the Shintō gods of the kiln). Perhaps, too, the marks relate to the frequent use of such pots as cinerary urns in Buddhist burials. On the pot shown here, for example, the marks—on the upper left an arc bisected by a vertical straight line; to its right a T-shaped mark—are similar to those found on a pot excavated from a temple ground and dated to the Kamakura period. The same markings appear on numerous other pots of the Muromachi period as well.

This pot dates to the Momoyama period because of its plump, globular body topped by a short, straight neck with a level rim. On and near the base, the bare clay is a pale, dull gray, while much of the rest of the body appears to have been exposed to the ash-laden smoke leaving a gray-brown glazelike coating on the surface. This coloration, reminiscent of the surface of Sue ware, suggests that the pot was fired in a Sue-type tunnel kiln, which was in use at Echizen until the early Momoyama period. In contrast to the somber lower surface, a richly mottled, varicolored natural ash glaze runs over the neck and shoulder and continues in a fringe of trails, each ending in the bead of glaze the tea masters called "dragonfly eyes." Within the translucent glaze appear streaks of amber, dappled patches of olive brown, and pools of milky blue-white, the last being the effect of rice-straw ash. The understated elegance of the glaze, evocative of Shōsō-in silk brocade, contrasts sharply with the traces of the rigors of firing—scars and chunks of cinder fused into the glaze. Precisely this sense of refined beauty emerging from the fire of the kiln attracted tea masters as they searched among common wares for ceremonial utensils. (L. C.)

Reference: Narasaki Shōichi et al. *Hokuriku no Kotō*. Gotō Museum (Tokyo) and Tokugawa Museum (Nagoya), 1967.

Arts Related to the Zen Sect

Zenga

Japanese Zen monks of the Edo period continued to work in ink painting long after the most serious, professional efforts in that medium came from secular artists—the Kanō painters, for example, or the Hasegawa, Unkoku, and Kaihō schools. Some monks were extremely prolific in painting and calligraphy; they saw these as forms of daily spiritual discipline and also as means of instructing parishioners who prized any work from the hand of a revered teacher.

Beginning with Isshi, Fūgai, and Takuan in the seventeenth century, the Zen monk-painters tended toward naive and simple brushwork, largely as a reaction to the highly sophisticated techniques developed in the secular ateliers—the handling of brush and ink in elegant and calculated ways and the elaborate screen paintings so often embellished with golden inks. Instead, the monks sought a kind of intuitive primitivism, a return to unstudied, elemental kinds of expression that have appealed greatly to contemporary Western taste, or that side of it which admires Paul Klee, Joan Miró, Jean Dubuffet, and folk arts. On the other hand, the informality of this Zen school and its tendency toward humor have frequently caused it to be discounted or ignored in the annals of orthodox art history.

The name *Zenga* (literally, "Zen painting") is used today to distinguish work of this school from the more formal efforts of the earlier monk-painters, Shūbun or Sesshū, for example. Throughout the Edo period, the masters of *Zenga* exerted considerable influence on other artists and were a vital part of the fabric of Japanese culture. The informality, naturalness, and inventiveness of *Zenga* were shared by the Kōetsu school through three generations and by the artisans serving the cult of the tea ceremony. We find in some *Zenga* the bawdy farcical spirit of the folk theatre called *kyōgen*, a spirit that is prominent in *ukiyo-e* as well, especially in the work of Hokusai. Witty caricature, verbal and visual puns, eccentric calligraphy, all appear in *Zenga* as part of a general release of rich humor in the Japanese people, which emerged in the mid-Edo period. In addition, the extraordinarily wide range of subject matter painted by Hakuin or Sengai, for example, come close to an encyclopedic attitude that appeared in Japanese history and sciences. This was the product of a people aware that they belonged to a "late" civilization, looking back on a long and complex heritage.

Finally, the Zen monk-painters often strived for the utmost economy of means, using plain ink on paper, reducing their images to the simplest possible composition and absence of detail. That brought them into very close harmony with the poets who cultivated the haiku, the artificially shortened, seventeen-syllable verse that has become perhaps the favored poetic form of the Japanese people. The outstanding master of haiku, Matsuo Bashō, was a lay disciple of Zen; the tense discipline and evocative power of his poems gave expressive resonance to the Zen vision of reality. Bashō and his followers actually painted illustrations along with the texts of their haiku, attempting to harmonize the visual image, the calligraphic style, and the poetic thought. The result was the *haiga*, a painting abbreviated like the haiku itself, which developed into a popular if minor idiom among Japanese artists in a variety of schools.

95. Hung-jên, the Fifth Ch'an Patriarch, as a pine tree planter

Edo period (early seventeenth century)
Takuan Shūhō (1573–1645)
Hanging scroll; sumi ink on paper
H. 27 × 12 3/8 in. (68.5 × 31.6 cm.)

This scroll is a product of the effort to return to an exceedingly simple mode of expression, which characterized much of Edo period *Zenga*. The artist, the monk Takuan, reduced the head of Hung-jên to a rough doughnut shape, the hat to a spider web. He made no effort to draw convincing anatomy in the arms and back; the lines are loose and undisciplined. There is a playful quality here, such as one sees in works of Joan Miró or Paul Klee, an attempt by the artist to free himself from the tension of highly sophisticated composition and techniques. This is entirely in keeping with the subject, which depicts the Fifth Ch'an Patriarch in China in the humblest possible guise, as a barefoot peasant with a pine sapling tied to his hoe.

The theme of a pine tree planter, frequently found in the Zen tradition, was used to depict monks of the Lin-chi, or Rinzai school, in which the pine tree was a prominent emblem. This version, however, treats the origin of the theme, an episode in the legendary biography of the Fifth Patriarch, Hung-jên, who died in 675 (see No. 78). It is said that he had been an illiterate pine planter but had encountered the Fourth Patriarch, Tao-hsin, who impressed him deeply. Unfortunately, Tao-hsin also told him that he was too old to begin the study of Ch'an. Whereupon the pine planter asked a woman washing clothes nearby if he might be reborn inside her. She agreed; the miracle was accomplished; he was reborn; but the woman's family threw the infant into a river. The next day, however, the child was found, floating upstream. Later he was given instruction by Tao-hsin, who designated Hung-jên his successor because of his intuitive insights, not his intellectual understanding of Buddhism.

The inscription here refers to the miraculous rebirth; it is based on a poem by a certain Wu Wei-tsu, possibly an eleventh-century government official and devotee of Ch'an Buddhism from Ch'eng-tu in Szechwan:

The Eulogy of Wu Wei-tsu

There can be no one without a father.
Yet the Patriarch has only a mother.

Who is the mother?
She is the youngest daughter of Mr. Chou.
The swollen stream of muddy water rushes into the great river.
Before the gate, there is, as of old, the road to Ch'ang-an.
>By the aged Takuan, who supplied both [the inscription] above and [the painting] below. [two seals of Takuan]

The allusion to the road to Ch'ang-an, one of the great cities of T'ang China, implies the path to spiritual salvation—perennial, always open to the traveler, the capital being an emblem of the ultimate goal of Enlightenment. The allusion to muddy water reaching the great river is, similarly, an ancient aphorism, wherein salvation is likened to the tiny, impure stream of an individual's identity joining the boundless ocean of ultimate reality.

Both painting and inscription are by Takuan Shūhō, who became the one hundred and fifty-fourth abbot of Daitoku-ji at the age of thirty-seven (see Nos. 77, 78). He was the Zen teacher of the Emperor Gomizuno-o, wrote on the tea ceremony and the relationship between Zen and swordsmanship, and resisted the efforts of the Tokugawa military government to strengthen its control over the Zen establishment. In 1627, Takuan and several other monks who went to Tokyo to protest government policy however, were forced into exile in the northeast of Honshu. In 1636, he was granted amnesty by the third shogun, Iemitsu; at Iemitsu's order, he opened the Tōkai-ji in Shinagawa, a district of Edo, which became the chief Zen monastery in the new capital; its garden was designed by Kobori Enshū (see No. 99), and Takuan ended his days there. A considerable number of paintings are attributed to Takuan, but they lack the strong personal style of men like Hakuin or Sengai.

Published: Noma Seiroku. *The Arts of Japan, Late Medieval to Modern* (Glenn Webb, trans.). Tokyo, 1967. Fig. 88; Awakawa Yasuichi. *Zen Painting.* Tokyo, 1970. Fig. 49.

96. Calligraphic scroll

Early Edo period (early seventeenth century)
Konoe Nobutada (1565–1614)
Hanging scroll; ink on coarse paper
H. 29 1/2 × 16 1/4 in. (74.9 × 41.3 cm.)

Written boldly on rough, humble paper by Nobutada, one of the leading calligraphers of the early Edo period, this phrase is familiar to all students of Ch'an Buddhism. Below it and next to Nobutada's cipher is a pestle used to hull rice shown in the most abbreviated form possible. Those elements were taken from the eighth-century *Platform Sūtra of the Sixth Patriarch*, from a crucial episode in the life of the Patriarch Hui-nêng (see No. 78).

While Hui-nêng was still a novice in the Monastery of the East Mountain in Hupeh Province, the Fifth Patriarch, Hung-jên, had urged each monk living in the monastery to write a verse. If any verse revealed its author to possess supreme insight, Hung-jên would give him the special teaching of the Dharma and designate him his successor. The head monk, Shên-hsiu, was the leading candidate to succeed Hung-jên. He wished to obtain the Dharma, but he knew that if he wrote a verse, it would also reveal his ambition to become the Sixth Patriarch. To reveal his ambition would be an obstacle to achieving it. So secretly, at midnight, he inscribed anonymously the following poem on the wall of a corridor of the temple:

> The body is the Bodhi tree.
> The mind is like a clear mirror.
> At all times we must strive to polish it,
> And must not let the dust collect.

The master Hung-jên recognized the lack of insight in this poem but pretended to admire it and urged that all disciples recite it. He then asked Shên-hsiu if he had written the verse; since it seemed to be successful, the latter confessed. Thereupon Hung-jên told him that he had not yet reached true understanding and urged him to compose another verse.

Hui-nêng, although only an illiterate novice working in the monastery threshing room, came to see the controversial poem. He had it read to him, and immediately thought of his own version which would correct the shortcomings of the other. He asked someone to write the following verses on the wall of the corridor:

> In essence Bodhi has no tree;
> The mirror also has no stand.
> The Buddha nature is always clean and pure.
> Where is there room for dust?

> The mind is the Bodhi tree.
> The body is the mirror stand.
> The mirror in essence is clean and pure.
> Where can it be stained by dust?

Reading this, the Fifth Patriarch realized that Hui-nêng had supreme insight, but he disguised his approval in order to protect the youth from Shên-hsiu and his followers. At midnight, he summoned Hui-nêng to him and expounded the meaning of the *Diamond Sūtra*; gave him the robe, the emblem of the rank of Patriarch, and designated him as his successor. Then secretly, he took Hui-nêng across the Yangtze for safety (see No. 78, scene 1).

The scroll contains only the first two lines of Hui-nêng's poem and the pestle, which was his symbol; but few Japanese in the circle of Nobutada would have failed to grasp the full meaning. Nobutada, like Kō-etsu and Shōkadō (see No. 98), was an outstanding calligrapher and cultural leader of his day. Often referred to by his honorific name, Sammyaku-in, he was born into a family long associated with the Imperial Court, and his father was also a distinguished calligrapher. Nobutada rose rapidly in court ranks. When Hideyoshi led his invasion of Korea, Nobutada tried to join it on several occasions but was thwarted by his close friend, the Emperor Goyōzei, and was assigned to the Satsuma region. After the war, Nobutada returned to Kyoto, and in 1605 he reached the lofty and privileged rank of Kampaku or Chief Minister. That was the highest position in the imperial government, as distinguished from the administration of the shoguns, in whose hands most real administrative power lay.

In this wide range of associates, Nobutada was familiar with such tea masters as Furuta Oribe, and his calligraphy fell very much under their influence—being bold and open as contrasted to the more elegant

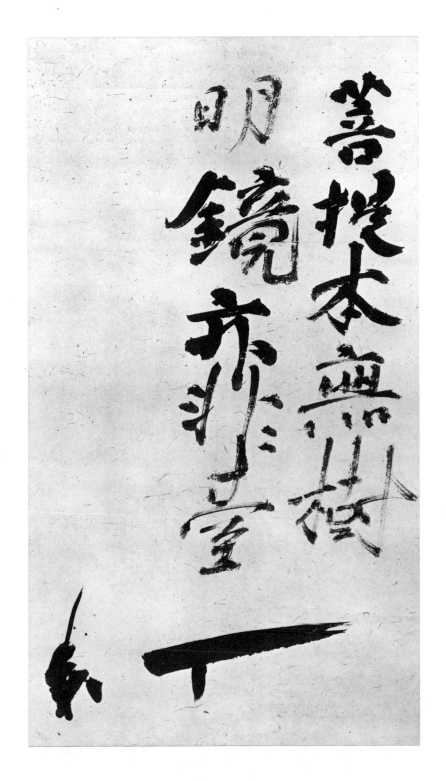

forms of Kōetsu. He studied Zen with a number of monks of Daitoku-ji, especially Takuan (see Nos. 77, 78, 95). This work, in its direct writing style and rough, coarse paper, is deeply redolent of the atmosphere of Zen circles.

Reference: *Shodō Zenshū*, vol. 22. Tokyo, 1959. Nos. 10–15; *Shodō Zenshū*, vol. 21. Tokyo, 1930. Nos. 21–23.
Quotations and account of Hui-nêng and Hung-jên adapted from Philip B. Yampolsky, *The Platform Sutra of the Sixth Patriarch*, New York, 1967.

97. A "bonze" owl in the moonlight

Early Edo period
Monk Isshi Monju (1608–1646)
Ink on fan-shaped paper
H. 15 1/4 × 10 in. (38.8 × 25.4 cm.)

Fluently painted in simple *sumi* ink on paper, this tiny owl is perched on a withered, vine-entangled branch. The bird is called, in common parlance, the *buppōsō-chō* (Buddhist monk-bird), and is found from the Indian Himalayas to China, Manchuria and Japan. The name, given to it in China, comes from the sound of its cry, which resembles a Buddhist chant. The motif of this bird sitting in the moonlight must have appealed greatly to Isshi, for he repeated it many times.

Isshi lived only thirty-nine years, but in that time attained great distinction in both religious and literary-cultural circles. He was descended on his maternal side from the ancient Kuga family, associated for centuries with the Imperial Court and from whom had come the famous thirteenth-century monk Dōgen, as well as several prominent Zen monks of the early Edo period. Isshi was closely associated with such figures as the monk Takuan (see Nos. 77, 78, 95), who was his main teacher of Zen doctrine; and with the courtier Karasuma Mitsuhiro who was his patron and disciple. He was also close to Konoe Nobutada (see No. 96) and his adopted son Nobuhiro, outstanding calligraphers and writers, and he was supported for a while by the retired Emperor Gomizuno-o. On his death, Isshi was given a posthumous title, "Butchō Kokushi," an honor accorded only monks of the highest prestige.

Isshi was a prolific painter, and he occupies a significant position in the development of painting in the Zen Buddhist monasteries. Proficient and well schooled, he attempted to sustain the techniques that had developed in the Muromachi period. In that respect, he resembled such conservative lay artists as Hasegawa Tōhaku and his son Sakon (see No. 78). On the other hand, Isshi would occasionally reduce his paintings to the simplest, most elemental components, turning to a kind of intuitive primitivism that was practiced by Hakuin (see No. 102) and Fūgai, both early masters of the so-called *Zenga*. This painting of the *buppōsō-chō* belongs to the former tradition in its mastery of calligraphic line, ink textures, and careful depiction of the shape of the bird. It should be seen more as a later expression of Muromachi painting than as an essay in *Zenga*.

To the right is a seal in red ink reading "Isshi." The attribution is attested to by the signature inside the box by Mori Daikyō, a modern collector of Zen paintings.

Published: Awakawa Yasuichi. *Zen Painting*. Tokyo, 1970.
Reference: *Isshi Oshō Iboku-shū*. Tokyo, 1966; Takeuchi Naoji. "Kindai Zenrin no Kaiga," *Museum*, no. 166 (January 1965).

98. Screen with love lyrics

Early Edo period
Shōkadō Shōjō (1584–1639)
Six-panel folding screen; ink on paper covered with gold leaf
H. 54 5/8 × 145 1/2 in. (138.8 × 359.6 cm.)

This screen of paper covered with gold leaf is one of a pair inscribed in black ink by Shōkadō Shōjō, a monk of the Shingon sect who lived as a semi-recluse at Otokoyama, south of Kyoto. He has been ranked as one of the Kan'ei Sanpitsu, "The Three [Outstanding] Brushes of the Kan'ei Period" (1624–1644), along with the aristocrat Konoe Nobutada (No. 96) and the craftsman Hon'ami Kōetsu (Nos. 105–107). Together the three men introduced new expressive forces to Japanese calligraphy that

reflected vital developments in the culture at large.

This screen is inscribed with sixteen romantic verses (*koi-uta*) selected from various poetic anthologies. They were done in *sōgana*, the rapid, cursive writing style of the Japanese *hiragana* syllabary. They were arranged in the so-called sprinkled writing form (*chirashi-gaki*), for the verse lines are of diverse sizes and lengths and appear to be strewn over the paper. The verses in the last two panels on the left are written in the *ashide-gaki* (reed type of writing) format, so called because it simulates a cluster of reeds swaying.

Shōkadō Shōjō was born in 1584 in the province of Yamato, the present Nara Prefecture. While still quite young, he became a pupil of the monk Takinomoto Jitsujō at Otokoyama. This was a great sanctuary of both Esoteric Buddhism and Shintō, built around the chief shrine of the War God Hachiman in the Kyoto region, the Iwashimizu Hachiman-gū. It was regularly visited by members of the imperial family, the aristocracy, and the military families of Kyoto. Shōjō became an accomplished, learned theologian, but he refused to accept high clerical administrative positions. Preferring rather an independent life, he retired to a small temple residence called the Takinomoto-bō on the slopes of Otokoyama and was able to devote considerable time to painting and calligraphy, poetry, the tea ceremony, and connoisseurship. A re-

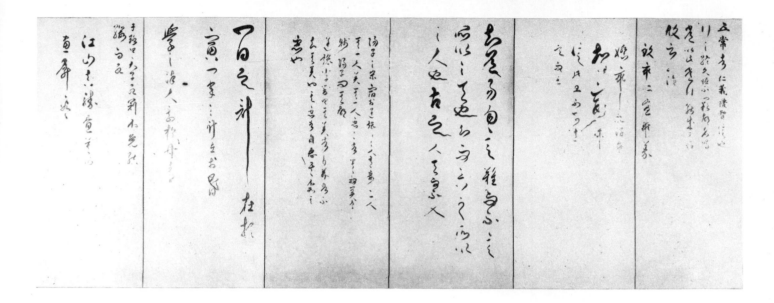

detail

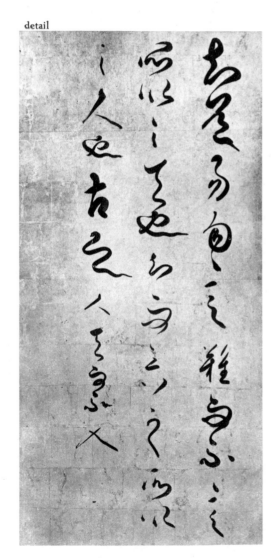

liable biographical account tells that he was by nature
most inclined to calligraphy but that he was also
adept in ink painting, for which he used as his models
the work of Mu Ch'i, Yin-t'o-lo, and other Ch'an
masters of the Sung and Yüan periods. He was by no
means a complete recluse. His sphere of activities was
quite wide, and he befriended some of the noted
creative personalities of the time. Among these were
Zen monks of Daitoku-ji, Kōgetsu Sōgan and Takuan
Shūhō, and the famous tea master and garden designer
Kobori Masakazu (who is better known as Enshū,
after his position as Governor of Tōtōmi Province).
Inscriptions by all three of these men are found on
Shōjō's paintings. He was also acquainted with the
pioneer Confucian scholars Hayashi Razan and Ishi-
kawa Jōzan.

Shōkadō Shōjō's outstanding achievement was his
mastery of the *sōgana* style of calligraphy, which can
be seen here in the studied informality, the flickering
precision of the strokes, the unexpected distortions
and attenuations of the letters. Like Kōetsu and
Nobutada, Shōkado learned the style of *sōgana* that
had long been taught at Shōren-in, a temple on the
eastern edge of Kyoto. For generations the abbots
there had been of imperial stock. The lineage of the
Shōren-in calligraphers went back to the mid-
fourteenth-century imperial prince Son'en, who had
taken the calligraphy of the mid-Heian period as his
classic pattern. By the sixteenth century, the Shōren-
in style of *sōgana* had become fixed, and one of its
most gifted practitioners was the monk-prince
Sonchō, who died in 1597. By then the style had

246

become the widely accepted standard for official documents, literary works, and even for ordinary correspondence of the common people. While the style was elegant and graceful, its uniformity resulted in a lack of expressive vitality—until the contributions of the great Kan'ei calligraphers.

Kōetsu is credited with integrating native *hiragana* writing with the Chinese script he carefully studied, especially that which originated with Chang Chi-chih of the Sung dynasty (see No. 107). Nobutada, partially influenced by the masculine Chinese style of calligraphy practiced by contemporary Zen monks, transformed the standardized *sōgana* into a uniquely bold and vigorous style, imbuing it with a strong touch of individuality. Shōjō, on the other hand, differed from both the mainstream style of Shōren-in and the other two men by returning to the classical eleventh-century manner. Nobutada and Kōetsu, mixing the cursive style of both Chinese characters and Japanese syllabaries, created strong contrasts of thick and thin strokes. Shōjō's *sōgana* shows characters that seem to flow in sinuous yet fluent strokes with only slight variations of thickness —a stylistic feature that, incidentally, recalls closely the Kōzei style. That Shōjō intimately appreciated the style of Heian and Kamakura period calligraphers can be seen in a collection of calligraphy fragments known as the *Yahata-gire* that were at one time in Shōjō's possession. Most significant among them are the works attributed to the mid-Heian master, Ono no Tōfū (894–966), who was considered by the early Shōren-in calligraphers as one of their mentors. If Kōetsu and Nobutada represented inventive aspects of the new style in *sōgana*, Shōjō represented a more conservative aspect. His works are seldom if ever accompanied by underdrawings and other decoration, in distinct contrast to the work of Kōetsu, which so often combined calligraphy and painting.

This screen shows traces of retouching in the lower half of the first two panels in the different kind of gold leaf applied there. And in the lower part of the third panel are suggestions that there might originally have been more poems similar to those above.

Accompanying this screen with its *sōgana* script is a screen, written in Chinese, with eight proverbs taken from the Four Classics of Confucius. It is not included in the exhibition, but is illustrated here. In this, Shōjō's style was greatly influenced by that of Kūkai, the early Heian period Shingon monk whose calligraphy exerted great influence during the Edo period (see No. 132). The depth of Shōjō's veneration is indicated by an apocryphal tale in which he is described meeting a mysterious old monk at Shitennō-ji in Osaka. Shōjō thinks him to be a reincarnation of Kūkai, and receives rigorous instruction from him in Kukai's distinctive Chinese script. In the corpus of Shōjō's calligraphy are many works that show this influence, especially in the snake-like terminal strokes that are so prominent here.

In this screen, also, the size of the characters varies radically from panel to panel, some stanzas written in small scale, others large and bold. For the most part, each character is distinct and separate from the next, composed independently. The overall effect of the placement of the stanzas resembles the *chirashi-gaki*, the more random, informal arrangement in the Heian tradition used in the first screen and also in the calligraphy of Kōetsu (see Nos. 105–107). Shōjō's calligraphy in this screen is quite close in spirit to his masterpiece in the Chinese style of Kūkai, his transcription on silk of the entire *Yüeh Chih-lun* ("Treatise on Pleasure") by Chung Ch'ang-t'ung, an eccentric scholar of the Later Han period. (S.S.)

Reference: Sato Torao. *Shōkadō*. Tōyō Bijutsu Bunko, vol. 37. Tokyo, 1939; *Shodō Zenshū*, vol. 22. Tokyo, 1959. Pls. 16–21, p. 192.

99. "Miwa-yama" (calligraphic poem)

Early Edo period (second quarter of the seventeenth century)
Kobori Enshū (1579–1647)
Hanging scroll; ink on paper
H. 8 1/4 × 7 3/8 in. (21 × 18.8 cm.)

This thin, darkened sheet of calligraphy belongs among the hauntingly fragile, highly personal products of the seventeenth-century revival of antique Japanese-style arts in Kyoto. In large part, the revival was a reaction against the ostentatious taste of the newly risen warrior class, embodied best, perhaps, in the ornate Tokugawa family shrine at Nikkō. Kobori Enshū, as an architect, garden designer, and tea master, occupied a prominent place among the leaders of the conservative movement—men like Kōetsu and his followers, the Shingon monk Shōkadō, the tea master Furuta Oribe, the courtiers Nobutada and Mitsuhiro, and the Imperial Prince Hachijōmiya.

The original purpose of this calligraphy page is unknown; it lacks signature, seal, or dedication. The poem appears to be an original one by Enshū, and it reads:

Miwa-yama	*Mount Miwa*
Kyō koso wa	On this very day,
Miwa no higashi no	Who shall hear
Hototogisu yukute no	The cry
koe o	Of the cuckoo
Tare ka kikamashi	As it flies
	To the east of Miwa?

Mount Miwa is a low, sacred mountain along the northern edge of the Asuka plain. As a prominent, familiar part of the Yamato region, it is frequently mentioned in ancient Japanese poetry, and this verse of Enshū's is clearly an attempt to join that tradition, to revive it. In the *Man'yōshū* (I.17–8), for example, Miwa-yama is described by the seventh-century Princess Nukata as a place of concealed beauty. The Heian poet Ki no Tsurayuki expressed the same notion in a verse in the *Kokinshū* collection, lamenting that flowers bloom unobserved, hidden by the spring haze on Mount Miwa. Enshū's poem also alludes to beauty unobserved, the call of the cuckoo, and to the ephemeral nature of things; the cry of the cuckoo is often the harbinger of death.

Enshū, as an expert connoisseur of tea ceremony utensils, gave the name Miwa-yama to a fine ceramic tea canister from the Seto kilns now in a Japanese private collection. On the inside of its storage box he inscribed the poem entitled Miwa-yama written by the ninth-century Lady Ise and taken from the *Kokinshū*. In ways like that, Enshū and his colleagues combined traditional Japanese sensibilities with the taste for natural, unaffected beauty cultivated by the Zen sect and originally based on imported Chinese modes of expression.

Enshū's capacities as a tea master had been developed at an early age, when he studied with Furuta Oribe, teacher of the second Tokugawa shogun, Hidetada. Enshū became the tea master of the third shogun, the redoubtable Iemitsu, and designed a number of celebrated tea houses. These include, for example, one at the Tōkai-ji, the Zen temple built in Edo by Iemitsu for the monk Takuan (see No. 95). In fact, Enshū's original profession was that of architect and construction overseer, which he had learned from his father, who had served Hideyoshi and other powerful samurai in the same role. Enshū attained even greater eminence than his father; and, correctly or not, his name is associated with many of the most ambitious building projects of the early seventeenth century. He is said to have worked for Hideyoshi and family at the Fushimi and Osaka castles, and he supposedly served the Tokugawa family at their Nagoya and Kyoto Nijō castles. He worked for the imperial family in Kyoto at the Imperial Palace and the Sentō-gosho. He is also reputed to have had a prominent role in the building of the Katsura Villa, but this has never been precisely determined; such projects often involved the collaboration of many specialists. His taste was strongly influenced by that of the Zen sect; he had taken instruction at Daitoku-ji under the monk Shunoku Shūon, who had also been a teacher of Mitsuhiro. Enshū designed gardens for several of the Daitoku-ji subtemples; the Ryōkō-in and the Kohō-an are the most famous, and his funeral monument was erected at the latter. Well-maintained gardens associated with Enshū's name combine a sense of rustic charm—humble brush fences, rough stepping-stones, irregularly shaped ponds with bridges

of massive stone slabs—with a powerfully disciplined design. The rocks were carefully selected and placed, the trees pruned in a calculated manner, the paths raked and smoothed with precision.

In style, this calligraphy follows the so-called Teika manner, a flowing script much like grass writing, which developed with such effortless charm in the Heian period. Fujiwara Teika was perhaps the out-standing poet and calligrapher in the late twelfth and early thirteenth centuries, and he exerted a profound influence upon men of Enshū's generation.

Reference: *Sadō Meikikan*, vol. 5. Tokyo, 1965. No. 58; *Shodō Zenshū*, vol. 22. Tokyo, 1959. No. 27, pp. 162, 189–190.

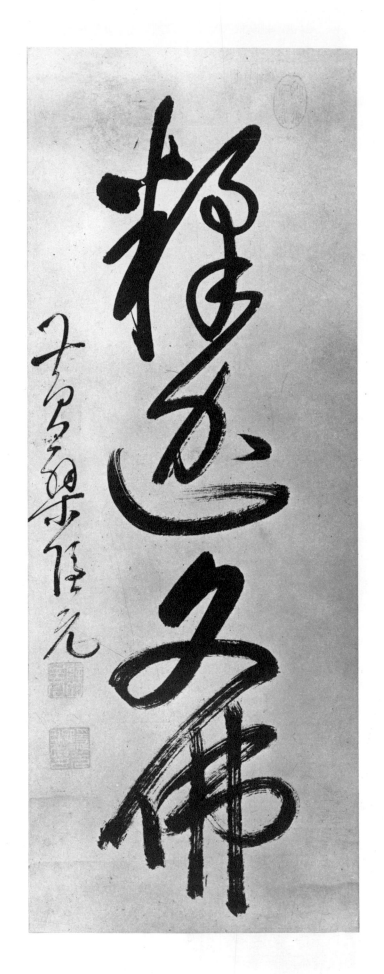

100. Calligraphic scroll

Early Edo period (ca. 1670)
Monk Yin-yüan (Ingen, 1592–1673)
Hanging scroll; ink on paper
H. 26 1/8 × 9 3/4 in. (66.4 × 24.6 cm.)

Written boldly in four Chinese characters are the syllables *Sha-ka-mon-butsu*, the transliteration of the name of Śākyamuni Buddha. The signature beside it reads Ōbaku Ingen (or Huang-po Yin-yüan) and belongs to the Chinese monk Yin-yüan, who had come to Japan in 1655. Arriving partly as a refugee from the Manchu invasion of his homeland, he was cordially received by both the retired Emperor Gomizuno-o and the Shogun Ietsuna. In 1661, he was granted a large tract of land at Uji, on the southern outskirts of Kyoto, where he built a vast monastery entirely in the contemporary South Chinese style. He named it Mampuku-ji of Mount Ōbaku, after the temple and mountain in China were he had long lived and studied, Wan-fu-ssu of Mount Huang-po. Located in Fukien Province in the south coastal zone, Mount Huang-po had long been a center of the Southern school of Chinese Ch'an; its name was taken from an aromatic shrub that grew on its slopes and whose leaves turn a strikingly handsome yellow in the autumn. A monk Hsi-yün, who lived there at the temple in the first half of the ninth century, had taken the name, Huang-po. He was a distinguished teacher, whose most famous pupil was Lin-chi, the outstanding intellectual leader of Southern Ch'an Buddhism and the founder of the Lin-Chi (Rinzai) branch of the sect. In this way, the name Huang-po was deeply impressed in the history of Chinese Ch'an; after Yin-yüan brought it to Japan, Huang-po (Ōbaku) became the name of the new Zen sect that he founded. Ideologically, the Zen taught by the Ōbaku sect does not differ materially from that taught at other Rinzai temples, such as Daitoku-ji, but it preserves Chinese language in its prayers and liturgy and the Chinese style in its sculpture and buildings. Mampuku-ji, the general headquarters of the sect, contains some of the purest examples of Ch'ing-style buildings in Japan, and there are around 480 branch temples throughout the country. Over twenty Chinese monks had accompanied Yin-yüan to Japan and most of the abbots were Chinese during the first century of Mampuku-ji's existence. Mampuku-ji thus became a center of Chinese learning near the imperial capital. Its influence on the Japanese Bunjin was great, especially in the realm of calligraphy. Men like Gion Nankai and Ike no Taiga, sympathetic to Zen and eager for any contact with Chinese culture, frequented the temple. Taiga did a number of paintings there, including one on sliding screens of the Five Hundred Arhats, painted in the late 1760s.

Yin-yüan, an accomplished calligrapher, brought to Japan a precious book of rubbings taken from stones engraved with the work of Sung Chinese calligraphers such as Su Tung-p'o. The Japanese became eager to possess writing in the Chinese style produced at the temple and particularly desired the works of the Ōbaku Sanpitsu, "The Three [Leading] Chinese Calligraphers of Mampuku-ji": Yin-yüan (Ingen), Mu-an (Mokuan), and Chi-fai (Sokuhi). Other monks were distinguished as well; unfortunately, the calligraphic production at Mampuku-ji was so voluminous that there is a considerable range in quality, with very routine work coming from the brushes of the most capable men. This example by Yin-yüan, however modest in scale, is written with great vigor in the grass-writing style, when great liberties are taken with the basic structure of the characters. After writing the radical for *sha*, the first character, Yin-yüan recharged his brush with ink and then, in a single brilliant, uninterrupted stroke, wrote the rest of the *ka*. He then completed that character with two strokes, in the last of which the ink was depleted and left a dry-brush effect. He used the same method in joining the next two characters, *mon* and *butsu*.

Reference: Special issue devoted to the calligraphies of the Ōbaku sect. *Bokubi*, no. 105 (1961); Hirakubo Akira. *Ingen*. Jimbutsu Sōsho, vol. 95. Tokyo, 1962.

101. Buddhist aphorism

Mid-Edo period
Monk Jiun Onkō (1718–1804)
Hanging scroll; ink on paper
H. 48 3/8 × 11 1/8 in. (123 × 28.3 cm.)

Written by Jiun, a revered Buddhist monk and ardent calligrapher, the five Chinese characters here were attenuated and simplified beyond the point of legibility:

Mu-goto Inactivity
Kore tatoi hito This is esteemed [among] men

The first two characters were run together, drawn in a single vigorous movement; the central downstroke of *koto* radically extended into the lower half of the page as the ink was exhausted. The meaning of the text may have been equally cryptic. Jiun did not intend to provide an immediately intelligible, obvious, simple statement, but rather to provoke thought through the semantic ambiguities of the five words and the formal power of the calligraphy. His purpose was akin to that of the Zen *kōan*, the somewhat illogical "proposition" formed by Zen monks to question and provoke their followers. Jiun wrote this same aphorism several times, but each time with a different style of brushwork with one or another part made clearer or more conventional.

Among a populace that esteemed calligraphy, especially from the brush of a holy figure, this kind of *bokuseki* (ink traces) became an especially powerful means of propagating ideas. As did Hakuin and Sengai (see Nos. 102–104), Jiun wrote maxims by the dozens, perhaps hundreds. Most are a single line of text; others are longer and more discursive. The texts usually evoke the Buddhist scheme of values, alluding to meditation, life and beauty, old age, and compassion.

Although Jiun occasionally did a few rather simple paintings, he was essentially a calligrapher. The style and content of his writings reflect the strong influence of Rinzai Zen, but, in fact, Jiun formally belonged to the Shingon sect. He was born in Naniwa (modern Osaka), the seventh son of Kōzu Yasunori, a warm and humane man, distinguished as a scholar of Shintō, Buddhism, and Confucianism. Jiun's career ultimately involved all three ideologies, but his formal education began with the last. At the age of thirteen, however, he entered monastic training at Hōraku-ji, in Kawachi (near Osaka), where he excelled in Esoteric Buddhist theology and austerities. When only twenty-two, he became abbot of this temple but two years later went on leave and traveled to Shinano to study with a celebrated Zen monk, Ōbai. After three years, he returned to Kawachi, to Chōei-ji, and vowed to realize within himself the basic nature of the Buddha and to adhere strictly to the rules of monastic discipline. He then founded a sect called Shōbōritsu (Discipline of the Correct Doctrine), which was a fusion of elements from the Shingon and Ritsu (Vinaya or Monastic Discipline) sects. During the next two decades, he traveled widely in western Japan—Kyoto, Wakayama, Nara, Arima—preaching and studying Zen and Sanskrit, and he began his enormous literary production. At the age of fifty-nine, he took over an old temple called Kōki-ji in Kawachi. By imperial rescript this became the headquarters of the Shōbōritsu sect, and he lived there for almost all the rest of his life. He was deeply interested in Shintō and created a movement in Shintō called the Unden school, in which Confucian and native Japanese religious elements are combined.

The quantity of Jiun's calligraphy is prodigious. This one is entirely characteristic of his style in its gruff, assertive vigor and roughness.

Reference: Kinami Takiuchi, *Jiun no Sho.* Osaka, 1963. Pls. 56–57; special issue devoted to Jiun, *Bokubi*, no. 127 (1963); Kōzu Myōgon. *Jiun Sonja Ihō.* Kyoto, 1938; *Shodō Zenshū,* vol. 23. Tokyo, 1960. Pl. 12, p. 188.

102. Daruma (Bodhidharma)

Mid-Edo period (ca. 1750–1760)
Hakuin Ekaku (1685–1768)
Ink on paper
H. 12 7/8 × 5 3/4 in. (32.7 × 14.6 cm.)

The face of Bodhidharma, legendary founder of the Ch'an sect in China, became a familiar theme in Zen painting of the Edo period, with the beard and glaring eyes often reduced to extremely simple formulas. In the profile shown here, the lines were done with a broad wet brush; pools of ink that dried unevenly give a random cadence to the dark accents. This tiny visage has a strange, haunting presence as it emerges, soft and ambiguous, from the darkened paper background.

The three seals in pale red ink are those of Hakuin Ekaku, probably the most revered and celebrated Zen monk of his day. His religious calling was intense, and he was long preoccupied with mystical experiences; despite these, he was a painter and calligrapher of prodigious energy, especially during the last two decades of his long life. In fact, he may be considered one of the most engaging and characteristic figures of middle Edo period painting, an encyclopedist like Ōkyo or Shōhaku or Hokusai—men with inquiring minds who explored a wide range of themes and artistic styles and were also moved to impart their knowledge. Hakuin was so concerned with communication, with conveying ideas and attitudes, that his style is at times extremely didactic, even cartoon-like. In keeping with this, he was known for his interest in the material and spiritual welfare of the humble villagers living near the monastery where he spent the last fifty years of his life, the Shōin-ji, in his native village of Hara, Saruga. The many elements of folk culture and humor that appear in his painting have diminished Hakuin's reputation as a serious artist in the eyes of some critics; but his purpose was to include the entire scope of human experience within the path of Enlightenment. He wrote, "Not knowing how near the Truth is, people seek it far away—what a pity!" and he sought to bring this message to ordinary folk.

The soft, evocative spirit of this painting is but one of the styles employed by Hakuin; more familiar is his trenchant manner, with strong contrasts of light and dark, powerful linear rhythms, and a tendency to caricature. This painting must have been done while he was in his seventies; the same rare combination of three seals appears on a few paintings of that time.

Reference: Henrich Dumoulin. *A History of Zen Buddhism.* New York, 1963. Pp. 242–268; Takeuchi Naoji et al. *Hakuin.* Tokyo, 1964. Pl. 219; *Hakuin Zenji Iboku-shū.* Tokyo, 1957. Pls. 126, 128, 138.

103. The Famous Aged Six Immortal Poets

Late Edo period (ca. 1811–1837)
Sengai (1750–1837)
Hanging scroll; ink on paper
H. 15 7/8 × 23 3/8 in. (40.5 × 59.4 cm.)

Deeply rooted in the Buddhist faith is the idea that the human body is fallible, unlovely, and constantly in decay. As a Zen monk whose paintings were done mostly in his old age, Sengai depicted themes of this kind—a lightning flash or a skull as allegories on the brevity of life and the certainty of death. The infirmities of old age, as shown here, preoccupied him as well; and a scroll with a painting and poem very similar to this one may be seen in the collection of the Idemitsu Gallery, Tokyo. It lacks, however, the sardonic touch present here, where the men are given the exalted label *kasen* (poet immortals) while shown foolishly mortal, nearsighted, and tottering.

Sengai's inscription reads:

The Famous Aged Six Immortal Poets
by Gai Ōju

Wrinkles line the face; the head is bald; the back
 is bent.
The ears can't hear; the eyes get dim.
The hands begin to tremble; the feet begin to
 totter; the teeth come out.
Indispensable to the body are a hood, muffler,
 cane, eyeglasses, also a hot-water bottle, heated
 stone,
Chamber pot, and back scratcher.
[The aged] are meddlesome, lonely, and fright-
 ened of death,
Perverse, and greedy,
Praising their children again and again in the same
 stories.
People dislike old people because of their brag-
 ging.

Reference: Idemitsu Art Gallery. *Sengai.* Tokyo, 1969.
No. 9.

104. Nan-chüan killing the kitten

Late Edo period (ca. 1811–1837)
Sengai (1750–1837)
Hanging scroll; ink on paper
H. 48 1/4 × 22 in. (122.5 × 55.9 cm.)

Nan-chüan cutting off the head of a kitten is one of the most celebrated parables in the history of Zen Buddhism (see No. 78, scene 10). The monk Sengai painted the theme many times and gave each version more or less the same inscription that appears here:

> Kill! Kill! Kill! Kill!
> Not only the kitten,
> But the head monks of both halls,
> And Old Master Wang [that is, Nan-Chüan]
> as well!

The inscription is Sengai's own response to the problem Nan-chüan had raised centuries before. While it is difficult in this catalogue to explore thoroughly this issue, which puzzles and disturbs many Westerners, the problem may at least be outlined. Nan-chüan held up a kitten before the monks of two dormitory halls who were quarreling over possession of the little pet. He demanded of them, "If anyone among you can say a word at this moment, the cat will be saved; if not, it will be killed!" When no one answered, the old monk cut off its head, to the utter shock of the acolytes. Later that evening, Nan-chüan's wisest disciple, Chao-chou, returned to the monastery and was presented with the problem. His response was merely to say nothing, take off his sandals, and place them on his head. This satisfied Nan-chüan, who said that it would have saved the kitten's life.

Chao-chou's paradoxical and apparently meaningless response indicated that no word was capable of treating such profound realities as life, death, or the "ownership" of being. Sengai's response, paradoxical, and even perverse, in its own right, blames the quarreling monks and Nan-chüan himself for the folly of taking such a delusory matter seriously. But, as Suzuki Daisetsu points out, the implications of Sengai's response are that Sengai himself would have to be killed for painting the picture. The artist surely realized this.

Sengai's paintings were almost all done during the last twenty-five years of his life, when he was a highly revered monk living in a rustic hermitage called the Genjū-an, outside of Fukuoka in Kyushu. He had retired in 1811 after over twenty years of service as the abbot of the oldest formal Zen monastery in the land, the Shōfuku-ji at nearby Hakata. Sengai's position there had been one of great honor, for he was in the apostolic line of succession from Eisai, the pioneer Japanese Zen monk who founded the temple in 1195.

Sengai's career was not distinguished by eccentricity or dramatic events. He had been born into a farming family in the Mino region north of Nagoya. He took his first religious orders at the age of eleven at a small temple near Mino city. When he was twenty he settled in Yokohama, at the Tōki-an, to study with Gessen Zenji, one of the most distinguished monks of the day. For thirteen years he remained with Gessen, until the latter died. Then Sengai began a long period of study-pilgrimage so common in the eighteenth century, wandering in search of an appropriate teacher or place to settle and study in. Finally, in 1788 when he was thirty-nine, he went to the Shōfuku-ji in Hakata at the invitation of a monk who had known him as a student under Gessen.

Sengai, like other masters of *Zenga* before him, became a painter and calligrapher as a means of self-discipline and also in order to instruct his pupils and laymen. In style, his work is considerably indebted to Hakuin (see No. 102), but he was far less adventurous than his predecessor; and he tended to work in a more unified, personal manner.

Reference: Idemitsu Art Gallery, *Sengai*. Tokyo, 1969. No. 36 (comments by Suzuki Daisetsu); Furuta Shōkin. *Sengai*. Tokyo, 1966.

Kōetsu, Sōtatsu and Their Tradition

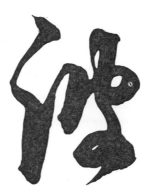

Toward the end of the sixteenth century, as the long period of destructive civil war drew to a close, the aristocratic families of Kyoto were able once more to indulge their taste in sumptuous articles— lacquer ware, ornate fans and screens, luxurious brocades, dyed silks, fine calligraphic books and scrolls, implements for the tea ceremony and for flower arrangement. The resumption of peace and stable government stimulated the Japanese economy, and from the new surplus of funds and energy came the support for a brilliant cultural revival.

A major new school of artists and craftsmen arose in the capital at this time led by Hon'ami Kōetsu and his kinsman, Nonomura Sōtatsu. Kōetsu was the eldest son of one of Japan's outstanding experts on swords, Hon'ami Kōji, who had served as adviser to such prominent warriors as Oda Nobunaga, Toku-gawa Ieyasu, and Maeda Toshiie (the lord of the Kaga region). Although Kōetsu had been trained by his father as a sword connoisseur, he became adept in a wide range of crafts: pottery, lacquer inlay, the casting of metal vessels, painting, and, above all, calligraphy. During his lifetime, Kōetsu gained renown as one of the three finest calligraphers of Japan, sharing the honor with the monk Shōkadō and Konoe Nobutada, a member of the Imperial Court.

Versatile in so many media, Kōetsu became the leader of a group of artists and craftsmen who catered to the renewed interest in aristocratic arts. Even though the Kōetsu group was newly established and competed with more traditional styles, it was quickly accepted by the highest levels of society—the shogunal government in Edo, the Imperial Court, and the cultivated aristocracy in Kyoto. Indeed, in 1615, the Shogun Ieyasu granted Kōetsu a tract of land at Takagamine, overlooking the capital city from the north. There he built a colony for himself and his colleagues, one that was strongly imbued with Buddhist religious principles. Kōetsu was an extremely pious man, and for generations the Hon'ami family had been devotees of the Nichiren sect.

Kōetsu and his colleagues were distinguished for the spontaneous and free spirit of their designs; they avoided minutely detailed, tightly disciplined work in favor of original, unexpected compositions. Moreover, this group often worked together in a collective, collaborative spirit. Poetry scrolls, such as Nos. 105–107, were written by Kōetsu himself over designs made by Sōtatsu on paper prepared by

Sōji, the paper master. In style, these men were greatly influenced by Heian calligraphy and decoration. Sōtatsu, for example, probably studied and repaired the exquisite twelfth-century scrolls dedicated by the Taira Family at the Itsukushima Shrine. Kōetsu himself owned calligraphy by Ono no Tōfū, one of the outstanding masters of the early Heian period. In general, among the aristocrats of Kyoto in the early seventeenth century, there was a very strong urge to return to established patterns of culture, to restore the unity of traditional Japanese life after a century and a half of intermittent rebellion and social instability. Heian styles in the arts offered both solace and guidance in the new age, but the elegance and precision of that older taste were modified somewhat by a feeling for spontaneity and the irregular, natural forms that had been cultivated by the so-called tea taste.

Once established, Kōetsu's school survived for nearly two hundred years, even though it was more informally organized than, say, the Kanō or Tosa schools and never assumed a universally accepted name. The outstanding masters of the first generation, Kōetsu and Sōtatsu, were succeeded by men of lesser talent, Kōho and Sōsetsu in the middle of the seventeenth century. But in the third generation, there appeared two figures of transcendent abilities, Ogata Kōrin and his younger brother Kenzan. While neither man was ranked as an outstanding calligrapher, Kōrin attained enormous success as a painter of screens and fans, employing many of the same motifs as did Sōtatsu but executed in a bolder and more dramatic spirit. Kenzan was a retiring, speculative person and specialized as a ceramist; he received the book of Kōetsu's pottery recipes from the latter's grandson, and Kenzan seems to have identified himself with Kōetsu's independent yet unassuming character.

Upon the death of these two men and of Kōrin's close follower Watanabe Shikō, the Kōetsu school tended to decline as it had done before them. In the early nineteenth century, it was given another era of vitality and prosperity by Sakai Hōitsu. A nobleman of elegant taste, he considered himself the successor of both Kenzan and Kōrin, published their works, and perpetuated their techniques and styles, if with a more formularized and hardened spirit of painting.

Of all the schools of Edo period art, the Kōetsu school was the most distinctly Japanese, owing very little to foreign influences. Antiquarian in taste, loyal to the ideal of the craftsman-amateur, pervaded by a religious sense of humility, accustomed to working in delicate and evanescent materials, it produced some of the most hauntingly fragile and personal expressions in all Japanese art.

105. Hand scroll of poems written on decorated paper

Early Edo period (ca. 1605–1610)
*Wood-block designs by Tawaraya Sōtatsu (first half of the seventeenth century); calligraphy by Hon'ami Kōetsu
(1558–1637); paper prepared by Sōji*
Silver and gold paint and sumi ink on glazed, colored paper
H. 12 5/8 × 135 1/4 in. (32.1 × 342 cm.)

Around the year 1605, Kōetsu and Sōtatsu began producing long hand scrolls of this kind, poems written in an elegant calligraphic style over designs made by rough wood-block prints. Reminiscent of the sumptuous calligraphic works of the Heian period, these scrolls must have greatly excited collectors in the capital, for over forty examples have survived, and other artists emulated the style and technique.

This scroll is important because of its immaculate condition. The first sheet is pale blue with a design of ivy leaves in gold ink that continues onto the next sheet, which is off-white in color. The ivy motif is shown close-up but gives way to a distant, low mountaintop with pine trees in soft silhouette. The third sheet shows a flight of plovers or cranes descending dramatically and flying up again, their legs and wings outstretched. The scroll ends with bamboo stalks and a few leaves shown very close to the picture plane, with the seal of Kōetsu in black ink in the lower left.

Unlike most scrolls of Kōetsu and Sōtatsu remaining today, this one has not been remounted or extensively repaired. Still intact is the lustrous, crisp freshness of the paper produced by a transparent glaze of thin glue and minute particles of mica. Still visible on the back is a design of butterflies stamped in gold and silver inks. A seal reading "Kamishi Sōji" (the Paper Master Sōji) is impressed over the junctions of the first and second sheets, and the third and fourth. Sōji was a well-known maker of ornamental papers and lived in Kōetsu's artisans' village north of Kyoto, not far from Kōetsu's own home.

The block prints were done in a free manner. Paint in a highly liquid state was brushed onto the wood-blocks and the paper rapidly printed, giving more the effect of painting than of a careful graphic process. Prints made from the same blocks used here can be seen in other projects of Kōetsu and Sōtatsu of this period. For example, a poetry scroll in the Atami Museum has identical ivy leaves; the same bamboos appear on a scroll in a private Japanese collection. The flying cranes, however, seem to have been done with a single stamp repeated many times.

The text on this scroll is taken from the *Shin Kokinshū*, an anthology of nearly two thousand poems commissioned in 1201 by the retired Emperor Go-Toba and compiled by a group of distinguished writers of the day. The poems here are numbers 945 to 952 of that collection. It is worth mentioning that in these calligraphic scrolls and elegant printed books, Kōetsu and his associates were much more concerned with antique literature than with contemporary work. Both in visual and literary dimensions, they attempted to recapture the stylish elegance of Heian arts.

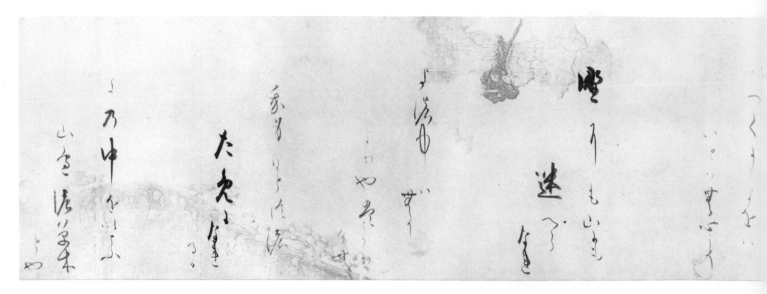

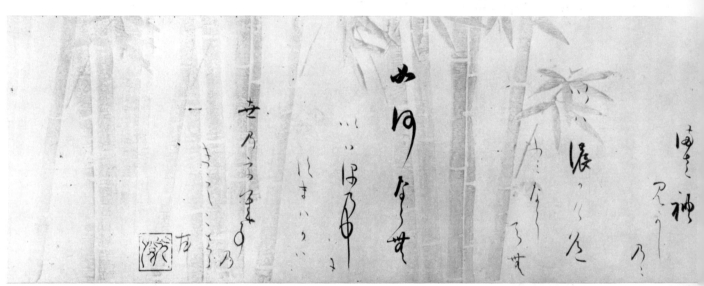

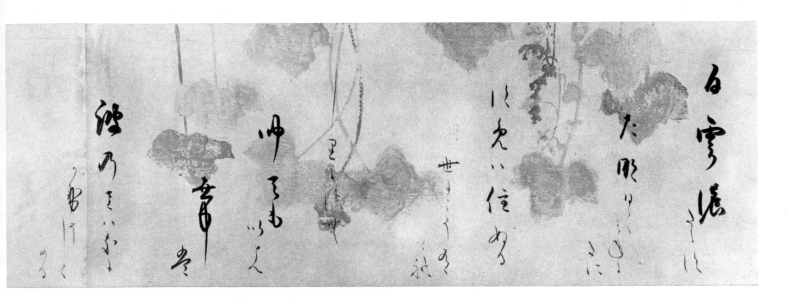

白雲晴

たゝよふ月に

世ｽ雲の月影

世をてらす光

にえにいさめる

里はなれ行

經のきこゆる

冲つ声も

いつく

音

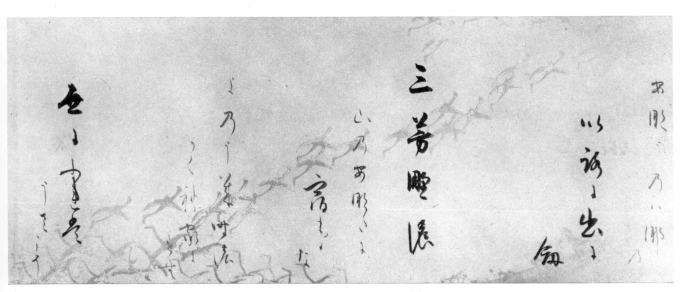

三芳野晴

山乃あけゆく

宮も

み乃ふ雲川

つく祢か山

色日ぐらし

出る

の諭ぁ出る

晴

お晴ゞ乃ハ晴

106. Hand scroll of poems written on decorated paper

Early Edo period (ca. 1605–1610)
Wood-block designs by Tawaraya Sōtatsu (first half of the seventeenth century); calligraphy by Hon'ami Kōetsu
 (1558–1637)
Black ink on glazed paper
H. 13 1/2 × 55 in. (33.6 × 139.1 cm.)

A branch of wisteria with heavy blossoms printed in a fluid black ink dominates this scroll, which is a composite of two sheets from a full hand scroll much like No. 105. Subdued bamboo stalks and a few leaves appear on the second sheet. The underdesigns are done in ink, not in gold and silver paint, and the effect is sober and restrained. The underdesign does not appear to continue from sheet to sheet. The small peony bud in the left sheet appears in other scrolls from the Kōetsu-Sōtatsu atelier as part of a large cluster of flowers. It is likely that the peony is part of a design that originally extended to the right.

The poetic texts come from the *Shin Kokinshū*, numbers 43 and 57. Like the underdesign, they are fragments of a larger whole. Despite the fact that this scroll is something of a pastiche, the parts are authentic. The wisteria design is an especially evocative display of the creative gifts of the Kōetsu school.

266

心あらむ

すみ

なには江

のほりま

ぬ

たにほり

ほりま

ぬ

難波の入江のほりまぬ

107. Section from the *Lotus Scroll*

Early Edo period (ca. 1620)
Underpainting by Tawaraya Sōtatsu (first half of the seventeenth century); calligraphy by Hon'ami Kōetsu (1558–1637)
Silver and gold paint and sumi *ink on separate sheets of tan and white paper*
H. 13 1/2 × 27 15/16 in. (34.2 × 71 cm.)

Two lotus blossoms are shown in silhouettes formed by pools of silver ink. The pigment dried in random, irregular shapes within the flowers, giving an effect that the Japanese call *tarashikomi* and that the painter Sōtatsu mastered with subtle skill. Over the centuries, the silver has oxidized to become grey and even blue in color, but the gold paint in the stems and lotus calyx to the right has retained its brilliance. The calyx may, however, be a later addition.

This composition was originally part of a long scroll belonging to the Ōkura family. Unfortunately, over half of the scroll was burned during the great Kantō earthquake of 1923, and most of the surviving fragments were cut apart, mounted as hanging scrolls, and dispersed in various collections.

The scroll originally depicted lotus plants in their entire life cycle, composed in a grandly coordinated manner. Round leaves floating on the surface of the water were shown first; then lotus buds and stems appeared rising through the leaves, and then came buds which opened into flowers. Next, the blossoms were shown fully developed and the large leaves riddled by insects. This painting belonged to that section near the end, with the flowers fully matured, the petals heavy and slack. Next, the petals were shown being blown by the wind; at the end of the cycle appeared new blossoms and flowers that were painted in simple outline.

Over the paintings were written the one hundred poems of the *Ogura Hyakunin Isshū*, an anthology attributed to Fujiwara Teika (1162–1241), one of the medieval poets who appealed greatly to the cultivated taste of the seventeenth century. The section shown here contains poem ninety-seven, composed by Teika himself. The first line consists of his official title (Gon no Chūnagon, the Provisional Middle Counsellor); the next gives his name. The poem is then arranged in short lines:

Konu hito o	Out on Matsuo Bay
Matsuo no ura no	In the evening calm they burn
Yūnagi ni	Seaweed for salt:
Yaki ya moshio no	So too is my body smouldering,
Mi no kogaretsutsu	Pining for one
	Who will not come.

We have no precise knowledge of the circumstances under which this important work was created, and there is much speculation in scholarly literature. At the end of the scroll is the signature of Kōetsu, undated but preceded by the words "Daikyū-an," the name of his home in the artisan's hermitage he built in 1615 at Takagamine. The earliest dated use of the name Daikyū-an is 1619, when Kōetsu signed copies he made of two of the fundamental texts on the Nichiren sect for a monk of the Kyoto temple of Myōren-ji.

It has been suggested that the scroll was done as a memorial to Kōetsu's mother, Myōshū, who died in 1618. The theme of the painting, the blossoming and fading of a flower, suggests this, because the motif has strong significance for Buddhists. However, if a memorial had been Kōetsu's intention, he would surely have indicated it. In fact, there is a playful, random quality to both the calligraphy and painting that are similar to other painted and inscribed scrolls—the celebrated *Deer Scroll*, for example, of which a major part is in the Seattle Museum.

The calligraphy is entirely by Kōetsu. At the beginning of the composition it is rather crowded and nervous in quality; at the end (and in the Powers work), it is much more open and relaxed, as though Kōetsu's mood had changed while writing. Within the writing style, we can detect a number of influences. The fluid, linear manner of Heian *kana* script may be seen. In addition, the rather disciplined construction of the Chinese characters reflects the style of Chang Chi-chih of the thirteenth century. For Westerners, calligraphy is perhaps the most difficult of East Asia's traditional arts to understand; but the style of Kōetsu is especially accessible, with its brilliant variation of line quality and ink tone and the masterful control of the balance and proportion of the characters.

The lotus paintings seem to have been done by two hands, and there is the possibility of later additions. A first hand executed most of the scroll (including the section shown here), and it was most probably that of Sōtatsu. There are several passages in which the broad, relaxed manner closely resembles that of the flowers in one of Sōtatsu's most memorable essays in ink paint-ing, a pair of kakemono called "Lotus Pond and Water Fowl" now in the collection of the National Commission for the Protection of Cultural Properties.

A second hand does seem to have interspersed flowers and leaves throughout the whole composition. This hand is more schematic and "hard" than Sōtatsu's. Most scholars think that it was Kōetsu who conceived the project as a whole, collaborated with Sōtatsu on it, and made his own changes and corrections.

Published: Yamane Yūzō. *Sōtatsu*. Tokyo, 1962; the same in Shimada Shūjirō, ed. *Zaigai Hihō*, vol. II. Tokyo, 1969; Hayashiya Tatsusaburō. *Kōetsu*. Tokyo, 1964.

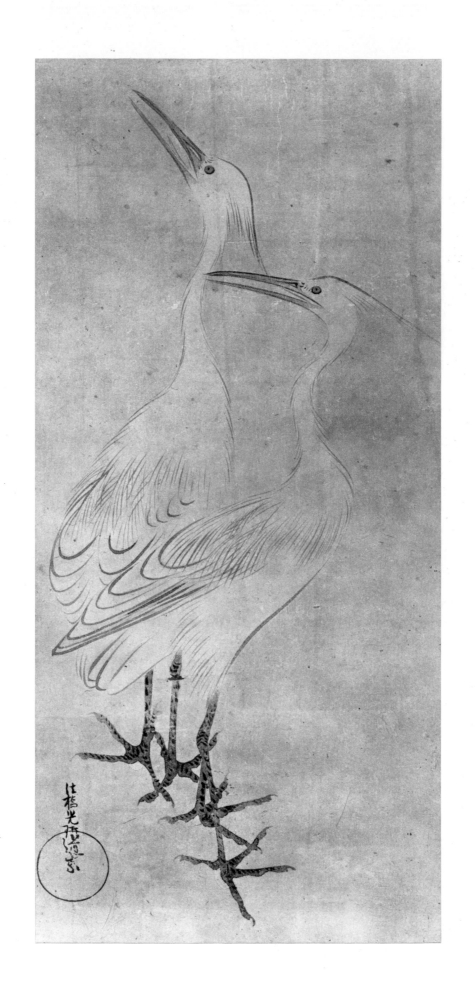

108. Two herons

Mid-Edo period
Style of Ogata Kōrin (1656–1716)
Hanging scroll; ink on paper
H. 34 3/8 × 15 3/4 in. (87.5 × 40 cm.)

In this delicate ink painting, a pair of herons, startled, look to the rear. They are subtle and understated; the tone of their bodies is the white of the paper set off against a background washed with thin gray ink. The strongest accents in the composition are the feet, established as silhouettes in gray with dark texture spots. In the left corner is Kōrin's signature, giving his honorary ecclesiastical rank of Hōkyō ("Bridge of the Law"), the highest honor that was accorded to lay artists; it was granted to him in 1701. The round seal in red ink reads "Dōshū."

This painting is a classic example of the problems of connoisseurship. The seal and signature do not inspire confidence; they seem fresher than the painting, and are subtly at variance with the best established examples of their kind in Kōrin's oeuvre. At the same time, the painting itself is of high quality even if it lacks the more obvious traits of Kōrin's style—especially the brilliant, unexpected innovations in design that he often achieved. However, the handling of the tail feathers, the definition of the eyes and beaks, the control of ink tonality—all are of a high order of realization, and similar to well-established works of Kōrin.

The identical composition appears as part of a screen in a wood-block printed book of 1815, the *Kōrin Hyakuzu*. This was published by the connoisseur and painter Sakai Hōitsu as a record of the authentic works of Kōrin that he had seen (see No. 111). The original screen itself may well have been little more than a pastiche, a collection of hanging scrolls, for in composition, each panel was independent of the others. None was shown with a seal or signature (and Hōitsu was careful always to record such things). In Hōitsu's drawing, the panel with a pair of birds like this painting is so similar that the two pictures must be very closely related, if, indeed, this work was not the one actually copied by Hōitsu. The only differences are that this composition seems to have been cut down at the top, and that Hōitsu's version includes no signature or seal. Moreover, in modern publications of Kōrin's work, two other heron pictures appear that are also identical to panels of the

screen in Hōitsu's book. Their measurements are similar to those of this painting, and they also have the same signature and seals. Thus, it is possible that the screen was taken apart and that three of the six panels are still in existence (including the painting shown here); but, concerning the attribution to Kōrin, the best that can be said is that Hōitsu, who was a knowledgeable connoisseur, thought the paintings were by Kōrin, and that someone after 1815 added the seal and signature to reinforce the attribution.

One reason that the heron paintings reveal little of Kōrin's originality—assuming that they were indeed by him—is that they were copied from work by Tawaraya Sōtatsu (see Nos. 105–107). Kōrin was widely schooled in painting, but he used Sōtatsu as his main stylistic source and emulated most of the older man's ways of working. He copied, for example, the famous "Wind God and Thunder God" screen pair now in Kennin-ji, Kyoto; he copied Sōtatsu's style of figure painting, which had been based on Tosa school prototypes in the *Yamato-e* manner; he also copied Sōtatsu's soft, wet-wash techniques. Two of the three remaining panels of the heron screen are line-for-line copies of paintings by Sōtatsu; there is, however, no precise source in the published work of Sōtatsu for the painting shown here. Despite the fidelity of the copies, there are remarkable differences between the paintings of men separated by about one hundred years. Sōtatsu's birds are much more evocative, closer in spirit to Zen *suiboku-ga* of Chokuan and Nichokuan or Kinkei Dōjin (see No. 71). In fact, one of Sōtatsu's heron paintings is inscribed by a monk of Myōshin-ji in the old tradition. Kōrin's herons, on the other hand, have a more humorous and decorative flavor, and lack the suggestions of mystery and metaphysical significance present in the earlier works.

Reference: Tanaka Ichimatsu. *Kōrin*. Tokyo, 1959. Figs. 31–34; Sakai Hōitsu. *Kōrin Hyakuzu*, vol. 3. Tokyo, 1815. Pls. 24–26; Yamane Yūzō. *Sōtatsu*. Tokyo, 1962. Pls. 106–108.

109. Enameled cups with white plum blossoms

Mid-Edo period
Ogata Kenzan (1663–1743)
Stoneware; white and black over green enamel glaze
H. 2 5/8 × 3 3/8 in. (6.5 × 8.5 cm.)

Blossoming plum branches, an ancient motif in Chinese and Japanese ink painting (see No. 77), have been used to decorate these five deep cups. The placement of the branches is random; the painting is relaxed and generalized, with a minimum of detail; the tips of the branches are drawn bending over the sides, down into the cups themselves. The spirit of the design is very close to that of the school of Kōetsu and Sōtatsu, which recognized no distinction between fine and applied arts and delighted in making unexpected combinations of aesthetic elements. In a sense, Kenzan combined the techniques of Ninsei, who taught him ceramics, with those of the Kōetsu school with which he had strong family ties. Through this combination, he made a major contribution to the development in Kyoto of the highly decorated ceramics that came to be known as Kyō-yaki (capital ware).

Sets of enameled dishes were produced in great numbers by Kenzan and his assistants. Usually the sets of dishes are made up of five members. In sets of triangular deep cups, however, there are six, and when the cups are arranged tip to tip, they form a large hexagon. In this set, however, one cup has been lost. Among the large quantity of material of this kind bearing the Kenzan signature are many later imitations. However, these cups have long been considered authentic.

Formerly in the Yura collection, Osaka
Published: Mitsuoka Tadanari, *Kenzan.* Tōki Zenshū, vol. 7. Tokyo, 1965. Pl. 7; Aimi Kōu in *Kobijutsu*, no. 16 (January 1967).

110. Small incense burner

Mid-Edo period (early eighteenth century)
Signature of Ogata Kenzan (1663–1743) on bottom
Painting with signature of Ogata Kōrin (1658–1716)
Square stoneware; cream-white underglaze with black enamel
H. including foot 4 1/4 × 4 3/4 in. (10.9 × 12.1 cm.)

The creative, imaginative brothers of the Ogata family, Kōrin and Kenzan, occasionally worked together. This vessel bears the signature of both: that of Kōrin as the painter of the landscape, that of Kenzan as the potter of the vessel itself. The art of these two famous men inspired many close imitations, both during their lifetime and after, and the problems of connoisseurship in ceramics of this kind are unusually severe. Concerning this piece, experts in Japanese ceramics have offered opinions that fit into the following categories:

1. The work is genuine and of high quality.
2. The work is genuine and of low quality.
3. The work is not genuine.
4. The vessel was made by Kenzan, but someone other than Kōrin painted the landscape.
5. Kōrin painted the landscape, but someone other than his brother, possibly the second-generation Kenzan or an assistant, made the vessel.

Even after a lengthy study, it has been impossible in this country to see enough original material to settle the issue conclusively, but the evidence suggests that the first and possibly the fifth opinions are most likely correct. A square vessel in the Museum of the Yamato Bunka-kan, Nara, is the only published work of the two men to resemble this one closely. Bearing both signatures, it too is ornamented with a *suiboku* landscape composed like a hand scroll, but the tonality of the ink effect is much richer, and the brush technique less crisp than here. Here the range of middle grays, as in the rocks by the waterfall, has somehow faded or been absorbed into the underglaze.

After the basic, boxlike shape of both pieces had been formed in clay, they were fired in a kiln two or three times. The first was the bisque firing of the unadorned clay body; then the thick, cream-white slip was added and possibly fired. Next, the landscape was painted with an enamel of black iron oxide. And finally, a thin transparent glaze was placed over the exterior and the upper parts of the interior and fired. During the firings, one of the sides of this vessel caved in slightly and cracked; the cream-white underglaze developed a crackle texture here and there. The ceramic process, however, did not demand the same high degree of skill as porcelain, for example, and indeed, Kenzan and his followers did not stress the technical side of their craft. In the accepted oeuvre of these men are many pieces of stoneware as warped and imperfectly glazed as this one.

The brothers Kenzan and Kōrin were born into a wealthy and honored family of artist-craftsmen. The Ogata family trade was designing and selling fine textiles, and the customers of their shop, the Karigane-ya, included the most elegant and aristocratic women of the capital. The father of the two men was Ogata Sōken, a calligrapher of high standing as well as a textile designer, and also an eager connoisseur of the Nō theatre. His taste was very much in the broad antiquarian tradition of Kōetsu and Sōtatsu, and his calligraphies are faithful exercises in the Kōetsu style. In fact, the Ogata family had maintained a house in the artists' colony founded by Kōetsu at Takagamine, Kyoto. Sōken's grandfather, Ogata Dōhaku, had married Kōetsu's sister, and may have begun the family's specialty in textile design; Sōken's father, Sōhaku, built the success and fame of the shop through his service to such high-ranking clients as the Lady Tōfuku-mon-in (daughter of the Shogun Hidetada and consort of Emperor Gomizuno-o), and the women of wealthy daimyo families.

Kōrin, the second son of Sōken, was born in 1648; Kenzan, the third son, was born five years later. The two brothers were like the proverbial ant and grasshopper, differing radically in temperament; Kōrin had been trained in textile design and in the Kanō style of painting. He was clearly a youth of the highest degree of talent and promise, but apparently dissipated his talent in a taste for Kyoto high life. His father had died in 1687, leaving a generous inheritance, but he squandered this, and through his lack of concern for business, the Karigane-ya went into bankruptcy. Kenzan, on the other hand, was of a

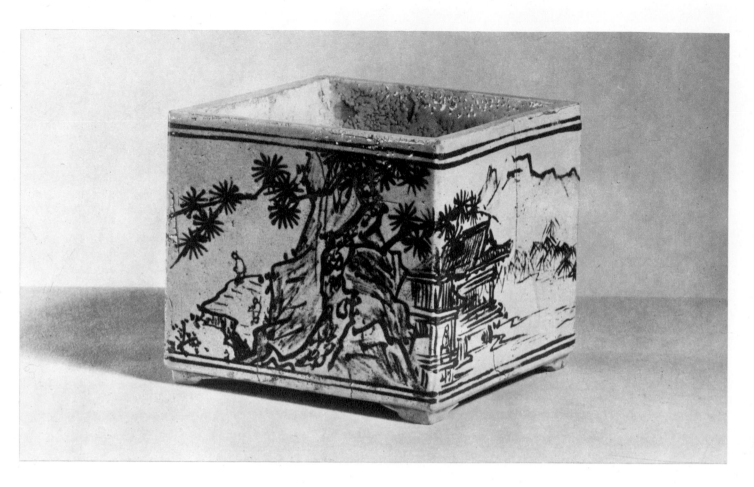

more thoughtful, restrained nature; with his inheritance, he built a house called the Shūsei-dō in the Omuro district, west of Kyoto. There his life-style was rather like that of a Bunjin or Literary Man; he practiced painting, calligraphy, and the tea ceremony, wrote serious and comic poetry, and had a wide circle of friends among the imperial courtiers and the old aristocracy. He was strongly attracted by Zen, and came under the influence of a monk who lived near him, Dokushō, a follower of Yin-yüan and the Ōbaku sect (see No. 100). Kenzan resisted the temptation to become a fully ordained monk, but for his entire life he was strongly under the influence of Zen notions of beauty and its respect for quiescence and informality.

While living in Omuro, Kenzan also came under the influence of the potter Nonomura Ninsei, who had a kiln in the district. Ninsei had developed a distinctive type of stoneware decorated with bright enamel glazes. Strangely, relatively little ceramic ware had been produced in the Kyoto region until the late sixteenth century. Hideyoshi had sponsored the making of a special kind of rough, unornamented tea ware

for his Kyoto palace, the Jūraku-dai, and this "Raku" ware became a local specialty. Ninsei also made Raku ware, with added enameled decor, and the range of his styles and techniques was great; his pottery became extremely popular and was much copied. Kenzan became an intimate friend of Ninsei, who was then an old man, and learned his pottery techniques. They became so close in fact that Kenzan adopted Ninsei's son, who eventually became Kenzan the Second. In 1699, however, Kenzan moved from Omuro to a site slightly farther west of Kyoto, Narutaki, where he opened his own kiln. He had used up his inheritance and had turned for support to Prince Tsunahira Nijō, a lifelong friend and wealthy amateur of the arts. He remained at Narutaki for over twelve years, working intensely with his adopted son and several assistants. During the first part of this period, up to 1704, Kōrin came frequently to decorate his brother's pottery ware. Kōrin's style of decoration was usually based, as here, upon ink painting, incongruous as it may have been to use this sober, restricted idiom when brightly colored glazes were available. Kōrin painted such Zen themes as

Hotei and Kanzan and Jittoku, or blossoming plums, orchids, pine, and cranes—reflecting his early training in the Kanō style. During this same time, Kōrin had begun to build his own brilliant career as a painter, receiving in 1701 the very signal honor of the title Hōkyō ("Bridge of the Law," see No. 108).

The incense burner shown here may date either from the years 1699–1704, when Kōrin and his brother collaborated in Narutaki, or else in 1710, when Kōrin came back to Kyoto from Edo to decorate some of Kenzan's pottery in order to increase their sales value and help his brother financially. The painted decoration is composed as a section of a long hand scroll, with each element divided to serve as an independent composition. The brushwork is summary in execution, but the sense of placement and design is of a high order.

References: Aimi Kōu in *Yamato Bunka*, no. 29 (April 1959); exhibition catalogue, Tokugawa and Nezu Museums, *Kenzan*. Tokyo, 1968. Pl. 11; Bernard Leach. *Kenzan and his Tradition*. London, 1966; Mitsuoka Tadanari. *Kenzan*. Tōki Zenshū, vol. 7. Tokyo, 1965.

111. Hibachi with painted floral decoration

Late Edo period
Painted by Sakai Hōitsu (1761–1828)
Cypress wood box, with copper lining; decorated with color and ink on plain wood
H. 7 7/8 × 10 5/8 in. square (20 × 26.9 cm.)

The design principles of the Kōetsu school, formulated two centuries earlier, remain very much in effect in this disarmingly simple, elegant piece of household furniture. The painted decoration is signed with the name of Sakai Hōitsu, the wealthy collector, painter, and art historian who devoted himself to studying and reviving the school, especially the work of Kōrin.

The motifs of grasses and flowers were painted on the outer sides of the hibachi, made of cypress. The wood was joined without a visible seam; it was planed with a feeling for the texture and grain of the wood,

detail

with that respect for the inherent quality of materials that gives Japanese carpentry an almost miraculous finesse. On this smooth wood surface, Hōitsu painted in subdued colors, and distributed the grasses and flowers in an asymmetrical, almost random manner reminiscent of the ornamented papers designed by Sōtatsu (see Nos. 105 and 106).

Hōitsu was familiar with the school chiefly through the large collection of paintings by Kōrin preserved by his family, which had supported Kōrin with a daily allowance for a number of years, beginning in 1707. The Sakai family were samurai of great wealth and power; Hōitsu's grandfather had been the lord of Himeji Castle, west of Kobe, one of the mightiest bastions of feudal power in the Edo period. Hōitsu was born in family estate in Edo and was given the conventional education of the day, with emphasis upon Chinese and Confucian learning. He was interested in painting and, like many youths of the late Edo period, was tempted and distracted by the great range of styles possible in Japanese art. He was given lessons in the Kanō style; he studied with the *ukiyo-e* master Utagawa Toyoharu. He also studied with Sō Shiseki, the Japanese artist who had learned Chinese bird-and-flower painting in Nagasaki. He also met Tani Bunchō, probably the leading painter in Edo of his day (see No. 89), who encouraged Hōitsu to revive the Kōrin style.

Hōitsu was a man of strong character and will; he became a fully tonsured Buddhist monk in 1797, in the Jōdo Shin sect, and settled for a period in Kyoto; and in 1809, he returned to Edo where he set up his own workshop. As an artist with monkish ways, he prospered; his output of screens, scroll paintings, and ornamented objects such as this hibachi, was extraordinarily high. The influences of the great variety of styles of the Edo period are clearly apparent in his work. One finds traces of the Chinese bird-and-flower painting, of *ukiyo-e*, of the style of Ōkyo and Jakuchū; some works are done in the Tosa manner; in others he turned to conventional Buddhist painting. Occasionally he made calligraphies very strongly in the Zen manner. The dominant influence, however, is that of Kōrin and Kenzan, and in some works, such as screens of flowering iris or the Wind God and Thunder God, his emulation was almost slavish. For the most part, though, he established his own distinctive variation of the Kōrin-Kenzan style, characterized by an extremely meticulous brush technique, a strong touch of descriptive realism, a pastel palette, and preoccupation with floral themes.

He collected original works by Kōrin and Kenzan. In 1815, on the hundredth anniversary of Kōrin's death, he published the *Kōrin Hyakuzu* with an introduction by Tani Bunchō, a kind of *corpus verorum* of works he had inspected (see No. 108). He also published a study of seals of the Ogata school. Hōitsu was a gifted poet in both haiku and comic verses; he was devoted to the tea ceremony and attempted to maintain a life style in the manner of Kōetsu and Kenzan, devoted primarily to the arts but with a strong religious vocation.

Reference: Shimizu Yoshiaki. *Japanese Paintings from the Collection of Joe D. Price*. Lawrence, Kansas, 1967. P. 30; Kyoto Museum catalogue, *Hōitsu Shōhin Gashū*. Kyoto, 1930.

Bunjin-ga

Paintings of the Literary Men

The culture of the Edo period was enriched by a vital new school of painting formed in the late seventeenth century by artists who called themselves the Literary Men (Bunjin). In style and subject matter, the school was strongly Chinese in spirit. Through it, scenes of pavilions overlooking the Yangtze, the poems of Tu Fu, the mountains of Szechwan entered the repertory of Japanese painting, along with the techniques of Chinese masters who had remained largely unknown to the Japanese before that time. Arising in the quasi-feudal social order of the Tokugawa regime, the Bunjin movement spread first among wealthy samurai, who had been encouraged by the government to study Chinese Confucianism and thereby strengthen their sense of social discipline and loyalty to the state. The first generation of Bunjin painters lived for the most part in provincial fiefs. Many later artists worked in the large cities of Osaka, Kyoto, and Edo; but the movement was nationwide in scope and lacked the kind of centerpoint that the Kōetsu and Kanō schools possessed. Rather, it was China that provided the focus, that vast and prestigious land, which remained inaccessible for most Japanese.

In China, the roots of the school (called *wên-jên-hua*) reached back to the origins of landscape and bird-and-flower painting in the early centuries of the Christian era. For the Wên-jên painters the arts were a branch of philosophy aimed, above all, at the cultivation of human character. The artist was not to work merely to fulfill the wishes of a patron. He was to be an amateur in the deepest sense of the word, to gain inspiration from a deep perception of nature, from the arts of the past, and from the fellowship of men with similar ideas. The artistic horizon of the Literary Men was broad. They practiced calligraphy, poetry, music, painting, and antiquarian studies with equal zeal. They lived simply and humbly, away from the noise and tension of the city, nourished by the beauty of the landscape and their gardens and by the precious company of friends. In their gatherings, the Literary Men would drink together, sing and compose verses, sometimes collaborate in calligraphy or painting projects. Highly individualistic and inspired by a sense of lofty purpose, the Chinese Wên-jên considered their style of living to be all important. They had little desire to establish a single correct style of painting; instead, they tended to be eclectic in the choice of models from the past. Their eclecticism, however, did not extend to excessive interest in or to emulation of the work of contemporary court painters, Buddhist

temple artists, or professional painters, for the Wên-jên had little respect for these other traditions.

For centuries in China, the Wên-jên approach was informally sustained. In the late Yüan and early Ming periods, it became more self-conscious and developed its own distinctive styles of painting. The Ming master Shên Chou and his disciple Wên Chêng-ming, for example, had a pictorial manner based first upon the use of pale, transparent washes of color. Strong dark brushstrokes were painted over these to establish the outlines of forms or the distinctive textural patterns of leaves or rocks. The effects were rather light and airy and did not encourage careful realistic rendering but a more rapid, spontaneous brush technique. In the landscapes of Shên Chou and Wên Chêng-ming, nature was presented in a less heroic, more intimate and playful guise than in the work, say, of the Northern Sung period.

The painter and critic Tung Ch'i-ch'ang, who was widely read in Japan, expounded the theory of Wên-jên arts so vigorously and dogmatically that it became a kind of orthodoxy in its own right and in violation of its own fundamental principle of informality and freedom. Tung and his followers advanced the term "Southern Painting" (*Nan-hua*, or *Nanga* in Japanese) to describe the style, comparing it with the Southern Sung school of Chinese Ch'an Buddhism, which had been more informal than the Northern school. That tendency to codify and systematize Wên-jên painting was reflected by the appearance in the early seventeenth century of manuals for artists, which were books illustrated with wood-block copies of famous works of the past. These included the *Eight Albums of Painting* (the *Hasshū Gafu* in Japanese), published in 1620, and the *Mustard Seed Garden Compendium* (the *Kaishi-en Gaden*), published in 1679, which were republished in Japan and served as the basic source book for the Japanese Literary Men painters.

The Wên-jên school had evolved gradually in China; in Japan it grew up suddenly as a fully developed style and spread with startling speed. Its growth was resisted by the Kanō school, which considered itself the guardian of the Chinese spirit in the arts. The Kanō painters cherished the sober, monochrome ink painting in the Southern Sung style as it had come to Japan in the fifteenth century, under the aegis of Zen Buddhism. The Literary Men promoted Chinese painting as it had been codified in the Ming period. This was a gayer, more brightly colored approach; it was less affected by Zen and more closely linked to Confucianism. The samurai of the shogunal government were attracted by both schools; the Kanō painters, with a position to defend, were jealous. Arguments raged between the two camps, and the records of the debate give a lively impression of that clash of taste. The pioneer *Nanga* master, Yanagisawa Kien, charged that in Kanō paintings things had skin but no bones or marrow (true spirit). He argued that the Kanō artists had not reached a deep understanding of the laws of painting, which could come only from the study of such ancient Chinese masters as Ku K'ai-chih, Lu T'an-wei, or Chang Sêng-yu. The counterargument against *Nanga* may be left to the words of the American, Ernest Fenollosa, who was trained in Kanō traditions during the 1880s. He expressed such strong arguments that the first Western students of Japanese art were discouraged from taking *Bunjin-ga* seriously. In fact, only within the past two decades have Westerners, their taste informed by European and Chinese expressionism, given that school the attention it deserves. Fenollosa's comments, masterpieces of deeply

felt invective, are scattered throughout his *Epochs of Chinese and Japanese Art* (London, 1912), and they include:

> A great school of Japanese "bunjin-ga" fanatics now grew up in Japan, whose style in following the most misshapen cows, gentlemen with trepanned skulls, and wriggle-worm branches of their masters shows even in its deliberate distortion a certain distinction. . . . Great specimens of their work are valued today by countless Japanese at exorbitant sums. And yet from any universal point of view, their art is hardly more than an awkward joke. . . .

Although the main life span of Japanese *Bunjin-ga* was less than two hundred years, the school developed in a coherent manner. The first generation, comprised of such men as Gion Nankai, Yanagisawa Kien, and Sakaki Hyakusen, were faithful to Chinese models, either the masterpieces known only through wood-block prints or rare originals of indifferent quality imported through Nagasaki. The second generation, dominated by Yosa Buson and Ike no Taiga, retained this fidelity but achieved a far greater sense of confidence and stylistic originality. Japanese *Bunjin-ga* began to take on features unknown in China. In the third generation, comprised of men who lived into the nineteenth century, *Bunjin-ga* became extremely complex stylistically. Eccentricity or wild expressionism appeared in the work of men like Uragami Gyokudō, Aoki Mokubei, and Okada Beisanjin. Artists like Tani Bunchō and Watanabe Kazan were more rational and eclectic, and they experimented with Western-style arts. Others, like Chikuden, remained faithful to Chinese models. At the end of the Edo period, *Bunjin-ga* retained perhaps more vitality and originality than any other school of Japanese painting, due mostly to its experimental attitude. Artists active in the 1850s show a varying degree of Western influence. But that is the result of spontaneous natural curiosity, and the Western traits are well integrated into the essentially Chinese vision of nature. Even after the Meiji Restoration and the death of so many traditional forms of Japanese art, *Nanga* survived in the work of a number of rugged traditionalists—Tomioka Tessai, for example, and Murakami Kagaku. But the intellectual and social basis of *Bunjin-ga* largely perished in Japan's conversion to a mercantile, commercial way of life.

112. Chinese poem

Mid-Edo period; summer, 1729
Gion Nankai (1677–1751)
Hanging scroll; ink on paper
H. 46 1/8 × 11 1/8 in. (117.3 × 28.3 cm.)

This original Chinese poem was composed by Gion Nankai, the first major Japanese artist in the Bunjin tradition. It is written in a deft, fluent grass-writing style, done when he was fifty-three years old, at the full height of his powers as a painter and calligrapher. It expresses a tender irony and melancholy that give, perhaps, a distinctly Japanese flavor to the poetic idiom.

> Jealously the rain strikes the window;
> Pistils and stamen wildly fly up.
> Spring departs not to return;
> Giving no thought to our sadness.
> Owing to this dusty, impure world,
> Men grow old.
> But relax! Fundamentally, the world
> Is not to be managed as we would like.
>
> In a small hermitage deep within
> A bamboo grove, hearing only the faint
> cry of a bird;
> Or in a solitary village surrounded by water,
> Where guest boats seldom stop;
> Even now if I had the leisure,
> To whose house should I go to drink?
> In my melancholy I prefer to sit in the green
> Shadows, enclosed by the cleansing light
> of midday.
>
> Summer, 1729
> [by] *Nankai Genyu*

Nankai, in his biography and life-style, was perhaps the archetype of the first generation of Japanese Bunjin. Like so many others in this tradition, he was associated with the medical profession, for his father had been a physician in Kii Province (the modern Wakayama). As a well-born youth in the feudal order of the Tokugawa regime, he was trained in Confucianism; his teacher, Kinoshita Jun'an, was the outstanding Confucian scholar of his day. Ordered to teach in Edo by the Shogun Tsunayoshi (see No. 114), Jun'an had an extensive library of Chinese books and scrolls; his pupils included such outstanding personalities and friends of Nankai as Arai Hakuseki and Muro Kyūsō, who provided the theoretical basis of many aspects of Japanese government and civil policy during the early 1700s. Nankai became an independent Confucian scholar in his own right, teaching in Wakayama and receiving a regular allotment of rice from the feudal government there. However, in 1700 he was exiled to a remote village because of "extravagance and profligacy." There may have been political or ideological reasons underlying this exile, but he is remembered as one of the most enthusiastic wine drinkers among the Japanese Bunjin. After ten years spent in real poverty, he was permitted to live in Wakayama city; by 1713, he had become the head of a *hankō*, a school of Confucian learning financed by the feudal government in Wakayama. He devoted himself increasingly to painting and calligraphy, and he frequently visited in Kyoto. He carefully studied the *Mustard Seed Garden Compendium* (see No. 115) and the *Hasshū Gafu*, and his earliest paintings, which date from 1719, show the influence of these wood-block printed manuals of Chinese painting. True to the credo of the Bunjin, Nankai continued his poetry, and he is ranked as one of the finer poets of his age in the Chinese manner.

Reference: Yoshizawa Chū. *Bunjin-ga*. Nihon no Bijutsu, no. 23. Tokyo, 1966. Pp. 23–25.

113. Calligraphy scroll; poetic stanza

Mid-Edo period (ca. 1720)
Ogyū Sorai (1668–1728)
Hanging scroll; ink on paper
H. 41 5/8 × 11 in. (105.8 × 28 cm.)

This calligraphy is by Ogyū Sorai, one of the most influential and brilliant of the Japanese Confucian scholars. Deeply expressive of the manner in which the Bunjin used Chinese sources, the text is taken from a poem entitled "While staying in the pavilion of the Yün-men monastery," by Sun T'i, a relatively obscure poet active around 730. It is included in one of the classical compendia of T'ang verses available to the Japanese, the *T'ang shu-hsüan*, and it evokes the mood and grandeur of the mountain setting at an ancient Buddhist sanctuary in Shantung. The passage written here, the third of eight stanzas, may be translated:

> Hanging up the lamps;
> A thousand peaks
> At nightfall.
> [signed] *Monobe*

It is difficult to know why Sorai selected this particular passage. The style of his calligraphy is extremely strong. It is a form of *ts'ao shu* (*sōsho*) or "grass writing," in which the characters are written with little emphasis on their intelligibility and logical structure. The first character, *hsüan*, "to hang" or "to suspend," is normally written with twenty strokes; here it has been reduced to six. The brush, heavily charged with ink, was wielded with a powerful, deliberate movement that conveys great feeling. The fifth character, *chang*, "cliff" or "range of peaks," has been written with eight strokes in the place of its normal fourteen and is almost completely unintelligible to someone not long steeped in this type of writing.

Ogyū Sorai, considered one of the leading students of Chinese calligraphy among the early Japanese Literary Men, may well have used the work of the Ming calligrapher Chu Yün-ming, an eclectic who worked in many styles, as a model and guide here.

Sorai was steeped in Chinese philosophy and poetry; his father had been a physician in the household of the lord who became the fifth shogun of the Tokugawa family, Tsunayoshi. The family's connections were thus among the highest strata of samurai society, and Sorai was given a Chinese-style education typical of this circle. However, his father was exiled to the remote area of Kazusa (modern Chiba Prefecture) for ten years, during which time Sorai concentrated all the more on his studies. Eventually, he entered the service of the daimyo of Dewa, Yanagisawa Yoshiyasu, who was an intimate adviser to the Shogun Tsunayoshi. Through these connections, Sorai returned to the shogunal court and was greatly concerned with the theoretical basis of the military government.

Tokugawa Tsunayoshi was an authoritarian and powerful ruler. He greatly promoted Confucianism as a means of strengthening his position and, at the same time, encouraged the growth of scholarship and antiquarian studies. After Tsunayoshi's death in 1709, however, Lord Yanagisawa fell from political favor, and Sorai, too, withdrew from the circle of shogunal government officials and devoted himself to his Confucian studies and teaching. Among his many pupils was the painter Yanagisawa Kien (see No. 114). Sorai's branch of Confucianism was not the orthodox school of Chu Hsi approved by the *bakufu* but, rather, a kind of fundamentalism based on the strict study of Confucius and Mencius, the ancient sources. He promoted the classical ideal of the quality of mind and life as the most important attainment of a sage. Stressing frugality and modesty in behavior, he opposed the sumptuous modes of life that flourished in Edo and condemned bourgeois attitudes and the rapidly spreading spirit of mercantilism.

Reference: J. R. McEwan. *The Political Writings of Ogyū Sorai*. Cambridge, 1962; Iwahashi Junsei. *Sorai Kenkyū*. Tokyo, 1934.

114. Calligraphy scroll of Chinese poems

Mid-Edo period
Yanagisawa Kien (1706–1758)
Hand scroll; ink on paper
H. 10 3/16 in. (25.9 cm.)

This long hand scroll comes from the brush of an outstanding pioneer among the Japanese Literary Men, Yanagisawa Kien. In every respect it is a classical example of their intellectual and aesthetic orientation. This inscription at the end states that it was given to a Confucian scholar and poet, Okayama Kagaku, who taught in the Ōmi district. According to tradition, Kien closely studied the calligraphy of two celebrated Chinese Wên-jên masters, Wên Chêng-ming and Tung Ch'i-ch'ang. In fact, the calligraphy employed in this scroll is really an amalgam of styles used by those men.

Kien belonged to the wealthy and influential Yanagisawa clan, and came from the Kōriyama district near Nara, where his father had received a rich annual allowance. The head of the clan was a high official of the *bakufu*, Yoshiyasu, an adviser of the fifth shogun of the Tokugawa family, Tsunayoshi. The latter had become an enlightened patron of many branches of the arts and letters—Confucianism, medicine, Buddhist studies, mechanics, and calendrical research—and the Yanagisawa family was closely associated with his efforts to promote learning.

In the pattern of the wealthy provincial samurai of the day, Kien was given an education based on Confucianism. He was tutored by the famed Ogyū Sorai (see No. 113), who had been supported for years by Lord Yanagisawa. Kien learned Buddhist doctrines from a member of the Ōbaku sect (see No. 100) and was given training in painting, calligraphy and medicine. As an artist, he was strongly influenced by one branch of the Nagasaki school that specialized in brightly colored, somewhat realistic, bird-and-flower pictures in the academic style of the Yüan and Ming periods. He also worked with more conventional landscape compositions based on the models of the *Mustard Seed Garden Compendium*, and he mastered painting with his fingers, one of the peculiar artistic conceits of the Literary Men's style.

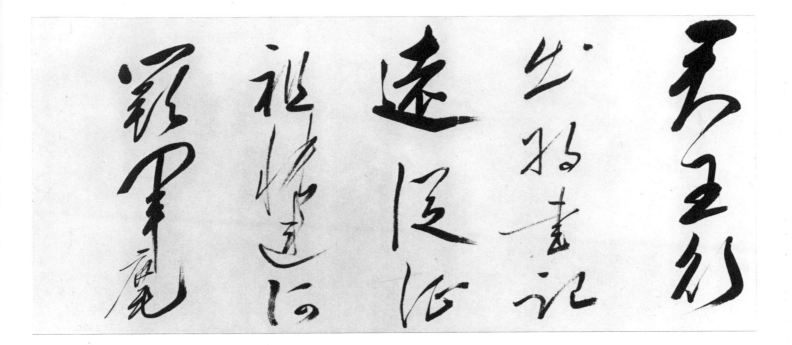

Kien was influential in garnering support for the Bunjin movement, and he played a major role in the life of Ike no Taiga (see No. 116). By tradition, he is credited with having recognized Taiga's genius in fan paintings the sixteen-year-old youth had done, and subsequently invited him to Kōriyama where Kien taught him Chinese painting techniques, calligraphy and textile dyeing. Thereafter, until the end of Kien's life, he served as Taiga's friend and patron.

Here Kien's flowing and yet disciplined writing style is most closely related to that of Wên Chêng-ming in such celebrated examples as his poetry scroll of 1583, the *Yu-t'ien ch'ih-shih*. Just as Kien had turned to a Chinese model of a century past in the anti-quarian spirit of the Wên-jên movement, so had Wên Chêng-ming used the style of the Northern Sung master Huang Ting-chien as his model. But Kien's scroll shows greater variation in the darkness and thickness of the line and also a greater playfulness.

These qualities can be traced to the influence of Tung Ch'i-ch'ang, in such works as his scroll of a poem of Li Po, the *Yueh-hsia-tu-chou* of 1616.

Reference: *Shodō Zenshū*. Edo period, vol. 23. Tokyo, 1958. Pl. 15; ibid., Yüan and Ming periods, vol. 17. Tokyo, 1956. Pls. 78–81; ibid., Ming period, vol. 21. Tokyo, 1961. Pls. 16–21.

115. "Four Types of Painting Models" ("Gashiki Yonshū")

Mid-Edo period (1762)
Ike no Taiga (1723–1776)
Four hand scrolls; ink and light color on paper
 "The hsieh-i style [for depicting human beings]"; H. 11 5/8 × 258 1/4 in. (28.02 × 657.78 cm.)
 "Forest of peaks"; H. 11 5/8 × 236 1/4 in. (28.02 × 597.98 cm.)
 "Models for [painting] trees in landscapes"; H. 10 3/4 × 257 1/2 in. (27.27 × 654.48 cm.)
 "Describing rocks"; H. 10 3/4 × 255 1/8 in. (27.27 × 649.42 cm.)

One of these four scrolls is dated 1762, and they all may have been done at the same time, when Taiga was almost forty years old. They were probably intended as painting instructions for a man identified only as Mr. An, for they are a condensation of rules of *Bunjin-ga*. The scroll that deals with human figures was carefully copied from the *Mustard Seed Garden Compendium*, the Chinese painting manual that served as a prime source for the Japanese Literary Men. The other three are more or less free inventions in the Chinese manner, based rather loosely on the *Mustard Seed Garden* and other manuals that were accessible to Taiga.

These four scrolls of Taiga demonstrate clearly the vital role played by such manuals in the development of Japanese painting during the Tokugawa regime. The isolation policy had made it impossible for Japanese to travel abroad (see No. 138), and only a few Chinese painters could work in Japan. The quality of original Chinese painting available for the Japanese to study could not have been very high, although this is difficult to determine today. The manuals condensed and distilled the history of Chinese painting. To well-schooled Chinese, the styles of the great artists of the past were deeply familiar, and the simplified reproductions of the wood-block printed manuals were mere reminders. For the Japanese, these pictures were their only access to the work of of such classical masters as Mi Fei, Kuo Hsi, and Tung Yüan. However, all traces of Chinese Buddhist and court painting had been eliminated by the authors of the manuals, and the aesthetic qualities of ancient masterpieces were radically transformed. The subtle delicacy of ink and brush effects in the originals were converted into the harsher graphic qualities of wood-block prints; Taiga, of all the Japanese Bunjin, was the most strongly affected by this peculiar situation. In his own paintings, he greatly exaggerated the strong linear patterns of rock, leaf, and mountain shapes as they had appeared in the prints.

The history of the *Mustard Seed Garden Compendium* is quite complex, for pirated and mutilated editions were issued early in both China and Japan. It may be sufficient to say here that the first of its three parts was published in Soochow in 1679, with a preface by a relatively obscure poet, playwright, and patron of the arts named Li Yü. The second and third parts were published in 1701. Li Yü is often falsely cred-

"The *hsieh-i* style"

ited with having compiled the work; Taiga himself calls the *Mustard Seed Garden Compendium* "the work of Old Li." In fact, the publisher was Li's son-in-law, Shen Hsin-yu, and the chief compiler was a certain Wang Kai, a follower of the remarkable eccentric master of Nanking, Kung Hsien. Of all these men, however, Li Yü was the most meaningful to the Japanese; his poem in praise of the quiet rhythm of life, centered on his small garden, the I-yuan, near Mount Lu, served as inspiration to Taiga and Buson for one of the most treasured products of the Bunjin movement. This is the pair of "Albums of the Ten Conveniences and Ten Attractions" ("Jūben Jūgi-jō") painted in 1771 by the two men, of which three versions exist. The title "Mustard Seed" actually refers to the I-yuan; it was used by Li Yü to describe its small scale.

These four scrolls of Taiga are too long to reproduce and describe here in their entirety (a definitive publication is being prepared). The most carefully painted of the four is the one depicting human figures, entitled "Sha-i-shiki" (literally, "copy-intention-style"). Taiga must have taken this title from a chapter heading in the fascicule of the *Mustard Seed Garden,* which deals with human figures. The last six pages of the fascicule come under the heading of "Sha-i-jimbutsu-shiki" ("human beings according to the *hsieh-i* style"). The preface to this section explains that the *hsieh-i* (*sha-i*) style is like the grass-writing manner of calligraphy (see No. 113) as described by the famous T'ang master Chang Hsü. The preface goes on to state that in this style the artist gives up unnecessary details, describes forms in the simplest possible manner, captures the spirit of nature, and gives expression to the invisible.

Taiga himself recorded his own mood and motives in painting this scroll in the two colophons at the end. The first is a poem in seven-character stanzas:

The Li Family treatise on *hsieh-i* is especially rare.
I spread my mat, take up my staff, and raise my cup.
Today I am lazy and, lacking new ideas, make an insignificant copy for you.
In doing the above drawings I have relied completely on the work of Old Li. Since it [my copy] is exact, there is no need to put in the [descriptive] headings. My friend Mr. An [*An-kun*] will correct it.

[signed] *Mumei* [The Nameless One]

Taiga's copies of the figures are indeed exact, but he took them in an almost random manner from the entire fascicule. He unfortunately omitted the labels given to the figures in the book. These convey something of the atmosphere of the Bunjin life-style; for example, "walking in autumn hills with arms clasped at the back"; "two men drinking tea among the flowers in the mountains"; "today playing the *ch'in* [lute] and singing in the fine clear weather." The figures are virtually emblems of the life-style of the Bunjin, for they embody a sense of genial humor and cordiality, of intimate brotherhood, of communion with nature; and Taiga painted them with a far greater sense of delicacy and personality than they possess in the Chinese wood-block prints. Most interesting, however, is the fact that Taiga at the very end of the scroll added two figures not in the book. The last is Bodhidharma seated in meditation with a quizzical look on his face; next are Han-shan and Shih-tê (Kanzan and Jittoku). Taken from Zen Buddhist painting, these seem to be a willful insertion by Taiga of his strong indentification with this creed (see No. 117). In addition, Taiga impressed his own seal

reading "Shunshō" on or near each of the figures to attest their genuineness.

The second scroll, entitled "Forests of Peaks" contains six examples of mountain landscape forms loosely derived from the classics of Chinese painting, and labeled according to terms found in the *Mustard Seed Garden*. Taiga painted in a free and almost careless manner at the beginning of the scroll; by the time he reached the fifth and sixth scenes, however, he had become fully engaged and produced carefully executed essays of the highest quality. The scenes themselves are labeled as follows, the parts illustrated here are marked with an asterisk:

1. straight wash strokes of Tung Yüan
2. horse-tooth strokes of the Great Li (Li Ssu-hsün)
3. hemp-fiber strokes of Fan K'uan
4. rolling clouds of Kuan T'ung
*5. alum heads of Kuo Hsi
*6. confused hemp strokes of Li Ch'eng

The short colophon at the end reads: 1762, autumn,

"Forest of peaks"

"Forest of peaks" 郭熙礬頭

"Models for trees in landscapes"

the eighth month, before the full moon. Sketched by Kyūka Sanshō.

The third scroll is entitled "Models of [painting] trees in a landscape." It, too, is closely related to the *Mustard Seed Garden* manual, but seems to have been done from memory in a free and personal way. It is by no means a careful copy and gives a total of twenty-three examples, ranging from full trees of different species, to combinations of up to five types. Illustrated here are the opening sections and the final one, each numbered according to their order from right to left:

1. the mixed strokes of Great Mi (Mi Fei)
2. black pepper dots of Pei Yüan (Tung Yüan)
3. tender leaf (strokes)
4. pine needle (strokes)
5. double outline black pepper dots

291

6. level top (strokes)
7. (leaves resembling) the character *chiai* (mustard)
8. double-outline *chiai* strokes
9. mouse foot (strokes)
10. (drooping) hair leaves
11. autumn leaves
12. uplifted head
13. head of the clan
14. ancient cypress
.
23. five trees intermingled

The colophon reads:

Mi [Fei's work] is full; Ni [Tsan's] is sparse; ancient and modern are different, but a sharp stroke and a wet daub are entirely the same pursuit. Creation has from the beginning developed in many directions. There is a wide variety of styles for men to follow.

[signed] *Kashō*

Rocks form the subject of the fourth scroll, which strays farthest of all from the *Mustard Seed Garden*. Much of the nomenclature is found in a treatise on rocks by Wang Lo-yu, the *Wang-shih-shan-hu-wang-hua-fu* of 1643, which in turn seems to have been adapted from a work by Tung Ch'i-ch'ang. The colophon at the end of Taiga's scroll contains an original poem in seven-character stanzas:

Who achieves excellence in showing the changes of contours and textures [of things]? Ching Hao, Kuan T'ung, Tung Yüan, Chü-jan [masters of the late ninth and tenth centuries]—all surpass Chang Kung. Rubbings and tracings [of ancient paintings copied in stone engravings] are hard to obtain today. My work is as minor as a small cloud in the blue sky.

[signed] *Kashō, again*

Taiga painted these rocks with special skill and care; their isolation from the landscape and the treatment of them as an independent artistic motif was a familiar trait in Chinese Wên-jên painting. This attitude is reflected in the rock screen of Yosa Buson shown here (No. 119), where it reaches a very high peak of attainment.

It is not certain that Taiga conceived these four scrolls as a unified set. There are slight differences in style and in the measurements of the paper; thus it is possible that they were formed into a group artificially.

He produced scrolls of this kind throughout his career, for the careful study and reproduction of Chinese models was essential to the Japanese Bunjin school. While he was still in his twenties, for example, he planned to publish his own painting manual like the *Mustard Seed Garden* and produced an album of preliminary drawings of human figures very similar to the first scroll here. The book was not published, but the drawings have been preserved. They are now in the Terao collection, Tokyo. When he was in his forties, Taiga painted a hand scroll illustrating the six types of perspective as shown in the work of the Northern Sung master Kuo Hsi (now in the Murayama collection, Hyōgo Prefecture). He also did a scroll of trees and rocks in the style of Tung Yüan (now in the Nakayama collection, Shimane Prefecture). His own painting methods were codified in a set of volumes called the *Taigadō Gahō*, which were published in wood-block print form after his death; some of the preparatory drawings remain in the Hosoya collection, Yamagata Prefecture. Probably the finest of all his essays in this idiom is a single scroll in the Hosokawa collection, Tokyo, that combines human figures, rocks, trees, and mountain forms. Long after his death his students had this copied onto wood-blocks and published in 1804 under the title *Taigadō Gafu*.

The four scrolls of Taiga shown here have long been known in Japan. Their drawings range from hasty sketches to brilliantly conceived and executed passages. Careful study of these brings one into close contact with the creative processes of one of Japan's most original and engrossing masters.

Published: *Ike no Taiga Sakuhin-shū*. Tokyo, 1960. Nos. 436–439; Yoshizawa Chū. *Bunjin-ga*. Nihon no Bijutsu, vol. 23. Tokyo, 1966. Fig. 141; exhibition catalogue, Tokyo National Museum, *Nihon Bunjin-ga*. 1965. Nos. 126, 130.
Reference: *Ike no Taiga Sakuhin-shū*. Tokyo, 1960. Nos. 86, 433, 485, 486, 627–630; A K'ai-ming Ch'iu. "The Chieh Tzu Yüan Hua Chuan," *Archives of the Chinese Art Society of America*, V. (1951), pp. 55–69; Raphael Petrucci. *Encyclopédie de la Peinture Chinoise*. Pp. 55–69. Paris, 1918; Mai-mai Sze. *The Tao of Painting*. Bollingen Series, XLIX, 2 vols. New York, 1956.

116. A gentleman visiting his friend

Mid-Edo period (ca. 1755–1765)
Ike no Taiga (1723–1776)
Two six-panel folding screens; sumi *ink on paper with faded washes of indigo and red ochre*
H. 57 3/4 × 143 1/4 in. (147.9 × 363.9 cm.) each

This monumental, intricate composition extends across two screens as a single scene. Its main line of organization is established by the man and his two servants on the right, beneath a twisted pine. They are strolling in the direction of a rustic house in the center of the left screen. Awaiting them is a man seated behind the window and looking in their direction.

The physical condition of these screens offers a challenge to the connoisseur. They seem to have been washed at some time in the distant past; portions of the composition must have faded and disappeared while others survived. It is difficult to be certain of the cause, but surely the distant parts of the landscape, painted in soft, thin washes of ink, are not as prominent as they once were. In the right screen, for example, only faint traces of mountains and a shoreline remain behind the man on the bridge and the pine tree. In addition, some strong black lines seem to have been deftly painted, possibly to reinforce and reunify the composition, and more foliage was added.

Despite this, the composition has not changed, and the work is essentially as Taiga conceived it, with the exception of the faded background. The viewer is still able to sense a great expanse of space receding behind the rocks and hills that rise near the foreground. Especially effective in the spatial organization is the towering massif on the right, which dramatically extends beyond the top of the composition. These spatial effects—the interplay between near and far distances—were revolutionary in their day. Taiga frequently created an almost Western sense of perspectival recession; he would place the horizon line relatively low in the composition, suggest a unified ground plane, and emphasize foreground elements to enhance the sense of depth.

Experimentation with spatial effects attracted artists of many Japanese schools in the last half of the eighteenth century. Indeed, there was a semi-organized school of European-style painting, the so-called *yōga* (see No. 146). But concern with Western perspective may also be seen in the paintings of Ōkyo and his followers and in the *ukiyo-e* school works of Katsukawa Shunshō, Okumura Masanobu, Utagawa Toyohiro, and even Utamaro. The Bunjin artists were attracted to Western techniques out of intellectual curiosity, out of the spirit of scientific inquiry that Confucian studies had encouraged. There is a record of Taiga having encountered Western arts

while still a young man, seeing them in Edo in the home of Noro Genjō, a doctor and botanist who had learned Dutch and become a pioneer scholar of Western learning.

Taiga, in 1751, made a panoramic drawing of Mount Asama, near Ise, and presented it to Gion Nankai (see No. 112). That tiny drawing, having a remarkable sense of pictorial depth and empirical description, was done during the years when Taiga first became an enthusiastic mountain climber. It communicates the exhilaration of heights, a sense of exploring the world in a spirit that appeared in the early Renaissance in the West in the poems of Petrarch and the landscapes of Baldovinetti and Piero. Taiga's sketch of Mount Asama, coincidentally, has certain elements in common with the screens shown here, most notably in the treatment of the clouds, which are drawn with distinct outlines rising from the ground like the morning mists.

Apart from the spatial effects in the background, however, the composition of these screens is loyal to the basic principles of *Bunjin-ga* and its orientation in Chinese art. The trees and rocks are clearly established by means of strong, dark, conventional brushstrokes rooted in the disciplined study of Chinese painting manuals. In fact, these screens are not far removed in time and spirit from the scrolls by Taiga exhibited here (see No. 115), based on the *Mustard Seed Garden Compendium*.

These screens come from Taiga's early maturity, his late thirties, and are similar to a number of large-scale screen compositions that proved to be a major source of his support. Most familiar of those, perhaps, are the *fusuma* paintings he made for a sub-

temple of the Kongōbu-ji atop Mount Kōya, the Henjōkō-in. His style in all those screens is tense and dour; the strong ink quality imbues them with sobriety rather than grace. Taiga had a strong expressionist impulse, apparent here especially in the rock formations, giving the landscape a dynamism that approaches the ink drawings of Vincent van Gogh in their vitality and expressive power.

Both screens are signed in black ink with his honorific name, "Kashō," and are stamped with a variety of Taiga's seals.

Formerly in the Akaboshi collection, Kanagawa; Kumagai collection, Kyoto.
Published: *Ike no Taiga Sakuhin-shū*, 2 vols. Tokyo, 1960. No. 213.

117. Calligraphy scroll of five characters

Mid-Edo period (ca. 1755–1765)
Ike no Taiga (1723–1776)
Hanging scroll; sumi *ink on paper*
H. 36 × 8 1/4 in. (91.4 × 20.7 cm.)

The calligraphic technique here is extremely rough and anticlassical, in contrast with the more orthodox style of Taiga's writing in the scrolls based on Chinese painting texts (No. 115). The brusque, almost illegible formation of the characters appears in many of Taiga's calligraphy works and reflects his strong intellectual and spiritual ties to the Zen sect, especially to Hakuin and his circle (see No. 102). The text, however, is a simple lyrical statement in the Bunjin manner:

Refreshing breezes; old friends come.

In 1751, when he was twenty-eight years old, Taiga heard some sermons given by Hakuin during one of the famous monk's rare visits to Kyoto. Immediately thereafter, Taiga began painting and writing calligraphic texts in Hakuin's style, without surrendering, however, his primary identification as a Bunjin. One of Taiga's close friends was a devoted disciple of Hakuin, the monk Teishū, who became abbot of the Jishō-ji monastery at Nakatsu, in Ōita Prefecture in Kyushu. Taiga may have visited the temple in 1764, and Teishū collected Taiga's work over a long period of time. Preserved in the Jishō-ji are *fusuma* (sliding door) paintings, landscape and calligraphy scrolls by Taiga, some of his finest and most original work in both the Bunjin and Zen traditions.

This scroll is undated but may have been written in the early 1760s, during approximately the same period of his early maturity as the other works exhibited here. The signature reads "Sangaku Dōja" (Pilgrim of the Three Peaks), one of his favorite pseudonyms. He first used it in 1749, after he had become an enthusiastic mountain climber in the manner of the artistic wanderers of the Edo period, like Bashō and Buson (see Nos. 120, 126). Taiga, however, was particularly drawn to the challenge of the extreme heights and hardships on the mountain slopes. For a period of over twenty years he engaged in climbing expeditions that demanded courage and physical stamina, which are reflected perhaps in the sheer vitality of his artistic work, in his refusal to seek grace and easy solutions.

Reference: *Ike no Taiga Sakuhin-shū*, 2 vols. Tokyo, 1960. Nos. 420, 421, 425.

118. The literary gathering at the Orchid Pavilion

Mid-Edo period (ca. 1790)
Totoki Baigai (1749–1804)
Hanging scroll; sumi *ink and light color on paper*
H. 62 1/2 × 31 in. (158.8 × 78.8 cm.)

This very large and fluently painted hanging scroll is by Totoki Baigai, a somewhat obscure *Nanga* master from Naniwa (modern Osaka) who came under the strong influence of Ike no Taiga. Very much in Taiga's style is the graphic quality of the picture—as though it were a greatly enlarged wood-block print. The coloring and soft ink washes are subordinate to the linear patterns of the tree leaves and the outlines of the mountain. Much of the plain surface of the paper is visible, giving the composition a luminosity and sense of openness that the Bunjin painters cherished.

The subject is the literary gathering at the Orchid Pavilion (Lan-t'ing, or Rantei in Japanese), one of the most common motifs found in Chinese and Japanese painting of the Literary Men's movement. On the third day of the third month, 353, the poet and calligrapher Wang Hsi-chih gathered together with forty-one friends to drink and compose poems at this retreat, the Lan-t'ing, near Shao-shing in Chekiang Province. Wang was asked to write a preface to the poems the others had done for the occasion. Deeply moved by the beauty of the gathering, he wrote a poem that became one of the classics of traditional Chinese culture, both for the quality of his handwriting and for the depth of the sentiment and insight. The poem expressed a melancholy view of life; realizing that despite the flawless beauty of the day and the joy of the gathering, all present were doomed, that pleasures fade. The manuscript of the Wang poem remained with his family for seven generations, and then it was stolen. Ultimately it came into the possession of the T'ang Emperor T'ai Tsung, who had it copied and engraved on stone. From that time on, even though the original had disappeared, it served as a major inspiration for calligraphers and poets and was reproduced countless times.

Baigai's painting shows Wang Hsi-chih sitting in the Orchid Pavilion gazing at his famous geese in the stream beneath him. The other poets are shown floating wine cups on lily pads to each other, composing their poems, discussing them with one another, and relaxing in the arcadian setting. At the upper right, Baigai has copied the opening part of Wang Hsi-chih's poem, and added his own signature and seal.

Baigai, a painter of great skill, has thus far received little attention from Japanese scholars of *Bunjin-ga*; his biography is known only in general outline. Born in Naniwa, he was educated in Edo in the Chinese classics, calligraphy, and painting. He became a dilettante in poetry and dancing. He learned to carve seals in the Chinese manner, and in Kyoto he studied painting with Taiga and Minagawa Kien. Broad in his interests, he became an authorized Confucian scholar. Baigai was summoned to Nagashima in Ise Province by the daimyo of that district, Masuyama Sessai, who was an enthusiastic patron of *Bunjin-ga* and Confucian studies. In 1784 Baigai opened a *hankō* (school for the local samurai families) in Nagashima, but, like Gyokudō in the next generation (see Nos. 127, 128), he seems to have rebelled against the restrictions and discipline of the Edo feudal order. He found himself in frequent difficulties with the local authorities; he became excessively fond of wine, of writing and painting while drunk. In 1790, he was given leave to visit Nagasaki, probably to seek out Chinese masters of the Literary Men's painting. He overstayed his leave and lost his position with the Masuyama clan. This cost him his income and his place in the tightly structured social order, and ultimately he returned to Osaka. In general, his paintings reflect the strong influence of Taiga but have a distinctive flavor of their own. Baigai was skillful in composition, and his work has a more genial, romantic flavor than that of Taiga.

Reference: Ijima Takeshi. *Bunjin-ga*. Nihon no Bijutsu, vol. 8. No. 4 (August 1966), p. 110.

119. Spring and summer landscape

Mid-Edo period (ca. 1760–1765)
Yosa Buson (1716–1783)
Six-panel folding screen;
Sumi ink and light color on raw silk satin
H. 66 × 148 in. (167.6 × 375.8 cm.)

The existence of an expanse of sea behind these gently rolling hillsides is suggested by the tiny boats in the upper right corner. A river flows to the left, while in the lower right foreground an inlet projects into the center of the composition. This balance of water and land, the benign bucolic landscape inhabited by humble villagers, was a favored theme of Yosa Buson. He depicted it many times, but always with a sense of grandeur and dynamic energy. Here, the gravitational axes of the composition, both horizontal and vertical, are tilted to the right, imparting a restlessness and instability that serve as a counterpoint to the idyllic tranquillity of the scene.

A man of deep poetic gifts, Buson regularly alternated between haiku verse and painting as expressions of a vision of the world that was eminently lucid, wholesome, and enraptured with the pleasures of rural living. He had been born into a farmer's family, probably a wealthy one, in a village near Osaka, and was devoted to the arts from his early youth. Some recent evidence indicates that he was even interested in the theatre and that in his early twenties he went to Edo for training as an actor. He mastered poetry in the strict Chinese style fashionable at the time, and he received training in haiku from a disciple of Matsuo Bashō. In painting, Buson studied the styles of the Kanō school, of Kōrin, the Tosa style, and also the newly flourishing *Bunjin-ga*, which appealed most directly to his character and background.

Buson gave up his acting ambitions; instead, he began a long period of poetic wandering, much in the spirit of Bashō, that indefatigable traveler he so deeply admired. Hiking through the countryside, staying with villagers, soaked by the rains, Buson journeyed through the Kantō district, the far northeast, and the Shinano region. From these trips came an intimate sense of nature that Buson so often expressed in his haiku poems.

Harusame ya	Spring rain:
Monogatari yuku	Telling a tale as they go,
Mino to kasa	Straw coat and umbrella.
Yado kasanu	Without lodging:

| Hokage ya yuki no | Flickering fires and snow of |
| Ie tsuzuki | The houses continue. |

(1768)

In 1751, at the age of thirty-six, Buson moved to Kyoto where he associated with several Zen monasteries; and he began to paint more ambitiously. Three years later, he went to live in Miyazu, a village in the hilly Tango district just to the northwest of Kyoto. For three years he stayed in a small temple, concentrating on his haiku and on the study of Chinese painting. When he returned to Kyoto after that period of seclusion, his artistic style had virtually matured. To support himself he began painting the large-scale screens of which this is a fine example. Often, he would work for a kind of collectors club, in which the members would each contribute small sums and then draw lots, the winner claiming a screen. By 1770, he was recognized as one of the two outstanding

painters in Kyoto (the other was Ōkyo) and as the leading haiku master in Japan. He became a friend and collaborator of Ike no Taiga, and he attracted disciples in both poetry and painting such as Yokoi Kinkoku (see No. 123).

This screen, which dates from the beginning of his fully mature painting style, was rather loosely and freely painted. The elephantine volumes of the mountains were modeled with Buson's characteristic "hemp fiber" strokes that define the inner contours. Tree leaves were done rapidly, the different species indicated by a great variety of strokes. On other Buson paintings of this era, there is more precise definition, and the brushstrokes are more closely based on Chinese wood-block printed manuals.

The signature, "Sha-shunsei," was frequently used during the early phase of his full maturity as a painter. So also were the two seals in red, "Sha-shunsei" and "Sha-chōkō."

Published: Suzuki Susumu in *Kobijutsu*, no. 19 (October 1967), pp. 97, 98.

120. Calligraphy scroll with a solitary heron

Mid-Edo period (ca. 1775–1780)
Yosa Buson (1716–1783)
Hanging scroll; sumi *ink and white paint on paper*
H. 44 3/8 × 5 1/4 in. (112.6 × 13.3 cm.)

The painting at the bottom of the scroll, chiefly in white paint against plain paper, is of a remarkably self-satisfied, truculent heron. At the top, the calligraphy is written in the style of such Chinese Wên-jên (Bunjin) of the Ming period as Wên Chêng-ming and Chu Yun-mei. At the right edge is a poem in Japanese grass writing, eccentric and condensed in form. The poems themselves were composed by Buson, and the entire ensemble demonstrated the range of his virtuosity in the arts of painting, poetry, and calligraphy.

The Chinese poem (*kanshi*) may be translated:

> Standing alone,
> The handsome heron
> Frightened by people
> Leaves the rocky shore;
> Seen in the distance
> Like a patch of snow
> Brilliant against the green mountain
> It flies away.

The Japanese poem (haiku) may be translated:

Shigururu ya to aru	An early winter shower;
Tokoro ni sagi hitotsu	There, a single heron.

The signature reads "Buson," the most common of the painter's names; the seals are those most often found on paintings or works of calligraphy connected with haiku: above, "Sha-chōkō"; below, "Shunsei-shi."

獨立煙に鷺警人雑石磯
遅有一竿雪濁映裂処鳥

とところ記とある
訳もある

川
舞

121. Study of two rocks

Mid-Edo period; spring, 1773
Yosa Buson (1716–1783)
Hanging scroll; sumi *ink and light red color on paper*
H. 18 1/2 × 12 1/2 in. (46.1 × 31.8 cm.)

Done some ten years before Buson's monumental screen painting of the same theme (see No. 119), these two rocks were quickly, boldly executed in fluid gray inks. Washes of red color were added to enliven the composition.

Buson, like other Bunjin painters of his generation, had learned his art in an additive manner under the guidance of the Chinese painting manuals (see No. 115). From their student days and continuing long into their mature years, they would diligently copy the separate parts of the landscape as illustrated by the Chinese wood-block prints—rocks, trees, bridges, mountains, animals. Buson was especially attracted to rock formations. Throughout his career, he would often emphasize them at the expense of other elements of a composition, painting their texture and shapes with great care. He would not attempt to analyze the rocks objectively or illusionistically. He used them as a point of departure for virtuoso performances of brush handling. As here, they would become remarkably unsolid and weightless, lacking a sense of gravity but imbued with energy through purely painterly effects of ink texture and line.

Rocks also play a prominent role in Buson's poetry, serving as motifs for many haiku. For example:

Yanagi chiri	Leafless willows;
Shimizu kare	Waterless springs;
Ishi tokoro dokoro	Scattered rocks.
Ishi ni shi o	Giving title to a
Dai shite	Poem about rocks:
Sugiru karenō kana	Crossing a withered field.
Kogarashi ya	The wintery wind;
Iwa ni	Over the rocks,
Sakeyuku mizu koe	The sound of splitting waters.

Such close parallels between his paintings and poetry bear out Buson's claim to having been loyal to an ancient aphorism concerning the T'ang courtier Wang Wei, that in his paintings are poems and within his poems are paintings.

The signature reads "done by Shunsei"; the upper seal is "Sha-chōkō," the lower "Shunsei."

Published: Nakamura Tanio in *Kobijutsu*, no. 28 (December 1969).
Reference: Shimizu Takashi. *Buson no Kaishaku to Kanshō.* Tokyo, 1956.

122. Rocks

Mid-Edo period; spring, 1783
Yosa Buson (1716–1783)
Six-panel folding screen; ink and light color on paper
H. 60 5/8 × 141 in. (154 × 358 cm.)

Hovering in an almost cosmic space, with a feeling of neither gravity nor mass, each of the twelve separate rocks is painted in a different technique. With sheer virtuosity, overlapping transparent washes are combined with heavy ink accents, especially on the spots of moss or the contour lines. The small rock at the bottom of the fifth panel was painted in pale earth red, the lines resembling a flattened coil.

This extraordinary composition was done during the last year of Buson's life; although sixty-eight years old, he was in full possession of his powers. Four months later he was taken ill, and on the twenty-fifth day of the twelfth month of 1783, at sunrise, he died. His funerary monument was erected on the grounds of the Kompuku-ji temple, Kyoto, near that of the poet Bashō. The signature on this screen is "Old Man Yahan," Buson's most familiar penname as a haiku poet. It was taken from his first settled residence in Edo, the Yahan-tei (Midnight Pavilion) near the Nihonbashi Bridge, where he gained his early fame as a haiku master.

As discussed in No. 115, studies of isolated rocks appear frequently in Bunjin paintings—in works by Taiga, for example, and Chikuden and Kinkoku. But nowhere else are rocks isolated without a landscape setting and given such monumental expression. Buson's precise intentions when he painted this screen are unknown. He may originally have planned to have fewer rocks and to work out a full, conventional landscape with figures and trees. Then, at some point early in the project, he may have decided to limit himself to the rocks alone. Or this may have been a pure Bunjin exercise, taking the idea of isolated rocks from the painting manuals and executing them on a grand scale. Whatever his reasons, Buson produced a composition of daring originality.

Published: Nakamura Tanio in *Kobijutsu*, no. 28 (December 1969).
Reference: Suzuki Susumu. *Buson*. Tokyo, 1958. Pls. 16, 17.

123. Self-portrait; carrying calabash gourds

Late Edo period; autumn, 1820
Yokoi Kinkoku (1761–1832)
Hanging scroll; ink and light indigo and earth red on paper
H. 52 3/4 × 15 1/4 in. (133.8 × 38.5 cm.)

This must be considered one of the most informative and eloquent of all Japanese self-portraits. Kinkoku, a relatively obscure figure in the history of Japanese art, presented himself as the epitome of the wandering artist-ascetic. This is very much in the tradition of Bashō, Buson, and Taiga; but Kinkoku's commitment to the religious aspect of austerities and the hardships of travel was far more extreme than with the others. Done when he was sixty-one years old, this self-portrait presents his face as ugly, almost brutish, his body bent, and his presence filled with an almost manic energy that strains at the bonds of convention and even sanity. He shows himself, moreover, as a servant or bearer, carrying on a pole the calabash gourds filled, perhaps, with water for a group of mountain-climbing ascetics.

Kinkoku was a monk of the Jōdo school from Ōtsu city, on the banks of Lake Biwa. Like other Japanese of the Edo period, he practiced many arts—haiku, sculpture, seal engraving, and even pottery. As a painter, he worked closely in the manner of Yosa Buson, a full generation his elder. For that reason Kinkoku is usually considered a member of the Literary Man's school, although his life style was not that of a typical Bunjin. This painting, together with No. 126 below, was done in the figural style of Buson, featuring bold calligraphic outlines executed over thin washes of color. However, Kinkoku worked here with an expressionist fervor not seen in Buson, in the heavy scrubbing of the black lines of the hat, for example, and the rough treatment of the feet.

The inscription which encloses the portrait vaunts Kinkoku's abilities as a mountain-climbing ascetic, despite his advanced age. Written by the painter, it lists the mountains he had mastered, from the extreme north of Honshu to Kyushu in the west. The names of the mountains suggest that Kinkoku was an active follower of Shugen-dō, an offshoot of Esoteric Buddhism in which monks in large groups would retire to one or another sacred mountain and spend up to nine weeks on the slopes. They would eat a meager diet, often of roots and herbs, spend long hours in meditation and prayer, and conceive of each stage of the ascent of the mountain as similar to the path of the spirit toward Enlightenment. Symbolically, the mountains were interpreted as mandalas, and climbing them was analogous to the Esoteric Buddhist rituals of climbing such complex mountainlike stūpas as that of Borobudur in Java. When the devotee had reached the summit, he had emblematically attained Nirvāna.

Kinkoku's interest in Shugen-dō is confirmed by an episode in his fragmentary biography in which he was said to have begged the abbot of the Sambō-in, a subtemple of Daigo-ji, to let him accompany a group of monks to Mount Ōmine. This mountain, together with Kimbu and Kumano, was one of three west of the Yamato plain that were sacred to the Shugen-ja. He was allowed to join the group and to carry the *oi*, the box-shaped container of robes, texts, and images used on the mountainside. He also carried the axe, a Shugen-ja emblem derived from the founder of the cult, the mythical seventh-century wonder worker, En-no-gyōja. In artistic representations of this demigod, one of his attendants is always shown holding that implement.

Some portions of this inscription are difficult to interpret, but it may be read more or less as follows:

In this world, he passes his days as lightly as a calabash. East and west, there is nowhere his feet do not take him; or north and south, where his staff does not lead him. Needless to say, he visited Mount Ōmine and Mount Katsuragi [between Nara Prefecture and the Kawachi district]. On Kimbu and Kumano, he accompanied as bearer [a group of monks]. He climbed Daisen in the Hōki Province [now Tottori Prefecture], Takachiho in Hyūga [now Miyazaki Prefecture], Hikosan in Buzen [now Fukuoka], Fuji and Asama mountains, Haguro and Gassan [in Yamagata], Mount Hakusan in Kaga [Ishikawa], Mount Tateyama in Etchū [Toyama], and Mounts Atago and Hiei [to the northwest and northeast of Kyoto, respectively].

Altogether he has gone to high mountains and broad marshes in over sixty provinces of Japan.

And at an age exceeding sixty years, he proudly calls himself the leader of the [Shu]gen-ja.

Who do you think this person is? It is I, the ascetic [*dōjin*] who journeyed to this district and left his mark. It is I, the axe [bearing] ascetic of Kimbu, Kumano, and Daigo [? Ōfu], bearing the rank of Hōin [Seal of the Law, a high rank among monks] and the title Sambu-zuhō Dai-ajari [the Āchārya Master of the Three Sūtras].

By Kinkoku of the long beard, while traveling in Seto, Owari Province [modern Aichi Prefecture], in Autumn, the ninth month, 1820.

The seal at the upper right is Kinkoku's, and its Confucian content may be translated, "At fifty-five I set my heart on learning." The seal by his signature reads, "Kinkoku Bokuchi" (Foolish Ink).

Reference: Okada Rihei. *Haiga no Sekai*. Kyoto, 1964. Pp. 96-97; Muramatsu Shōfū. *Honchō Gajinden*. Tokyo, 1940. Vol. 1, pp. 273-274; Itsuō Bijutsukan, ed. *Haiga Kyōshitsu 5*. Osaka, 1967. Pp. 15-16; Fujimori Seikichi, ed. *Kinkoku Shōnin Gyōjō-ki*. Tokyo 1965.

124. Landscape under newly fallen snow

Late Edo period (early nineteenth century)
Yokoi Kinkoku (1761–1832)
Hanging scroll; ink with faint color on paper
H. 50 × 18 1/2 in. (127 × 47 cm.)

If the following snowy landscape was done in the manner of Buson (No. 125), this one reflects the style of Taiga. The simple linear outlines were done in Taiga's characteristic technique, as were the spreading and blotting of the lines that define the foreground rocks.

The mood here is that of the utter silence and purity that follow a heavy fall of snow. An old man gazes through the window of his house at the spectacle of the transformed world. The white of the paper, set off by the thin ink washes in the sky and around the trees, gives the effect of luminous snow. Yet the flickering lines of the limbs of the trees impart a plastic motion and energy that is the hallmark of Kinkoku's style.

The composition is remarkably similar to the preceding one in the underlying mode of organization. Kinkoku was not a profoundly original painter. Buson was his main source of inspiration, but in this as in other of his works one finds reflections of the styles of Taiga, Chikuden, Bunchō, and Mokubei. There are also paintings by Kinkoku in the traditional Buddhist style and in a modified *ukiyo-e* manner. His works have a deeply rewarding richness and sense of energy that make him one of the more appealing figures among the latter-day Bunjin.

125. Landscape in falling snow

Late Edo period (early nineteenth century)
Yokoi Kinkoku (1761–1832)
Hanging scroll; color and ink on paper
H. 53 7/8 × 25 1/8 in. (136.9 × 63.8 cm.)

In a small flat-bottomed boat sits an old man; before him is a table with his books and a pitcher; his ferryman stands at ease while around them swirl fine flakes of snow. The old man, probably a poet, must have had the boat come out into the middle of the lake so that he could read or compose poetry in peace. This scene, with the rustic village on the shore and the towering rocks above, is a pure example of a Bunjin theme, evoking the essential spirit of a moment of communion with nature.

As in Kinkoku's paintings of haiku poets (No. 126), the style of this landscape is dependent on that of Yosa Buson. It has a sense of violent energy, however, that is not typical of Buson but accords more with the eccentricities of the third generation of Bunjin artists. Buson's techniques may be seen in the handling of the thin washes of *sumi* ink in the rocks and mountains; yet the tree in the foreground is done with a brush technique that produces an arbitrary and jagged effect. The thin washes of a bluish black ink establish the effect of a cloudy, snow-laden sky through which the sun shines faintly. Soft tints of a plum color are blended into the mountain and rock forms. Falling snow is suggested by the dots of heavy white pigment that were spattered randomly over the surface.

In his tall, vertical hanging scrolls, Kinkoku often employed a V-shaped arrangement of elements, based on a rock, as here, or on some prominent element in the foreground. The elements above are usually arranged in a diagonal fashion, like irregular chevrons. An almost electric sense of nervous energy pulsates in the landscapes of Kinkoku, in contrast to the grand, sylvan moods so often found in Buson.

Reference: Exhibition catalogue of the Biwako Bunka-kan, *Kinkei Dōjin Ihō-ten*. Ōtsu, 1965.

126. Portraits of three haiku poets

Late Edo period (early nineteenth century)
Yokoi Kinkoku (1761–1832)
Album leaves, mounted as hanging scrolls; ink and light color on paper
Each leaf: H. 7 7/8 × 7 1/2 in. (20 × 18 cm.)

Kinkoku, in both his literary and pictorial styles, was strongly dependent on Yosa Buson (see Nos. 119–122), a full generation his senior. These three tiny portraits were done very much in the idiom developed by Buson for depicting the haiku masters of the past with whom Buson identified himself. The thin washes of pale indigo and flesh tones, the rapid, calligraphic outlines, the humorous touch, all are traits of Buson's style of portraiture—better yet, semi-portraiture, for no effort was made to explore seriously the appearance or character of the subjects. Instead, these images of haiku poets are ultimately variants of the traditional paintings of the immortal poets (*kasen-zu*) that had grown out of courtly taste in art and poetry of the late Heian period. Buson and Kinkoku's paintings are expressions of enthusiasm for this newer style in poetry and, by extension, a style of life.

The portrait of Matsuo Bashō, the central personality in this school of haiku and *haiga*, shows him seated, wearing a low peaked cap, his traveling hat at his side. It is labeled merely "Okina" (the old man), but the poem above is a celebrated one. It was composed by Bashō in 1688 on the eve of a journey to Yoshino, a mountainous district famous for its stands of cherry trees (see No. 134). Accompanied by a small group of friends and eager to set out, he wrote this haiku on his rustic umbrella made of slats of cypress wood, addressing it to the umbrella itself:

Yoshino nite At Yoshino
Sakura mishō zo I'll show you
 the cherry blossoms:
Hinoki gasa Ah, cypress umbrella.

The poet Enomoto Kikaku, like the other two, is shown huddled over, his hands in his sleeves. Kikaku was one of Bashō's most intimate and gifted disciples, and the poem accompanying this portrait is characteristic of his rather earthy and concrete literary style:

Uguisu no	From the topsy-turvy
Mi o sakasama ni	Nightingale:
Hatsune kana	The first song.

Bashō's disciples numbered over three hundred, but ten of them formed an especially close circle. The third man shown here, the poet Kawai Sora, is occasionally listed as a member of that intimate group. This poem was written when he accompanied Bashō on the renowned, six-month journey of 1689, which inspired Bashō's famous *Oku no Hosomichi*. Sora had been taken ill and was forced to stay behind at a temple in Kaga as Bashō continued his trip. The poem suggests his regrets and loneliness; it was published in the collection of works of Bashō and his school, the *Sarumino* ("The Monkey's Straw Coat") of 1690:

Yo mo sugara	All night long,
Aki kaze kiku ya	Listening to the autumn wind
Ura mo yama	—the hills behind.

Reference: Harold Henderson. *The Bamboo Broom: an introduction to Japanese haiku*. London, n.d.

127. "Mountains in Spring; Vestiges of Snow"

Late Edo period (ca. 1813)
Uragami Gyokudō (1745–1820)
Kakemono; sumi *ink, with light red color on paper*
H. 50 3/4 × 20 3/8 in. (128.9 × 51.8 cm.)

This roughly painted, brooding landscape by Gyokudō gives clear evidence of the breaking down of ancient conventions of picture making and their replacement by highly personal ones. The crest of the center mountain and the foliage of the trees, for example, are formed by large areas of watery ink that spread and blotted in a barely controlled manner. The outlines of the mountainside temple and the village houses are tremulous and in places undecipherable.

There are nearly a dozen works in Gyokudō's published oeuvre that were painted in this loose manner during his sixties. Historical precedents for the style may lie in the so-called *haboku* (broken-ink) landscapes of such Zen painters as Sesshū, Sesson, and Tōshun. From China analogies are found in the work of Tao-chi and Chu-ta, but Gyokudō's style in these paintings is unique for its balance of freedom and discipline and feeling of inspired artistic liberation. Underlying this freedom, however, is Gyokudō's profound intuitive mastery of pictorial organization, which sustains the intelligibility of the images and enhances their interest.

The seal used by Gyokudō here reads "Suikyō" (Drunken Minister), and on several works of this style he actually wrote that he had painted while drunk. Moreover, his colleague, the Bunjin master Tanomura Chikuden, recorded that trait in a eulogy of Gyokudō in his *Chatterings of a Man up in the Mountains (Sanchūjin Jōsetsu)* of 1835. He wrote that Gyokudō ". . . was one who adapted ancient paintings and calligraphy while exhilarated under the influence of wine. When he was drunk, his work attained a natural sublimity far different from normal human workmanship." Composing while tipsy was important in the art of the Chinese Wên-jên; in Japan, Gion Nankai and Yanagisawa Kien (see Nos. 112, 114) had already become noted for their tippling, but nowhere in Japan of the day did this become so apparent as in Gyokudō's work.

Of the many eccentric artists of the Edo period, Gyokudō was one of the most extreme. Critics who have attempted to explain Gyokudō's rebellious nature emphasize that something in his character caused him to become a social outcast. Although his biography is known only in its general outline, and many of its details are unclear, it is nevertheless certain that the bulk of his paintings were done after his fiftieth year (1794). At this time, he suddenly severed his connections with the feudal administration of the Ikeda family in the Okayama district in western Honshu. An extremely serious step, this resulted in his becoming a *rōnin,* a masterless, impoverished samurai who wandered throughout Japan. After quitting his fief, he became increasingly eccentric. There are descriptions of him dressed in a costume adorned with heron's feathers, swaggering, affecting the exaggerated manners of an old-fashioned person, and carrying his koto across his back. He finally settled in Kyoto in his last years, and he seems to have sustained himself not as an artist but as a physician and by occasional trading.

Records of the Ikeda family are critical of Gyokudō, saying that he neglected his obligations to public administration; instead he preferred painting, calligraphy, composing poetry, and playing his koto. The records state, moreover, that he was constantly in search of curiosities, and that his appearance revealed his (presumably bad) character. Apart from his distaste for bureaucracy, Gyokudō had apparently allied himself with an unfashionable school of Neo-Confucianism. It was that of the Ming period scholar Wang Yang-ming, who was something of a hero to the Bunjin scholars because he had stressed intuition and moral behavior rather than reason, ceremony, and purely governmental matters. One of Gyokudō's closest friends and patrons in Okayama, the physician Kōmoto Ichia, had operated a private school teaching the doctrines of Wang Yang-ming. An edict of the Edo government prohibiting unauthorized doctrines forced the closing of the school in 1795; Gyokudō's friend went into exile, where he ended his days.

The title of this painting was written by Gyokudō himself in the upper right side, using the formal square style (*kaisho*) derived from Chinese seal script.

Published: Miyake Kyunosuke. *Gyokudō,* vol. I. Tokyo, 1956. Pl. 21.

128. "Lofty Peaks of the K'ung T'ung Mountains"

Late Edo period (ca. 1815)
Uragami Gyokudō (1745–1820)
Kakemono; sumi *ink on paper*
H. 49 × 24 in. (124.5 × 61 cm.)

This bristling, linear composition painted with stiff brushes is characteristic of Gyokudō's style in the last decade of his life. So also is the seal, which reads "Hakushu Kinshi" (White-Bearded Koto Master). His published oeuvre contains a number of works in this style—lucid and buoyant in spirit, free of the moodiness seen in No. 127.

As a painter he seems to have been largely self-taught. The rare surviving works done before 1795 have no unified style but rather a strong awareness of Chinese models and occasional excursions into the use of bright colors on silk. After breaking with his fief, Gyokudō's style matured into a strongly consistent, personal one, with little use of color and great sophistication in choice of inks and brushes.

The emphatic use of brush lines establishes the main, recognizable elements of the composition. The broad gray accents at the hilltops are done in a scrubbed, dry-brush technique. In the foreground trees, some of the foliage is painted with sharp, diagonal lines which are parallel to each other and completely artificial in spirit; but they are done with a precision and decisiveness that pervades the entire work. If analogies between poetry and painting preoccupied Yosa Buson (see Nos. 119–120), then Gyokudō, who was a serious musician, used his brush in much the same spirit as he plucked the strings of his koto. Analogies to musical structure and especially to the rhythms of the koto come to mind as one's eye explores the carefully orchestrated patterns of the brushstrokes—the accented passages, the interrupted rhythms, the lengthy intervals between patterns, as in the right section of the middle ground.

He had learned to play with a medical officer of the Edo government; he later obtained a famous seven-stringed koto which was called the "Gyokudō Sei'in" (The Pure Tone of the Jeweled Hall); and from this he took the artist's name by which he is most commonly known.

The title in the upper right was written by Gyokudō in cursive Chinese characters. Typical of the indebtedness of the Japanese Bunjin to Chinese themes, it gives the name of a celebrated mountain range in Kansu and Honan provinces; but there is nothing of careful topography in this landscape. It is a schematized composition rooted in Gyokudō's imagination.

Formerly in the Yoshida collection, Shimane Prefecture.
Published: Catalogue of the Nihon no Bunjinga-ten, Tokyo National Museum, 1965. No. 225; *Masterpieces of Asian Art in American Collections*, II. The Asia Society, Inc., 1970.

129. Autumn landscape

Late Edo period (1820)
Uragami Shunkin (1779–1846)
Hanging scroll; ink and pale color on paper
H. 62 1/2 × 29 1/2 in. (158.8 × 77.5 cm.)

Uragami Shunkin was the eldest son of Gyokudō, probably the most eccentric and willful of all the Bunjin masters (Nos. 127, 128). The father's preoccupation with the long Japanese lute, the *kin* or *koto*, is reflected in the older son's honorific name of "Shunkin," which means "Spring Lute," and in that of a younger son, "Shūkin," ("Autumn Lute"). When Gyokudō went into voluntary exile from the Ikeda fief in 1794, the two boys accompanied him. Finally, Gyokudō and Shunkin settled in Kyoto, where the son developed into a distinguished painter in his own right. He joined the conservative Bunjin circle of Rai Sanyō, which numbered over forty men; his close friends were such restrained and disciplined artists as Chikutō, Bai'itsu, and Kaioku (see Nos. 131, 132). Shunkin thus developed a Bunjin painting style markedly different from that of his father and he also experimented with the naturalism of the Ōkyo school and of the Nagasaki bird-and-flower painters.

This large landscape, however, was painted in the eighth month in the year of his father's death, 1820, and has many traces of Gyokudō's style—the strong, rigid horizontal strokes in the trees and the same hesitant, sketchy lines defining the architecture. Despite these similarities, it lacks the brooding power and almost manic energy of the father's work. It is far more lyrical and gentle and, in its atmospheric effects, shows the influence of the careful study of Chinese originals conducted by the conservatives. Many of the trees are painted with a pale vermilion, which enhances the sense of autumnal coloring.

Reference: *Bijutsu Kenkyū*, no. 38. (February 1953); Yoshizawa Chū. *Nanga to Shasei-ga*. Genshoku Nihon no Bijutsu, vol. 18. Tokyo, 1969. P. 195.

130. Preparing tea above a mountain gorge

Late Edo period; summer, 1824
Aoki Mokubei (1767–1833)
Hanging scroll; sumi ink, with indigo and red ochre pigment on paper
H. 9 × 15 3/4 in. (22.9 × 40 cm.)

In this tiny composition, two figures drawn with fragile delicacy can be seen in the center foreground. A servant boy is fanning a small portable stove to boil a tea kettle. Facing him at the edge of the ravine is an old man, seated as though awaiting his tea. Towering behind the figures are a cliff and large boulders, painted with such dynamic outlines and such disregard for the laws of gravity that they seem to be falling. The kinetic atmosphere is further emphasized by the splashed and staccato rhythms of the ink and the sense of nervous energy that pervades the entire composition.

The inscription states that the painting was done during the summer of 1824 in the pavilion or studio called the "Kan'un-rō." The signature and seal are those of Aoki Mokubei, the celebrated ceramist of Kyoto who achieved distinction as a painter during the latter part of his life. During the year of 1824, Mokubei did a number of pictures including his most widely known work, a series of panoramic landscapes of Uji and the Byōdō-in, of which a dated version is in the Tokyo National Museum.

A strong-willed, highly individualistic man, Mokubei was a close friend of several equally remarkable members of the Bunjin school, Gyokudō (see Nos. 127, 128) and Chikuden, for example, whose painting styles influenced him. The poet-painter Rai San'yō even inscribed a number of Mokubei's pictures. However, he was primarily a potter, and by bringing the principles of the literati movement into this art, he helped revive the aesthetic creativity of the Kyoto kilns in the decades following the death of Kenzan (see No. 110). Mokubei had carefully emulated the style of Chinese blue-and-white ware; he also made celadons and enameled polychrome vessels. He sometimes used ceramic surfaces for lengthy inscriptions of Chinese poems, and some of his decorations in the blue-and-white style closely resembled his landscape paintings.

Most of his pottery was made for the special form of tea drinking developed by the Bunjin. It centered on the use of leaf tea (*sencha*) instead of the powdered green tea (*matcha*) favored by the Zen tea ceremony, and it was far less formal. Mokubei often depicted the preparation of *sencha* in his paintings, as he did in this work, showing the tall round ceramic stove and the ceramic kettle with a hollow handle. In other paintings, one can see other distinctive *sencha* implements, such as the tall water pitcher, the round teapot, a table to hold the tea canister, the tiny teacups, and the pail for surplus water—all of which he had himself made.

This painting differs in some respects from the six or seven other ones he did during the year of 1824. It is more nearly square in format; the seal used here, reading "Mokubei," appears on none of the others; and the colophon was written in a distinctly more erratic manner. It is difficult to explain these discrepancies, but they do not seem to affect the authenticity of the painting.

Published: Yoshizawa Chū in *Kokka*, no. 883 (October 1965); *Sekai Bijutsu Zenshū*, vol. 10. Tokyo, 1963. Fig. 26; Yoshizawa Chū et al. *Nanga to Shasei-ga*. Genshoku Nihon no Bijutsu, vol. 18. Tokyo, 1969. Fig. 50.

131. "Lake and mountains at daybreak, summer"

Late Edo period (ca. 1835–1845)
Nakabayashi Chikutō (1776–1853)
Kakemono; ink on silk
H. 49 1/4 × 17 1/2 in. (125.1 × 44.4 cm.)

Delicate, pointillist-like handling of brush and pure ink characterize this landscape by the conservative Nakabayashi Chikutō. Chikutō was part of a widespread current within the Bunjin movement which advocated a return to orthodoxy and tranquillity in the generation that followed the almost explosive innovations of men like Gyokudō and Mokubei.

Chikutō was born in the city of Nagoya, one of the main seats of the Tokugawa regime. Like so many Bunjin, he was subject to the intellectual challenge of the medical profession, perhaps the most vital scientific discipline in Edo Japan. His father was a medical doctor, an obstetrician. As a young man, however, Chikutō became interested in the arts and, at the age of fifteen, came under the patronage of a wealthy Nagoya citizen named Kamiya Ten'yū. Ten'yū had a large collection of Chinese paintings that Chikutō carefully studied, and his home was a center for local artists. One day, in an episode famous in the history of Japanese *Bunjin-ga*, the older man took Chikutō and another ardent young painting student to a local temple, where they saw two Yüan period Chinese ink paintings, one of bamboo and the other of a plum. Ten'yū then gave the youths their honorific names, "Chikutō" (or "Bamboo Cavern") with reference to the bamboo, and "Bai'itsu" ("Plum Leisure"), to the plum. Bai'itsu, of course, became as distinguished a painter as Chikutō; the two remained close associates for most of their lives and strongly influenced each other's development.

At the age of twenty, Chikutō established his own studio in Nagoya with Ten'yū's assistance. Poor and struggling to find other support, he refrained from marriage and lived frugally in a small Nagoya temple. He formed a society of local painters and calligraphers, and he began publishing Chinese-style theoretical treatises on painting, a custom that he continued throughout his life. In 1803, he and Bai'itsu went to Kyoto to live, attracted by the Confucian scholar and painter Rai San'yō, who had formed a large, active circle of Bunjin that included Nukina Kaioku and Uragami Shunkin (see Nos. 132, 129). There Chikutō remained to become a most prolific theorist and painter of landscapes and bird-and-flower compositions. His pictures were often inscribed with statements that he had been inspired by such Chinese masters as Kao K'o-kung or Tung Yüan. Emotionally, his landscapes took on a quiet tranquillity not unlike that of the French Barbizon painters or the landscapist Corot, who was his younger contemporary.

Reference: Umezawa Seiichi. *Nihon Nanga-shi*. Tokyo, 1919. Pp. 695–711.

藥熟香清宜客家到門可喜

雪啼花落無人和自偶然

海屋生書

132. Calligraphy: two ten-character Chinese poems

Late Edo period; autumn, 1841
Nukina Kaioku (1778–1863)
Two hanging scrolls; ink on paper
Each scroll: H. 47 5/8 × 5 1/2 in. (121 × 14 cm.)

Although an accomplished landscape painter, Kaioku is best remembered as the outstanding calligrapher among the conservative Bunjin in Kyoto in the first half of the nineteenth century. In the nation at large, his reputation was equaled only by that of Ichikawa Beian, leader of the Literary Men in Edo.

Kaioku was born to a samurai family in Awa, Shikoku, his father having served as archery expert to the feudal lord of that region. Kaioku himself was trained as an archer but failed to distinguish himself in martial skills. Instead, he turned to the arts and letters and was tutored by local specialists in calligraphy and painting (especially the Kanō style). He also went to Mount Kōya, where he studied calligraphy and Buddhist matters under his uncle, who was a monk; there Kaioku became especially engrossed in the writing style of Kūkai (Kōbō Daishi) (see No. 98).

Following his stay at Mount Kōya, he traveled extensively in search of ancient calligraphy to study; and a love of travel, so characteristic of Edo period culture, was a major feature of his middle years. He went three times to Nagasaki in Kyushu, where he studied the calligraphic principles of the so-called Southern School of *Bunjin-ga*, working chiefly with the monk Tetsuō (see No. 133). He also spent three years in the Takayama district of the Hida region, near Gifu, primarily because of its scenic beauty. Attracted by the culture of the Bunjin, he went to Edo, where he enthusiastically took up the study of Confucianism in various forms. He opened his own Confucian academy in Osaka and finally went to Kyoto, where he opened another school, the Shuseidō in what is now the Okazaki district. His life in Kyoto became one of increasing devotion to study and retirement. At his death at the age of eighty-six, just before the Meiji Restoration and the Westernization of Japan, he was the most revered embodiment of the ancient ideal of the Confucian scholar in Japan.

As a calligrapher, he was an expert in the history of Chinese writing styles, and he assiduously collected and copied rubbings taken from famous engraved calligraphy on the mainland. He also studied traditional Japanese calligraphy in the Chinese manner, and at times he tried to combine the two traditions. This pair of scrolls, however, was done primarily in the Chinese manner, based on prototypes of the Sung and Ming periods, and written in the so-called running-standard script (*hsing-k'ai-shu*). Written when he was sixty-four years old, they are extremely fine specimens of his work; the ten-character poems, moreover, seem to be his own. True to the Bunjin spirit, they invoke the apparently contradictory joys of fellowship and solitude.

Right scroll:

> The pure fragrance of ripening tea;
> A guest reaching the gate.
> What pleasure!

Left scroll:

> Vast and calm in its own right
> Is the place where a bird sings,
> A flower falls, no man intrudes.

The right scroll bears Kaioku's seal, reading "Bokurin," and the cyclical date. The left scroll has his signature and two other seals.

Reference: *Shōdō Zenshū*, vol. 23. Tokyo, 1958. Pp. 17–19, 195–196, pls. 78–89; *Bokubi*, no. 115 (1962); ibid., no. 173 (1967).

133. "Mountains rising through spring clouds"

Late Edo period (1847)
Hidaka Tetsuō (1791–1871)
Hanging scroll; ink on silk
H. 12 5/8 × 14 5/8 (32 × 37.2 cm.)

Done on pale gray silk and dated in 1847, this loosely brushed landscape reveals a close study of original Chinese paintings. The effects of mist and atmosphere and the orthodox restraint of its brush-work show, for a Japanese Bunjin, an unusual degree of awareness of Chinese originals. The artist, Hidaka Tetsuō, was a Zen Buddhist whose monastic name was Somon. A native of Nagasaki, he trained as a painter first with a local Bunjin named Ishizaki Yūshi. He next studied with an immigrant Chinese, Chiang Chia-pu, who arrived from the mainland in 1805 and seems to have been a member of the orthodox Wên-jên school of Wang Hui. Chiang is an obscure figure in Chinese art history, but in Japan he exerted great influence. This work of Tetsuō shows close similarities in brush handling to the few paintings of Chiang that have been published. However, even greater correspondences to Chiang's style can be found in the work of such conservative Kyoto Literary Men as Chikutō and Kaioku (see Nos. 131, 132); the latter actually came to Nagasaki and studied with Tetsuō.

As the sole entrepôt of foreign persons and ideas in the Edo period, Nagasaki contained many Chinese as well as Dutch nationals. Among the Chinese, two different schools of painting were practiced: a courtly bird-and-flower school in the manner of Ch'en Nan-p'in; and the Wên-jên tradition represented by Chiang Chia-pu, Tetsuō, and Tetsuō's close friend Itsu'un. Tetsuō actually practiced both styles, as did some of the conservative Bunjin of Kyoto, but he attained greatest distinction as a landscapist.

A monk of the Rinzai Zen sect, Tetsuō became abbot of the monastery of Shuntoku-ji in Nagasaki. His reputation, however, was that of an "eccentric monk"; no trace of *Zenga* influence is to be seen in his published work, even though he must have been aware of Sengai, who had been active in Kyushu a generation earlier (see Nos. 103, 104).

Reference: *Kokka*, no. 497 (April 1932); ibid., no. 607 (June 1941); ibid., no. 711 (June 1951).

Genre Themes in Painting and the Decorative Arts

In Japan as in the Catholic countries of the West, the emergence of genre art—subjects taken from daily life with no firm religious significance—accompanied the gradual waning of the spiritual and intellectual authority of the established church. The implications of this were enormous in both Japan and the West and are felt to this day. Christ and the Saints, the Buddhas and Bodhisattvas—ancient, traditional sources of spiritual grace and solace—were no longer the central theme of public arts. Instead, artists and patrons sought fulfillment in depictions of mundane matters, of their professions and entertainments and fashions, of battles and historic encounters. Whatever may have been their interest in the fate of their souls, they no longer insisted that salvation be the prime concern of the arts.

The Japanese term for genre painting is *fūzoku-ga* (pictures of manners and customs). In Japan, as in the West, such elements had appeared in medieval religious art; scenes of city and country life may be found in such narrative scrolls of Buddhist history as the *Shigisan Engi* of the 1160s and the *Ippen Shōnin E-den* of 1299 and in the decorated fans inscribed with the *Lotus Sūtra* donated to Shitennō-ji. The genre elements were done with such fluency and ease that one is aware of a strong, latent gift for such painting in the very heart of the *Yamato-e* tradition. This gift did not, however, attain much prominence during the centuries in which the taste of the aristocracy was dominated by the arts associated with the Zen sect. *Fūzoku-ga* did not fully emerge until the sixteenth century, not until enthusiasm for ink painting had started to wane. One of the major landmarks of this emergence is the famous six-panel folding screen by Kanō Hideyori, the son of Motonobu, showing citizens of Kyoto having picnics and enjoying the beauty of the mountains of Takao to the west of the capital. Datable from around 1535, this screen has strong color effects; it celebrates the joys of daily life; it offers none of the metaphysical overtones of landscape painting in the Zen tradition.

The rise of genre and decorative styles in the arts accompanied the breakdown of the political and cultural authority of the Ashikaga shogunate. The long decades of misrule and civil war—with the frequent conflagrations in the capital city, with famine and banditry in the countryside—ceased with the appearance, at the pinnacle of power, of three successive military leaders who finally enforced unity and peace in the nation. The first was Oda Nobunaga, who entered Kyoto with his army in 1563 and

formally ended the fiction of rule by the Ashikaga family. After Nobunaga's assassination in 1582, power was seized by Toyotomi Hideyoshi, a man of boundless energy and ambition whose building projects in the Kansai region engaged a legion of artists and craftsmen. After Hideyoshi's death in 1598, supreme secular power in Japan was administered by the more cautious Tokugawa Ieyasu, who had served his two predecessors. He established so rigorous and effective a system of feudal administration that the Tokugawa family maintained its power for two and one-half centuries.

The gradual establishment of peace and unity in the nation released such a surge of creativity in the arts that the period of the late sixteenth and early seventeenth centuries is one of the most dramatic and complex in the history of Japan. Among the chief outlets for this new spirit were large decorative screens, often employing broad areas of gold and silver leaf, suitable for the lavish palace and estate buildings commissioned by the samurai. The taste of these military families is strongly imprinted in the artistic themes that were illustrated on the screens:

Scenes of great battles, such as Sekigahara or the siege of Osaka Castle

Martial sports, such as horse racing, archery contests, and hunting

Great public events, like Hideyoshi's lavish parties or the enormous festival at the Hōkoku Shrine marking the seventh anniversary of his death

Panoramic views of the capital city and its environs, the so-called *rakuchū-rakugai* screens

Subjects of widespread curiosity, like the Namban—the Portuguese and Spanish traders and missionaries who made a tremendous impact on the Japanese in the latter decades of the sixteenth century

Scenes of Chinese Confucian history and morality, newly emphasized by the Tokugawa government to promote doctrines of loyalty and civic responsibility

Fairs and popular theatricals, like those held at the east edge of Kyoto, at Shijō and Kawaramachi

Paintings of dancers, handsome courtesans, and even bathhouse girls who catered to the leisure-time pleasures of the samurai

The demand for screens of this type was met by the major ateliers. The Kanō and Tosa families had the highest standing, followed by the Hasegawa, Kaihō and Sumiyoshi schools—all competing for the favor of the most important patrons. In addition, a number of less ambitious city art shops (*machi e-shi*) served portions of the same public, and most of these genre screens were produced by an almost industrial process. The basic composition would be sketched in by the head of the atelier or his assistant; then specialists in *sumi* painting, costumes, heads, tinting, gilding, and landscape would make their individual contributions. The head of the atelier, having overseen the whole operation, might then put in final corrections and details. Some of the most popular themes, such as horses in a stable and the *rakuchū-rakugai* scenes, were stereotyped and repeated many times, virtually without change. In social and economic terms, competition among both artists and patrons was intense. The imperial and shogunal families and their closest associates were able to command the services of the finest artists; the lesser nobility and provincial daimyo (feudal lords) had to be satisfied with less lavish and well-executed

work by the main ateliers, or by the products of second-ranking schools. Finally, the daimyo of the lowest ranks and the newly enriched merchant class were served by the small workshops of the professional *machi e-shi*, whose work often had a folk art flavor. This situation was further complicated by the development of the arts of Kamigata, of the old-fashioned, educated people of Kyoto who resisted the more flamboyant taste of the samurai. Clinging to traditional ideals of beauty, they patronized men like Kōetsu and Sōtatsu. Their taste was strongly affected by Zen standards of simplicity, humility, and restraint; yet they were unable to resist completely the growing vogue for decorative screens employing lustrous surfaces of gold.

By the end of the seventeenth century, the more elegant and sophisticated side of *fūzoku-ga* had begun to atrophy. The Kanō and Tosa schools continued their work in this vein but without major innovations. In a land where novelty had become a virtue, this was a severe shortcoming for which both schools were criticized. At the same time, the Literary Man's style of painting (*Bunjin-ga*) had arisen. Appealing to samurai who respected Confucianism and Chinese learning, *Bunjin-ga* became a major new factor in the culture of educated Japanese, and it began to attract talented and serious young artists. But as the aristocratic side of genre arts weakened, the more popular, plebeian side began to flourish. The spirit of *fūzoku-ga* appealed strongly to the uprooted and resettled masses in Japan's new cities. In particular, the seat of the *bakufu* at Edo, the Eastern Capital (Tokyo), was becoming one of the most rapidly expanding, dynamic cities in the world, with a population in 1700 of around half a million; and, as in London and Paris of the day, a new type of urban culture was rapidly developing. Many samurai were forced to live in the capital because of the strict residence requirements of the *bakufu*; wealthy but underemployed, they found diversion in the pleasure district of Yoshiwara, filled with restaurants, theatres, and lavish brothels.

By 1700, this vital new movement in the arts had clearly taken form in Edo and Osaka. It flourished to a much smaller degree in Kyoto, which retained more of the traditional social fabric and values. The movement was given the name *ukiyo* (literally "floating world"), a term that is frequently found in ancient Mahāyāna Buddhist texts to denote the brevity and instability of human life and its sensual pleasures. Much of Heian literature, under the influence of Buddhist thought, had centered on the melancholy concept that the charms of this world—the beauty of fresh-fallen snow, of a nightingale's call at night, of a blossoming plum, of the love for a fine woman—are inescapably, poignantly fleeting. Something of this atmosphere is found in the arts of the *ukiyo* movement. But, for the most part, *ukiyo* painting and literature are ebullient in spirit, embracing the delights and fashions and follies of this world with wholehearted enthusiasm. Through the novels of Ihara Saikaku and Ejima Kiseki, masters of *ukiyo* prose, pass a boistrous procession of courtesans, amorous samurai, merchants and peddlers, actors, and anxious mothers. In the works of the earliest *ukiyo* artists—Hishikawa Moronobu, who was a colleague of Saikaku; Kaigetsudō Ando, and the men of the Torii school—one finds scenes of daily life in Edo, illustrations of popular novels and erotic manuals, monumental depictions of fashionable courtesans, and portraits of kabuki actors in their most dramatic roles. In the early works,

one also finds what was to become a dominant tendency in the *ukiyo-e* school—the need to produce inexpensive wood-block prints to satisfy the mass urban audience. The designing and producing of the prints demanded a whole new range of skills, particularly in the development of the *nishiki-e* (the intricately colored multiblock print) in the late 1760s; but nearly all *ukiyo-e* artists continued to make paintings, which remained an important part of the tradition.

The *ukiyo-e* thus began as an offshoot of the well-developed tradition of genre painting, informed by centuries of the Japanese experience in the decorative and narrative arts. But because it served a new clientele and developed the new technology of block printing, it began as a new departure and went through distinct evolutionary stages—primitive, developed, mature, and degenerate—over a period of two hundred years. During these two centuries, thousands of men considered themselves *ukiyo-e* artists; among them are some of the most original and creative talents in the history of Japanese art—Sharaku, Utamaro, and Hokusai. Despite this, the idiom was never considered a fine art by the Japanese upper classes; it did, however, exert considerable influence on other artists. Works in the *ukiyo-e* manner were done, for example, by Ogata Kōrin, Maruyama Ōkyo, and Yokoi Kinkoku. *Ukiyo-e* masters were greatly susceptible to Western influence on the depiction of perspective and on the idea of empirical drawing, and the school was helpful in bringing about the acceptance of these attitudes in Japan.

After the full maturation of the school in the 1780s and 1790s, it went into a very rapid decline, which is one of the most puzzling and challenging problems in the history of Japanese art. Men of the highest achievement, such as Utamaro and the first Toyokuni, seem to have faltered in the later stages of their careers; the careful composition and subtle color harmonies of their earlier works seem, beginning around 1800, to have given way to carelessness and disharmony. The causes of this general decline in aesthetic level may lie in social and political spheres, in the decreasing effectiveness of the Tokugawa government and the signs of political and economic disruption. However, under analogous conditions in the last half of the fifteenth century, Japanese ink painting attained some of its greatest heights. Perhaps the causes lay in a general exhaustion of the idiom of actor and courtesan prints themselves. Only the development of the landscape prints of Hokusai and Hiroshige and the limitless personal creativity of Hokusai and Kuniyoshi redeem *ukiyo* arts of the nineteenth century from their rapid decline in quality and interest.

134. Hideyoshi visiting the blossoming cherries at Yoshino

Momoyama period (ca. 1594)
Six-panel folding screen; color and gold leaf on paper
H. 42 1/4 × 103 7/8 in. (107.4 × 263.8 cm.)

This screen records the visit of Toyotomi Hideyoshi, the supreme military ruler of Japan, to the famous blossoming cherry trees of Yoshino (see No. 126). According to historical records, which describe the event in great detail, he reached the mountain sanctuary on the twenty-seventh day of the second month, 1594. That this screen must have been painted within a few years of the visit is supported by its stylistic characteristics. Also, it is quite unlikely that a major work of art extolling the person of Hideyoshi would have been made after his successor, Tokugawa Ieyasu, had consolidated his power as shogun. The latter ruthlessly suppressed Hideyoshi's family along with any public signs of support or affection for them.

Hideyoshi appears here in the lower foreground beneath a red umbrella, wearing an unusual cap and a splendidly colorful coat over his armor. The artist attempted a small-scale portrait, capturing the narrow jaw that gave Hideyoshi's face its characteristic, almost simian, look. With a groom on either side of his horse, the Taikō (the title by which he is usually called, signifying the father of an imperial adviser) sits in a passive position; he seems strangely small and reduced in scale considering his political importance. However, his appearance here is far more robust than the feeble old man shown in the screen depicting his famous party held beneath the blossoming cherries of Daigo-ji, just before his death in 1598. In the screen shown here, moreover, many of the horsemen in his entourage were also given a portrait-like appearance. Included among them were such prominent warriors and officials as the Taikō's adopted son Hidetsugu; Imadegawa Harusue, Hidetsugu's father-in law; Maeda Toshiie, one of Hideyoshi's most trusted advisers; and, still subordinate to the Taikō, Tokugawa Ieyasu himself. It is possible thus that this screen was ordered as a memorial of the visit by one of the persons who took part in it.

Hideyoshi, born in relatively humble circumstances, had risen through his courage and wiles to become one of the most ambitious figures in Japanese history and, indeed, in all of Asia. After having unified the nation following a century and a half of civil turmoil, he challenged the might of Ming China in 1592 by launching an invasion of Korea with nearly a half-million men, the first of two such expeditions.

detail

When the pressure of state affairs became great and during intervals in the conduct of the war, Hideyoshi liked to divert himself with elaborate entertainments. Three of these were unforgettably sumptuous: the great tea ceremony at the Kitano Shrine, Kyoto, in 1587; the visit to Yoshino in 1594; and the flower-viewing banquet at Daigo-ji in 1598. A large and detailed pair of screens showing the Yoshino trip was discovered in 1962 and is now in the Hosomi collection, Osaka. Thought to have been painted by Kanō Mitsunobu, son of Eitoku, it shows the Taikō being carried in a palanquin approaching the temple Kimbusen-ji atop Mount Yoshino. The Powers screen was first published in 1967 as a new discovery.

Without question this screen is a major document of the development of Momoyama genre painting and of the Yoshino visit itself. Ingeniously conceived, the composition is centered on Hideyoshi in the foreground; the line of travelers moves from the lower right, then out of the picture at the lower left, and then returns to move into the distant middle ground. The head of the procession has crossed the Muda River and approaches the Yoshimizu-in, where Hideyoshi was to spend the evening. Beyond, at the upper left, are the great metal *torii* (gate) of Kimbusen-ji and the buildings, which are more prominently featured in the Hosomi screens. Bands of clouds wind through the composition, setting off individual cells of landscape space. In style, the painting is not completely unified. On the one hand, it does not seem to be the product of one of the professional city ateliers (of the *machi e-shi*) that were laying the groundwork for the development of the *ukiyo-e* style; on the other, it is not entirely in the manner of the Kanō school, whose leader Eitoku and other members were especially close to Hideyoshi. Despite the strong decorative qualities in the gold leaf and the rich colors, the painter was surely a master of *suiboku-ga*, as indicated by the skillfully executed pine trees, a plowman and his bull, and a pair of travelers, all in the upper right corner. Mastery of the Chinese idiom of landscape painting is also shown in the trees and creased rocks, but the artist (or artists) was skilled in genre painting in the *Yamato-e* manner as well. Groups of local people are drinking, dancing, and holding picnics beneath the trees; they are distracted by the passing procession; a warrior near Hideyoshi bends to tie his sandal and steals a glance at the girls seated by the road. Riding with the entourage are dancing girls and men in exotic, Western-style hats. Servants lead imported dogs. Scattered throughout the composition are the white cherries of Yoshino in full bloom.

Almost every screen painting of this era has suffered from excessive handling, fading, cleaning, and retouching, and this work is no exception. The paper has darkened; and in some parts, the pigment has faded away. However, the conception of the work is unchanged, and many of the figures are as originally painted. Despite the darkening, we need not fear that the condition of the work distorts the artist's original intentions. (T.I.)

Published: Narazaki Muneshige in *Ukiyo-e Geijutsu*, no. 17 (1967), pp. 32ff; Washizuka Yasumitsu in *Kobijutsu*, no. 20 (December 1967).
Reference: Narazaki Muneshige. *Shoki Ukiyo-e*, vol. I. Tokyo, 1962. Pl. 12; the same in *Kokka*, no. 795 (June 1958); *Kokka*, no. 731 (February 1953).

135. Equestrian archery drill

Early Edo period (early seventeenth century)
Two six-panel folding screens; color and gold leaf on paper
H. 67 1/2 × 140 in. (170.4 × 356 cm.)

Warriors in medieval Japan favored sports that sharpened their martial skills—sword drills, horse races, archery contests. From as early as the thirteenth century, they practiced the singular custom of shooting dogs from horseback, using arrows whose tips were padded. Descriptions of this *inu-ou-mono* (dog chasing) custom appear from time to time in documents of the Muromachi period. It was occasionally banned because of its cruelty, but in the early seventeenth century, there is a detailed record of the revival of the event by the powerful lords of Satsuma, the Shimazu family.

The old written accounts of the custom correspond closely to the scene presented in this pair of screens. A fenced enclosure of around five hundred and forty feet square was reserved for the event, which was attended by large crowds of warriors and their families. At the south end, a dog would be placed in the center of a small circle; the hunters on horseback were arrayed around a larger circle made of a heavy rope about one hundred and twenty-five feet long. At a signal, the dog was released. When he crossed the outer circle, he was chased to the north end of the enclosure by the horsemen, each of whom had three padded arrows. Judges would grade each archer on his skills and accuracy; a hit on the dog's head or legs, for example, would be discounted. The horsemen were organized into teams; in this scene the teams consist of seventeen men each. As many as one hundred fifty dogs would be used in one day, with fourteen or fifteen being released in a single *inu-ou-mono* contest.

As with the stable theme (No. 136), large numbers of screens of the dog shooting drill have been preserved, and in no case do they seem to depict a particular, given event. The subject is shown in a remarkably uniform, stereotyped manner. These screens, for example, are virtually identical with a pair in the collection of the Tokiwayama Bunko in Kamakura that are generally considered the oldest

extant versions of the theme. The position and gestures of the figures are identical; there are differences only in the handling of tree leaves and the coloring of the individual garments. The entire surface of the Tokiwayama screens is covered with gold leaf; here, only the cloud bands at the top and bottom are so covered. Otherwise, the works are identical. Yamane Yūzō has suggested, with very good reason, that the Tokiwayama Bunko painting was done by Kanō Sanraku during the first quarter of the seventeenth century and that the Powers painting was done by a follower of Sanraku during the second quarter of that century. The handling of the figures in the former work is strikingly close to the figures in Sanraku's most celebrated painting in the *Yamato-e* manner, the large screen illustrating the battle of the carts from *The Tale of Genji*. The figures in the screens shown here have a more humorous, satirical flavor and in some ways are more animated.

In the right screen, the last panel on the left was damaged and, from the bottom of the fence downward, is a modern restoration.

Published: Yamane Yūzō. *Momoyama no Fūzoku-ga*. Nihon no Bijutsu, vol. 17. Tokyo, 1967. Pp. 147–50. Reference: Sugahara Hisao. *Hibai Yokō* (selected catalogue of the Tokiwayama Bunko). Kamakura, 1967. No. 40; Narazaki Muneshige. *Nikuhitsu Ukiyo-e*, vol. I. Tokyo, 1962. No. 27; Takeuchi Naoji, *Museum*, no. 73 (April 1957), pp. 8–13; *Kokka*, no. 693.

136. Stable with fine horses

Early Edo period (early seventeenth century)
Six-panel folding screen; color and gold leaf on paper
H. 66 7/8 × 144 1/8 in. (170 × 366 cm.)

Beneath a floral canopy of willow and flowering cherry, six elegant prize horses are tethered in a spotless stable. Originally this was the left half of a pair of six-panel screens; in the right half, the floor boards were angled to the right in the reverse of normal perspective effects. The motif of fine horses in a stable had come into vogue among the samurai during the sixteenth century and flourished steadily until the early decades of the eighteenth. Over twenty screens of this era still remain; the type shown here is the most familiar one—the horses are placed one to a panel in an unbroken frieze, without grooms or other human figures. In a less common type, the entire stable is shown in a landscape, with grooms and warriors in attendance in the foreground.

Screens of both types must have been produced in professional ateliers of high standing. Some are attributed to Kanō painters, others to the Tosa or Sumiyoshi schools. For the most part they are well executed, with a strong sense of vitality in design. Originally, the horses may have been depicted with a sense of individuality, for the historical origins of the type lie in the careful, realistic depictions of prize bullocks and horses in narrative scrolls of the thirteenth century. However, by the late sixteenth century, the horses were never really individualized. Their poses are dramatic: some bite their tethers, others kick their hind legs, others strain their necks. Their colors differ: some are sorrel, some palomino, others spotted gray or black and white. But the artists made no effort to depict any one particular steed. This is an astonishing commentary on the relationship of the Japanese decorative style to natural forms, for surely the warriors of this period owned horses of which they were unusually proud. Nevertheless, like many other decorative motifs—the arrival of the Western "barbarians," the dog hunting screens, or scenes of the professions and the different parts of the city of Kyoto—the artists depicted the idea of an event, the archetype of the motif, rather than the particular event in itself. Hence, in the United States alone, there are at least three sets of screens with horses identical in pose and even coloring to this screen. One is in the Boston Museum, with the seal of Kanō Tomonobu (active *ca.* 1565); another is in an anonymous private collection, but was shown recently in Dallas; the third is in the Price collection, Bartlesville, Oklahoma.

Despite their basic uniformity, however, this type of screen varies according to the floral elements added above the stable. In this case, the cherry blossoms and willow branches are lavishly embellished with cloud patterns in gold and with squares of silver leaf. The blossoms, moreover, are modeled in raised plaster of paris (*moriage*). The exuberant floral patterns are quite close to those in a series of screens produced by the Kyoto Kanō painters, by Sanraku, for example, and Yamaguchi Sekkei. Characteristic examples are in the Daigo-ji and Nezu collections. In those, cherry and plum blossoms fill the picture plane with a blizzard-like swirl of color and texture.

This screen has come with an attribution to Kanō Sanraku. Although neither seals nor inscriptions support this, it is indeed likely that the screen came from a Kanō workshop in Kyoto; and it is one of the most decoratively appealing examples of its kind.

Reference: Yamane Yūzō, *Momoyama no Fūzoku-ga.* Nihon no Bijutsu, vol. 17. Tokyo, 1967. Pp. 143–146; Tsuji Nobuo in Shimada Shūjirō, ed., *Zaigai Hihō,* vol. 2. Tokyo, 1969. No. 13; Shimizu Yoshiaki, *Japanese Paintings from the Collection of Joe D. Price.* Lawrence, Kansas, 1967. No. 3; Dallas Museum of Fine Arts catalogue, *Masterpieces of Japanese Art.* Dallas, 1969. Pl. 34; R. T. Paine, Jr., *Japanese Screen Paintings: Birds, Flowers, and Animals.* Boston, 1935. No. 5.

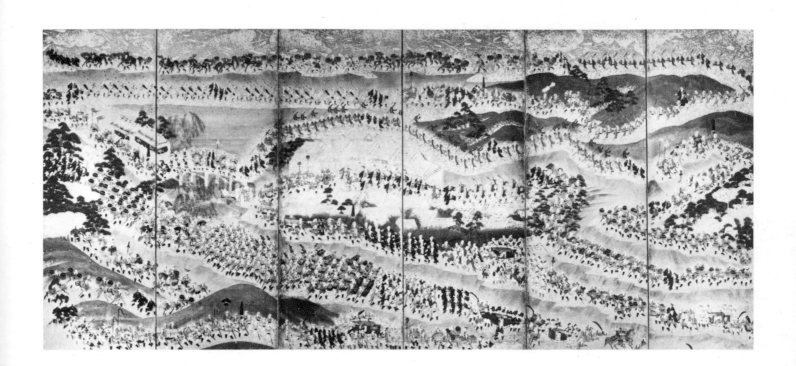

137. The procession of a daimyo

Edo period (mid-seventeenth century)
Six-panel folding screen; color and gold leaf on paper
H. 60 5/8 × 135 in. (153.9 × 344.8 cm.)

This large screen, painted around 1650, is crowded with over a thousand figures sweeping through the composition in a single procession. In its sense of military organization and the vast scale of its conception, it reflects one of the most striking social and political phenomena of the Edo period, the travel of court officials and feudal lords with their vast retinues. Here, the chief figure is in the palanquin shown near the center of the third panel from the right, leaning on his elbow and gazing out the window. It has not been possible to learn his identity, but he must have been the powerful, wealthy lord of a large feudal domain, coming to or from the capital city of Edo. Such processions were often noted by early Western visitors to Japan. The German physician Engelbert Kaempfer, who served the Dutch trade and diplomatic mission in Japan from 1690 to 1692, was so deeply impressed that he devoted many pages of description to them in his *Historia Imperii Japonici*, which was translated into English and published in London in 1727. He stated that it was "scarce credible, what numbers of people daily travel on the roads of this country." He noted that princes and lords were attended by their entire courts and were obliged to journey with the pomp and magnificence befitting their own standing and wealth; the train of a most eminent man filled up a road for days. Kaempfer was also impressed by the order and discipline of the processions:

> It is a sight exceedingly curious and worthy of admiration, to see all the persons, who compose the numerous train of a great prince . . . marching in an elegant order, with a decent becoming gravity, and keeping so profound a silence, that not the least noise is to be heard, save what must necessarily arise from the motion and rustling of their habits, and the trampling of the horses and men. What appears still more odd and whimsical, is to see the Pages, Pikebearers, Umbrella and hat bearers . . . chestbearers, and all the footmen in liveries, affect a strange mimic march or dance, when they pass through some remarkable

Town, or Borough, or by the train of another Prince or Lord. Every step they make, they draw up one foot quite to their back, and in the mean time stretching out the arm on the opposite side as far as they can, and putting themselves in such a posture, as if they had a mind to swim through the air. Meanwhile . . . whatever . . . they carry, are danced and tossed about in a very singular manner, answering the motion of their bodies.

(This last observation of Kaempfer seems to be reflected by the peculiar gestures of the men on the bridge and those passing through the village in the center of the composition.)

detail

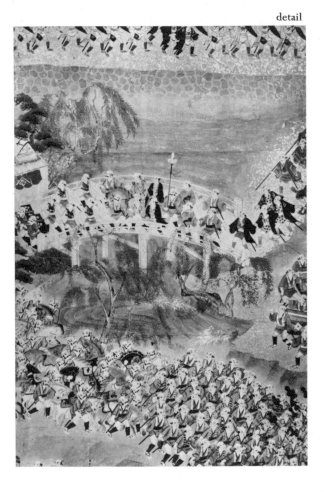

One of the chief reasons for such lavish processions was the wish of the Tokugawa military government that all major feudal lords come to the capital city to pay homage. The custom began in 1603, on the accession of Ieyasu as shogun, when a number of the daimyo came spontaneously to Edo to pledge their allegiance. In 1615, just before Ieyasu's death, the custom was made more formal. It became strictly mandatory in 1635 under the second shogun, Hidetada, who promulgated the *Buke sho-hatto*, the rules of behavior for the military clans. Under the new regulations, each daimyo was obliged to maintain a household in Edo where members of his family were to live, virtually as hostages, as assurance of loyalty to the shogun. The daimyo themselves, according to their rank and the distance of their fief from the capital, were obliged to spend up to four months of each year or every other year in the capital. This system, called the *Sankin Kōtai* (literally, "coming for audience in alternate [residence]"), had a profound impact on Japanese life. It kept the regional lords under the close scrutiny of the shogun, and it strengthened the control of the central government over the outlying districts. The maintenance of lavish estates (*yashiki*) in Edo contributed to the rapid economic growth of the city; the constant traffic of the daimyo processions to and from the capital promoted the development of inns, ferries, and other aids to transportation. This was especially true along the Tōkaidō, the main highroad leading from Edo to Nagoya, Kyoto, Osaka, and points west.

This screen must have been ordered as a memorial to such a journey. It must also have come from a professional city art shop rather than from the more prominent or pretentious ateliers of the Kanō, Tosa, or Hasegawa schools, which also did screen paintings for the samurai. The execution of this work is somewhat routine, the figures done in a rather mechanical, repetitive manner with something of the spirit of folk art about them. But the aesthetic impact of this screen grows from its sense of tumultuous energy in the large troop of travelers and from the boldness of the composition whereby the long procession winds

in and out of the picture. The head of the procession is at the upper left, in the distance; the rear of the procession is in the center foreground. The makeup of the procession fits, with astonishing closeness, the description written by Engelbert Kaempfer, who numbered the different elements as given below and called the principal figure a prince. Only the order of the elements differs occasionally between Kaempfer's description and the screen.

1. At the head of the train are numerous troops of forerunners, harbingers, clerks, cooks, and other inferior officers.
2. The prince's heavy baggage is packed in small trunks marked with his emblem and carried by horses and porters.
3. Then come great numbers of smaller retinues belonging to the officers and noblemen who accompany the prince; some are carried in palanquins, others go on horseback.
4. The prince's own numerous train is divided into several troops:
 a. about five fine horses;
 b. five or six porters carrying the prince's personal apparel in lacquered chests, trunks, and baskets;
 c. ten or more fellows with scimitars, pikes of state, firearms, and other weapons in lacquered wooden cases (in this screen these appear just leaving the village in the center, marching to the right);
 d. two or three men with pikes of state as badges of the prince's authority, adorned at the upper end with bunches of cock feathers (these appear in the fifth panel, just inside the small village);
 e. gentlemen carrying the prince's hat;
 f. gentlemen carrying the prince's umbrella covered with black velvet;
 g. more porters, with trunks of varnished leather;
 h. sixteen of the prince's pages and Gentlemen of the Bedchamber (in the screen painting, this must be the troop of men in dark blue kimonos marching before the palanquin of the principal lord);

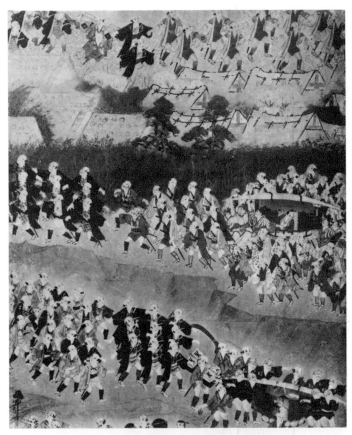

detail

i. the prince in a stately palanquin carried by six or eight men clad in rich livery, with their relief carriers at their side; two or three Gentlemen of the Bedchamber walk by his side to give him what he asks for;

j. two or three horses of state;

k. two pike bearers (only one is shown here, just before the horses);

l. "ten or more people, carrying each two baskets of a monstrous large size, fix'd to the end of a pole, which they lay on their shoulders in such a manner, that one basket hangs down before, another behind them. The baskets are more for state than for any use" (these appear in the first

two panels and precede rather than follow the daimyo's place in procession).

5. Six to twelve horses with leaders, grooms, and footmen following (here about twenty horses may be seen just beneath the bridge).

6. Then a multitude of domestics and other officers of the court; some of the officers are carried in their own palanquins. If one of the prince's sons accompanies his father, he follows with his own train immediately after that of the prince. (This seems to be the case with the palanquin at the lower edge of the picture, which carries another man of high standing.)

Japanese sumptuary laws controlled the size of these processions. A daimyo whose annual income in rice was above 250,000 *koku* (one *koku* equals 4.96 bushels) was allowed fifteen to twenty horsemen, one hundred twenty foot soldiers, and between two hundred fifty and three hundred attendants and porters. Men with smaller incomes had smaller retinues.

This screen is more than a historical and cultural document; aesthetically it also communicates the sense of energy, the massive scale of organization, and the discipline that the Tokugawa government imposed on the Japanese nation. It is a work of a routine professional atelier that has been inspired by the great events occurring around it and lifted it to a high peak of achievement.

Published: Noma Seiroku. *The Arts of Japan: Late Medieval to Modern*, translated by Glenn Webb. Tokyo, 1967. Fig. 138.
Reference: Engelbert Kaempfer. *Historia Imperii Japonici*, translated by J. G. Scheuchzer. London, 1727. Pp. 429–432.

138. Maps of Japan and the world

Early Edo period (ca. 1650)
Two six-panel folding screens; color and gold paint on paper
Each screen: 41 × 105 in. (104.5 × 267 cm.)

Painted against a background of deep indigo blue, these two maps create a striking aesthetic impact, with their intricate outlines and pastel shading in pinks, blues, and pale orange. They were indeed intended as decorative objects, but they are equally important as projections of the Japanese image of their own nation and of the world in the mid-seventeenth century. As such they are somewhat deceptive, for at first glance it appears as though the world map is, for its time, relatively scientific and thorough, whereas the large map of Japan is schematic and un-scientific. The entire upper half of the main island (Honshu) has been truncated, and Hokkaido island is omitted. Kyushu is overly large, as is the Kii Penin-sula, south of Kyoto and Nara. And the Japanese islands are not accurately oriented toward the four cardinal points of the compass, even though the names of the directions are prominently written in gold.

The date of this pair of screens has been determined by Akioka Takejirō to fall between 1648 and 1655. At this time, the edicts that isolated Japan from the outer world were being strictly enforced. Formed by the Shogun Iemitsu in the 1630s, this isolation policy was intended to protect Japan from the threats of Spanish and Portuguese imperialism, from the ap-parently subversive influences of Christianity and Western political notions, and from the economic disruptions of free foreign trade. Under the exclusion edicts, Japanese vessels were forbidden to leave for a foreign country without a license; Japanese nationals were not allowed to travel abroad; those who had been abroad were generally not allowed to return; Chris-tianity was severely suppressed; foreigners, chiefly Dutch and Chinese, were permitted to live only at Dejima, at the head of Nagasaki Bay; and foreign ships were allowed to stop in Japan only under stringently controlled circumstances. This extra-ordinary isolation and exclusion had the most pro-found effect on Japanese culture, shutting it off from

many of the main currents of intellectual and technological activity in the outer world.

The world map shown here may be seen as a residue of earlier Western influences. Approximately twenty screens of this type remain today. The oldest are in the collection of Jōtoku-ji in Fukui Prefecture, in the Yamamoto collection in Osaka, and in the Kobayashi collection, Tokyo. These, however, date no earlier than 1594; hence the period of production of this type of screen was limited to little more than a half century. Although they differ slightly from one another, their precise prototypes have not been found. Conceptually, they are extremely close to the maps of the Flemish cartographer Gerardus Mercator published in 1569 and widely distributed. Mercator's maps were made primarily for the benefit of navigators at sea, and they greatly distorted the size of the polar regions in order to indicate the correct relationship among the main continental landmasses. Those distortions appear in this map, but are compensated for by the two circular insets, which show maps of the world as seen from the North and South Poles. Similar arrangements based on Mercator projections appear in maps published in the first half of the seventeenth century by the Flemish cartographer Ortelius and the Dutch firm of Blaeu. The three horizontal lines running through the screen are the Tropics of Cancer and Capricorn and the Equator, and their significance is explained in Chinese.

One striking feature of this world map is the careful indication of fishing banks. Clearly shown by stipple patterns are the Grand Banks off Labrador and Newfoundland; the banks that extend from England to Denmark; those to the west of Madagascar and southwest of India; and the rich fishing zones of the East Indies, off the coast of Annam, and in the South China Sea. Similar indications appear in the lavishly colored world map screen in the Kobe Museum of Namban Arts (where it is paired with the famous screen of the four Western capitals—Lisbon, Madrid, Rome, and Istanbul). The Kobe screen is older than this one, and the fishing banks are fewer in number.

This world map is clearly in the tradition of the so-called Namban arts inspired by the appearances and ideas of the "Southern Barbarians"—the Western Europeans who approached Japan by the sea routes from the south (see No. 139). Shown in this map are many European galleons; one approaches the west coast of Mexico; another rounds the Cape of Good Hope; others are approaching and leaving the Philippines; one heads for Sumatra; and three ships are sailing between Kyushu and the China coast. The names of the various countries, except for those of East Asia, are written in *hiragana* and imitate European pronunciation; the East Asian names are written in Chinese. Compared to the older versions of the type, such as the Jōtoku-ji screen, this map is more schematic and unrealistic. The Nile River has dis-

appeared, as have the Tigris and Euphrates; the Amazon is less realistically shown; and fanciful lakes appear in the western hemisphere and Africa that were not present in the older maps. In other words, this map belongs to a chain of copies from an imported original and is considerably removed from the original inspiration. The originals may have been brought from Europe by Jesuit missionaries. A delegation of Japanese Christians brought a world map from Rome and presented it to Hideyoshi in 1590. The Jesuits and Franciscans may have brought Western-style maps printed in Peking by Matteo Ricci in 1602; others may have been brought by seamen. Missionaries report having seen a world map hanging in Nobunaga's room in 1579, and Ieyasu owned three world maps at the time of his death. In a land whose geographical horizons had been limited to the lands of East Asia, India, and, perhaps, Iran, these demonstrations of the roundness of the world and the existence of hitherto unknown continents must have excited the greatest wonder and curiosity.

The map of Japan is far more concrete and practical, even though it is less accurate geographically. In fact, it is a variant of the most ancient type of native Japanese map, named after the famous eighth-century monk Gyōki. He assisted the Emperor Shōmu in building Tōdai-ji and establishing the system of state-founded monasteries in each province. To this latter end, he seems to have commissioned a national map, which remained the standard type in Japan until the Edo period. It was an extremely simple outline of provinces in the four main islands, innocent of compass coordinates, major landforms, and rivers. With the establishment of the Tokugawa military government, dedicated to bringing the nation under the most rigid feudal control possible, more detailed national maps were essential. Formal land surveys were carried out in 1605 and again from 1644 to 1647. However, since internal travel in Japan involved no major navigation problems, it was not necessary to improve the basic cartographic methods, and the schema of the Gyōki maps were retained at least until the latter half of the seventeenth century.

This screen map and two others like it listed in the Masuda and Yoda collections were probably based on a very detailed map dated 1649. Now in the Ueno Library, Tokyo, it may well have been used by the central government. The screen maps are more simplified and decorative, but one can still see, as here, indications of the major highways and stage stops, coastal shipping routes, boundaries of the provinces (kuni), indications of the castle towns, names of the major daimyo added on paper slips, and the rather general indication of mountain ranges. Rivers are omitted. Written in gold in the margins are the names of the various kuni, with their annual income of rice given in koku (4.96 bushels).

Advanced techniques of map making and surveying were being mastered in Japan at the same time this schematic map was being painted; by the end of the seventeenth century, Japanese maps became far more scientific. These were the same decades, however, during which Matsuo Bashō and his companions tramped through the back country and mountains, enraptured with the boundless beauty and novelty of the landscape.

Published: Okamoto Yoshitomo. *Namban Bijutsu.* Nihon no Bijutsu, vol. 19. Tokyo, 1965. Fig. 94; Akioka Takejirō. *Nihon Chizu-shi.* Tokyo, 1955. Pp. 107, 116–117.
Reference: M. Ramming. "Evolution of Cartography in Japan," *Imago Mundi,* II (1937); Leo Bagrow and R. A. Skelton. *History of Cartography.* Cambridge, Mass., 1964.

139. Nest of boxes (*jūbako*) showing Namban ships

Early Edo period (latter half of the seventeenth century)
Lacquer, with inlaid mother-of-pearl
H. 10 3/4 in. (27.2 cm.), 9 1/16 in. (23 cm.), 8 1/2 in. (21.3 cm.)

The two exotic ships—one Portuguese, one Chinese—traversing the four faces of this lacquer box embody the Japanese fascination with the foreign traders who sailed into Japan's western ports in the sixteenth century. The first Portuguese reached southern Kyushu from their established trading centers in south China and the Malay Peninsula in the 1540s. And from then until 1638, when Iemitsu banished them unconditionally following the insurrection of Japanese Christians, the yearly advent of Portuguese and (until the 1560s) Chinese ships in Kyushu ports drew crowds of merchants from Kyoto, Osaka, and Sakai eager to bargain for their exotic cargo. To Japan the Portuguese brought raw silk and brocades from China, obtained for spices from Sumatra and Java, and exchanged those goods for Japanese silver, which they traded once more in Chinese ports before returning to Goa. The dashing and romantic figures of those traders—themselves adventurers and romantics, as well as merchants—appeared countless times in the paintings (especially screens) and decorative arts of the late sixteenth and seventeenth centuries. Called "Namban" art, using the general Japanese name for the "Southern Barbarians" or *Namban*, these representations of foreigners show with painstaking detail their beards and enlarged noses, capes, pipes, pointed shoes, tall hats, and parasols.

Within those representations of the Southern Barbarians, no symbol was more powerful or more compelling than the tall-masted, high-riding merchant ship sailing into the harbor. Two such ships form the central motif of this nest of lacquer boxes of the type popular from the Momoyama period for carrying cold food on picnics. The four boxes themselves are absolutely plain in design, and their flat surfaces have been treated as a neutral ground for a detailed but fanciful pictorial treatment. Shown are a Chinese junk and a Portuguese merchant ship with its high prow and stern. Pairs of Namban screens frequently combine Portuguese and Chinese vessels in the same fashion. In particular, the Portuguese ship here is rendered in a manner almost identical to the one on a Namban screen belonging to the Maeda family. The

screen is traditionally attributed to the hand of Sumiyoshi Jokei, an Edo painter who died in 1670, and is considered to belong to the early Kambun era (1661–1673). The screen and this box are probably contemporary. The fact that, by this time, the Portuguese merchants had long since departed Japan may account for the particularly fanciful and light-hearted portrayal of the ships in the Maeda screen and here; decorative impulses replaced the more literal, factual renderings of Namban art before 1638.

The decorative patterns are purely Japanese, employing the rich variety of lacquer techniques (see No. 140), including gold *hira-maki-e* and inlaid mother-of-pearl, all set against a ground of vermilion lacquer imbedded with gold flecks. The particular choice of pearl inlay suggests that the artist had at the back of his mind the memory of similar inlaid boxes brought by the Chinese merchants; the technique itself thus gives a certain impression of foreign luxury.

The sails of the Portuguese ship have been transformed into glorious drapes of brocade patterned with gold diamonds on black and superimposed five-petaled flowers in nacre. The hull of the ship repeats these diamond and circle shapes in shell textures and gold, as do the droplets of spray flying up from the waves. The linear treatment of the peaks and valleys of the water is continuous on all four sides, leading the eye around as does the placement of the ships themselves. The Chinese ship is hardly inferior in the splendor of its sail and hull, which are entirely rendered in mother-of-pearl and gold.

On the glossy black lacquer decks appear a jumble of Portuguese, Chinese, and Japanese, all socializing freely. Trade negotiations appear to be under way; on the deck of the Portuguese ship, the chief Chinese merchant sits in a chair beneath a gold canopy, a Portuguese dog at his feet, while his assistants hover expectantly nearby. Meanwhile, several Portuguese on board the Chinese vessel covetously eye a chest full of Oriental ware. The Japanese seem equally at home on both ships, gambling with dice on the Portuguese and playing *go* on the Chinese. Two Portuguese on the rear deck of the junk smoke their pipes and watch the

Japanese, while others swing sportively from the rigging or gaze somewhat wistfully out on the waves.

As this arbitrary mixing of nationalities would suggest, the lacquer box is not the record of an observed event (for the artist may well have lived in Edo) but a voyage in the mind of the artisan, who records in exuberantly rich materials a nostalgic fantasy of wealth and exoticism. (L. C.)

References: Nagami Tokutarō. *Namban Byōbu*. Tokyo, 1930; Okamoto Yoshitomo. *Namban Bijutsu*. Nihon no Bijitsu, no. 19. Tokyo, 1965.

140. Lacquer basin

Mid-Edo period (early eighteenth century)
Black lacquer, with gold and silver lacquer decoration
H. 7 7/8 in. (20 cm.); diam. of rim 21 1/4 in. (51.4 cm.)

Together with a matching hot water pitcher (now lost), this large lacquer basin was an elegant feature in its lady's toilette. A similar set of pitcher and wash-basin belongs to the lacquer ware designed for the marriage of the Shogun Iemitsu's eldest daughter in 1637 by Kōami Nagashige. He was the tenth generation head of the Kōami family of official lacquer makers, who had originally served the Ashikaga Shogun Yoshimasa in the fifteenth century. Nagashige's design for the bridal lacquer continued the elaborate style of *taka-maki-e* (relief decoration), which flourished in the Muromachi period. This basin, however, belongs to a much simpler tradition of *hira-maki-e* (flat lacquer).

Hira-maki-e with its precedents in Heian lacquer was revived in the Momoyama period to embellish the furnishings, utensils, and architectural decorations of the Kōdai-ji monastery in Kyoto, built by Hideyoshi's widow in 1605. Technically, the Kōdai-ji lacquers eliminated all ornate *taka-maki-e* procedures such as cut gold and inlaid shell. The basic design was formed in flat gold and silver, embellished only with powdered gold *e-nashiji*, to create nuances of light and dark, and with *harigaki* (drawing with a needle point in the wet lacquer to form delicate outlines). So, too, the Kōdai-ji lacquers turned away from narrative subject matter toward lyrical depictions of field grasses and flowers in *Yamato-e* tradition. The Kōdai-ji style of *hira-maki-e* set the pattern for lacquer ware in the Momoyama and early Edo periods, inspiring numerous masterpieces of seemingly random but flawlessly planned design. After the Genroku period, however, the *hira-maki-e* style passed its peak; the designs tended to lose their integral relationship to the shape of the vessel and were reduced to simple decorative surface patterns. Such is the case with this basin, on which the design of lotus flowers, crabs, and waves is adequately but not perfectly fitted to the cylindrical shape of the basin. The lotus pattern is found frequently on earlier lacquer pieces belonging to temples, such as the miniature shrine doors from the Taima-dera in Nara Prefecture, dating from the Heian period. Here, however, the lotus flowers and leaves are poised heavily, almost sensuously on their bending stems, and the whimsical introduction of the crabs emphasizes the fading, in this piece, of the Buddhist significance of the lotus. The more direct inspiration of this motif may not be religious wares but objects from the Sōtatsu-Kōetsu tradition such as the *Lotus Scroll* (No. 107), which also use simple harmonies of silver and gold.

This basin does demonstrate the heritage of the Kōdai-ji *maki-e* style in its techniques. The base of bent wood is finished in plain black lacquer. The design is worked out in a combination of flat areas of gold and silver and textured areas of powdered metal (*e-nashiji*), which together vary the tonality and contrast with the fine linear rendering of the waves, flower petals and leaf veins. In feeling, this piece is quite modern. While it echoes traditional patterns, the design has no burden of symbolic or narrative content and exists purely for the sake of its fresh, decorative quality. (L. C.)

References: Beatrix von Ragué. *Geschichte der Japanischen Lackhunst*. Berlin, 1967; Arakawa Hirokazu Kowa. *Maki-e*. Nihon no Bijutsu, no. 35. Tokyo, 1969; Okada Jō. *Chōdo*. Nihon no Bijutsu, no. 3. Tokyo, 1966.

141. Sumiyoshi dancers

Mid-Edo period (ca. 1730)
Folk painting from Ōtsu city
Hanging scroll; ink and color on paper
H. 13 1/2 × 9 3/4 in. (34.2 × 24.6 cm.)

The two young girls pictured here are performing an ancient folk dance associated with the Sumiyoshi Shrine in Osaka and its many branches throughout Japan. The dance (*odori*) originated in the Mitaue festival, an annual planting of rice that would be offered after harvest to the gods. During the Edo period, the cult of the Sumiyoshi gods became extremely popular. The female performers at the shrine dance were often taken from local pleasure houses, which contributed to the support of the sanctuaries; and the Sumiyoshi *odori* is often seen in sumptuous detail as a theme in *ukiyo-e* wood-block prints. The girls in this painting are static and doll-like, having been reduced to the simplest possible formula. Their kimonos are painted in black *sumi* ink with circular stripes of light blue. They wear sleeveless jackets, now a faded orange; their obis and fans are a faded magenta. Overhead is a large umbrella. Inscribed around three sides of the composition are three thirty-one-syllable poems written with a simple, moralistic purpose:

> Never lose the mind of a child;
> Obey your father.
> Be attached to your mother.

> The infant gradually gains in wisdom,
> Goes far from [the innocence of] the Buddha.
> How sad!

> When we regain the unselfish spirit of children,
> There is always the Sumiyoshi dance.
> [This is a play on words; *sumiyoshi* can also mean "to live in ease" and the line might be read "we will always live in ease."]

Simple paintings of this kind were made in several villages near the old town of Ōtsu, eight miles east of Kyoto along the shores of Lake Biwa. They were sold to the crowds of travelers who passed through Ōtsu, which was the last regular stopping place before Kyoto on the Tōkaidō, the great highroad that joined Kyoto and Edo. Entire families mass-produced these pictures, one person painting the large areas of color, another the outlines, and a third adding the inscription. Many of the pictures have Buddhist subjects and were sold to pilgrims visiting the large Tendai temple of Onjō-ji, or Mii-dera, along the edge of the town. The oldest *Ōtsu-e* date from the seventeenth century and are mostly religious in character. In the second phase of the art form, from roughly 1730 to 1800, the pictures often have secular themes with the same kind of moralistic inscriptions that appear in this work. Those of the later phase, from the nineteenth century, usually have no inscriptions and are almost entirely secular in character.

In Japan of the Edo period, travel was a major preoccupation, and persons passing through Ōtsu would buy these paintings as cheap souvenirs. Despite their low price, the pictures were cherished for their simplicity and ingenuousness, which at times approaches that of *Zenga*. Matsuo Bashō, for example, wrote a haiku in their honor:

Ōtsu-e no	At the start of the
Fude no hajime wa	Ōtsu-e brush
Nani Botoke	Which Buddha?

Shops selling these paintings appear in Hiroshige's views of Ōtsu, part of his block print series of the "Fifty-three Stages of the Tōkaidō." *Ōtsu-e* were prominently featured in the *mingei* (folk art) movement begun in the 1920s to revive the practice and appreciation of Japanese folk arts and crafts. The first exhibition of these paintings in the West was held at Harvard University in May, 1930, organized by Langdon Warner, who was a close friend of the leader of the *mingei* movement, Yanagi Sōetsu. A few families in Ōtsu city still produce these pictures, but the original atmosphere that imbued these works with a sense of childlike charm and simplicity has long since disappeared.

Published: Yanagi Sōetsu. *Ōtsu-e*. Tokyo, 1960. P. 131.
Reference: Yanagi Sōetsu. "Peasant Paintings of Ōtsu, Japan," *Eastern Art*, II (1930), pp. 5–36.

140. Lacquer basin

Mid-Edo period (early eighteenth century)
Black lacquer, with gold and silver lacquer decoration
H. 7 7/8 in. (20 cm.); diam. of rim 21 1/4 in. (51.4 cm.)

Together with a matching hot water pitcher (now lost), this large lacquer basin was an elegant feature in its lady's toilette. A similar set of pitcher and washbasin belongs to the lacquer ware designed for the marriage of the Shogun Iemitsu's eldest daughter in 1637 by Kōami Nagashige. He was the tenth generation head of the Kōami family of official lacquer makers, who had originally served the Ashikaga Shogun Yoshimasa in the fifteenth century. Nagashige's design for the bridal lacquer continued the elaborate style of *taka-maki-e* (relief decoration), which flourished in the Muromachi period. This basin, however, belongs to a much simpler tradition of *hira-maki-e* (flat lacquer).

Hira-maki-e with its precedents in Heian lacquer was revived in the Momoyama period to embellish the furnishings, utensils, and architectural decorations of the Kōdai-ji monastery in Kyoto, built by Hideyoshi's widow in 1605. Technically, the Kōdai-ji lacquers eliminated all ornate *taka-maki-e* procedures such as cut gold and inlaid shell. The basic design was formed in flat gold and silver, embellished only with powdered gold *e-nashiji*, to create nuances of light and dark, and with *harigaki* (drawing with a needle point in the wet lacquer to form delicate outlines). So, too, the Kōdai-ji lacquers turned away from narrative subject matter toward lyrical depictions of field grasses and flowers in *Yamato-e* tradition. The Kōdai-ji style of *hira-maki-e* set the pattern for lacquer ware in the Momoyama and early Edo periods, inspiring numerous masterpieces of seemingly random but flawlessly planned design. After the Genroku period, however, the *hira-maki-e* style passed its peak; the designs tended to lose their integral relationship to the shape of the vessel and were reduced to simple decorative surface patterns. Such is the case with this basin, on which the design of lotus flowers, crabs, and waves is adequately but not perfectly fitted to the cylindrical shape of the basin. The lotus pattern is found frequently on earlier lacquer pieces belonging to temples, such as the miniature shrine doors from the Taima-dera in Nara Prefecture, dating from the Heian period. Here, however, the lotus flowers and leaves are poised heavily, almost sensuously on their bending stems, and the whimsical introduction of the crabs emphasizes the fading, in this piece, of the Buddhist significance of the lotus. The more direct inspiration of this motif may not be religious wares but objects from the Sōtatsu-Kōetsu tradition such as the *Lotus Scroll* (No. 107), which also use simple harmonies of silver and gold.

This basin does demonstrate the heritage of the Kōdai-ji *maki-e* style in its techniques. The base of bent wood is finished in plain black lacquer. The design is worked out in a combination of flat areas of gold and silver and textured areas of powdered metal (*e-nashiji*), which together vary the tonality and contrast with the fine linear rendering of the waves, flower petals and leaf veins. In feeling, this piece is quite modern. While it echoes traditional patterns, the design has no burden of symbolic or narrative content and exists purely for the sake of its fresh, decorative quality. (L. C.)

References: Beatrix von Ragué. *Geschichte der Japanischen Lackhunst.* Berlin, 1967; Arakawa Hirokazu Kowa. *Maki-e.* Nihon no Bijutsu, no. 35. Tokyo, 1969; Okada Jō. *Chōdo.* Nihon no Bijutsu, no. 3. Tokyo, 1966.

141. Sumiyoshi dancers

Mid-Edo period (ca. 1730)
Folk painting from Ōtsu city
Hanging scroll; ink and color on paper
H. 13 1/2 × 9 3/4 in. (34.2 × 24.6 cm.)

The two young girls pictured here are performing an ancient folk dance associated with the Sumiyoshi Shrine in Osaka and its many branches throughout Japan. The dance (odori) originated in the Mitaue festival, an annual planting of rice that would be offered after harvest to the gods. During the Edo period, the cult of the Sumiyoshi gods became extremely popular. The female performers at the shrine dance were often taken from local pleasure houses, which contributed to the support of the sanctuaries; and the Sumiyoshi odori is often seen in sumptuous detail as a theme in ukiyo-e wood-block prints. The girls in this painting are static and doll-like, having been reduced to the simplest possible formula. Their kimonos are painted in black sumi ink with circular stripes of light blue. They wear sleeveless jackets, now a faded orange; their obis and fans are a faded magenta. Overhead is a large umbrella. Inscribed around three sides of the composition are three thirty-one-syllable poems written with a simple, moralistic purpose:

> Never lose the mind of a child;
> Obey your father.
> Be attached to your mother.

> The infant gradually gains in wisdom,
> Goes far from [the innocence of] the Buddha.
> How sad!

> When we regain the unselfish spirit of children,
> There is always the Sumiyoshi dance.
> [This is a play on words; sumiyoshi can also mean
> "to live in ease" and the line might be read
> "we will always live in ease."]

Simple paintings of this kind were made in several villages near the old town of Ōtsu, eight miles east of Kyoto along the shores of Lake Biwa. They were sold to the crowds of travelers who passed through Ōtsu, which was the last regular stopping place before Kyoto on the Tōkaidō, the great highroad that joined Kyoto and Edo. Entire families mass-produced these pictures, one person painting the large areas of color, another the outlines, and a third adding the inscription. Many of the pictures have Buddhist subjects and were sold to pilgrims visiting the large Tendai temple of Onjō-ji, or Mii-dera, along the edge of the town. The oldest Ōtsu-e date from the seventeenth century and are mostly religious in character. In the second phase of the art form, from roughly 1730 to 1800, the pictures often have secular themes with the same kind of moralistic inscriptions that appear in this work. Those of the later phase, from the nineteenth century, usually have no inscriptions and are almost entirely secular in character.

In Japan of the Edo period, travel was a major preoccupation, and persons passing through Ōtsu would buy these paintings as cheap souvenirs. Despite their low price, the pictures were cherished for their simplicity and ingenuousness, which at times approaches that of Zenga. Matsuo Bashō, for example, wrote a haiku in their honor:

Ōtsu-e no	At the start of the
Fude no hajime wa	Ōtsu-e brush
Nani Botoke	Which Buddha?

Shops selling these paintings appear in Hiroshige's views of Ōtsu, part of his block print series of the "Fifty-three Stages of the Tōkaidō." Ōtsu-e were prominently featured in the mingei (folk art) movement begun in the 1920s to revive the practice and appreciation of Japanese folk arts and crafts. The first exhibition of these paintings in the West was held at Harvard University in May, 1930, organized by Langdon Warner, who was a close friend of the leader of the mingei movement, Yanagi Sōetsu. A few families in Ōtsu city still produce these pictures, but the original atmosphere that imbued these works with a sense of childlike charm and simplicity has long since disappeared.

Published: Yanagi Sōetsu. Ōtsu-e. Tokyo, 1960. P. 131.
Reference: Yanagi Sōetsu. "Peasant Paintings of Ōtsu, Japan," Eastern Art, II (1930), pp. 5–36.

142. The mysterious maiden Ling-chao, paragon of filial piety

Early Edo period (ca. 1670, Kambun era)
Hanging scroll; bright color and gold paint on paper
H. 36 5/8 × 15 5/6 in. (92.8 × 38.9 cm)

With her impudent face framed by an elaborate coiffure of black hair and her kimono painted in brilliant vermilion with a border of indigo blue, this woman embodies the spirit of the *ukiyo-e* school as it was emerging from the older traditions of Japanese art.

The work has neither signature nor seal. A date in approximately the Kambun era (1665–1673) is firmly established on the basis of the simplified scheme of bright coloring, the delicate floral patterns of gold on red and the dark blue on the pale blue of her skirt, and the brazen, dissolute expression of her face. These qualities are found abundantly in paintings of the Kambun period depicting bathhouse girls, dancers, and courtesans, the era that saw the birth of the *ukiyo-e* movement in the paintings of Hishikawa Moronobu. The monumentality of such figures continued in the early eighteenth century in the work of the Kaigetsudō school.

With this date in mind, it is surprising to read the bold assertions on the storage box and accompanying certificates of this painting that it had been painted by Kanō Motonobu, who died a century earlier in 1559, and who is best known for his *suiboku* paintings. As is often the case, however, a traditional attribution, even when obviously mistaken, has a valuable residue of significance. For the subject itself, the maiden Ling-chao (Reishō) was often painted by Japanese Zen monks and *suiboku* masters. In fact, this painting is a line for line copy of one done in a more fluent, calligraphic technique by a certain sixteenth-century painter, Kogetsu Shūrin, who is said to have been a disciple of Motonobu. Hence it is not impossible that the figure and pose could be traced back one step further to Motonobu himself. The stiffness of the posture here is an anachronism in a work of the 1670s; female figures of this period, in keeping with the bold decorative color effects, are far more mobile and eloquent in their poses.

The face has such an air of determined dissolution that it is difficult to decide whether or not the figure is an irreverent *ukiyo-e* satire, done in the spirit of Moronobu or the novelist Saikaku, on the original subject. Ling-chao is a figure from Ch'an Buddhist literature of the later T'ang period, a mythical creature who combined the virtues of Confucian piety with the mysterious powers of a Taoist nymph and the paradoxical intellect of a Ch'an Buddhist. As the loyal daughter of a certain P'ang-wen, she daily wove baskets and sold them to support her mother and father. When her father died, she sat in his chair and instantly died as well. The motif of Ling-chao is very similar to two forms of Kuan-yin that were widely adopted by Ch'an Buddhist painters; the so-called fish seller Kuan-yin, in which the deity is disguised as a slatternly maid; and the Ma-liang-fu Kuan-yin, in which, as a beautiful girl, she married the poor Mr. Ma. These are essentially Buddhist folktales of holy mysteries that were given a Ch'an Buddhist gloss; as artistic motifs, they survived far longer in the arts of Japan than in China.

Reference: Matsushita Takaaki, *Muromachi Suiboku-ga*. Tokyo, 1960. No. 131; *Kokka*, no. 321 (February 1917).

143. The monk Saigyō and the courtesan Eguchi no Kimi

Edo period (first half of the eighteenth century)
Miyagawa Chōshun (1682–1752)
Hanging scroll; color and ink on silk
H. 15 1/4 × 23 7/8 in. (38.8 × 60.6 cm.)

Although the event depicted in this scroll took place in the twelfth century, the figures are shown in Edo-style dress. The scene shows the monk-poet Saigyō being turned away from an inn by the handsome courtesan of Eguchi. To the right of the picture is a haiku commenting on the event, written by a man who styled himself Ryōkō:

Aoyagi ya	A green willow;
Tsurenai fū wa	Its cruel, indifferent air
Kaze ni shite	Gusts like the wind.

In the poem, the green willow is a metaphor of the young woman, inhospitable yet attractive; it relates also to the willow deftly painted behind the house and over the head of Saigyō.

The scene is Eguchi, once a prosperous trading and fishing port near Osaka, at the mouth of the Kanzaki River. Its courtesans were famous for their skills and often set out in small boats to serenade the boatmen as they came in from the sea. Saigyō, the wandering monk, passed through the town en route to the temple of Shitennō-ji in Osaka. As described in his *Senjū-shō*, he was caught in a sudden storm and happened to ask for lodging at the place of the loveliest of all courtesans, called Eguchi no Kimi. She refused to take the

355

monk in; disappointed, he responded with this poem:

> How difficult it is [for you, a layman]
> To renounce this world;
> You, who deny me a temporary lodging.

This poem is a complex play on meanings. Saigyō chided the woman for failing to ignore her profession. "Temporary lodging" (*kari no yadori*) has overtones of meaning in a Buddhist sense, expressing the impermanence and instability of the everyday world, which would include the pleasures offered by the courtesan. Eguchi no Kimi understood his poem and responded immediately:

> Realizing that you are a man
> Who has renounced the world,
> My only thought was that
> You should not set your heart
> Upon a temporary lodging.

Whereupon she invited him in, and they spent the night together—in poetic conversation.

The episode became famous in Japanese literature. In the fifteenth century it was made the subject of one of the oldest Nō dramas, *Eguchi*, in which a latter-day monk visits the spot where Saigyō had come and the ghost of Eguchi no Kimi appears to him, protesting that she had not really rejected Saigyō. The story's appeal for later generations seems to have been its stress on the lack of distinction between sacred and profane, for the courtesan was seen as an incarnation of the Bodhisattva Fugen (Samantabhadra). The theme became a familiar one in early *ukiyo* painting (both the encounter of Saigyō and Eguchi no Kimi and the courtesan shown as Fugen). If Saigyō could spend the night with Eguchi no Kimi, then Mahāyāna Buddhists could maintain that if one distinguishes superficially between moral and immoral, he fails to recognize the divine unity of all creation; and *ukiyo* literature could extol the lighthearted pleasures of city life without a sense of guilt.

This delicate painting, with soft washes of muted

detail

reds and blues, is an example of the more literate and aristocratic strain that appeared in *ukiyo-e* as it evolved into its stylistic maturity. The painter, Miyagawa Chōshun, seems to have synthesized several stylistic currents of the early seventeenth century, but like many artists of this period, his biography is known only in sketchy detail. His oeuvre is quite large; but again the stylistic development within it is uncertain, because few dated works have survived.

Chōshun was a native of the Owari region, near Nagoya. As a youth he was carefully trained in the Tosa style, and this grounding in the classical *Yamato-e* tradition may help explain the restraint and gentility that appear in his later work. Here, he has signed his name Miyagawa Chōshun preceded by *Nihon-e* (Japanese [style] painting). He eventually became interested in *ukiyo-e* and followed two of the dominant figures in the early stages of the movement, Hishikawa Moronobu and Kaigetsudō Ando. Although he was an active figure in the movement, Chōshun did not become a designer of wood-block prints. All of his surviving works are paintings on paper and silk. Some are in the spirit of the monumental figure compositions of the Kaigetsudō school; others, like this one, have the smaller scale and genre spirit of Moronobu. Chōshun seems to have also done many erotic paintings, also in the Moronobu fashion.

It is thought that during much of his adult life Chōshun worked in the city administration in Edo, probably as a low-ranking bureaucrat. One of the few detailed accounts from his life describes a clash between him and Kanō Shunga, a little-known member of the Kanō school. Apparently, both men were engaged in repainting and repairs at the Tōshōgū Shrine at Nikkō, the funerary memorial of the Tokugawa family. In an argument between them over payment, Chōshun was bound with a coarse rope and led off toward a refuse heap. He was, however, rescued by his son, who thrashed Shunga and his helpers. Miyagawa Chōshun was then said to have been exiled from Edo for two years and then pardoned and allowed to resume his administrative post. Variations on this story say that a follower of Chōshun, Miyagawa Ippō, was sent into exile; whatever the true facts were, the story suggests a degree of social cleavage between the Kanō artists and the lower-ranking professional artisans who formed the heart of the *ukiyo-e* movement. Despite this, however, Chōshun avoided the boisterous and vulgar aspects of *ukiyo-e*. Like his contemporary, Nishikawa Sukenobu, who was active in Kyoto, Chōshun's work is decorous and classical in spirit.

Published: exhibition catalogue of the *Edo Bijutsu-ten*. Tokyo, 1961.
Reference: *Ukiyo-e Taika Zenshū*, vol. 3. Tokyo, 1931; *Kokka*, no. 680 (November 1948); Noel Peri. *Etudes sur le Nō*. Tokyo, 1944. Pp. 337ff; Chikuma Shobō, ed. *Gendai Yōkyoku Zenshū*, vol. 2. Tokyo, 1962.

144. Negoro lacquer flask

Edo period
Red and black lacquer on wood
H. 11 5/8 in. (29.4 cm.)

The surface of this boldly shaped flask is coated in lustrous cinnabar red lacquer, worn away on the angular and convex surfaces to reveal the underlying black lacquer in random patterning. The characteristic red and black lacquer identify Japanese ware known as *Negoro-nuri*. Most Negoro ware was intended for daily use in households and temples or as simple ceremonial utensils. This piece is a *heishi*, wine flask, and the shape is a familiar one in East Asian ceramics. It is found, for example, in Chinese Tz'u-chou ware and in the celadons of the Koryo and Yi dynasties of Korea; but in Japanese Negoro lacquer, the pedestal-like effect of the narrow bottom and swelling shoulders is usually more dramatically accentuated.

Unlike the more elaborate Japanese lacquer techniques (see No. 140), Negoro derives its understated, archaic beauty from both monkish austerity and peasant simplicity. It takes its name from the Negoro Temple in Kii Province (modern Wakayama Prefecture) where, according to tradition, the monks and neighboring artisans produced lacquer utensils for use in the temple. The Negoro Temple was founded as a branch of Kōya-san in 1130; although burned by Hideyoshi's troops in 1585, it was rebuilt and continued as a center of lacquer production. Undoubtedly, itinerant monks sold the ware and pilgrims carried it home; in time "Negoro" became the generic name for all such red and black ware.

Cinnabar and black lacquer, with its distant origins in the Han dynasty, was already well known in the Heian period. One of the outstanding pieces of Heian lacquer is a black *heishi* belonging to the Tamukeyama Shrine in Nara Prefecture, and Negoro *heishi* were widely used during the Kamakura and Muromachi periods for serving saké in temples and shrines. The Japanese *heishi* of each period show a subtle evolution of shape, from the voluminous body and gentle curves of the Tamukeyama Shrine piece to the tense, angular lines of the *heishi* belonging to the Namboku-chō and Momoyama eras. In this piece, the exaggerated contrast of elements—widely swelling shoulders, abruptly tapering lower body, and broad foot—suggest a still later date. Yet even this sophisticated version of the

Negoro *heishi* presents the mellow, glossy surface of red lacquer with the final brushstrokes left purposely undisguised. The bands of black lacquer visible where the thick upper coat of red has worn away exemplify a peculiarly Japanese aesthetic principle, that respectful use of an object in its proper function can only enhance its beauty. This humble principle, which found expression in the elaborate doctrines of the tea ceremony, has its verification in Negoro lacquers, which manifest, in the rich, endlessly varied patternings of their surfaces, the beauty of long and considerate use. (L. C.)

Reference: Arakawa Hirokazu. *Negoro*. Atami, 1966.

tional skill he captured the likenesses and characteristic gestures of the actors, and he often showed them in their dressing rooms preparing to go on stage or relaxing after a performance. His influence, especially the quality of psychological realism, is strongly present in the work of Sharaku; it also appears in that of Utamaro and Kiyonaga, as well as that of his own legion of followers.

Shunshō had been trained originally by a pupil of Miyagawa Chōshun, and his early work was in the Miyagawa style. He gradually developed his own distinctive manner, however, and much of his maturity was spent in designing an extraordinarily large number of wood-block prints and printed books. In his later years, though, he concentrated far more on painting, and most of his paintings on silk date from the last decade of his life. In these album leaves, almost all the major traits of Shunshō's painting style are visible. Outstanding, perhaps, is the almost obsessive concern with textiles. Clearly, precisely depicted in these three leaves are fabrics of wax-resist tie-dye silks, embroidered silk, soft silk satin, cotton *kasuri* (cotton woven of predyed threads), and gauze. The textile patterns are shown with fluent ease and aesthetic harmony. Particularly fond of the peacock feather motif seen on the robe of the kneeling woman on the frontispiece, Shunshō depicted it in

many of his other paintings. His sense of careful realism extended to such details as the seamstress's scissors and ruler and the smoking gear and kimono rack in the frontispiece. In the other leaves of this album, Shunshō's interest in psychological realism is also revealed, with many careful studies of the emotional states of the lovers. However, as it so happens, the faces in these three leaves are rather masklike, done according to the typical formulas of the *ukiyo-e* school. In the scene of the courtiers, though, the artist adopted a more formal, linear style reminiscent of the Tosa school and drew the woman's hair in a courtly manner that harks back to the Heian period.

Shunshō composed large numbers of erotic paintings and printed books, for this was a major aspect of the *ukiyo-e* school, a major source of patronage and sales, a major factor in its emotional tenor. A list of artists who genuinely excelled in this idiom would include Moronobu, Chōshun, Kiyonobu, Harunobu, Utamaro, and Eishi; and Shunshō is ranked among the most gifted of all. No radical sense of impropriety was involved in such work, since the *shunga* or *embon* (romantic books) were intended as a private rather than a public art; the most common formats for this material were a hand scroll, a twelve-leaf painted album, and a printed book. Some erotic books were primary media of sex education, and it

was customary to include a printed book or painted album in the chest of drawers given to a bride. Other works, such as this, were more sensational, or scandalous, treating physical love as a suitable theme in its own right, to be bought and enjoyed by those caught up in the excitement of the new life of the growing cities. During the lengthening decades of peace and internal stability, the nightlife of Edo, as in Osaka and Kyoto, became ever more boisterous, fueled by the semi-idle, wealthy samurai and the newly rich merchants. In the vast Yoshiwara pleasure quarter in Edo and the Shimabara district of Kyoto, the popular kabuki and puppet (*bunraku*) theatres flourished, along with elaborate restaurants and "tea-houses." These served as elegant brothels, each with its celebrated courtesans, whose charms were advertised in the prints. In its indulgence, color, and romance, the "floating world" served as an emotional outlet for an intensely organized, rigid social order created by the military government to bring order to a nation that had known rebellion and disorder for many decades.

At the age of twenty-six, Shunshō moved from Osaka to Edo. From that time on, he became a genuine enthusiast of the theatre, and spent his life immersed in the pleasure world of his day. But in his erotic prints and paintings, for all their inherent carnality, he preserved a sense of human insight and aesthetic harmony that make them among the most moving and original works of the Edo period; the term "obscene" is not appropriate to describe them. Among *ukiyo-e* artists, he was an educated, cultivated man; he had the rare ability to read Chinese and devoted much energy to calligraphy.

His funeral monument stands on the grounds of the Seifuku-ji temple in the Asakusa district of Tokyo, and its poetic inscription might be an epitaph of the *ukiyo-e* movement as a whole:

Kareyuku ya	Withering away,
Ima zo iu koto	The good and the bad,
Yoshi ashi mo	There is nothing left to say.
Sore ni shitemo	Even so,
Wabishii	It is sad.

Reference: Hayashi Yoshikazu. *Shunshō*. Embon Kenkyū. Tokyo, 1963; Richard Lane. "The erotic theme in Japanese painting and prints," *Ukiyo-e*, nos. 35–38 (Winter 1968—Autumn 1969); Narazaki Muneshige et al. *Nikuhitsu Ukiyo-e*, vol. 2. Tokyo, 1963. Pls. 14–29; *Shunshō*. Ukiyo-e Taika Shūsei, vol. 8. Tokyo, 1934.

146. A courtesan blowing soap bubbles

Edo period (ca. 1775–1781)
Suzuki Harushige, also called Shiba Kōkan (1747?–1818)
Hanging scroll; color on silk
H. 37 1/4 × 14 in. (94.6 × 35.6 cm.)

In this delicately tinted, decorous composition, a small boy pulls at the kimono of the young woman who beguiles him by blowing soap bubbles from a tube. The work was done in the *ukiyo* style by one of the most eccentric and absorbing figures of the Edo period, Shiba Kōkan. He later rebelled against *ukiyo-e* and became an outstanding advocate of Western science and art and a master of vanishing point perspective, copper engraving, and oil painting. At this time, however, he may have been a member of the circle of Suzuki Harunobu, the most refined and fashionable print designer in Edo in the 1760s. Kōkan signed this painting "Shōtei Harushige," and impressed on it the seal of Harunobu; it is a faithful exercise in the Harunobu style. The architectural background is almost as severely restrained and geometric as a work of Mondrian. The figures of the woman and boy are miniature and fragile. The colors are softly restrained, very much in the spirit of the limited editions of prints on fine paper that Harunobu and his associates produced for a small group of patrons in Edo. In fact, the perfection of multiple-block color printing is usually credited to Harunobu. There is present in the work of Harunobu and his followers little of the boisterous spirit that motivated so much of *ukiyo-e*, and this style represents an important stage in the internal evolution of the school toward more elegant and refined modes of expression.

The apparent innocence of this genre scene, however, is contradicted by the poem in Chinese above. Written by an unidentified man calling himself "Tankyū," the poem injects a note often encountered in *ukiyo* literature, one that unites impudence and erotic overtones with a gentle touch of melancholy:

> The young girl, with her lips
>> Blows through the bamboo tube.
> One bubble after another,
>> Flies away dancing on the fragrant breeze.
> The child watches,
>> His fingers fluttering in her petticoat.
> And then he sees a blush of shyness
>> Faintly coloring her beautiful cheeks.
>> [by] *Tankyū*

Works by Kōkan in the style of this scroll are relatively rare, and his full artistic and personal biography is difficult to reconstruct. In fact, even his birth date is uncertain; most scholars of Edo painting place it in 1738, although according to recent studies, the year 1747 seems to be more likely. He was born into an artisan's family in Edo, and his given name may have been Andō Kichijirō. He showed precocious skill in drawing and was given training in the Kanō style at an early age. He was later apprenticed to Sō Shiseki, a painter of birds and flowers in a realistic Chinese style. Kōkan also studied Confucianism; but while still young, he encountered the famous Hiraga Gennai, the botanist who had become an enthusiast for Western learning. He joined Gennai in a search for precious metals in the Chichibu mountains. Gennai also attempted to paint in the Western style, and his influence, together with that of Sō Shiseki, encouraged Kōkan to do nature studies in a careful, empirical manner. However, around 1770, he suddenly began to work in the style of Harunobu. As Kōkan described it later in his book of essays *Shunparō Hikki* (1811):

> While I was studying painting under Sō Shiseki, an artist of the *ukiyo-e* tradition named Suzuki Harunobu was illustrating the female modes and manners of his day. He died suddenly when he was a little over forty, and I began making imitations of his work, carving them on wood-blocks. No one recognized my prints as forgeries, and to the the world I became Harunobu. But I, of course, knew I was not Harunobu, and my self-respect made me adopt the name "Harushige." I then employed the coloring techniques of such [Ming Chinese] artists as Ch'iu Ying and Chou Ch'en in painting beautiful Japanese women. I painted "Summer Moon," depicting a girl dressed in thin robes through which one could see her body. . . . Side-lock ornaments used in dressing women's hair were coming into fashion at that time and were bringing about a great change in hair styling. I illustrated the new style, which con-

sequently became exceedingly popular. But I feared that such work would damage my reputation, and I gave it up.

This description of transparent robes and hair ornaments fits closely this painting and a few others on silk with the signature "Harushige," done in the Harunobu manner. However, Kōkan was often given to exaggerations and extravagant fancies in his writing, and scholars cannot take everything he said at face value. While certain prints ascribed to Harunobu may indeed have been forged by Kōkan, there are many Harunobu-style prints with the Harushige signature. In all likelihood, Kōkan was a member of Harunobu's circle, along with men like Ippitsusai Bunchō, Yamamoto Fujinobu, and the poet-artist Kikurensha Kyōsen. In any event, by 1781, Kōkan seems to have given up ukiyo-e entirely for Western studies. In 1784, he made his own camera obscura; in 1788, he took a momentous trip to Nagasaki, where he sought out Dutch traders and Japanese who knew the Dutch language and sciences. For the remainder of his career, he executed numerous works in an oil-painting style; he mastered the art of copper engraving;

he studied and published books on Western astronomy, geography, and navigation. Near the end of his life, however, he seems to have been attracted once again by traditional Asian values, especially Taoism and Zen, studying the latter at Engaku-ji in Kamakura. However, in 1811 he completed the manuscript of his reminiscences and notes, the *Shunparō Hikki*, containing many critical comments on Eastern thought:

> In China, there is no natural philosophy; nor are we Japanese at all given to abstract inquiry. We trick out our writings with meretricious ornaments so as to make them seem cultured and literary; what we say has no bearing on realities. We all have minds like women. Women are in a perpetual state of muddle. They believe what they are told, and have no sense of fact.

Similarly, in his *Tenchi Ridan (Discussion of Natural Science)* of 1816 he remarked:

> Buddhist priests who believe in Mount Sumeru know nothing whatever about the order or the movements of the planets and have no conception of the causes of solar and lunar eclipses. Their explanations of these things are sheer nonsense, but Japanese people are deluded simply because they are so accustomed to hearing Buddhist teachings. In Europe, on the other hand, a sound knowledge of the heavens is basic to all scholarship.

Little of Kōkan's intellectual fervor and spirit of inquiry appears in the painting shown here, apart from the careful investigation of transparency in the bamboo screen and the woman's kimono. This work is a more conventional essay in *ukiyo-e,* but done with skill and conviction.

Published: Narazaki Muneshige, ed. *Nikuhitsu Ukiyo-e*, vol. II. Tokyo, 1963. Pl. 30, fig. 11.
Reference: Calvin L. French. *Shiba Kōkan*. Ph. D. dissertation, Columbia University, 1966; exhibition catalogue of the Museum of the Yamato Bunka-kan, *Shiba Kōkan-ten*. Nara, 1969; Arthur Waley. "Shiba Kōkan (1737–1818)," *Ostasiatische Zeitschrift*, V (1929), pp. 60–75.

147. Courtesan and young boy

Mid-Edo period (ca. 1790)
Ukiyo-e *school*
Fan painting
H. 13 3/4 in. × 7 3/16 in. (34.9 × 18.4 cm.)

This deft, elegant drawing presents a typical *ukiyo-e* theme: a courtesan and her young attendant rushing along on an errand. The picture has been defaced by the addition of a crude copy of the signature of Utamaro, which is not a surprising choice. The treatment of the faces is very much in the style of this master of *ukiyo-e* in the 1790s, so famous for his studies of beautiful women. However, the handling of the hands and feet and the robes is clearly not that of Utamaro. This drawing could more likely be from the brush of a member of the Utagawa school, such as Toyoharu, or even from a follower of Shunshō, who specialized in composing on fan-shaped paper turned vertically as is this one.

The manner in which the girl's wind-blown kimono is rendered reveals that the artist was trained in the careful observation of nature. He was also a master of gesture drawing; he has captured the characteristic pose of the boy clutching a bundle to his chest and of the girl with her head hunched down against the wind, her hair covered with a cloth to protect her elaborate coiffure. This is essentially a brush drawing, with pale washes of orange over the girl's kimono, a touch of red at her collar and on the boy's belt. In front of her head are the remnants of large European-style letters, which had been written on the delicate, mica-coated paper and were later partially effaced.

148. Beauty chasing fireflies

Late Edo period
Teisai Hokuba (1771–1844)
Hanging scroll; ink and color on silk
H. 37 1/2 × 14 in. (95.2 × 35.5 cm.)

A romantic, *fin de siècle* mood is evoked by this scene of a girl in full dress wading into the waters of the Sumida River, chasing fireflies with a fanlike screen. In the background is one of the landmarks of old Edo, the Ryōgoku Bridge, its long roadway and wooden pilings familiar features in the prints of Utamaro, Kiyonaga, Hokusai, and Hiroshige. The "Bridge of Two Provinces" linking Musashi and Shimoda, it is shown here in vanishing point perspective in the Western manner, and crowded with hundreds of people as it fades into the gathering dusk. On the river are small ferries and lighters, and a large restaurant barge. One must always resist the temptation to invent literary content of *ukiyo-e* paintings that lack inscriptions, but this scene is extraordinarily evocative. The gestures of the woman's body are dramatic, her figure in lonely isolation in the water; her face has an almost manic expression as she pursues the tiny insects.

Teisai Hokuba was a prolific painter and one of the most distinguished talents of the *ukiyo-e* movement in its last stages. He was a pupil, perhaps the outstanding one, of Katsushika Hokusai, but his work was overshadowed by the boundless vitality and inventiveness of his master, who outlived him by five years. In the print field, Hokuba designed many *surimono*, delicately printed greeting cards that became one of the most important forms of *ukiyo-e*. As a painter, he specialized in *bijin*, the elegantly dressed beauties of the Yoshiwara, continuing thus a tradition that began over a century and a half before him. In this work, for example, his handling of the woman's clothing is in the same detailed, highly descriptive mode that Hokusai practiced, having learned it when he was a pupil of Katsukawa Shunshō (see No. 145). Shunshō in turn had studied with a follower of Chōshun (see No. 143), who had learned the manner of depicting fine textiles from Moronobu and the Kaigetsudō school. The radial patterns of the red undergarment, done in the tie-dye method, may be seen through the transparent silk gauze of the violet kimono. On the obi is a brocade pattern of wave lines and medallions.

The free use here of Western perspective, both linear and atmospheric, clearly anticipates the massive changes in the arts that were to come in the 1860s and 1870s, when the Japanese nation devoted itself wholeheartedly to Westernizing its entire culture. Here, however, the subject and mood remain very much those of the "floating world."

Reference: *Ukiyo-e Taisei*, vol. 9. Tokyo, 1931. Pp. 11–12, pls. 7, 16–18, 214–250.

149. Woman in profile

Late Edo period
Hosoda Eishi (1756–1815); inscription by Ōta Nanpo (1749–1823)
Hanging scroll; ink and color on paper
H. 39 3/4 × 11 3/8 in. (101 × 28.9 cm.)

Beneath a flowering cherry, a stylish woman in full kimono stands in profile. Although the subject is entirely that of *ukiyo-e*, the handling of the brush and black ink is informed by the skills of traditional *suiboku-ga*. The heavy sleeve is painted with a pooling and blotting of intensely black ink; the back of the skirt of the kimono is depicted with the economy of a single sweeping stroke. Absent here is the feeling for strong, two-dimensional design that characterize the mainstream of *ukiyo-e* in the work of men like Shunshō (see No. 145), Utamaro, and the prints of Eishi himself.

This painting is one of a number by Eishi in which he revealed his early training in the Kanō style under the senior master of the school in Edo, Kanō Eisen'in Michinobu. However, he broke with his teacher around 1780, when he fell under the sway of *ukiyo-e*. Eishi soon became a leading designer of color prints, a peer of Utamaro and Torii Kiyonaga in the public eye, if not quite as original or imaginative as either.

Eishi's conversion to *ukiyo-e* was all the more remarkable since he was not a member of the artisan class that provided most of the talent for the *ukiyo-e* movement. His father was a samurai, an administrator of accounts for the military government; his great-grandfather had been lord of Tamba Province. And Eishi himself, as a young man, had been admitted to the circle of cultivated men gathered around the tenth Tokugawa shogun, Ieharu. The shogun appointed him to a high court rank with a generous income, encouraged him as a painter, and granted him the artist's name Eishi. However, the appeal of the floating world was so strong that Eishi resigned his position. He had been attracted by the style of the Torii artists, who comprised one of the most distinctive of the subschools of *ukiyo-e* and even adopted the name Chōbunsai in emulation of the Torii school nomenclature. Despite this, he did not become a member of the school but rather kept his own artistic identity. In fact, he attracted a large number of followers, whose artist names were modeled on his own. His specialities were much the same as Utamaro's and Kiyonaga's—fashionable courtesans and erotica—but, as in this ink sketch, he imbued his pictures with refinement and gentility that reflected his patrician background.

The inscription on this painting was written by a poet closely associated with the *ukiyo-e* movement, Ōta Nanpo, whose portrait was painted both by Eishi and Tani Bunchō (see No. 89). Nanpo is celebrated for his comic and satirical poems, which, like this one, often embrace a wide range of meanings:

Naka no chō	Beside the
Uetaru hana no	Flowering cherries
Katawara ni	Of Naka no chō
Miyamagi	Not a single
Nado wa	Tree from the
Hitomoto mo nashi	Deep mountain valleys.
	[signed] *Shokusanjin*

"Naka no chō" refers to the main street in the Yoshiwara pleasure quarter of Edo, which was planted with flowering cherries that became virtually the symbol of the district and its diversions. The poem implies that no uncultivated country women would be found among the Yoshiwara courtesans; conversely, it suggests that none of the rustic virtues of country women would be found among the splendid but artificial beauties there. These interpretations, however, only hint at the range of possible interpretations of the poem.

Eishi signed this painting "Chōbunsai Eishi no ga," and used a vase-shaped seal in red reading "Eishi."

Reference: *Ukiyo-e Taisei*, vol. 7. Tokyo, 1933. Pl. 496; Yoshida Teruji. *Ukiyo-e Jiten*, vol. 1. Tokyo, 1965. P. 185; Hamada Giichirō. *Ōta Nanpo*. Jimbutsu Sōsho, vol. 102. Tokyo, 1965.

150. Pottery plate (*ishizara*)

Late Edo period (early nineteenth century)
Seto kilns, Aichi Prefecture
Diam. 10 3/16 in. (25.8 cm.)

During the Edo period, pottery kilns flourished throughout Japan in unprecedented numbers under the patronage of the various feudal clans. The activities of these kilns had two aspects: on the one hand, as "official kilns," they supplied their patrons with tea ware and other items for personal use; on the other hand, as intensely commercial ventures, they turned out enormous quantities of inexpensive everyday ware for the popular market. As a result, for the first time pottery utensils became commonplace in even the humblest farmhouse kitchens.

Typifying that colorful utilitarian ware are the *ishizara* (stone plates) produced at the Seto kilns near Nagoya. With a long tradition beginning with Sue ware, Seto was renowned during the middle ages for its elegant brown-glazed bottles (modeled on Sung ware) and later for Temmoku-type tea ware. In the Edo period, under the management of the Owari clan, Seto became the major producer of everyday ware in central Honshu. Its enormous step-kilns held as many as ten thousand pieces at a single firing. Such was the popularity of those wares—unglazed or glazed mixing bowls, cooking pots, and storage jars—that "Setomono" became the generic name for all household pottery, just as, in the West, all porcelain is called "china."

The versatile *ishizara* was widely employed as a kitchen utensil, but its name derives from its particular use in roadside eating houses along the Tōkaidō for serving boiled fish or beans (apparently *ishizara* is a transformation of *nishin-zara* [herring plate] or *nishime-zara* [boiled-food plate]).

So common were these plates that very little of their history has been documented; only with the nostalgic Japanese "folk art boom" has interest awakened. But, according to oral tradition in Seto, *ishizara* were made at kiln sites on the mountain ridge between the villages of Hora (center for household ware production) and Nishi Shingai (location of one of the Owari clan's "official kilns"). One particular kiln site in that area has yielded great numbers of *ishizara* shards which seem to date to the latter half of the Edo period.

The present plate, probably made at the Hora kilns, can be dated to the middle period of *ishizara* production (late eighteenth to early nineteenth century) by the iron glaze applied to its narrow, flattened rim. The plate is decorated in the so-called Oribe manner, whereby a translucent blue-green glaze is applied to part of the surface while the rest is decorated with motifs in brown iron pigment and covered with a transparent glaze. This format derives its name from tea ware designed during the Momoyama period by the soldier and tea master Furuta Oribe (1544–1615), who commissioned ware at various kilns throughout Honshu, centering around the kilns in Mino Province to the north of Seto. According to another old Seto tradition, two Mino potters are said to have been summoned by the Owari clan in the early seventeenth century to manage the kilns in the vicinity of Hora. Possibly they transmitted Oribe techniques; the present plate demonstrates how, two centuries later, the opulent Oribe tea ware patterns and glazes had devolved through popular culture to become ornamentation for common kitchen ware. The motif of cryptomeria trees also appears on shards from the original Oribe kiln sites in Mino. Here it is combined with sketchy sails, evoking the famous coastal beauty spot, Matsushima, with its hundreds of pine-covered islands. The olive green Oribe glaze applied to opposite edges of the plate suggests a verdant coastline on which several small dwellings are shown. The total design was applied with a free touch born of constant repetition (one artist decorated several hundred plates in a day). Yet, despite the festive appearance of this dish, its cost must have been very low, for all materials, including pigments for the glazes, came from the local area. This plate was probably passed down through several generations of careful housewives, to whose kitchens it added a colorful touch. (L. C.)

Reference: M. Yanagi. "A Note on Ishizara," *Eastern Art* III, (1931), pp. 39–45; Tanaka Kana, ed. *Ishizara to Aburazara*. Kyoto, 1960.

151. Bronze mirror

Kofun period (fourth century A.D.*)*
Cast bronze, with blue-green patina
Diam. 6 15/16 in. (17.7 cm.)

This cast bronze mirror was made in Japan, but the design of its back is a combination of well-known Chinese mirror types of the Han period. The Japanese simplified the original ornamental decor and probably did not recognize its symbolic significance, but they considered bronze mirrors to be objects of the highest value. Indeed, a bronze mirror is one of the three sacred insignia of the Japanese Imperial Throne; a symbol of the Sun Goddess Amaterasu-ō-mikami, it is kept in the Inner Shrine at Ise (see No. 62).

Mirrors were also included among the funeral equipment of Japanese nobles during the Tumulus (Kofun) period. They were treasured because of the high value of the bronze metal, which was still rare, and because of the semimagical properties of mirrors in Chinese cosmology, which were enhanced by the perfect symmetry and roundness of the silvered face and their ability to reflect and concentrate light. In the Kinai region (Nara-Osaka-Kyoto) from which this example must have come, mirrors were often placed in a container next to the corpse, together with stone bracelets and jewels called *magatama*, swords, daggers, and other weapons. As many as thirty mirrors have been found in a single tomb. Because mirrors were often kept for generations by a family before burial, mirrors from the same tomb are often of varying ages.

Mirror backs of this type are distinguished for the flatness of their ornamented surface, the design being a highly unified essay in pattern with no ulterior symbolic significance. The unity of the design is truly extraordinary. Responding, for example, to the four corners of the square around the central knob are the eight graceful arcs. These in turn are coordinated with the eight small circles in the outer band, each circle joined by a pair of parallel lines. The design is an interplay of concentric and eccentric elements, of concave and convex, of radial forces and those which enclose, of delicate linear elements and flat or volumetric ones. This achievement reflects the deeply rooted talent of the Japanese people for exploring purely formal relationships. The most original expressions of this trait are the mirror designs called *chokko-mon* (straight and bow-shaped pattern), which

break from the symmetry shown here into a random, puzzling asymmetry and owe far less to the Chinese than this mirror does.

The Chinese mirrors which exerted the strongest influence here belong to the type called *chang-i-tzu-sun* (may you forever have dutiful sons and grandsons) taken from an inscription commonly found on the backs. This type was produced in China from the first century B.C. until the end of the Han dynasty, the third century A.D. The latest mirrors of this sequence are considerably more coarse and simplified than the earlier ones, and they differ from this Japanese type only in having deeper relief on the surface. Large numbers of *chang-i-tzu-sun* mirrors have been found in the Kinai region, and Chinese annals such as the *Hou-Han Shu* and the *San-kuo Chih* tell of Japanese envoys returning to their homeland with gifts of Chinese mirrors. The Japanese imitations, however, were rarely slavish; here, for example, elements were added from the Chinese TLV-type mirror, which has been shown to possess strong astrological significance. From these came the square frame around the center boss and the simplified tendril patterns, but the astrological meanings must have been lost.

Formerly in the Nonoguchi collection, Kyoto. (Recorded in 1878.)
Reference: Umehara Sueji (translated by Money L. Hickman). "Ancient Mirrors and their Relationship to Early Japanese Culture," *Acta Orientalia*, vol. 4. (1963), pp. 70–79; Umehara Sueji. *Kankyō no Kenkyū*. Tokyo, 1925; Schuyler Camman. "The 'TLV' Pattern on Cosmic Mirrors of the Han Dynasty," *Journal of the American Oriental Society*, vol. 68. (1948), pp. 159–167; S. Sugihara. *Seidō-ki*. Nihon Genshi Bijutsu, vol. 4. Tokyo, 1964.

152. Sue ware flask (hiraka)

First half of the seventh century
Gray stoneware, with accidental green ash glaze
H. (including spout) 5 1/4 in. (13.5 cm.); diam. of body 5 3/4 in. (14.7 cm.)

This characteristic Sue ware shape was called *hiraka* or "flat flask," according to the record of Sue ware tribute in the *Engishiki* of the early tenth century. Over the several centuries of Sue ware production, the *hiraka* shape underwent a marked stylistic development; its transformations are proof of its value as one of the types of serving vessels for liquids for which the high-fired Sue ware was so well suited.

The present piece represents a point in development midway between the early, round-bodied, workaday type and the later, stylish, angular body with attached handle, modeled on Chinese Yüeh ware. Here, the body has a pleasing lithe compactness. A distinct shoulder line, somewhat above center, appears at the point where the two saucerlike halves of the body, thrown separately on a potter's wheel, were joined together. Flattened horizontal planes on the lower half indicate that it was trimmed with a bamboo scraper to perfect the proportions. Later *hiraka* would have foot-rings for stability; this piece is round-bottomed, but a shard attached before firing forms an improvised foot. The neck rises at a sprightly angle to one side of the center of the gently rounded shoulders. It was formed separately, then joined to the body. Its placemen' makes the *hiraka* shape reminiscent of that of a floati' waterfowl, and in fact there are examples of *hirak* which abbreviated wings were added in a playf' aggeration of that resemblance.

The olive green ash glaze completely co' shoulders, pools around the crease of the ' runs down in several translucent trails ' Such heavy glazing was accidental, but' major development in later Sue ware: ' application of glaze. During the Nara' gray Sue ware was overshadowed b' toceladon ware imported throug' Yüeh kilns in China. In easter' foreign goods were difficult to ' Sanage, near present-day Na' ganic ash glaze to pieces, ' incised decorations of Yü' gained popularity, the ' the demand without s'

given to individual pieces; the ' decline in potting technique ' presents the attainment of ' in producing an attractive' necessity of forsaking s' ming of the lower bod'

References: '
1960. P. 18 '
Pp. 136–'
Pl. 22 ar'

151. Bronze mirror

Kofun period (fourth century A.D.*)*
Cast bronze, with blue-green patina
Diam. 6 15/16 in. (17.7 cm.)

This cast bronze mirror was made in Japan, but the design of its back is a combination of well-known Chinese mirror types of the Han period. The Japanese simplified the original ornamental decor and probably did not recognize its symbolic significance, but they considered bronze mirrors to be objects of the highest value. Indeed, a bronze mirror is one of the three sacred insignia of the Japanese Imperial Throne; a symbol of the Sun Goddess Amaterasu-ō-mikami, it is kept in the Inner Shrine at Ise (see No. 62).

Mirrors were also included among the funeral equipment of Japanese nobles during the Tumulus (Kofun) period. They were treasured because of the high value of the bronze metal, which was still rare, and because of the semimagical properties of mirrors in Chinese cosmology, which were enhanced by the perfect symmetry and roundness of the silvered face and their ability to reflect and concentrate light. In the Kinai region (Nara-Osaka-Kyoto) from which this example must have come, mirrors were often placed in a container next to the corpse, together with stone bracelets and jewels called *magatama*, swords, daggers, and other weapons. As many as thirty mirrors have been found in a single tomb. Because mirrors were often kept for generations by a family before burial, mirrors from the same tomb are often of varying ages.

Mirror backs of this type are distinguished for the flatness of their ornamented surface, the design being a highly unified essay in pattern with no ulterior symbolic significance. The unity of the design is truly extraordinary. Responding, for example, to the four corners of the square around the central knob are the eight graceful arcs. These in turn are coordinated with the eight small circles in the outer band, each circle joined by a pair of parallel lines. The design is an interplay of concentric and eccentric elements, of concave and convex, of radial forces and those which enclose, of delicate linear elements and flat or volumetric ones. This achievement reflects the deeply rooted talent of the Japanese people for exploring purely formal relationships. The most original expressions of this trait are the mirror designs called *chokko-mon* (straight and bow-shaped pattern), which

break from the symmetry shown here into a random, puzzling asymmetry and owe far less to the Chinese than this mirror does.

The Chinese mirrors which exerted the strongest influence here belong to the type called *chang-i-tzu-sun* (may you forever have dutiful sons and grandsons) taken from an inscription commonly found on the backs. This type was produced in China from the first century B.C. until the end of the Han dynasty, the third century A.D. The latest mirrors of this sequence are considerably more coarse and simplified than the earlier ones, and they differ from this Japanese type only in having deeper relief on the surface. Large numbers of *chang-i-tzu-sun* mirrors have been found in the Kinai region, and Chinese annals such as the *Hou-Han Shu* and the *San-kuo Chih* tell of Japanese envoys returning to their homeland with gifts of Chinese mirrors. The Japanese imitations, however, were rarely slavish; here, for example, elements were added from the Chinese TLV-type mirror, which has been shown to possess strong astrological significance. From these came the square frame around the center boss and the simplified tendril patterns, but the astrological meanings must have been lost.

Formerly in the Nonoguchi collection, Kyoto. (Recorded in 1878.)
Reference: Umehara Sueji (translated by Money L. Hickman). "Ancient Mirrors and their Relationship to Early Japanese Culture," *Acta Orientalia*, vol. 4. (1963), pp. 70–79; Umehara Sueji. *Kankyō no Kenkyū*. Tokyo, 1925; Schuyler Camman. "The 'TLV' Pattern on Cosmic Mirrors of the Han Dynasty," *Journal of the American Oriental Society*, vol. 68. (1948), pp. 159–167; S. Sugihara. *Seidō-ki*. Nihon Genshi Bijutsu, vol. 4. Tokyo, 1964.

152. Sue ware flask (*hiraka*)

First half of the seventh century
Gray stoneware, with accidental green ash glaze
H. (including spout) 5 1/4 in. (13.5 cm.); diam. of body 5 3/4 in. (14.7 cm.)

This characteristic Sue ware shape was called *hiraka* or "flat flask," according to the record of Sue ware tribute in the *Engishiki* of the early tenth century. Over the several centuries of Sue ware production, the *hiraka* shape underwent a marked stylistic development; its transformations are proof of its value as one of the types of serving vessels for liquids for which the high-fired Sue ware was so well suited.

The present piece represents a point in development midway between the early, round-bodied, workaday type and the later, stylish, angular body with attached handle, modeled on Chinese Yüeh ware. Here, the body has a pleasing lithe compactness. A distinct shoulder line, somewhat above center, appears at the point where the two saucerlike halves of the body, thrown separately on a potter's wheel, were joined together. Flattened horizontal planes on the lower half indicate that it was trimmed with a bamboo scraper to perfect the proportions. Later *hiraka* would have foot-rings for stability; this piece is round-bottomed, but a shard attached before firing forms an improvised foot. The neck rises at a sprightly angle to one side of the center of the gently rounded shoulders. It was formed separately, then joined to the body. Its placement makes the *hiraka* shape reminiscent of that of a floating waterfowl, and in fact there are examples of *hiraka* to which abbreviated wings were added in a playful exaggeration of that resemblance.

The olive green ash glaze completely covers the shoulders, pools around the crease of the neck, and runs down in several translucent trails to the base. Such heavy glazing was accidental, but it portends a major development in later Sue ware: the intentional application of glaze. During the Nara period, the plain gray Sue ware was overshadowed by green-glazed protoceladon ware imported through Kyushu from the Yüeh kilns in China. In eastern Japan, where those foreign goods were difficult to obtain, the Sue kilns at Sanage, near present-day Nagoya, began applying organic ash glaze to pieces, imitating the shapes and incised decorations of Yüeh ware. As the glazed ware gained popularity, the potters were unable to meet the demand without sacrificing the close attention given to individual pieces; the result was an inevitable decline in potting technique. The present piece represents the attainment of a high degree of efficiency in producing an attractive shape without, as yet, the necessity of forsaking such refinements as the trimming of the lower body. (L. C.)

References: Hayashiya Seizō. *Yakimono no Bi.* Tokyo, 1960. P. 18; *Nihon no Kōkogaku*, vol. VI. Tokyo, 1967. Pp. 136–143; *Sekai Tōji Zenshū*, vol. I. Tokyo, 1958. Pl. 22 and p. 301.

153. Silla ware (Korea) or Sue ware jar

Latter half of the fifth century
Gray stoneware, with accidental ash glaze
H. 8 1/2 in. (21.5 cm.); diam. of mouth 4 in. (10 cm.)

The elegance of this jar lies in the extreme economy of its form and decoration. The greatest diameter of the globular body is somewhat above center, so that the strong semicircular silhouette of the lower body with its round bottom exactly counterbalances—both visually and physically—the wide conical neck. The outsized neck is the most unusual feature of this pot, and on it is concentrated all decoration. Two slightly swollen bands divide the neck horizontally into three equal sections. These bands have the appearance of being separate strings tightly bound around the neck, constricting it slightly so that the silhouette is not smooth but undulates gently. A pair of bands marks the jointure of the neck and the body, while a sharply delineated brim sets off the neck from an inverted rim, on which a flat lid originally rested. In each of the three horizontal bands, panels of wave-pattern combing have been applied, with a many-toothed wooden tool, in beautifully controlled movements.

On the parts of the jar that faced the flames in the kiln—the shoulders of the body and the sides of the neck, both inside and out—a glaze formed naturally during firing where ash from the burning pine settled and fused with molten feldspar in the clay. An accident, this glaze did not unite perfectly with the body and in large patches it has since fallen off, exposing the bare, light gray clay. But the lower half of the body and the unglazed portions of the neck show a slightly metallic, lustrous dark gray. That appearance is the result of the Sue potter's technique of *kusube-yaki*, whereby, at the very end of the firing, damp leaves were thrust into the kiln and the firing hole sealed off, creating a reducing atmosphere in which the pure carbon ash from the burning leaves adhered to the hot surface of the pot. This technique sealed the pores of the pot, rendering it semiwaterproof; in effect, it created a protoglaze. Below this darkened carbonized surface the bottom of the pot, where it was partially buried in sand on the floor of the kiln, is still pale gray.

Whether this pot was made in Japan or imported from Korea along with the potters who were to teach those advanced continental techniques to Japanese artisans must remain an open question. Prior to the introduction (in the mid-fifth century) of this type of pottery—made on a wheel and fired at a high temperature to a porcelaneous consistency in a reduction atmosphere—the only native Japanese ceramic ware was a continuation of the neolithic Yayoi tradition of porous, low-fired red earthenware. But when political confusion on the mainland caused large-scale immigration of Korean refugees, including potters, the Japanese clans, already familiar with the superior Korean ware through tribute, lost no time in organizing those craftsmen into corporations, or *be*. The ware produced by the corporations of repatriated potters, the Iwaibe, is known as Sue ware, after the old pronunciation of the Chinese character meaning "pottery," as distinguished from Haji or "earthen" ware. Entries in the *Kojiki*, the historical chronicle of the period, tell of the settlements of immigrant potters from Silla and Paekche throughout the Yamato area, including the earliest great kiln center at Sue no Mura south of present-day Osaka, where over two hundred kiln sites are known. The most reliable of the *Kojiki* records is dated 463; the earliest examples of native Sue ware excavated from tumuli (burial mounds) date from the latter half of the fifth century.

The skills incorporated in Japan to produce Sue ware had been established only a century earlier in the Silla and Kaya regions of southern Korea. The definitive factor in the evolution of Korean pottery from soft earthenware to hard gray stoneware was the introduction, presumably from southeast China, of a new type of kiln. The Korean refugees brought this so-called tunnel kiln to Japan. It was constructed on the natural slope of a hillside either as an actual tunnel or as a roofed-over ditch about thirty feet long and four feet wide. The strong updraft resulting from the average angle of thirty degrees produced temperatures above a thousand degrees centigrade, and a primary concern of the potters was to find better quality clay to withstand the high temperatures.

The all-male corporations of Sue potters settled in areas meeting the requirements for construction of the kiln and for raw materials. The tough, nonporous

Sue ware produced in the tunnel kilns by these specialists quickly became established both as ceremonial ware—for rituals and for tomb burials—and as serving and storage vessels, especially for liquids. This jar, for example, could have been used either for storing food or for carrying water, its long neck useful in preventing spillage. Almost identical jars found in Koryong Tomb 3, in the Kaya region of southeastern Korea, dating to the first half of the fifth century, give strong support to the possibility—reinforced by the technical aspects of skillful construction and a body color darker than the usual Sue ware—that this piece is Korean in origin. Whether a Korean import or one of the earliest products of a native kiln, this pot represents a crucial turning point in the development of Japanese ceramics. (L. C.)

References: Kim Won-Yong. *Studies on Silla Pottery.* Seoul, 1960. Pp. 73–86, pl. 22, figs. 2–4; *Sekai Kōkogaku Taikei*, vol. 3. Tokyo, 1963. Pp. 132–137; Hayashiya, Seizō. *Yakimono no bi.* Tokyo, 1960; *Sekai Tōji Zenshū*, vol. 1. Tokyo, 1958. Pp. 192–206.

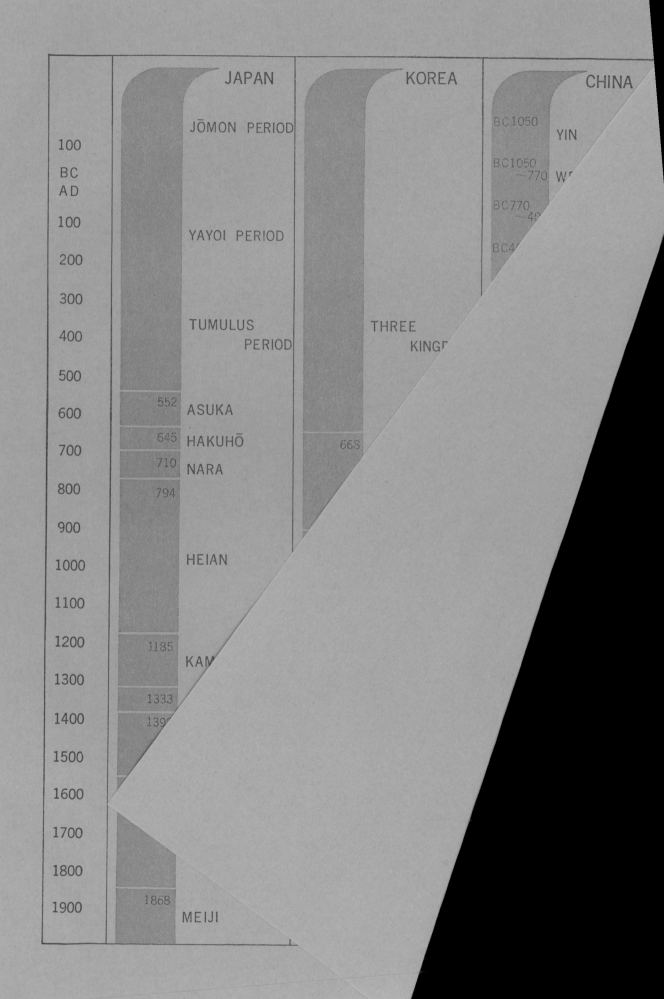

153. Silla ware (Korea) or Sue ware jar

Latter half of the fifth century
Gray stoneware, with accidental ash glaze
H. 8 1/2 in. (21.5 cm.); diam. of mouth 4 in. (10 cm.)

The elegance of this jar lies in the extreme economy of its form and decoration. The greatest diameter of the globular body is somewhat above center, so that the strong semicircular silhouette of the lower body with its round bottom exactly counterbalances—both visually and physically—the wide conical neck. The outsized neck is the most unusual feature of this pot, and on it is concentrated all decoration. Two slightly swollen bands divide the neck horizontally into three equal sections. These bands have the appearance of being separate strings tightly bound around the neck, constricting it slightly so that the silhouette is not smooth but undulates gently. A pair of bands marks the jointure of the neck and the body, while a sharply delineated brim sets off the neck from an inverted rim, on which a flat lid originally rested. In each of the three horizontal bands, panels of wave-pattern combing have been applied, with a many-toothed wooden tool, in beautifully controlled movements.

On the parts of the jar that faced the flames in the kiln—the shoulders of the body and the sides of the neck, both inside and out—a glaze formed naturally during firing where ash from the burning pine settled and fused with molten feldspar in the clay. An accident, this glaze did not unite perfectly with the body and in large patches it has since fallen off, exposing the bare, light gray clay. But the lower half of the body and the unglazed portions of the neck show a slightly metallic, lustrous dark gray. That appearance is the result of the Sue potter's technique of *kusube-yaki*, whereby, at the very end of the firing, damp leaves were thrust into the kiln and the firing hole sealed off, creating a reducing atmosphere in which the pure carbon ash from the burning leaves adhered to the hot surface of the pot. This technique sealed the pores of the pot, rendering it semiwaterproof; in effect, it created a protoglaze. Below this darkened carbonized surface the bottom of the pot, where it was partially buried in sand on the floor of the kiln, is still pale gray.

Whether this pot was made in Japan or imported from Korea along with the potters who were to teach those advanced continental techniques to Japanese artisans must remain an open question. Prior to the introduction (in the mid-fifth century) of this type of pottery—made on a wheel and fired at a high temperature to a porcelaneous consistency in a reduction atmosphere—the only native Japanese ceramic ware was a continuation of the neolithic Yayoi tradition of porous, low-fired red earthenware. But when political confusion on the mainland caused large-scale immigration of Korean refugees, including potters, the Japanese clans, already familiar with the superior Korean ware through tribute, lost no time in organizing those craftsmen into corporations, or *be*. The ware produced by the corporations of repatriated potters, the Iwaibe, is known as Sue ware, after the old pronunciation of the Chinese character meaning "pottery," as distinguished from Haji or "earthen" ware. Entries in the *Kojiki*, the historical chronicle of the period, tell of the settlements of immigrant potters from Silla and Paekche throughout the Yamato area, including the earliest great kiln center at Sue no Mura south of present-day Osaka, where over two hundred kiln sites are known. The most reliable of the *Kojiki* records is dated 463; the earliest examples of native Sue ware excavated from tumuli (burial mounds) date from the latter half of the fifth century.

The skills incorporated in Japan to produce Sue ware had been established only a century earlier in the Silla and Kaya regions of southern Korea. The definitive factor in the evolution of Korean pottery from soft earthenware to hard gray stoneware was the introduction, presumably from southeast China, of a new type of kiln. The Korean refugees brought this so-called tunnel kiln to Japan. It was constructed on the natural slope of a hillside either as an actual tunnel or as a roofed-over ditch about thirty feet long and four feet wide. The strong updraft resulting from the average angle of thirty degrees produced temperatures above a thousand degrees centigrade, and a primary concern of the potters was to find better quality clay to withstand the high temperatures.

The all-male corporations of Sue potters settled in areas meeting the requirements for construction of the kiln and for raw materials. The tough, nonporous

Sue ware produced in the tunnel kilns by these specialists quickly became established both as ceremonial ware—for rituals and for tomb burials—and as serving and storage vessels, especially for liquids. This jar, for example, could have been used either for storing food or for carrying water, its long neck useful in preventing spillage. Almost identical jars found in Koryong Tomb 3, in the Kaya region of southeastern Korea, dating to the first half of the fifth century, give strong support to the possibility—reinforced by the technical aspects of skillful construction and a body color darker than the usual Sue ware—that this piece is Korean in origin. Whether a Korean import or one of the earliest products of a native kiln, this pot represents a crucial turning point in the development of Japanese ceramics. (L. C.)

References: Kim Won-Yong. *Studies on Silla Pottery*. Seoul, 1960. Pp. 73–86, pl. 22, figs. 2–4; *Sekai Kōkogaku Taikei*, vol. 3. Tokyo, 1963. Pp. 132–137; Hayashiya, Seizō. *Yakimono no bi*. Tokyo, 1960; *Sekai Tōji Zenshū*, vol. 1. Tokyo, 1958. Pp. 192–206.

	JAPAN	KOREA	CHINA
100 BC	JŌMON PERIOD		BC.1050 YIN
			BC1050 ~770 WESTERN CHOU
AD 100	YAYOI PERIOD		BC770 ~403 EASTERN CHOU
200			BC403 ~221 WARRING STATES
300			BC221 ~AD8 FORMER HAN
400	TUMULUS PERIOD	THREE KINGDOMS	AD8 ~220 LATER HAN
500			AD220 ~577 NORTHERN WEI
600	552 ASUKA		581 SUI
700	645 HAKUHŌ	668	618
	710 NARA		T'ANG
800	794	SILLA	
900		918	907 FIVE DYNASTIES
1000	HEIAN		979 NORTHERN LIAO SUNG
1100			
1200	1185	KORYO	SOUTHERN CHIN SUNG
1300	KAMAKURA		1280 YÜAN
1400	1333 NAMBOKU-CHŌ	1092	1338
	1392		
1500	MUROMACHI		MING
1600	1568 MOMOYAMA		
1700	1614	LI DYNASTY	1644
	EDO		
1800			CH'ING
1900	1868		
	MEIJI	1910 KOREA	1912 REPUBLIC OF CHINA

GLOSSARY

Listed below are the names of artists, technical terms, Japanese temples and shrines, and Buddhist and Shintō deities used in the text. The appended numbers refer to catalogue entries. Political figures, secular literature, and religious texts are not included. For these, readers are referred to E. Papinot, *Historical and Geographical Dictionary of Japan* (Tokyo, n.d.); B. Nanjio, *A Catalogue of the Chinese Translation of the Buddhist Tripitaka* (Oxford, n.d.); *Hōbōgirin: Dictionnaire Encyclopédique du Bouddhisme*. Fascicule annexe (Tokyo, 1929).

Acala; *see Fudō*

Aizen (Rāgarāja) 愛染
One of the Myō-ō (q.v.); symbolizes the conception that human passions and illusions are identical to Enlightenment. 19, 56

Akshobhya Buddha; *see Ashuku*

Amida (Amitābha) 阿彌陀
A Buddha; personification of boundless light and compassion; dwells in the Western Paradise. See also Kannon, Jōdo. 2, 4, 13, 28, 36, 39

Aoki Mokubei (1767–1833) 青木木米
Kyoto Bunjin ceramist and painter. 130

Ashide-gaki 葦手書
Mode of writing and drawing developed in Heian period with reedlike or water ripplelike contours.

Ashuku (Akshobhya) 阿閦
A Buddha; "the imperturbable," "immovable"; one of the Five Wisdom Buddhas of Esoterism; thought to dwell in his own Pure Land in the East.

Avalokiteśvara; *see Kannon*

Batō Kannon (Hayagrīva) 馬頭
"Horse-headed Kannon"; Esoteric Buddhist deity; also classed as Myō-ō (q.v.). 54

Benzai-ten (Sarasvatī) 辯才天
Goddess of music, learning, eloquence, longevity; of Indian origin; admitted to Shintō pantheon.

Bishamon-ten (Vaiśravana) 毘沙門天
One of the Shitennō (q.v.); divine guardian of northern quadrant. 41, 59

Bodhisattva; *see Bosatsu*

Bokkei (mid-15th cen.) 墨谿
Zen monk-painter of Daitoku-ji; member of Ikkyū's circle.

Bokuseki 墨蹟
"Ink trace"; term describing calligraphies by distinguished Zen monks.

Bosatsu (Bodhisattva) 菩薩
"Enlightenment Being"; large class of Mahāyāna deities destined to attain satori, but who postpone this in order to assist mankind. Includes Fugen, Kannon, Miroku, Jizō.

Buddha; *see Nyorai*

Bugaku 舞樂
"Dance music"; temple dances imported from mainland in Nara period; now preserved at a few shrines (e.g.

Kasuga, Itsukushima).

Bunjin (Wên-jên) 文人
Chinese ideal of man of letters and spiritual cultivation; term designates Japanese school of painters in the Chinese manner, 17th–19th centuries.

Bunsei (mid-15th cen.) 文清
Zen monk-painter of Kyoto; disciple of Shūbun. 68

Byakue Kannon 白衣觀音
"White-robed Kannon"; deity shown seated on rocky crag. 70

Byōdō-in, Kyoto 平等院
Personal temple of Fujiwara Yorimichi, son of Michinaga; in Uji district south of Kyoto. See Jōchō, Takuma Tamenari.

Byōdō-ō 平等王
Eighth King of Hell. 49

Ch'an; see Zen

Chang Chi-chih (1186–1266) 張郎之
Chinese calligrapher much admired by Hon'ami Kōetsu (q.v.).

Chang Hsü (8th cen.) 張旭
T'ang poet and calligrapher; specialist in ts'ao-shu (q.v.).

Chang-i-tzu-sun 長宜子孫
Inscription on Han mirrors. 151

Chang Sêng-yu (ca. 500–550) 張僧繇
Early Chinese master painter.

Cha-no-yu 茶の湯
Ceremonial tea making.

Chao-chou (778–897 sic) 趙州
Ch'an monk, disciple of Nan-chüan (q.v.). 78, 104

Ch'en-jung (active 1250s) 陳容
Southern Sung poet and painter specializing in dragons.

Ch'en Nan-p'in (mid-18th cen.) 沈南蘋
Chinese bird-and-flower painter; arrived Nagasaki 1731.

Chiang Chia-pu (early 19th cen.) 江稼圃
Chinese Wên-jên painter, resident in Nagasaki.

Chia-shan (805–881) 夾山

Chinkai (1092–1153) 珍海
Monk of Daigo-ji; specialist in Buddhist painting and iconography. 31

Ch'in-kao 琴高
Chinese Taoist immortal, or wonder-worker. 74

Chion-in, Kyoto 智恩院
Headquarters of Jōdo sect.

Chirashi-gaki 散らし書
Calligraphy style of irregular, random spacing of lines.

Ch'i-tz'u (契此)
Ch'an monk of Ssu-ming region; known as Pu-tai (Hotei, q.v.). 76

Chiu Huai (ca. 1461) 九懷
Painter of No. 77.

Ch'iu Ying (1st half 16th cen.) 仇英
Professional painter; lived chiefly in Suchou.

Chōei-ji, Osaka 長榮寺

Chōhō-ji, Kyoto 頂法寺
Formal name of Rokkaku-dō.

Chokko-mon 直弧文
Distinctive pattern of arc and straight lines found in pre-Buddhist Japanese funereal arts.

Chōnen (938–1016) 奝然
Japanese monk who brought the Seiryō-ji Shaka statue from China.

Chou Ch'en (ca. 1500–1535) 周臣
Suchou painter; specialist in landscapes and figures.

Chōyū (active ca. 1394–1427) 朝祐
Sculptor in Kamakura region. 55

Chūan Shinkō (late 15th–early 16th cen.) 仲安眞康
Zen monk painter of Kamakura.

Chü-chih (9th cen.) 俱胝
Ch'an monk famous for teaching by holding up one finger in silence. 78

Chu Hsi (1130–1200) 朱熹
Confucian scholar; founder of his own school of Neo-Confucianism.

Chūson-ji, Iwate Pref. 中尊寺
Twelfth-century temple built by Fujiwara family, northern Honshu. 32

Chu-ta (1625–after 1705) 朱耷
Eccentric Ch'an monk painter in Wên-jên style.

Chu Yün-ming (1460–1526) 祝允明
Ming scholar-calligrapher.

Cintāmani; see Nyoi-hōju

Daian-ji, Nara 大安寺
Originally one of the largest monasteries of Nara.

Daigo-ji, Kyoto 醍醐寺
Shingon sanctuary southeast of city.

Daihō Shrine, Shiga Pref. 大寶神社

Dai-itoku Myō-ō (Yamāntaka) 大威德明王
A Myō-ō (q.v.); "Great majestic power"; symbolic of the conquest of death by Enlightenment.

Dainichi (Mahāvairocana) 大日
Supreme deity of Esoteric Buddhist pantheon; symbol of great generative force at the heart of all creation. 29

Daitoku-ji, Kyoto 大德寺
Vast Zen monastery compound on northern edge of city.

Denkō-ji, Nara 傳香寺

Deva; see Ten

Dhāranī
Mystic syllables which epitomize the essence of a sūtra or lengthy prayer; often thought to possess magic power.

Dharma
"Law"; usually refers to the law or truth of Buddhist doctrine.

Dōgen (1200–1253) 道元
Outstanding monk in early history of Zen in Japan.

Dōji (Kumāra) 童子
Youth wishing to become monk; servant of monks and great deities. 52, 53, 61

Dōmyō-ji, Osaka 道明寺

Dōshaku-ga 道釋畫
"Paintings which elucidate the path (to Enlightenment)"; category of didactic Zen imagery.

Eiman-ji, Fukuoka 永萬寺

Eison (1201–1290) 叡尊
Abbot of Saidai-ji, Nara; evangelist, leader of temple reconstruction projects.

Emma-ō (Yama Rāja) 閻魔王
Fifth king of Hell; king of the realm of the dead. 48, 49

E-nashiji 繪梨地
Sprinkled lacquer effect. 140

Engaku-ji, Kamakura 圓覺寺
Major Zen temple; founded late 13th century.

En-no-Gyōja (634–?) 役行者
Ascetic, mountain-climbing monk. 123

Enno-ji, Kamakura 圓應寺
Temple possessing celebrated statues of

Ten Kings of Hell.

Enryaku-ji, Shiga Pref. 延暦寺
Vast sanctuary; headquarters of Japanese Tendai sect.

Esoteric Buddhism
Buddhist movement emphasizing magic and semimagic practices to invoke powers of enlarged pantheon; also designated as Tantric Buddhism. See Kūkai, Shingon.

Fudō Myō-ō (Acala) 不動明王
"The Immovable One"; one of the Myō-ō (q.v.); symbolic of steadfastness in the face of passion, egoism, temptation. 45

Fugen (Samantabhadra) 普賢
Bodhisattva; personifies the teaching, meditation, and spiritual practices of the Buddha. 34, 35

Fujiwara Teika (1162–1241) 藤原定家
Celebrated calligrapher; also called Sada'ie.

Fujiwara Yukinari (972–1027) 藤原行成
Distinguished calligrapher; also called Kōzei.

Furuta Oribe (1543–1615) 古田織部
Samurai, tea master; patron of ceramic kilns in Mino, Owari region.

Ganeśa
Hindu deity; elephant-headed son of Śiva and Parvati; god of prosperity and good fortune.

Gangō-ji, Nara 元興寺
One of the ten great Nara temples.

Ganjō-ji, Kumamoto 願成寺

Gakuō Zōkyū (early 16th cen.) 岳翁藏丘
Zen monk-painter of Kyoto; style of Shūbun and Sōtan.

Geiami (1431–1485) 藝阿彌
Son of Nōami; painter and connoisseur in service to Shogun Yoshimasa.

Genjū-an, Fukuoka 幻住庵

Genshin (942–1017) 源信
Monk of Enryaku-ji; influential preacher of Pure Land doctrines. Known also as Eshin Sōzu.

Genshō (ca. 1145–1206) 玄証
Monk-painter who was resident chiefly at Daigo-ji. 31

Gigaku 伎樂
Oldest of imported continental dance traditions, performed in Nara temples in 7th and 8th centuries. No longer extant.

Gion Nankai (1677–1751) 祇園南海
Bunjin painter, calligrapher from Kii Province. 112

Godōtenrin 五道轉輪
Tenth of the Ten Kings of Hell. 49

Gokan 五官
Fourth of the Kings of Hell. 49

Gokuraku-ji, Kamakura 極樂寺
Founded 1260 by Ninshō, evangelist from Saidai-ji, Nara.

Goma (homa) 護摩
Esoteric Buddhist fire ceremony; burning of inscribed wooden slats to achieve material and spiritual benefits.

Gukyoku Reisai (d. 1450) 愚極礼才
Monk calligrapher and painter; resident chiefly at Tōfuku-ji. 64

Guze Kannon 救世觀音
Variant form of Shō Kannon; Shōtoku Taishi believed to be incarnation of Guze Kannon.

Gyōgi (667–749) 行基
Prominent monk-adviser to Emperor Shōmu; active in project to build Nara Daibutsu.

Gyokushitsu Sōhaku (d. 1641) 玉室宗珀
Abbot of Daitoku-ji. 77

Gyōsho 行書
Calligraphic style; rapid execution of characters without major distortion of legibility.

Hachiman 八幡
Shintō War God; worshiped in shrines coordinated with major Buddhist temples.

Hakuin Ekaku (1685–1768) 白隱慧鶴
Prominent Zen monk, painter, and calligrapher. 102

Han-shan (Kanzan) (early 9th cen.) 寒山
Ch'an Buddhist poet-monk; often painted with Shih-tê (q.v.); emblem of child-like simplicity and acceptance of the world.

Harigaki 針描

Technique of lacquer decor. 140

Hase-dera, Nara 長谷寺
Sanctuary of miraculous statue of Eleven-headed Kannon. 61

Hasegawa Kakugyō (1541–?) 長谷川角行
Theologian of sectarian Shintō creed centered on Mt. Fuji. 84

Hasegawa Sakon (first half 17th cen.) 長谷川左近
Son of Tōhaku. 78

Hasegawa Tōhaku (1538–1610) 長谷川等伯
Screen painter characterized by personal variations of Kanō style; founder of Hasegawa school.

Heishi 瓶子
Wine-flask shape. 144

Hensei 變成
Sixth King of Hell. 49

Henshōkō-in, Wakayama Pref. 遍照光院

Hidaka Tetsuō (1791–1871) 日高鐵翁
Zen monk-painter in Bunjin style; lived in Nagasaki. 133

Hiraga Gennai (1726–1779) 平賀源内
Botanist and painter; pioneer of Western learning in Edo period. 146

Hiraka 平瓮
Form of Sue ware. 153

Hira-maki-e 平蒔繪
Technique of lacquer decoration without raised relief. 140

Hishikawa Moronobu (1618–1694) 菱川師宣
Pioneer ukiyo-e painter and print designer of Edo.

Hōjō-ji, Kyoto 法成寺
Vast temple compound built on east edge of Kyoto by Fujiwara Michinaga; no longer extant.

Hokke-ji, Nara 法華寺
Nunnery near site of Nara Imperial Palace; originally chief official state nunnery.

Hompa-shiki 翻波式
"Rolling-wave-style"; method of carving garment folds in late 8th and early 9th century Buddhist images in which a sharp angular ridge was placed between each fold in the garment.

Hompō-ji, Kyoto 本法寺

Hon'ami Kōetsu (1558–1637) 本阿彌光悦

喜多川歌麿
Ukiyo-e *master painter and print designer.*

Kitano Tenjin; *see Sugawara Michizane*

Kitano Tenman-gū, Kyoto 北野天満宮
Shintō shrine, northern part of city, dedicated to spirit of Sugawara Michizane (q.v.).

Kōami Nagashige (1599–1651) 幸阿彌長重
Lacquer master of hereditary family of lacquer experts. 140

Kōan 公案
"Public proposition"; enigmatic statement in Zen Buddhism that serves as theme for meditation and philosophic speculation. 78, 104

Kōbō Daishi; *see Kūkai*

Kōboku (first half 16th cen.) 興牧
Zen monk-painter active in Kamakura region. 72

Kobori Enshū (1579–1647) 小堀遠州
Celebrated garden designer, architect, calligrapher, and tea master. 99

Kōdai-ji, Kyoto 高臺寺
Founded by widow of Hideyoshi in 1605; celebrated for lacquer decoration. 140

Kōetsu (early 16th cen.) 興悦
Zen monk-painter of Kamakura.

Kōfuku-ji, Nara 興福寺
Vast tutelary temple of Fujiwara family; begun 8th century. 14

Kōgen-ji, Shiga Pref. 向源寺

Kogetsu Shūrin (mid-16th cen.) 孤月周林
Painter; disciple of Kanō Motonobu. 142

Kōgetsu Sōgan (1574–1643) 江月宗玩
Calligrapher; 157th abbot of Daitoku-ji. 77

Kōki-ji, Osaka 高貴寺
Ancient temple, Kawachi district; used by Jiun as headquarters of Shingon Shōbōritsu sect.

Kokubun-ji 國分寺
Eighth-century system of official monasteries in each provincial capital; headquarters at Tōdai-ji.

Kokūzō (Ākasagarbha) 虚空藏
Bodhisattva; "Womb of the Void"; Esoteric Buddhist deity, frequently shown in five separate forms symbolizing five types of wisdom.

Koma-inu 狛犬
"Dog of Koryo"; popular name for type of guardian lion. 51

Kōmoku-ten (Virūpāksha) 廣目天
"Enlarged Eyes"; guardian of the West; one of the Shitennō (q.v.). 41

Kongara (Kimkara) 矜羯羅
"Servant" or "slave"; one of eight boy servants of Fudō; endowed with supernatural power. 52

Kongōrin-ji, Shiga Pref. 金剛輪寺

Kongōshō-ji, Mie Pref. 金剛證寺
Buddhist sanctuary once affiliated with the Ise Shrine. 62

Konjiki-dō 金色堂; *see Chūson-ji*

Konoe Nobutada (1565–1614) 近衛信尹
Courtier and calligrapher of great distinction. Also named Sammyakuin. 96

Kōsei (mid-14th cen.) 康成
Buddhist sculptor of the Kei school.

Kōshun (first half 14th cen.) 康俊
Buddhist sculptor; head of Kōfuku-ji workshop.

Kōya-san, Wakayama Pref. 高野山
Remote, rugged mountain site selected by Kūkai for sanctuary of Shingon sect.

Kōzan-ji, Kyoto 高山寺
Temple once part of Jingo-ji; became independent sanctuary under Myō-e Shōnin; site of important Buddhist painting atelier. 21

Kōzei; *see Fujiwara Yukinobu*

Kshitigarbha; *see Jizō*

Kufuku-ji, Nara Pref. 弘福寺
One of the oldest temples in Yamato area; also known as Kawahara-dera.

Kūkai; Kōbō Daishi (774–835) 空海
Founder of Shingon sect in Japan; outstanding calligrapher, patron of temple architecture and sculpture. 98

Ku K'ai-chih (ca. 344–406) 顧愷之
Among most distinguished early Chinese painting masters.

Kung Hsien (d. 1689) 龔賢
Strongly individual landscape painter of Nanking.

Kunō-ji-kyō 久能寺經
Set of ornamented sūtras donated ca. 1141 by group of aristocrats to Kyoto temple of Kunō-ji; texts now dispersed.

Kuo Hsi (ca. 1020–1070) 郭熙
Northern Sung landscape master.

Kusumi Morikage (active ca. 1700) 久隅守景
Student of Kanō Tan'yū; broke with Kanō school to become independent painter. 81

Kyōgen 狂言
Theatrical form; rough, burlesque popular theater converted into refined entr'actes in Nō.

Kyosen (mid-18th cen.) 巨川
Print designer; associated with Suzuki Harunobu.

Kyōzuka 經塚
"Sūtra Mound"; buried deposits of holy texts and images awaiting the coming of Maitreya. 22–24

Lan-tsan (9th cen.) 懶瓚

Lin-chi (Rinzai) (d. 867) 臨濟
Major Ch'an teacher in South China; founder of sub-sect of Ch'an Buddhism, stressing intuition, great freedom of action, use of the kōan. 78

Ling-chao; *see Reishō*

Ling-yün (d. 729) 靈雲
South Chinese Ch'an monk; attained Enlightenment while looking at a peach tree. 65, 78

Li Yü (1611–?1680) 李漁
Poet, dramatist, essayist; author of preface to Mustard Seed Garden Painting Compendium. 115

Lu Hsiu-ching (early 5th cen.) 陸修靜
Taoist priest and wonder-worker.

Lü Hui-ch'ing (11th cen.) 呂惠卿
Northern Sung government official whose vision of Mañjuśrī is origin of Nawa Monju painting type. 64

Lu T'an-wei (4th cen. A.D.) 陸探微
Outstanding early Chinese painting master.

Mahāsthāmaprāpta; *see Seishi*

Mahāvairocana; *see Dainichi*

Maitreya; *see Miroku*

Mampuku-ji, Kyoto 萬福寺
Near Uji; headquarters of Ōbaku sect; founded 1654 by Ingen. 100

Mandara (mandala) 曼荼羅
Schematic diagram showing relationship

Art critic, painter, calligrapher; greatly influenced the Wên-jên theory of the arts; widely studied and admired in Japan.

Tung Yüan (mid-10th cen.) 董源

Unkei (late 12th–early 13th cen.) 運慶
Master Buddhist sculptor of Kōfuku-ji; founder of Kei school (q.v.), together with his brother Kaikei.

Unkō (17th cen.) 運好
Sculptor who repaired Jizō image (No. 37); considered himself in line of artistic descent from Unkei.

Unkoku Tōgan (1547–1618) 雲谷等顔
Ink painter; assumed official succession to the style of Sesshū; founder of Unkoku school.

Uragami Gyokudō (1745–1820) 浦上玉堂
Bunjin painter and koto master from Okayama. 127, 128

Uragami Shunkin (1779–1846) 浦上春琴
Bunjin painter; son of Gyokudō. 129

Utagawa Toyoharu (1735–1814) 歌川豊春
Ukiyo-e print designer; founder of Utagawa school.

Utagawa Toyohiro (1773–1829) 歌川豊廣

Vaiśravana; see Bishamon-ten
Vidyārāja; see Myō-ō
Vimalakīrti
Semilegendary India layman of Vaiśalī; possessed of wisdom surpassing that of Bodhisattvas; described in Vimalakīrti-nirdeśa-sūtra.
Vinaya; see Ritsu
Virūpāksha; see Kōmoku-ten
Vishnu
Great Hindu deity; source of creation, sustenance, and destruction of universe.

Wang An-shih (1021–1086) 王安石
Chinese imperial adviser and radical government reformer.

Wang Fu (1362–1416) 王紱
Yüan period master of landscapes and bamboo.

Wang Hsi-chih (321–379) 王羲子
Celebrated calligrapher. 118

Wang Hui (1632–1717) 王翬
Early Ch'ing master of orthodox landscape painting in Wên-jên tradition. Style influential among conservative Japanese Bunjin.

Wang Kai (17th cen.) 王概
Compiler of Mustard Seed Garden Compendium. 115

Wang Wei (699–759) 王維
T'ang courtier, poet, and painter.

Watanabe Kazan (1793–1841) 渡邊華山
Bunjin; student of Tani Bunchō; portraitist.

Wên Cheng-ming (1470–1559) 文徵明
Ming period Wên-jên painter and calligrapher, greatly admired in Japan.

Wên-jên; see Bunjin

Wu Chen (1280–1354) 吳鎮
Yüan-period landscapist.

Wu-chün Shih-fan (d. 1249) 無準師範
Ch'an monk; influential theologian at sanctuary of Mount Ching, near Hangchou.

Wu Wei-tsu (11th cen.) 無為子
Poet quoted in No. 95.

Yakushi (Bhaishajyaguru) 藥師
Buddha; healer of ills of the body and spirit; popular figure in early Japanese Buddhism.

Yakushi-ji, Nara 藥師寺
One of the main eighth-century temples of Nara; worship centered on Yakushi.

Yamada Dōan (mid-16th cen.) 山田道安
Samurai; master of suiboku-ga. 76

Yamaguchi Sekkei (d. 1669) 山口雪溪
Kyoto decorative painter in Kanō style.

Yamamoto Bai'itsu (1783–1856) 山本梅逸
Bunjin painter from Nagoya; settled in Kyoto for a period.

Yama Rāja; see Emma-ō

Yamato-e 大和繪
Native-style Japanese painting as distinguished from that based on Chinese forms.

Yanagisawa Kien (1706–1758) 柳澤淇園
Pioneer painter and calligrapher of Japanese Bunjin. 114

Yang-ch'i (d. 1049) 楊岐

Northern Sung Ch'an monk; portrait painted by Bunsei.

Yasha (Yaksha) 夜叉
Indian folk deities of animist nature; widely worshiped in East Asian Buddhism.

Yen Hui (14th cen.) 顔輝
Chinese painter of Buddhist and Taoist themes, well-known in Japan.

Yin-t'o-lo (late 13th cen.) 因陀羅
Ch'an Buddhist monk-painter active in Hangchou region.

Yin-yüan Lung-chu; see Ingen Ryūki

Yokoi Kinkoku (1761–1832) 横井金谷
Monk of Jōdo sect; painter in Bunjin style of Buson. 123–126

Yōryu Kannon 楊柳觀音
"Kannon of the Willow"; form similar to that of the Byakue and Suigetsu Kannon (q.v.); widely depicted in Ch'an painting.

Yosa Buson (1716–1783) 與謝蕪村
Master of Bunjin-ga and haiku verse. 119–122.

Yosegi-zukuri 寄木造
Assembled wood-block method of constructing Buddhist statues. 20

Yōsō Sō-i (d. 1458) 養叟宗頤
Abbot of Daitoku-ji; portrait painted by Bunsei; adversary of Ikkyū.

Yü Chien (active ca. 1230) 玉澗
Ch'an monk-painter, Hangchou region; ·widely admired in Japan for broken-ink (haboku) technique.

Yūnen-ji, Nara 融念寺

Zen (Ch'an, Dhyana) 禪
Major sect of Buddhism established in Japan in early 13th century; emphasis upon traditional Buddhist self-descipline combined with recognition of secular art forms as vehicles of spiritual content; long prior development in China.

Zenzai Dōji (Sudhana) 善財童子
Youthful prince in search of truth; figures prominently in literature

Zōbō 像法
"Counterfeit Law"; second stage of the Buddhist conception of the devolution of the faith. See Shōbō, Mappō. 22–24

Produced by KODANSHA INTERNATIONAL Ltd., Tokyo, Japan.
Design and layout by MAEDA DESIGN ASSOCIATION, Tokyo, Japan.

between deities; commonly used by
Esoteric Buddhist sects.

Manibhadra
*Indian folk-deity; a Yasha (q.v.);
Lord of Wealth.*

Mañjuśrī; *see Monju*

Mappō 末法
Part of conception of progressive devolution of Buddhist Law; third and the final stage in the devolution of the faith.
22–24

Marishi-ten (Marīci) 摩利支天
Esoteric Buddhist goddess; deification of power of sun's rays. 21

Maruyama Ōkyo (1733–1795) 圓山應擧
Leading Kyoto artist; combined traits of Kanō and Western style in a highly personal manner.

Maruyama-Shijō school 圓山四條
School of painting that combines elements of Maruyama Ōkyo's style with that of his pupil Goshun; active late Edo—early Meiji period.

Ma-tsu (707–786) 馬祖
Chinese Ch'an monk; outstanding teacher in Southern Ch'an tradition. 78

Matsuo Bashō (1644–1694) 松尾芭蕉
Leading master of haiku. 126

Ma Yüan (active 1190–1225) 馬遠
Leading landscape painter of Southern Sung Academy, Hangchou.

Mi Fei (1051–1107) 米芾
Northern Sung landscape painter; style distinguished by use of strong horizontal brushstrokes.

Mii-dera; *see Onjō-ji*

Minagawa Kien (1734–1807) 皆川淇園
Bunjin master, Kyoto-Osaka region; Confucian scholar.

Minami Hokke-ji, Nara Pref. 南法華寺
Founded early 8th century, Yamato district. Also called Tsubosaka-dera.

Miroku (Maitreya) 彌勒
Bodhisattva and Buddha of Future; dwelling now in Tushita Paradise, awaiting time for rebirth on earth.

Miyagawa Chōshun (1682–1752) 宮川長春
Ukiyo-e painter; founder of Miyagawa school. 143

Moku'un Ryūtaku (died 1508) 黙雲龍澤

Kyoto Zen monk.

Monju (Mañjuśrī) 文殊
Bodhisattva; personification of wisdom.
44, 64

Moriage 盛上
Use of gesso ground to model in relief portions of a screen painting, such as blossoms and tree leaves.

Mu Ch'i (1177–1239) 牧谿
Ch'an monk-painter of Hangchou region widely admired in Japan.

Murakami Kagaku (1888–1939) 村上華岳
Kyoto traditionalist painter, specializing in Buddhist and Bunjin themes.

Murata Jukō (1423–1502) 村田珠光
Monk of Daitoku-ji; disciple of Ikkyū; pioneer of tea ceremony. 66

Musō Soseki (1275–1351) 夢窓疎石
Zen monk; adviser to Ashikaga Takauji; garden designer, poet, and calligrapher.

Myō-e (1173–1232) 明惠
Abbot of Kōzan-ji; outstanding theologian, Kegon sect, and patron of the arts.

Myō-ō (Vidyārāja) 明王
Class of Esoteric Buddhist deities; embodiments of the furious energy for destruction of evil and the protection of good. See Aizen, Fudō.

Myōren-ji, Kyoto 妙蓮寺

Myōshin-ji, Kyoto 妙心寺
Vast Rinzai Zen monastery compound, west of city; founded 14th century.

Nagasawa Rosetsu (1755–1799) 長澤蘆雪
Eccentric painter; former student of Ōkyo. 87, 88

Nakabayashi Chikutō (1776–1853) 中林竹洞
Bunjin painter from Nagoya. 131

Nakayama-dera, Kuzunuki 中山寺, 葛貫
54

Namban 南蠻
"Southern Barbarian"; designation of Europeans and other foreigners coming to Japan in 16th and 17th centuries.

Nan-chüan (late 8th cen.) 南泉
Chinese Ch'an monk; disciple of Ma-tsu. 78, 104

Nanzen-ji, Kyoto 南禪寺

Rinzai monastery, east of city; founded
late 13th century.

Nara Kantei (16th cen.) 奈良鑑貞
Suiboku painter.

Natsumi-dera, Mie Pref. 夏見廃寺

Negoro-dera, Wakayama Pref. 根來寺
Headquarters of Shingi Shingon sect; center of popular style of lacquer ware.
144

Nehan (Nirvāna) 涅槃
The supreme spiritual state of Enlightenment; attained by extinguishing all illusions.

Nembutsu-ji, Kyoto 念佛寺
Popular temple of Pure Land creed, west of city.

Nichiren (1222–1282) 日蓮
Founder of Hokke sect; passionate believer in saving grace of Lotus Sūtra.

Nikkō, Tochigi Pref. 日光
Site of the Tōshō-gū (q.v.).

Ninna-ji, Kyoto 仁和寺
West of Kyoto in Omuro district; Shingon sect.

Ninshō (1217–1303) 忍性
Monk-disciple of Eison of Saidai-ji.

Nishi Hongan-ji, Kyoto 西本願寺
Headquarters of Jōdo Shin sect.

Nishikawa Sukenobu (1671–1751) 西川祐信
Ukiyo-e painter and print designer; resident of Kyoto.

Ni Tsan (1301–1374) 倪瓚
Poet, calligrapher, and painter of landscapes.

Nō 能
Theatrical form that arose under strong Zen influence during Muromachi period, imbuing traditional Japanese literary themes with strong metaphysical overtones. 63

Nōami (1397–1471) 能阿彌
Painter, adviser to the Shogun Yoshimasa; father of Geiami.

Nukina Kaioku (1778–1863) 貫名海屋
Bunjin calligrapher and painter, settled in Kyoto. 132

Nyoi-hōju (Cintāmani) 如意法珠
Fabulous gem held by Buddhist deities, capable of gratifying every wish.

Nyoirin Kannon 如意輪觀音
Esoteric form of Kannon, holding the

century syncretic combination of Amidism with Esoteric Buddhism; headquarters at Negoro-dera. See Kakuban.

Shingon (Mantra) 眞言
Chief Esoteric Buddhist sect in Japan; stresses use of secret, magic phrases, such as dhāranī (q.v.). See Kūkai, Tō-ji, Kōya-san.

Shinkaku (d. ca. 1180) 心覺
Compiler of Besson Zakki. 41

Shinkō 秦廣
First of the Ten Kings of Hell. 49

Shinkō-in, Kyoto 神光

Shin Yakushi-ji, Nara 新藥師寺
Founded in 747 by Empress Kōken for sake of Emperor Shōmu, then ill.

Shishi (Simha) 師子
Transliteration of Sanskrit name for lion. 51

Shitennō 四天王
Divine kings of the four quadrants of the compass; guardians of Buddhist altars, temples, and devotees. 15, 41

Shitennō-ji, Osaka 四天王寺
One of the oldest full-fledged monasteries in Japan; founded late 6th cen.

Shōbō 正法
In Buddhist conception of the devolution of the faith, the period of the True Law immediately following the death of the Buddha. 22–24

Shōbōritsu 正法律
School of Shingon Buddhism established by Jiun. 101

Shōfuku-ji, Fukuoka 聖福寺

Shōkadō Shōjō (1584–1639) 松花堂昭乗
Shingon monk, calligrapher, and painter. 98

Shō Kannon (Ārya Avalokiteśvara) 聖觀音
Most common form of Kannon; shown without demonic features or multiple limbs. 27, 54

Shōkei Ten'yū (mid-15th cen.) 松谿天遊
Monk-painter; member of Shūbun's circle, Kyoto. 69

Shokō 初江
Second of the Ten Kings of Hell. 49

Shōkoku-ji, Kyoto 相國寺
Sometimes pronounced Sōkoku-ji; one

of five major Zen temples of Kyoto in Muromachi period.

Shokusanjin 蜀山人
Penname of Ōta Nanpo (q.v.).

Shōmei-ji, Kamakura 聖名寺

Shōren-in, Kyoto 青蓮寺
Temple founded in 1144 in Higashiyama district; center of distinctive style of calligraphy. 98

Shōri-ji, Nagoya 勝利寺

Shōsō-in, Nara 正倉院
Repository of 8th-century imperial donations and temple treasure at Tōdai-ji.

Shōtoku Taishi (574–622) 聖德太子
Prince Regent; great patron of Buddhist faith; author of Constitution in Seventeen Clauses; believed to be incarnation of Guze Kannon. 50

Shūbun; see Tenshō Shūbun

Shūfuku-ji, Shiga Pref. 崇福寺

Shugen-dō 修驗道
Training in severe asceticism in mountains; offshoot of Esoteric Buddhism.

Shunjōbō Chōgen (1120–1206) 俊乘房重源
Monk of Tōdai-ji; led rebuilding of monastery; patron of Kaikei.

Shuntoku-ji, Nagasaki 春德寺

Soga Chokuan (late 15th–early 16th cen.) 曾我直庵
Specialist in suiboku bird-and-flower themes; work in Daitoku-ji.

Soga Dasoku (mid-15th cen.) 曾我蛇足
Believed to be monk-painter of Daitoku-ji; associate of Ikkyū.

Sōgana 草がな
Writing of native hiragana script in grass-writing (sōsho, q.v.) style.

Soga Nichokuan (active ca. 1656) 曾我二直庵
Son and artistic follower of Chokuan.

Soga Shōhaku (1730–1781) 曾我蕭白
Highly individualistic painter of Kyoto. 82–86

Sōji (early 17th cen.) 宗二
Papermaker associated with Kōetsu; resident at Takagamine. 105

Sokuan Ryōchi (d. 1419) 足庵靈知
Monk of Tōfuku-ji; inscribed Josetsu's painting of catfish and gourd. 65

Sonchō (d. 1597) 尊朝
Calligrapher of imperial blood in Shōren-in.

Son'en (1298–1356) 尊圓
Calligrapher; son of Emperor Fushimi; abbot of Shōren-in.

Sō Shiseki (1712–1786) 宋紫石
Specialist in Chinese-style bird-and-flower painting.

Sōsho (Ts'ao-shu) 草書
"Grass writing"; writing style developed in Later Han times in China; utmost abbreviation of character forms and rapidity of writing; the origin of Japanese hiragana.

Sōtei 宋帝
Third of the Ten Kings of Hell. 49

Srī-lakshmī; see Kichijō-ten

Sue ware 須惠器
Ceramic type introduced from Korea; gray, high-fired, utilitarian ware; current from Asuka through Kamakura periods.

Sugawara Michizane (845–903) 菅原道眞
Heian period courtier; slandered and exiled; after death, worshiped as Shintō deity, named Kitano Tenjin; became patron spirit of native Japanese letters and culture.

Suigetsu Kannon 水月觀音
Similar to Byakue (q.v.) form; Kannon shown meditating upon reflection of moon in water; theme popular in Kegon and Zen sects.

Sumiyoshi Jokei (1599–1670) 住吉如慶
Tosa-style painter; founder of Sumiyoshi school of Yamato-e.

Sumiyoshi Shrine, Osaka 住吉神社

Su Tung-p'o (1036–1101) 蘇東坡
Outstanding Chinese poet and essayist.

Suzuki Harunobu (1725–1770) 鈴木春信
Ukiyo-e print designer; credited with perfection of multiple color wood-block print.

Suzuki Harushige (1738–1818) 鈴木春重
Follower and imitator of Harunobu for brief period; became active artist in Western style. 146

Tachibana-dera, Nara Pref. 橘寺

Art critic, painter, calligrapher; greatly influenced the Wên-jên theory of the arts; widely studied and admired in Japan.

Tung Yüan (mid-10th cen.) 董源

Unkei (late 12th–early 13th cen.) 運慶
Master Buddhist sculptor of Kōfuku-ji; founder of Kei school (q.v.), together with his brother Kaikei.

Unkō (17th cen.) 運好
Sculptor who repaired Jizō image (No. 37); considered himself in line of artistic descent from Unkei.

Unkoku Tōgan (1547–1618) 雲谷等顔
Ink painter; assumed official succession to the style of Sesshū; founder of Unkoku school.

Uragami Gyokudō (1745–1820) 浦上玉堂
Bunjin painter and koto master from Okayama. 127, 128

Uragami Shunkin (1779–1846) 浦上春琴
Bunjin painter; son of Gyokudō. 129

Utagawa Toyoharu (1735–1814) 歌川豊春
Ukiyo-e print designer; founder of Utagawa school.

Utagawa Toyohiro (1773–1829) 歌川豊廣

Vaiśravana; see Bishamon-ten
Vidyārāja; see Myō-ō
Vimalakīrti
Semilegendary India layman of Vaiśalī; possessed of wisdom surpassing that of Bodhisattvas; described in Vimalakīrti-nirdeśa-sūtra.
Vinaya; see Ritsu
Virūpākśa; see Kōmoku-ten
Vishnu
Great Hindu deity; source of creation, sustenance, and destruction of universe.

Wang An-shih (1021–1086) 王安石
Chinese imperial adviser and radical government reformer.

Wang Fu (1362–1416) 王紱
Yüan period master of landscapes and bamboo.

Wang Hsi-chih (321–379) 王義子
Celebrated calligrapher. 118

Wang Hui (1632–1717) 王翬
Early Ch'ing master of orthodox landscape painting in Wên-jên tradition. Style influential among conservative Japanese Bunjin.

Wang Kai (17th cen.) 王概
Compiler of Mustard Seed Garden Compendium. 115

Wang Wei (699–759) 王維
T'ang courtier, poet, and painter.

Watanabe Kazan (1793–1841) 渡邊華山
Bunjin; student of Tani Bunchō; portraitist.

Wên Cheng-ming (1470–1559) 文徵明
Ming period Wên-jên painter and calligrapher, greatly admired in Japan.

Wên-jên; see Bunjin

Wu Chen (1280–1354) 吳鎮
Yüan-period landscapist.

Wu-chün Shih-fan (d. 1249) 無準師範
Ch'an monk; influential theologian at sanctuary of Mount Ching, near Hang-chou.

Wu Wei-tsu (11th cen.) 無為子
Poet quoted in No. 95.

Yakushi (Bhaishajyaguru) 藥師
Buddha; healer of ills of the body and spirit; popular figure in early Japanese Buddhism.

Yakushi-ji, Nara 藥師寺
One of the main eighth-century temples of Nara; worship centered on Yakushi.

Yamada Dōan (mid-16th cen.) 山田道安
Samurai; master of suiboku-ga. 76

Yamaguchi Sekkei (d. 1669) 山口雪溪
Kyoto decorative painter in Kanō style.

Yamamoto Bai'itsu (1783–1856) 山本梅逸
Bunjin painter from Nagoya; settled in Kyoto for a period.

Yama Rāja; see Emma-ō

Yamato-e 大和繪
Native-style Japanese painting as distinguished from that based on Chinese forms.

Yanagisawa Kien (1706–1758) 柳澤淇園
Pioneer painter and calligrapher of Japanese Bunjin. 114

Yang-ch'i (d. 1049) 楊岐

Northern Sung Ch'an monk; portrait painted by Bunsei.

Yasha (Yaksha) 夜叉
Indian folk deities of animist nature; widely worshiped in East Asian Buddhism.

Yen Hui (14th cen.) 顔輝
Chinese painter of Buddhist and Taoist themes, well-known in Japan.

Yin-t'o-lo (late 13th cen.) 因陀羅
Ch'an Buddhist monk-painter active in Hangchou region.

Yin-yüan Lung-chu; see Ingen Ryūki

Yokoi Kinkoku (1761–1832) 横井金谷
Monk of Jōdo sect; painter in Bunjin style of Buson. 123–126

Yōryu Kannon 楊柳觀音
"Kannon of the Willow"; form similar to that of the Byakue and Suigetsu Kannon (q.v.); widely depicted in Ch'an painting.

Yosa Buson (1716–1783) 與謝蕪村
Master of Bunjin-ga and haiku verse. 119–122.

Yosegi-zukuri 寄木造
Assembled wood-block method of constructing Buddhist statues. 20

Yōsō Sō-i (d. 1458) 養叟宗頤
Abbot of Daitoku-ji; portrait painted by Bunsei; adversary of Ikkyū.

Yü Chien (active ca. 1230) 玉潤
Ch'an monk-painter, Hangchou region; widely admired in Japan for broken-ink (haboku) technique.

Yūnen-ji, Nara 融念寺

Zen (Ch'an, Dhyana) 禪
Major sect of Buddhism established in Japan in early 13th century; emphasis upon traditional Buddhist self-descipline combined with recognition of secular art forms as vehicles of spiritual content; long prior development in China.

Zenzai Dōji (Sudhana) 善財童子
Youthful prince in search of truth; figures prominently in literature

Zōbō 像法
"Counterfeit Law"; second stage of the Buddhist conception of the devolution of the faith. See Shōbō, Mappō. 22–24

Produced by KODANSHA INTERNATIONAL Ltd., Tokyo, Japan.
Design and layout by MAEDA DESIGN ASSOCIATION, Tokyo, Japan.